THE DEATH OF THE BAROQUE
AND
THE RHETORIC OF GOOD TASTE

In late seventeenth- and early eighteenth-century Rome, a rhetorical war raged among intellectuals in the attack and defense of language, literature, and the visual arts. *The Death of the Baroque and the Rhetoric of Good Taste* examines the cultural upheaval that accompanied attacks on the baroque predilection for ornament, extended visual metaphors, grandiloquence, and mystical rapture. Rome's Academy of the Arcadians emerged as a potent social and cultural force in the final decade of the seventeenth century, and throughout the eighteenth century it provided a setting for arguments on artistic taste and reforms in literature and religion. This book describes the waning days of the baroque, and ends with an analysis of the Parrhasian Grove, the Arcadian garden on the slopes of Rome's Janiculum Hill.

Vernon Hyde Minor is professor in the departments of art and art history, and comparative literature and the humanities, at the University of Colorado, Boulder. A Fellow of the American Academy in Rome and member of the Association of Members of the Institute for Advanced Study, he is the author of *Art History's History, Baroque and Rococo: Art and Culture*, and *Passive Tranquility: The Sculpture of Filippo de la Valle*. He is currently the Editor of the *Memoirs of the American Academy in Rome*.

THE DEATH OF
THE BAROQUE

AND

THE RHETORIC OF
GOOD TASTE

VERNON HYDE MINOR

CAMBRIDGE
UNIVERSITY PRESS

CAMBRIDGE UNIVERSITY PRESS
Cambridge, New York, Melbourne, Madrid, Cape Town, Singapore, São Paulo

Cambridge University Press
40 West 20th Street, New York, NY 10011-4211, USA

www.cambridge.org
Information on this title: www.cambridge.org/9780521843416

First published 2006

Printed in Hong Kong by Golden Cup

A catalog record for this publication is available from the British Library.

Library of Congress Cataloging in Publication Data
Minor, Vernon Hyde.
The death of the baroque and the rhetoric of good taste / Vernon Hyde Minor.
p. cm.
Includes bibliographical references and index.
ISBN-13: 978-0-521-84341-6 (hardback)
ISBN-10: 0-521-84341-3 (hardback)
1. Arts, Baroque – Italy. 2. Arts, Italian – 16th century. 3. Aesthetics, Modern – 17th century.
4. Art criticism – Italy – History – 17th century. I. Title.
NX552.A1.M55 2005
700'.9'032 – dc22 2005011725

ISBN-13 978-0-521-84341-6 hardback
ISBN-10 0-521-84341-3 hardback

CONTENTS

v

ILLUSTRATIONS

ACKNOWLEDGMENTS

I first encountered references to *buon gusto* back in the 1970s when I was scouring through Caterina Chracas's gossipy little Roman newspaper *Il diario ordinario*. Nearly every time she described the dedication of a new work of art in early-eighteenth-century Rome, she inserted this phrase. It was clear to me that there was some considerable meaning lying behind what seems on the surface to be an innocent appeal to good taste. Because I have, in fact, been thinking about the subject of this book since graduate school days, my debts of gratitude are legion. My doctoral adviser, Robert Enggass, was there at the beginning and spoke with me about Roman art of the settecento just before his death late in 2003. There are no words to describe his encouragement and support – and so I will leave it at that.

I did not actively begin the research and writing of this book until 1997–1998, when I was fortunate enough to be, while on sabbatical from the University of Colorado, a member of the Institute for Advanced Study (IAS) in Princeton. There Irving Lavin was an important presence and an encouraging colleague. He and his wife, Marilyn, organized Monday lunches for those of us interested in visual studies, and I have vivid memories of the stimulating conversations we had. And the fun. Marian Zelazny, the administrative officer of the School of Historical Studies at the IAS, made everything work, and Allen Rowe, the associate director of the Institute, became a friend, and is one to this day. He helped me in any number of ways during my tenure there.

In 1999–2000, I was the National Endowment for the Humanities (NEH) senior Rome prize fellow at the American Academy in Rome. The director of the academy, Lester Little, organized "shop talks," which we all enjoyed. When it was my turn, I spoke on *buon gusto* and the Academy of the Arcadians. There is nothing like the fellowship shared at such a place, nor no more beautiful setting than the American Academy in Rome. I thank Adele Chatfield Taylor, Wayne A. Linker, Pina Pasquantonio, Lella Gandini, Anne Coulson, and Christina Huemer of the American Academy who work tirelessly for the benefit of the fellows and this wonderful place. The continued collaboration of the National Endowment for the Humanities, who sponsored my fellowship, is

crucial to the success of the academic mission at the academy. I am grateful to the NEH.

For three months in the spring of 2001, I was a visiting fellow – in fact, a "scientific guest" – at the Bibliotheca Hertziana in Rome. Elisabeth Kieven, codirector of the Hertiziana, has been a colleague since the days when we were both writing our dissertations. The Hertziana and the Max Planck Gesellschaft are fortunate indeed to have Elisabeth at the helm. She was gracious and endlessly helpful during my time in Rome. John Pinto of Princeton University, also a fellow at the Hertziana, was kind enough to share his office with me. We had a number of adventures together in Rome and became fast friends. He has read parts – and indeed, all – of this manuscript probably more times than he would like to remember. His ability to give just the right suggestion for changes and rearrangements amazes me. I thank him and his wife Meg for their friendship and support.

Many at the University of Colorado at Boulder have been superb mentors and colleagues. I especially want to thank Paul Gordon, David Ferris, Erika Doss, and Claire Farago. Tod Gleeson, dean of the College of Arts and Sciences, along with associate dean for the Arts and Humanities Graham Oddie, have been unfailingly helpful and generous.

On a number of occasions, the Graduate Committee on Arts and Humanities and the Council on Research and Creative Work have provided me with much needed and much appreciated travel grants.

The Roman library that holds in its Fondo Antico the documents and texts of the Accademia degli Arcadi, the Biblioteca Angelica, is a delightful place to work. Vanvitelli's beautiful reading room, which soars like a cathedral, inspired me in my studies. I thank the director of the Angelica, Marina Panetta, along with Daniela Scialanga, who assisted me with acquiring photographs of documents in their collection.

Janice Powell of Princeton University's Marquand Art Library has made me feel welcomed and has assisted me beyond anything I had a right to expect in the use of one of the world's premier collection of art historical texts. It heartens me that such places exist. We are all the richer for people like Jan, custodians of vast bibliographic wealth and delightful spaces in which to study. Liesel Nolan, head librarian of the University of Colorado's art library, never failed to help me find resources for my researches, and I thank her for her assistance over the years.

Finally, I thank my wife Heather for everything. To her I dedicate this book.

INTRODUCTION

As one ascends Rome's Janiculum Hill by the Via Garibaldi, mounting the steep incline toward Bramante's Tempietto, the Bosco Parrasio appears to one side among the trees and tall grass, laurels, myrtle, and ilexes. In this spot of tranquillity and peace, the Parrhasian Grove provided a charming setting in the eighteenth century for "great writers, philosophers, or artists, all the noble lords, all the rich bankers, all the astute lawyers, all the well-known doctors, all the sainted priests, all the beautiful ladies" of Rome.[1] Here, in a place named after a sacred grove of Apollo in Greece, these literati gathered for pastoral ceremonies. The Accademia degli Arcadi set the tone for good taste in Rome. The Arcadians dressed as shepherds and shepherdesses, adopted bucolic names, played harps and spinets, flirted, and made quiet conversation. This was, so they believed, a return to nature – a highly cultivated nature, to be sure.

In this book I write a series of essays generally organized around such topics as the climate of taste, especially as it was under the sway of the Academy of Arcadians, their promotion of *buon gusto*, and the collision of rhetorical values in late-seventeenth-, early-eighteenth-century Rome. I follow a cultural and artistic tradition through the environs of Rome's academies and the haunts of her intellectuals, art patrons, ecclesiastics, poets, painters, architects, and sculptors. The story is about pastoral poetics, good and bad taste, the emerging public sphere in the guise of an Arcadian academy, the Franco–Italian debate on language and style, the republic of letters, and the academicians. I try to account for both a waning baroque sensibility (although I do this more in rhetorical than political and religious terms) and a burgeoning insistence on *buon gusto* in culture, literature, and art.

What I call "climate" can also be seen as a discourse of power, in Michel Foucault's terms. The power Foucault means when articulating the actions and behavior of discourses is not one of domination or repression; it is, rather, a "making possible." As Arcadianism and its companion *buon gusto* circulated through Rome and its institutions in the eighteenth century, it abetted and allowed certain things to happen. It could regulate, adjust, arrange, manage, and order events in such a way that certain notions and abstractions – such as *buon*

gusto – became fairly standard beliefs. Systems of power, like the Arcadian movement, can subjugate individuals in a positive sense, make men and women into subjects, give them identity and individuation. And give them ideas.

By looking closely at circumstances in the arts and letters in Rome from the later seventeenth into the early eighteenth century, I try to engage with matters that are part of the practice of art but that also reach into broader areas of culture, politics, and religion. As I have intimated, this text is also about the weakening of the baroque style as it confronted the elusive matter of taste, specifically "good" taste. Although the Arcadians are central to the story that I try to tell, they are not its essence; the Accademia degli Arcadi was probably as symptomatic of complex cultural workings as any other group, institution, or powerful individual of the time. As we hardly need reminding, every effect arises from multiple causes; there rarely, if ever, is a prime mover in art or physics. That is why this text is as much a cultural and literary history as it is an art history; in other words, the "inflowings" that we call influences existed throughout the religious, artistic, and literate culture of the settecento and are not simple phenomena that move only between and among artists.[2] Although I try to trace some of the larger and more general contours of the period and its history, I am also interested in specific readings of works of art and analyzing various rhetorical strategies, such as the way narratives unfold in various paintings and statues.

I do not follow Liliana Barroero and Stefano Susinno, who, in their important article for the catalogue of the exhibition *Art in Rome in the Eighteenth Century*, held in 2000 in Philadelphia and Houston, characterized the new style promoted by the Arcadians as "classical."[3] This is, in my estimation, a rather anemic categorization and portrayal of something more deserving of close rhetorical examination. I argue that pastoral poetics have more to tell us about how things looked in early-eighteenth-century Rome than do old warhorses of classical and romantic or linear and painterly.

A more pressing question at the moment might be this: Why did the baroque (I am thinking of what has traditionally been called the "high" or "dramatic" baroque), as a set of stylistic strategies – or, better, as a rhetorical stance – decline? What has driven so many critics and art historians from different cultural backgrounds over such a long period of time to dismiss this extraordinary rhetorical mode as "tinged by the bizarre," as the "excess of the ridiculous," and the "superlative of the bizarre," as that which is "irregular, bizarre, uneven?"[4] The recurrence of the word bizarre in these quotations suggests more than the usual loathing that accompanies the end of a particular style or cultural expression; these connotations of the whimsical and eccentric, of deviance and decadence, seem to have been uttered with distaste by baroque's enemies. The divergence from accepted taste (although the taste from which the baroque deviated had not yet occurred) soon enough came to be called "bad" taste, as in Giovanmario Crescimbeni's cry, "Esterminare il cattivo gusto!" Stamp out bad taste!

Who controls taste, controls culture; who controls culture, controls Italy. Against taste, baroque sins; against culture, baroque sins; against Italy, baroque sins.

This polemic (in the form of a *gradatio*) is not mine but belongs to the eighteenth century. We realize that there are any number of reasons why styles and modes of individual and cultural expression change, and this text cannot provide a full accounting for such a complex historical occurrence. My intention is to demonstrate how Franco–Italian literary debates, the phenomenon and discourse of Arcadianism and pastoralism, and the Italian version of *buon gusto* – which anticipates much of the Anglo–German debates on taste – provide the fertile soil out of which change could grow and cultural conflicts flourish.

I must advise the reader that what follows is not a history of art in early-eighteenth-century Rome. Rather than attempt something comprehensive, I have opted for essays that approach taste, art, and culture from various points of view. In the first chapter, I try to isolate certain aspects of "bad taste" – the despised *cattivo gusto* so often excoriated by the Arcadians and like-minded intellectuals. I hope it is clear that what they despised I admire; and yet, despite my approbation, I do not attempt to take full measure of baroque visual rhetoric. I try to sketch the contours of *secentismo* as contemporaries understood it, without offering an extensive historical accounting. That deserves a fuller treatment in another venue. Chapters 2 and 3 are more sustained essays on *buon gusto* and the attendant issues of Arcadianism and pastoralism. Chapter 4 addresses the question of whether we can, with any legitimacy, talk about Arcadian architecture. In Chapter 5, I provide a brief history of the Accademia degli Arcadi. Although the Arcadians have in no way been ignored by Italian historians and critics of literature, art historians have come rather late to the game. As I have mentioned, only in 2000, as part of the superb exhibition *Art in Rome in the Eighteenth Century*, has the Academy of the Arcadians been taken seriously, especially in the English-speaking world, as an institution of real art historical significance. Finally, in Chapter 6, I explore the now largely forgotten Bosco Parrasio, a tangible if rudimentary artifact of Giovanmario Crescimbeni, the long-lived chief herdsman of the Arcadians, and his academy of Arcadian shepherds. I treat the old garden as an embodiment of early-eighteenth-century Roman pastoralism, almost as if it were a free-standing idyll. I take seriously what Crescimbeni and his accademicians took seriously: Arcadia is a landscape of art.

ONE:

CATTIVO GUSTO AND SOME ASPECTS
OF BAROQUE RHETORIC

How does one account for the contempt held by the Arcadians (and other theorists of the early settecento) for the poets, writers, and artists of the seicento?

Indeed, even in the twentieth century, one finds critics expressing such opinions as "it was the very formlessness of the 'seicento' that was responsible for Italy's literary undoing." This same writer also opines that "[t]he taste for fantastic thinking, for the 'concetti' of Marini [the poet Giambattista Marino, 1569–1625] and his followers, became universal, and paralyzed all serious literary effort."[1] James Mirollo portrays the attitude of the Arcadi and others: "As they saw it, the Marino period had been a bad dream, a time of a national literary disease soon to be called *seicentismo* – literally, seventeenth centuryism. And Marino, it was universally agreed, had been the leading germ carrier."[2]

In the world of literature, the seventeenth century in Europe seemed to be awash with "ismo": *marinismo* and *secentismo* in Italy; *culteranismo* and *gongorismo* in Spain.[3] Somewhat comparable movements appeared in Germany (*Schwulst*) and in England (Euphuism). Also, the Metaphysical poets in England were famous for their "far-fetched" conceits.[4] In France, the Pléiade continued the styles of the sixteenth century into the seventeenth, and, as a reaction against the apparent licentiousness of the court of Henri IV, a group of poets known as the *Précieuses* grew up around the salon of the Marquise de Rombouillet. All of these more or less self-conscious literary movements formed the congeries of the baroque and, eventually, raised aesthetic hackles throughout Europe. Molière's *Les Précieuses ridicules* (1659) was merely the first in a series of attacks on the French version of the literary baroque.

I mentioned earlier some of the assaults on *marinismo*. Francesco Algarotti (1712–1764) made specific connections between the baroque style of Marino and the visual arts, especially the architecture of Francesco Borromini.[5] The Arcadian and more general antibaroque camps never lost sight of the old notion of *ut pictura poesis* – as is poetry so is painting (and sculpture, and architecture) – and they condemned with a broad brush, as it were.[6] No artist who was highly dependent

on the marvelous, the element of surprise, and the use of elaborate visual conceits was free of their enmity.

In this chapter, I discuss the *visual* rhetoric of baroque spectacle; but first, I would like to examine a few other aspects of that stylistic phenomenon of the baroque to which its critics so vigorously objected. As Giambattista Marino himself acknowledged, his grand and magniloquent poems consisted more of "digressions and luxuriances," embellishment, intricate tableaux, and extended metaphor than of actual narrative. His love of the marvelous and of astonishment won him a few adherents in the seventeenth century (actually quite a few in Italy) but brought scorn down on him from abroad and, later on, from within Italy itself.

The *antimarinisti* of the early eighteenth century attacked baroque conceits as well. *Concettismo* is one of those "ismos" despised by the cognoscenti of the eighteenth century. Samuel Johnson in his *Life of Cowley* complained of the conceits of the metaphysical poets that they imitate "neither...nature nor life."[7] As we will see in the next section, *concettismo* has to do with hyperbole and the pushing of odd and sometimes highly intellectual comparisons as far as possible.

The French writer Jean Chapelain's view of Marino's poetry as a "bottomless and edgeless sea" is a complaint against extreme *concettismo* as that which is formless, boundless, nebulous, or inchoate. Marino's days as the poet laureate of the baroque were numbered. The next volleys against him and Italian literature of the preceding centuries (at least since Dante and Petrarch) came from, as we shall see (Chapter 2); a Frenchman, Père Bouhours, whose *Entretiens d'ariste e d'Eugène* of 1671 was followed quickly by Nicolas Boileau's *Art poétique* of 1674. The texts denigrated not only *marinismo* but also the Italian language itself. Not content with his first sally against baroque literature and the Italian language, Bouhours became ever more venomous in the *Manière de bien penser dans les ouvrages de l'esprit* of 1687. The battle lines now were clearly drawn, and the Italians came out swinging for their language and culture, if not in defense of Marino himself.

From its very beginnings, the baroque style was under attack.[8] The extreme inventiveness, performativeness, and magniloquence of baroque spectacle and *concettismo* were caught up in complex ways with debates on free will and religious experience. Although there was little mention of the religious overtones to the baroque style on the part of those who assailed it, it seems clear in retrospect that the Arcadians and others who hated the baroque were also taking close aim at Jesuit poetics.[9] Boileau in France as well as Lodovico Antonio Muratori and Gianvincenzo Gravina in Italy found fault in an intensely Catholic mode of expression. If not openly stating it, they were at least insinuating that the traditional Jesuit promotion of emotive images was in fact *cattivo gusto*. Although there is not space here to trace anti-Jesuit and specifically pro-Janesenist rhetoric from the mid–seventeenth century to the early eighteenth century, suffice it to say that in the intellectual circles of Paris and Rome there was a discernible shift in worldview. When Blaise Pascal attacked the Jesuits in *Les provinciales* (1656), he

launched a campaign that finally was to bring the society to its knees by the middle years of the eighteenth century.[10] He ridiculed Jesuit probabalism, its doctrine on grace, belief in free will, and "laxity" of morals. In succinct and vivid prose, Pascal made an argument on the side of the Jansenists, one that was in favor of a rigorous search for truth, belief in predestination, and the assertion that salvation emanates from divine grace rather than good works. Boileau was later to see that Pascal's cogent use of language marked the beginning of a new French literary tradition as well.

Despite the Church's repeated attacks on Jansenism (witness Clement XI's bull *Unigenitus*, signed in 1712), Roman Jansenists continued to meet more or less openly. Clement XII's *nipote*, Cardinal Neri Corsini, invited the Jansenists (many of whom belonged to the Accademia degli Arcadi) to gather in his home. One of the important patrons of eighteenth-century art and a leading Jansenist, Giovanni Gaetano Bottari (whose Arcadian name was Agesia Beleminio) was a great and close friend of Neri.[11] There certainly was a connection between Jansenism and *buon gusto*, but untying the intricate knot that fastens taste to religious ideology awaits another opportunity. Hanns Gross has presented the case for the importance of seeing Jansenism as a nexus for cultural studies in the Roman settecento: "A great deal of what happened in Rome during the ancien régime can only be explained in terms of the Jansenist controversy. Even areas beyond the strict confines of theology were shaped by events and thought patterns that on the surface had little to do with the confrontation of Jansenists and Jesuits, but which were still couched in those terms."[12] He may have overstated the case, in fact; but I believe that there is no denying the preoccupation of so many in France and Italy with the Jansenist controversy, the power of the papacy, the religious sovereignty of the French Church, and the cultural antagonism between the French and Italians. Indeed, there was a Franco–Italian war in the last quarter of the seventeenth century, one that raged in the salons; among the *eruditi* and savants; in the republic of letters; in the writing of sacred history; in the attack and defense of language, literature, and the visual arts; and in the very souls of these two languages, cultures, and traditions. The battles went on and on into the middle of the eighteenth century, when things calmed down for a while, with many in France turning their thoughts to revolution.

Before continuing with the Italians' own campaign against the baroque, I want to analyze those things that constitute the baroque vision and style. I am mindful of and quite in agreement with Mieke Bal's assertion that "style . . . refers to cultural attitudes and states of consciousness which encompass intellectual and aesthetic, political and scientific, assumptions and thoughts."[13] The cultural skin worn by style cannot be cut away without exposing its sinews to destructive elements; yet for the purposes of this study and for the sake of brevity, I am going to do just that. Then I attempt to redress baroque rhetoric in time for its meeting with Arcadian rhetoric.

THE RHETORICAL TURN

In his essay "Semiology and Rhetoric," published in 1979, Paul de Man put forward what he characterized as a modest effort at going beyond the form–content debate that had dominated literary (and, I would add, art historical) criticism since the 1930s. Form had been seen as the "inside" of an artifact, content its "outside." On close examination, de Man found this to be a false dichotomy, not because form *is* content – he had no interest in a McLuhanesque "medium as message (and massage)" – but because the languages of art, literature, and criticism inevitably mix up the two. De Man's close reading both of the traditions of metaphor and grammar and of particular texts led him to the observation that "the deconstruction of metaphor and of all rhetorical patterns such as mimesis, paronomasia, or personification that use resemblance as a way to disguise differences, takes us back to the impersonal precision of grammar and of a semiology derived from grammatical patterns."[14] There are consequences to collapsing metaphors into grammatical structures and asking rhetorical questions about the rhetorical element in any text. De Man refers not to so-called rhetorical effects such as ornament, eloquence, or persuasion but to "the study of tropes and of figures," which are things that arise out of the grammatical structure of language.[15] Although I have no intention of avoiding reader and viewer responses, I do agree that riveting one's attention only on persuasion will tell us little about what the Arcadians so despised. On the other hand, were we to accept the Arcadians disdain for ornament, we might miss the deeper issues of the controversy between good and bad taste.

By reattaching figural language to grammar, to the bare bones of syntax and the logic of sentences, de Man was able to jettison a misguided but time-honored notion that conceits and metaphors, tropes and figures, are "add-ons" used by rhetorical artists as nothing more than flourishes or so much icing on the cake.[16] At the same time, he was able to question the apparent rationality and logic of grammatical structures – the cake beneath the icing, so to speak. One can conclude from de Man's intricately worked-out studies and deconstructions of texts that he would have understood the complexities of *cattivo gusto* while remaining deeply suspicious of the claims of *buon gusto*.

Art historians studying the early modern period also have taken into account the importance of visual rhetoric. In the early 1950s, a conference was held in Venice on the topic of rhetoric and the baroque.[17] In his contribution to the proceedings, Giulio Carlo Argan drew a parallel between baroque art and the enthymeme, a rhetorical rather than a demonstrative argument.[18] Aristotle (*Prior Analytics*, ii, 27) contrasts the enthymeme with the syllogism because it induces probabilities or propositions that would strike one as being *generally* valid. In modern logic, enthymeme is a less explicit form of the classical syllogism because it is based on unexpressed premises – things that are tacit, that "go without

saying." It is, in effect, a rhetorical form of the syllogism.[19] In terms of baroque art, an enthymeme can be seen, among other things, as the religious attitude of the viewer. As Argan contends, Caravaggio's religious paintings do not necessarily express the artist's spiritual values nor attempt to prove the general validity of religious propositions; rather, they take into account the assumptions of the faithful and, in so doing, deliver a discourse that is sharp-edged, concise, violent, and (this is the rhetorical part) persuasive (although in an indefinite sense).

Baroque art does not attempt to persuade its audience of the truth of Christianity nor (necessarily) the legitimacy of the Catholic Church (although some art can be outright propaganda). But the baroque artist's many techniques, as Argan argues, move the viewer, touch his or her desires, uncover and reveal fundamental human reactions, and, in assuming the religious and moral base of existence, go beyond them to reveal in larger terms the whole scope of public and private life, its grief and joy, its mysteries and pleasures. Agostino Tassi uses *quadratura*, for instance, not to advance the study of Euclidean geometry but to draw on our knowledge of geometry and thence to plumb the depths of how we think about and experience space so that we allow ourselves the pleasure and emotional thrill of a virtual, visionary journey and experience. In this sense, the rhetoric of the baroque constitutes a repertory of tropes and schemes marshaled by the artist to engage (not just persuade in the narrow sense) the viewer in some profound way. This engagement or encountering can become aggressive, contestatory, and combative or, on the contrary, soothing, gentle, calming, and reassuring. Whether baroque rhetoric riles the viewer or puts her in a meditative, contemplative state, it inevitably incites in her mind what Charles Sanders Peirce calls interpretants – mental images that are parts of the process of signification. No sooner does one interpretant appear than another takes its place, signs leading to signs like a string of firecrackers firing rapidly and consecutively. Rather than following the semiotic trail of transforming interpretants, however, I want to ponder those tropes, figures, and techniques that constitute baroque rhetoric.

Conceit, Ekphrasis, and Metaphor

I have already intimated that *concettismo* (associated with *secentismo*) brought derision down on a century's worth of language, imagery, and culture. As used in Renaissance treatises and discourses on art, the *concetto* is the idea lying behind a specific execution, whether that idea exists in the mind of the artist or is somehow hidden in the inchoate material out of which the art object springs (the familiar idea that the marble contains the image *in potentia*).[20] Michelangelo's *concetto* is, in a sense, the nucleus of art, the prior idea of which the final form (the painting, the statue) derives.

But to restrict the *concetto* to an idea or concept gives short shrift to the metaphorical and sometimes occult implications of the term. Conceit as *discors concordia* involves the comparison of unlike things, the finding of similarity in dissimilarity. The *concetto*, however, is not immediately associated with metaphorical language in late Renaissance Italian treatises. An early comment in Italian critical literature on the *concetto* appears in Giulio Cortese's *Avertimenti nel poetare* (1591), where he describes the *concetto* as "that meditation which the spirit makes on some object offered to it, of what it means to write about."[21] In other words, the *concetto* is the treatment given by an author to a particular subject, how the author casts his or her theme, what words are chosen, what tone and point of view are adopted, what rhetorical strategies are brought to bear on it. Bernard Weinberg observes that "[t]he poet must take particular care to see that the words are adapted to the style in which he is writing and that the sounds are at once fitting to the thought and harmonious among themselves."[22] In this demonstration of the *concetto* in Italian literature, it does not appear to be much more than an attempt to match form and content, to give an appropriate style to a particular subject. An eighteenth-century critic such as Crescimbeni would have thoroughly approved and have seen this as an example of *convenevolezza*, a suitable and seemly decorousness.

Camillo Pellegrino's *Del concetto poetico*, 1598, in the form of a dialogue, has its star discussant Giambattista Marino say that the *concetto* "is the thought formed by the intellect as an image or resemblance of a real thing, signified by these latter [which are *senso, sentimento, sentenza*]."[23] Pellegrino in his assertion that the concetto is "a thought of the intellect, an image or resemblance of true things and of things which resemble the truth, formed in the fantasy" summons forth the importance of verisimilitude (*verosimile*). The poet can traffic in similitudes rather than the truth. That is to say, verisimilitude is here taken not as realism but as something different from (although related to) the truth; it is a product of the imagination – it is true, but similar rather than identical to something else. Whereas the orator persuades and sticks to that which is true, the poet gives pleasure and depends on his or her *fantasia*. Pellegrino continues in this vein by explaining that "[p]rose in expressing conceits uses pure forms of expression, proper words, and when it uses metaphors and figurative language it uses them rarely and with moderation; whereas verse, with greater liberty and sometimes with excessive boldness expresses its conceits with figures and metaphors distant from literal meanings."[24]

We are now in the country of Metaphysical and Marinesque conceit, where complex, extended metaphors compare objects, experiences, and sensations so distant from one another – and yet always connected by a slender if tenacious thread – that they create a sense of surprise and intellectual excitement. In the following sonnet, Marino makes the not unreasonable comparison of his beloved's hair to the sea. But when the ivory comb becomes a precious ship, milady's ivory

hand, the stern captain, and the lover's rebellious spirit, a heart shipwrecked on her diamond clips and drowned in her golden waves, we see how remarkable a conceit can be.

> Through waves of gold, the waves which were her hair,
>> A little ship of ivory sailed one day,
>> A hand of ivory steered it on its way
>> Through precious undulations here and there.
> And while along the tremulous surge of beauty
>> She drove a straight and never-ending furrow,
>> From the rows of tumbled gold Love sought to borrow
>> Chains to reduce a rebel to his duty.
> My shipwrecked heart veers down to death so fast
>> In this stormy, blond and gilded sea that I
>> Am caught forever in its waves at last.
> In golden gulfs, at last, I come to my
>> Tempestuous end, on rocks of diamond pressed,
>> – O, rich disaster in which submerged I die.

Poesie varie, 78; trans. Frank J. Warnke

Frank J. Warnke, one of our best commentators in the 1960s and 1970s on baroque literature and rhetoric, adopts art historical nomenclature in his texts *European Metaphysical Poetry* and *Versions of Baroque* by identifying a particular kind of seventeenth-century poetry as "High Baroque."[25] He makes a distinction between what he considers to be the mannerist style of John Donne and the high baroque of Richard Crashaw (and, on the Continent, Marino and Góngora), which he characterizes as "expansive, hyperbolic, sensuous."[26] As is true of many of the critics of his generation, Warnke shows a particular interest in drawing strong distinctions between Renaissance and baroque discourses and in the making of qualitative judgments on writers (Marino was "very good"; Góngora "great"). Although he shies away from tying literature to specific political and social circumstances, he does seem to follow Ernst Cassirer and Suzanne Langer in sensing that poetic language conforms not just to the intrinsic patterns of literary history but also to deep and broad intellectual currents and forms of apprehension. For Warnke, baroque rhetoric symbolizes underlying forms and realities. He reifies the baroque as a kind of mind or sensibility that has lost its (Renaissance) faith in appearances, in sensuous reality. He writes that there is an "irritable doubt as to the precise relationship between seen and unseen worlds." Although I find Warnke to be a strong writer on baroque rhetoric, I sense that his emphasis on "deceptive appearances" might lead one to see baroque spectacle as hostile to the sensuous and the material. Of course, Warnke does not say exactly that; he stresses, instead, the sensuousness of the baroque and asserts that things

and matter tend to predominate over words and forms. Yet his correct attention to the abundant and even furious paradoxes of the baroque leads him to contend, unreasonably I believe, that there was a profound disillusionment with reality. He writes that Marino's obsession with sensuous "trivialities" indicates "a doubt as to the philosophical reality of the sensuous world" and adds that "Marino's imagery . . . presents through tireless wit a sensuous phantasmagoria in which the elements of earthly experience are so identified with each other as to become themselves meaningless."[27] I would not want to argue with Warnke's critical acumen on baroque literature, but for my interests in sketching a plausible picture of baroque visual rhetoric, it is less important to accentuate differences between Renaissance and baroque attitudes toward the phenomenal world. In my view, baroque rhetoric does not abandon the phenomenal world; rather, it places it in a more dynamic relationship with human self-knowledge and imagination or *fantasia*. This very tension between the worldly and the transcendent is at the core of the conceit; fantasy is that which allows us to triumph over – but not disbelieve – the real.

Baroque rhetoric finds itself engrafted into the physical world in painted scenes of the Massacre of the Innocents, especially those by artists who had read (or heard) G. B. Marino's *Strage degli innocenti*. Elizabeth Cropper and Charles Dempsey explore the rhetorical associations between Marino and his friend Nicolas Poussin.[28] One would be hardpressed, I believe, to cast Poussin as a promoter of *concettismo*, baroque spectacle, or the emotive image. The traditional view of Poussin is, of course, as a classicist. Anthony Blunt's characterization of Poussin along these lines is too well known to be examined here in any detail, but it is worth quoting one of Blunt's more pellucid passages: "[Poussin's] pursuit of a rational form of art was so passionate that it led him in his later years to a beauty beyond reason; his desire to contain emotion within its strictest limits caused him to express it in its most concentrated form; his determination to efface himself, and to seek nothing but the form perfectly appropriate to his theme, led him to create paintings which, although impersonal, are also deeply emotional and, although rational in their principles, are almost mystical in the impression that they convey."[29]

Cropper and Dempsey argue that Marino had, in a sense, issued a challenge to contemporary painters to attain the same high level of *enargeia* that he had in his poetry. Because painting makes the absent present (as was commonly expressed in the early modern period), one would think that poetry could not compete in the category of making things vivid, living, visible.

There is a useful connection between metaphor and analogy. As Barabara Stafford organizes the multifarious elements of analogy, she directs the reader's attention to the "similarity-in-difference" trope. Visual analogies operate not in a reductive but in a productive manner, simultaneously spinning off and drawing in energy.[30] Metaphors and conceits are analogies (and are analogous to one another, for that matter) in the sense that once one is turned on, so to speak, we are encouraged to become aware of the association of inner and outer – the imagination

and the world-out-there – the existential and the ontological, the literal and mystical, the noumenal and the phenomenal, the world of life and the world of art.

How, then, do we understand figurative language in baroque art? One begins by observing that painting and sculpture especially are by their nature figurative and metaphorical, for they expose similarity in dissimilarity: stone can be transformed into recognizable figures, just as paint can be pushed around on a stretched canvas or wooden panel to create narrative and iconic images. John Milton thought of metaphors in precisely these terms when he wrote of "disjunct similitude," in which a piece of obdurate stone can be made recognizable as Moses, for instance. We tend to brush aside the essentially figurative and metaphorical nature of the representational arts, while taking that occult transformation from substance to subject as perfectly "natural." Therefore, we have to consider the ways in which baroque art can generate conceits on top of the basic conceit, metaphors beyond the essential metaphor.

Let us look at Caravaggio's *Crucifixion of St. Peter* (Rome, Santa Maria del Popolo, 1601, Fig. 1) first of all for its metaphorical components (leaving the issue of the conceit aside for the moment).

Caravaggio throws an intense beam of light on a perfectly ordinary looking man in his sixties who is nailed to a cross and is about to be pulled upside down. Peter chose to suffer one of Rome's customary forms of punishment, usually reserved for thieves, slaves, and assorted evildoers, in this unaccustomed manner so that he would not be compared to Jesus. The executioners in their rough, torn garments have no easy time of it. The man kneeling on the ground, awkwardly gripping a shovel, tries to heave up his backside while getting purchase in the dry dirt. He will probably accomplish little and end up with splinters in his neck. Caravaggio underscores the laboriousness, earthiness, and brutality of this event, (apparently) draining it of transcendental substance.

A metaphor is a particular – if not so easily interpreted – instance of a trope, defined by Quintilian (an important source for sixteenth- and seventeenth-century critics) as "the artistic alteration of a word or phrase from its proper meaning to another."[31] We might say that the proper meaning here is what Erwin Panofsky would call the pre-iconographic meaning – in this instance, an execution in progress.[32] Caravaggio heightens the disjunction of the comparison by straining the tropological change from ordinary to allegorical, moral, and anagogic. Peter himself seems more confused than resolute, refractory (in Howard Hibbard's characterization) than acquiescent. This is a metaphor because Caravaggio takes the historical Peter, known only through texts, and gives him sensory reality. Because religious culture had already mapped the story of Peter onto the discourse of painting, one can associate the inverted cross and the bearded man (recognizable as Peter from earlier paintings) with a particular tradition and identification. Caravaggio fuses the abstract with the concrete and thus conjures up a metaphor. Of course, any painting of a saint does precisely the same thing, but Caravaggio creates that intuitive sense of likeness in unlikeness favored by Aristotle. Instead

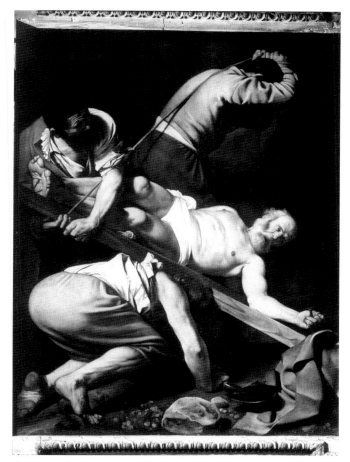

1. Michelangelo Merisi da Caravaggio, *Crucifixion of St. Peter*, 1601–02, Santa Maria del Popolo, Rome. Photo: Art Resource, New York.

of the heroic Peter, the first pope and bishop of Rome, the founder of Christ's Church, the keeper of the keys to the kingdoms of heaven and earth, we see an unidealized, (apparently) godforsaken man in meager, brutal, and desperate circumstances. There are virtually no hints (other than the aforesaid projecting of one discourse onto another) of either immanent or transcendent meaning. In addition, the painter subverts the viewer's expectations by providing an oblique point of view (rather than one that is straight on and perspectival), encouraging a sense that the observer, workers, and condemned man share a metaphorical (or better yet, existential) space and that the observer just happens onto the scene (when entering the Cerasi Chapel, the viewer sees the painting at just this angle), witnessing it accidentally, seeing something relatively meaningless – just one more execution (novel only because it is inverted) in a busy day. To repeat: Caravaggio's intuition of likeness in unlikeness is first that Peter looked like and died as a common man in

an event that had no appearance of historical or religious significance (in a sense, making the traditional metaphor run backward like a mixed-up clock), and second that one can be both an illusory and authentic witness of the event, over and over again. Another thing that makes this experience typical of baroque figurative language is that subject and object are enfolded so that the witness-subject has lost traditional (and Renaissance) autonomy. The painting's rhetoric implicates – enfolds – us in the event. As passersby who refuse to get involved, we are in a sense complicit, committing the sin of omission – of refusing to get involved.

Caravaggio mastered an unusual and provocative form of *acutezza*, or, as it is better known in English, *wit*. Because his paintings strike us as being somehow acutely aware of the presence of the observer, we ineluctably and unconsciously attend to the way in which we are being addressed. Several of Caravaggio's critics have observed of the Borghese *St. John the Baptist* (Fig. 2) and the painter's other versions of the same "subject" that these images never really transform into St. John. Howard Hibbard writes about Caravaggio's "perversity" in presenting the Capitoline *St. John* in such a way that "we are not sure that he meant to paint a St. John at all."[33] He includes the Borghese painting as another example of Caravaggio's penchant for iconographical ambiguity. Leo Bersani and Ulysse Dutoit, moving from "perversive" to subversive in their critical appraisal of the Borghese painting, also observe that "nowhere in Caravaggio do we have a greater sense of the model having been posed – and of the meaning of the pose having evaporated in the model's very acquiescence in it."[34] By refusing to settle down into a prescribed role, the model becomes as much a spectator as are we, the "real" spectators. Bersani and Dutoit's sense of "John's" indifference leads them to contend that the model agreed "without interest and without rebellion, to do as he has been told."[35] His passive resistance frustrates the transfer from signifier to signified (or, as they put it, from the historical to the ontological). They suggest that there is a "revolutionary consciousness" on the part of the model: through impassivity, he resists exploitation by the artist.

Although it may not be so obvious in a photograph, the effect produced by the painting in person (at least on me), is that of a smirk, a sly and subtle smile that deflates both the religious meaning and the supreme fiction of the work of art. I suspect the smile originates with Caravaggio rather than with the model. Franco Croce observes that these jests turn up all the time in Marino's poetry as a way of "correcting" the sentiment of his elaborate *concetti*.[36] Francesco Flora wrote of the Marinesque smile as being directed toward the "cleverness of what is being said or . . . the contradiction contained in it . . . [the smile] is not an invitation to arrive at a moral conclusion contrary to the one just proposed (as in the case of logical or moral irony). It is rather a comment, in the form of a joke, an expression of modesty, or an exoneration of vanity of expression, twisted words, and harsh meanings. It is a form of emphasis that is 'corrected' by a becoming gesture-one, in other words, that is toned down or modified rather than being stated explicitly."[37] I read the pseudo-John's smile as telling me that

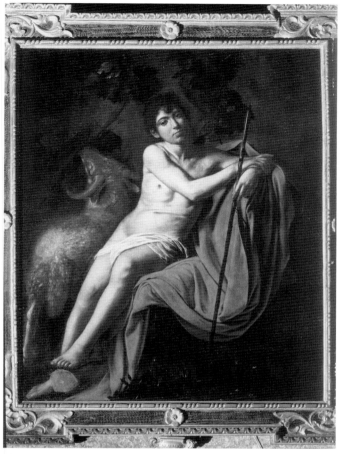

2. Michelangelo Merisi da Caravaggio, *St. John the Baptist*, 1609–10, Villa Borghese, Rome. Photo: Art Resource, New York.

he and I both know about a form of representation that in its self-absorption betrays no awareness of an audience. But we are not fooled. Had the sitter and the artist known of Coleridge's "willing suspension of disbelief," they probably would have laughed out loud (so much for "poetic faith"). Caravaggio wants us to know that he knows that our minds never really succumb to virtual realities; we always maintain a distance and a certain discontent with attempts to seduce us, to draw us into a realm that presumes our abandonment of critical judgment. Just as a bit of brandy "corrects" an Italian coffee in a *caffè corretto*, so, too, does a smile draw attention to and play with that boundary between the construction of artifice – the making of a painting – and the recognizable imagery.[38] Caravaggio corrects, laces, spikes – and thereby enhances by undermining – the central *concetto* of early modern painting. He throws into doubt the proper functioning of art, creating that rhetorical figure of an *aporia* – of a (feigned) doubting as to what is

going on. A painting is more bittersweet, more clever, fresher, more ingenious, wittier for raising a degree of perplexity, for teasing those conceptual categories of perception that seek to separate levels of (un)reality. In his artful reading of texts, Paul de Man repeatedly found those specific elements, such as imagery, that are supposed to create meaning often fail to "converge" with meaning. He recognized that often a text "implicitly or explicitly signifies its own rhetorical mode and prefigures its own misunderstanding as the correleative of its rhetorical nature."[39] He would have found Caravaggio's work a rich vein to mine.

It is interesting that one of the more detailed studies in recent years of the paintings of St. John spills a lot of ink over the question of the age of the lamb-ram in the Capitoline St. John and the Borghese St. John. Conrad Rudolph and Stephen Ostrow try very hard to establish a specific and settled iconographic theme for the Capitoline painting by arguing that the animal in that picture is a ram (that is, an older male lamb), which is appropriate to an image of Isaac.[40] The horned lamb in the Borghese St. John is younger, they argue, with only slightly bent horns, typical of a yearling. Theirs is a traditional (and highly intelligent) art historical study of iconography and how one can establish the subject matter of a painting. Although the authors acknowledge that there are questions about the apparent instability of meaning, they push ahead in an effort to find a secure identification of the primary figures (the Capitoline painting represents Isaac; the Borghese painting is perfectly acceptable as a painting of St. John). My argument is that attention to baroque visual rhetoric allows an art historian to act as a critic sensitive to the action and impact of rhetorical strategies, to go beyond the rather settled science of decoding or *décryptage*. Rudolph and Ostrow's positivistic detection of the subject matter strikes me, for all of its clever observations, as too limiting. By attempting to nail down the "identity" of Isaac, they seem to accept the fact that the viewer's subjective experience is of relatively little consequence, that the image is transparent and is more than willing to spill its contents if only we bring the right keys to open the lock. They certainly demonstrate sensitivity to the way in which figures in Caravaggio's paintings engage with the viewer, but their conclusion that "Isaac" (in the Capitoline painting) smiles at us (the laughter is partly a play on his name) because *we* (the spectators) take on Abraham's role – which is a brilliant insight – might just the same be stronger had the authors given more consideration to the ins and outs of Caravaggio's rhetoric.

Stanley Fish and Baroque Rhetoric

Stanley Fish turned the baroque world upside down in the early 1970s with his *Self-Consuming Artifacts: The Experience of Seventeenth-Century Literature*.[41] He alarmed his contemporaries by relocating meaning from text or artifact to the reader or percipient, and then he argued that the work disappears after it has been "consumed."[42] That is to say, meaning does not reside in the artifact but in its consumer, who is the viewer or reader. As a consequence, once the meaning is

uncovered, it and the original artifact disappear, while the end user soldiers on to new experiences. In addition, Fish's system denies a rhetorical status (while at the same time reestablishing one) to baroque objects.[43] He goes about his wizardry by dividing the world in two: for instance, there are two kinds of experiences – rhetorical and dialectical – and two ways of seeing things – the classic and the baroque (although he does not use those precise terms). When an artifact addresses us, it can do so rhetorically or dialectically. A poem (or, as I am using Fish's formulation, a work of art) can speak to us about that which is "placed and contained within the categories and assumptions of received systems of knowledge."[44] In other words, it can tell us what we already know. From Plato's point of view (the one that Fish adopts), rhetoric can assuage and comfort us by saying what we want to hear, and, like an advertiser, the rhetorician usually wants something in return for his consoling and reassuring message. He may be, in other words, at his worst a dangerous man, at his best, one with dubious motivations. On the other hand, he who tells us something we do not already know but which can be beneficial to us, is the Good Physician. He turns up regularly enough in baroque literature as the agent of conversion. Once we have learned from the Good Physician, we can move to another plane of consciousness. It is then that we no longer have use for him or his message; he and it disappear.

Fish must have been reading Wölfflin when he came up with his bipolar, archetypal modes of seeing the world:

> The first is the natural way of discursive, or rational, understanding; its characteristic motion is one of distinguishing, and the world it delivers is one of separable and discrete entities where everything is in its proper place. The second way is antidiscursive and antirational; rather than distinguishing, it resolves, and in the world it delivers the lines of demarcation between places and things fade in the light of an all – embracing unity. In a dialectical experience, one moves, or is moved, from the first to the second way, which has various names, the way of the good, the way of the inner light, the way of faith; but whatever the designation, the moment of its full emergence is marked by the transformation of the visible and segmented world into an emblem of its creator's indwelling presence . . . and at that moment the motion of the rational consciousness is stilled, for it has become indistinguishable from the object of its inquiry.[45]

The dialectician's art points away from itself to another reality, taking us beyond what we recognize to that which we do not: "A dialectical presentation succeeds at its own expense; for by conveying those who experience it to a point where they are beyond the aid that discursive or rational forms can offer, it becomes the vehicle of its own abandonment. One moves toward a new truth." Note, too, that Fish finds the linear and the painterly, the classic and the romantic,

the Renaissance and baroque linked to one another in progression, as if the former were a platform from which to launch the mind on its road to God. Renaissance is the Beginning; baroque is the Way.

I have been writing about the rhetoric of the baroque, but at this point, were I to accede to Fish's arguments, I might have to demonstrate that although baroque visual art uses rhetoric, it is itself not rhetorical. Rather, it is, in Fish's terms, dialectical. In this view of things, Renaissance paintings are, because of their geometrically and perspectively ordered composition, clear boundaries, sequences of planes, precise demarcations, quantifiable spaces – or in Fish's phrasing "separable and discrete entities where everything is in its proper place" – rhetorical. As we will see later, Giovanni Bottari, a formidable proponent of good taste and the new, more "rational" shape of architecture in 1730s Rome, also wanted everything to be in its proper place. Fish makes a clever point here, but it is not one to which he always adheres. In a later essay, he concedes that there is a traditional view that puts the virtuous in opposition to the rhetorical, resulting in the following polarities (this is Fish's list, admittedly partial and clearly set up with deconstructionists in mind): inner–outer, deep–surface, essential–peripheral, unmediated–mediated, clear–colored, necessary–contingent, straightforward–angled, abiding–fleeting, reason–passion, things–words, realities–illusions, fact–opinion, neutral–partisan.[46] Most critics of historical style would tend to see the baroque on the rhetorical – that is, the "second-term" – side of these oppositions. Fish, of course, does not countenance these binary antagonists – except as straw-man exercises. In fact, he sees pretty much all discourse as rhetorical. Just the same, in his reporting of the *usual* view of rhetoric, we would have to acknowledge that the more pronounced forms of baroque (the traditionally and misleadingly titled "high baroque") are rhetorical. So, although not giving up the idea of baroque rhetoric, I adopt Fish's assertion that the form of discourse we often associate with the baroque in which "the lines of demarcation between places and things fade in the light of an all – embracing unity," is in fact a vehicle that may (not all artifacts succeed) bear the worshipper, supplicant, member of the congregation, and priestly novice to the divine, to a place where the vehicle no longer serves any purpose and so is, in a sense, left behind.

Fish draws our attention away from text, artifact, and painting toward reader, pilgrim, and spectator. Most criticism assumes that there is an audience or consumer of artifacts but nonetheless focuses on texts and objects themselves. We have Wimsatt and Beardsley's famous admonition in their essay on the affective fallacy that one should not confuse a poem and its results – "what it *is* and what it *does*."[47] In Fish's terms (and there are legions of critics who have followed in his footsteps), however, painting and poetry are events that occur and accumulate in the spectator. Studying this reservoir of effects and interpretation that reside in readers and viewers is part of reception theory.

Ignatius of Loyola would have agreed in principle with this critical stance. His images were those of the imagination, always residing inside the worshipper

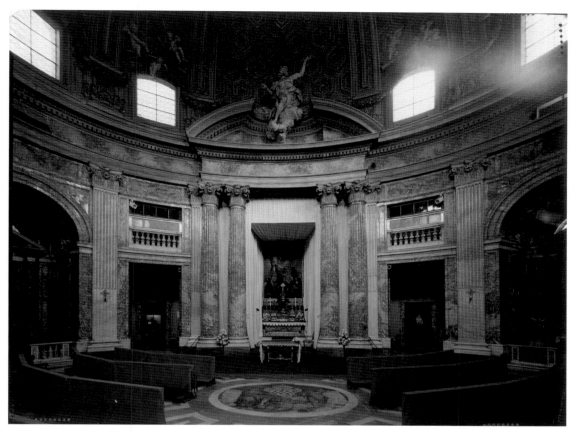

3. Gianlorenzo Bernini, *Interior of Sant'Andrea al Quirinale*, 1658–70, Rome. Photo: Art Resource, New York.

and exercitant. Imaginative visions, as opposed to external or corporeal visions on one hand and intellectual visions – visionary experiences without a visual component (like meeting Jesus in a dark room, as St. Teresa described it) – on the other, can be the product of the individual's will. Some imaginative visions occur during mystical experiences and therefore originate from the divine. But the Ignatian sort of imaginative vision begins in the exercitant and helps to direct the soul, by way of application and "working out," toward the divine and the eternal life of the soul. External images, such as those in baroque altarpieces, make up the raw material, the stuff of visual experience that nourishes the mind's eye, which is a puissant resource in one's travels along the path toward salvation. External images, however, are more than an unprocessed product or, as I have suggested, a means toward an end. Paintings have an inescapable, analogous relation to the "eye of the soul." And that makes them not just analogy but also – and similarly – metaphor. There is that sense of to-and-fro between vision and sight, the former being spiritual or inner, the latter physical or external.

Even outside and beyond the *Spiritual Exercises*, the engagement between reader and text, viewer and painting is immensely complex. The receiver is, after all, the "end user" for baroque artifacts.

Gianlorenzo Bernini's church of Sant'Andrea al Quirinale, Rome, provides a model for Fish's early theses (Fig. 3). Constructed for Jesuit novitiates, Sant'Andrea also epitomizes Bernini's biographer Filippo Baldinucci's definition of the *bel composto*: "The opinion is widespread that Bernini was the first to attempt to unite architecture with sculpture and painting in such a manner that together they make a beautiful whole (*bel composto*). This he accomplished by removing all repugnant uniformity of poses, breaking up the poses sometimes without violating good rules although he did not bind himself to the rules. His usual words on this subject were that those who do not sometimes go outside the rules never go beyond them."[48]

By abandoning the comparison and division of painting, sculpture, and architecture in the tradition of the *paragone*, Bernini breaches what had been firm and even antagonistic boundaries to create a "beautiful whole" in which the worshipper and the novice may see the invisible and follow St. Andrew into the empyrian.

The geometry of the elliptical ground plan positions the worshipper and novitiate in concreteness and a commensurable, material world, one that is, nonetheless, already transformed by the traditional model of the Heavenly Jerusalem.[49] As St. Ignatius tells us in an addendum to his *Spiritual Exercises*, we are, when thinking about the church, obliged "to praise the adornments and buildings of churches as well as sacred images, and to venerate them according to what they represent."[50] It is "what they represent" that leads our spiritual selves into the empyrean. There is nothing unique about the journey, one that was well established by Catholic tradition. Yet here in the confines of Sant'Andrea, the experience of the journey itself is singular. The worshipper, focusing first of all on the altar, will see the painting by Borgognone (Guglielmo Cortese, 1628–1679) of St. Andrew on the Cross. Rather than being nailed to the cross, Andrew was bound with ropes to the X-shaped cross known to the Romans as decussate (which, unbeknownst to them, stood for the first letter of the Greek word for Christ). The expectation was, apparently, that Andrew would suffer longer. In fact, his suffering went on so long, according to the *Golden Legend* (one of Ignatius's favorite texts), the people of Achaia demanded that their governor release him. On the third day, however, when the soldiers attempted to untie Andrew, they could not even touch the knots. God had intervened. Andrew prayed that his body be taken from him, for it had become a burden. When Andrew finished his prayer, a light hid him from the others' view; when the shining abated, his soul departed.

Ever attentive to matching image and word, Bernini gives us light both within the painting and through a small cupola in the presbytery. The Jesuit novice, who has been artfully trained in the *Spiritual Exercises*, can look up into the cupola in the altar space and reexperience the blinding, all-encompassing

light. As Ignatius behooves us, we are to see the event and the place – in this case St. Andrew and the angels surrounding the cupola – in every detail, even taking into account our own point of view and all of our senses. We imagine the sounds of the crowd, the voice of St. Andrew crying out, the sensation of our hands on the rough wood, the singing of the angels, the blinding light, the ascent of his soul. In his contemplations for the *Spiritual Exercises*, Ignatius makes several points:

> The first point is to see the persons in my imagination, contemplating and meditating in detail the circumstances surrounding them, and I will then draw some spiritual profit from this scene. The second point is to hear what they are saying, or what they might say, and I will reflect within myself to draw some fruit from what I have heard. The third point is to smell and taste in my imagination the infinite fragrance and sweetness of the Divinity, and of the soul, and of its virtues, and of all else, according to the character of the person I am contemplating. And I will reflect within myself to draw spiritual profit therefrom. The fourth point is to use in imagination the sense of touch, for example, by embracing and kissing the place where the persons walk or sit, always endeavoring to draw some spiritual fruit from this.[51]

Ignatius prescribes all of these sensations in the practice of his *Spiritual Exercises*. Giovanni Careri writes that "The *composto* exemplified in Sant'Andrea al Quirinale almost leads one to think of a purely instrumental religious art in which the sole purpose of the spectacle of the martyrdom and the apotheosis of the saint was to be expelled, at the proper moment, from the imagination of the novice/spectator.

"Jesuit texts and devotional practices – first among them, the *Spiritual Exercises* of Igantius of Loyola – functioned in precisely that manner: new images came to dislodge old ones until the viewer reached the ideal goal of an imageless contemplation."[52]

Careri employs the term "instrumental" to characterize what Fish might think of as a disposable item serving a single purpose. In his argument about means and ends, Ignatius argues that nothing should stand in the way of our desire for praise of the Lord and for salvation of our souls. "Therefore, whatever I choose must have as its purpose to help me to this end. I must not shape or draw the end to the means, but the means to the end. . . . Thus, nothing should move me to use such means or to deprive myself of them except it be only the service and praise of God our Lord and the eternal salvation of my soul."[53] In the *Spiritual Exercises*, one intensifies imagination and the senses toward a specific goal not just for purposes of improving one's powers of visualization and sensitivity, but for the salvation of one's soul.

Yet despite Ignatius's unambiguous position on means and ends, he does tell us that right thinking leads us to praise "adornments and buildings of churches as

well as sacred images," always keeping in mind, of course, the traditional Catholic prohibition of idolatry. When Ignatius states that we venerate images according to the prototype they represent, he is voicing a well-known phrase also used at the Twenty-fifth Session of the Council of Trent. When he writes that we should praise the church building, its decoration, and its images, he affirms standard practices of the Latin Rites: the priest shows respect by incensing sacred pictures as he passes them. It is consistent with Church thinking that one venerates, honors, and praises images without adoring them (adoration being reserved for what they represent). Just the same, the image shares the honor of its prototype; in addition, the worshipper learns from images what it is he or she adores. What this all means, then, is that pictures are cared for and honored; they are not – at least not literally – self-consuming artifacts. They have a special standing within the Church that would seem to exempt them from the status of simple "means" or mere instrumentality.

But what relation do sacred images – means toward an end though (in part) they may be – have to Ignatius's other kinds of images, those that exist in the mind's eye? He famously calls on the exercitant to apply his imagination to the creation of a mental image of a particular place. He writes: "It should be noted . . . that when the meditation or contemplation is on a visible object, for example, contemplating Christ our Lord during His life on earth, the image will consist of seeing with the mind's eye the physical place where the object that we wish to contemplate is present."[54] This kind of visualization, which seems natural enough, something we all can do, is in fact profoundly complicated in terms of the meaning that it creates. First of all, there is a highly problematic relationship between the mind's eye and the external eye. The mind's eye would seem to constitute a synthesizing capacity of the brain (mind) to draw from memory as much data and as many impulses as possible to create an analog to the information originally brought in by the external eye. This overdetermined image called up by the mind (more specifically, by the imagination) then becomes a "place" where the exercitant can situate himself or herself. The Fifth Exercise of the First Week of the *Spiritual Exercises* requires that the exercitant, even were he or she to forget the love of God, know the fearsome pain and suffering of the damned. Ignatius specifies five sensory experiences here: "To see in imagination the great fires, and the souls enveloped, as it were, in bodies of fire; To hear the wailing, the screaming, cries, and blasphemies against Christ our Lord and all His saints; To smell the smoke, the brimstone, the corruption, and rottenness; To taste bitter things, as tears, sadness, and remorse of conscience; With the sense of touch to feel how the flames surround and burn souls."

With all their sharp-edged clarity – indeed, in rhetorical terms their vehemence, Ignatius's mental sensations – far more descriptive than they are narrative[55] – have an analogous relation to baroque painting. Barbara Stafford's study of visual analogy examines the "inherent mimeticism" that adheres to ana-logical operations, and she makes the pointed observation that "[w]hen analogical

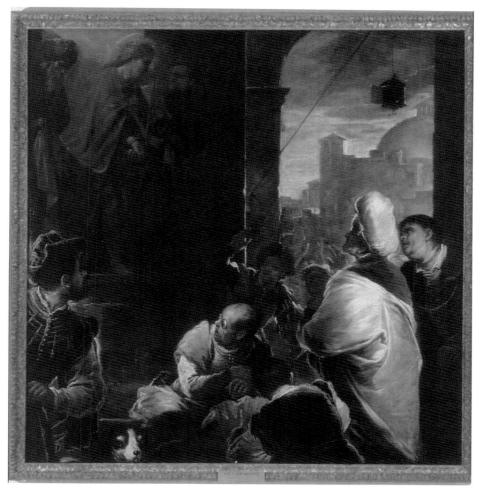

4. Luca Giordano, *Ecce Homo*, 1659–60, Pinacoteca di Brera, Milan. Photo: Art Resource, New York.

communication was identified solely with irrational occultism – as happened during the Enlightenment – it was because vision itself had become equated, not with Cartesian clarity and rational distinctness, but with Jesuitical delusion and mystical obfuscation in general."[56] She makes the essential connection, in other words, between Ignatius's mental images and sensory analogies with the baroque; at the same time, she points up the contempt held by the Enlightenment (and promoters of *buon gusto*) for that very kind of visual analogy. Whether consciously or not, many baroque painters created rhetorical structures that represent Ignatian mental images.

Let me demonstrate what I mean by reference to Luca Giordano's *Ecce Homo* (Fig. 4). There can be no true objectivity, of course, in the rendering of an event long since past, already recorded in text (John 19:4–16) and made famous by

numerous artists, especially Albrecht Dürer, whose *Great Passion* woodcut series published in 1511 Giordano knew well. In other words, Giordano does not give us a scene freshly realized, nor, so far as we know, does he respond directly to the *Spiritual Exercises*. Just the same, using an "intertextual" strategy, we can presuppose certain texts, one of which is certainly the *Spiritual Exercises*.[57] In any sort of visual focalization, as promoted by Ignatius, there is a psychosomatic process or experience based on the position of the viewer. Giordano's large canvas (158 × 155 cm) situates "us" (as a single spectator) in the midst of a crowd and at a particular vantage point below Christ, who stands in his misery on the steps of Jerusalem's municipal building. A dog fixes us with his gaze; a courtier in green velvet passes to our left, while looking back over his shoulder at what must have seemed to him an unremarkable event. There are a fat man, a turbaned man, a bespectacled man, and gesturing hands. We can hear and see the chief priests and officers shouting, "Crucify him, crucify him!" The telling detail of the lantern hanging from an arch situates the event in a place of plain, everyday details. The light, the atmosphere, the humiliation of Christ, even the perplexity of Pilate seem clear to us, so that we can relive that moment, and, because of the figures seen from behind (which are our surrogates), place ourselves in the midst of the mad, teeming throng. According to Ignatius, the hearing, tasting, smelling, and touching proceed from the seeing. Giordano's painting can excite, if not represent, those very sensations.

Even though we are in the crowd, there is, paradoxically, no stable position for the viewer, no sense of orientation. We grasp at objects as if in a dream. Things shift and are in flux. Whereas some forms rise in sharp relief, others sink into shadow. We have no cognitive or aesthetic distance. Like phantasmogoria, the events exist in our minds as if we hallucinated them or were subject to autosuggestion. We are, as a result, primed exercitants.

The study of visual rhetoric arises from any number of concerns and circumstances. Because the institutions, religious orders, and minions of the Roman Church had complex and extensive interests that they chose to promote, rhetoric as an art of experience was important in baroque visual imagery. Although there was little doubt in Catholic lands about the Church as an establishment that represented, indeed embodied, ultimate truth, there was a pressing need to reassert the Church's legitimacy in light of the Protestant Reformation. Hundreds of expensive and elaborate church buildings sprang up in the streets and piazze of Rome from the middle of the sixteenth to the middle of the eighteenth centuries. All of these contributed in some way to the Church's authority as a teaching institution. Baroque visual rhetoric depends at least in part on the principle of magisterium or tradition, which in turn is based on the idea that revealed truths exist not just in sacred scripture (the Protestant view), but in the transmission of revelation and Divine instruction from Jesus to his Apostles and finally to his Church. The Council of Trent reasserted this latter point. In short, baroque visual rhetoric had as part of its program of persuasions the assertion of the divine magisterium.

One also has to attend to baroque rhetoric in Paul de Man's terms as a matter of tropes and figures, metaphors and conceits. Caravaggio not only found similarities in dissimilarities in his construction of visual metaphors, he could bring down the whole house of cards by testing one of his metaphors with a smirk.

Visual rhetoric is a study in effects. The very rhetoric that excites an exercitant exhausts itself in its function, only to be resurrected and used again and again by legions of practitioners and observers.

TWO:

BUON GUSTO

European Taste in the Eighteenth Century: History and Theory

Before turning to the immediate and specific matter of *buon gusto* within the Italian and specifically Arcadian milieus, I begin my examination with a survey of the broader, European contours of taste in the early modern period.[1] Already in the sixteenth and seventeenth centuries, the word "taste" (*gusto, goût, geschmack*) could be found in writings on art, literature, and society in England, Spain, Italy, France, and Germany.[2] Michelangelo, Dolce, and Varchi all used the word in a general sense to signify some aspect of beauty, which everyone understood to mean (after Alberti and the ancient traditon) a certain harmony and agreement among elements of an object achieved with such a delicate balance that beauty would be compromised were anything added, taken away, or otherwise altered.

An early, comprehensive, and prescient narrative on taste is Baltasar Gracián's *El Héroe* (1637). The Spanish writer and Jesuit priest pointed out the social dimension of taste and how it depends more on intuition than rules. Although Gracián (1601–1658) believed that everyone has it within his or her capacity to achieve taste, he realized that few ever do. A conception of taste is necessary for the courtier and the political leader. Because of his breeding and class, Gracián's hero is born with taste and need only perfect it through erudition. Gracián understood the strong "subject position" in matters of taste and found it to be one of taste's virtues; that is to say, it is common enough for one person to despise the taste of another, whereas the latter will in turn loathe the former's. Such is the folly of the world. It remains for the hero to establish taste and true discrimination, and then perhaps others will succeed in emulating him.

By associating *gusto* with "je ne sais quoi" (Gracián used the French phrase), he anticipated what was to be a central, binding element of eighteenth-century discussions of taste. He observed that some people, because they lack a breadth of knowledge and the right kind of sensibility (noble), simply do not perceive or acknowledge this "something," this "I-don't-know-what." Their perception

is gross rather than fine, awkward rather than delicate, blunt rather than acute. But those of properly tuned perception recognize "Je ne sais quoi" – the *nescio quid* – and understand how it manifests itself in the free and effortless behavior of the ideal courtier, who can effect a quick judgment without a conscious turning to rules or principles. Taste is spontaneous, so embedded in one's spirit and so associated with good breeding that it appears to exist prior to rules and to be the outer mark of a true courtier.

For all his apparent sympathy, *avant la lettre*, with an eighteenth-century discourse on taste, Gracián argued his notion of taste from a baroque position. He believed that "*Je ne sais quoi*" and *gusto* show themselves to their best advantage in *conceptismo*, the elaborate literary conceits so despised by the promoters of taste in the eighteenth century. His hero, who is a courtier and leader (he was, in a sense, a reinvention of Machiavelli's prince), behaves in a manner that is analogous to elaborate, drawn-out literary conceits. As a Jesuit priest, Gracián saw the advantage of urging his aristocratic, royal, and political readers to assume a manner and posture allied with a kind of literature that had propagandistic value in the Counter-Reformation. For the Jesuits, the baroque style of spectacle best conveyed mystical vision, which when represented in art, literature, and the ideological-spiritual structure of the Church constitutes visual propaganda of great power.

That exclusivity, power, class, and insider knowledge could form the groundwork for taste was well understood by many in the seventeenth century. In Spain and Italy especially, it signified the antithesis to what it was to mean soon thereafter. *Buon gusto* is not a stable concept; rather, it is a marker in the game of discourse, a term used for persuasion and control. There is an inevitable and considerable slippage between signifier and signified in the word and in the cultural use of the concept of good taste. One has to ask, as Cicero (*Pro Milone*, 32) reminds us Lucius Cassius Longinus always did, *cui bono*? By the eighteenth century, it is no longer the supporters of baroque rhetoric who benefited.

In France, Molière, and La Fontaine adopted the term *goût* (or *goust*) for the purposes of discussing beauty. La Rochefoucauld applied the term more broadly, distinguishing between *goût* and *bon goût*, with the latter having applications that go beyond beauty and that potentially encompass (what was later to be called) aesthetics and rational judgment on social and cultural matters. La Rochefoucauld was the first in a line of French writers on taste (the other two whom I discuss are Bouhours and Boileau) who caught the attention of the Italians and fomented so much ill will between the French savants and the Italian *Arcadi*.

François VI, duc de La Rochefoucauld and (until 1650) prince de Marcillac (1613–80), was a fiercely independent noble who fought alongside the Great Condé in the Fronde of the Princes in 1650. The nobles' revolt succeeded in overthrowing La Rochefoucauld's bitter enemy and the king's chief minister, Cardinal Mazarin, but only for a short time. The young Louis XIV and Mazarin soon enough regained power and dominance over the the Great Condé and the Parisian Parlement. The ability of the old nobility to offset the monarchy's

dominance of politics and national affairs was lost forever, and La Rochefoucauld retired from military life, scarred and humiliated. He made his peace with the king and spent his later years developing an interest in conversation, literature, and poetry. He joined a circle of intellectuals who listened to readings of, among other texts, Boileau's *L'Art poétique*. La Rochefoucauld also played with remarkable avidity the new courtly game of epigrams, in which one composed short, piquant, and aphoristic comments on deportment and manners. With great success, he later published his carefully crafted bon mots under the title *Maximes*. Having arisen in the midst of game playing and conversation, the discourse of taste had shifted to published form, where it was in effect memorialized. La Rochefoucauld's place or role changed from "player" and speaker to that of author, a situation that let him fix in concise form his thoughts on good taste and how it promotes, benefits, and gives identity to the *noblesse d'épée*, an apprehensive if still proud class (also styling itself in cultural terms as *les honnêtes gens*) bent on vindication.

La Rochefoucauld's Maxim 13 states, "Notre amour-propre souffre plus impatiemment la condamnation de nos goûts que de nos opinion" – Our self-love endures more impatiently the condemnation of our taste than of our opinions. The duc de La Rochefoucauld was not incapable of sensing the poignancy of his situation, and the importance of self-love in noble self-identification. His maxim shows how interested (as opposed to disinterested) taste can be, and at the same time implies a condemnation of this sort of motivation. In Maxim 390 we read: "On renonce plus aisément à son intérêt qu'à son goût" – we give up more easily our self-interests (or welfare) than our taste. La Rochefoucauld would like, in other words, to shift one's attention from self-love and self-interest to taste, which, as he also betokens, holds a higher place than *amour-propre*. With Maxim 379 ("Quand notre Mérite baisse, notre goûte baisse aussi"), he makes the tie ever more secure between individual character and taste. By introducing taste into the tradition of a "life philosophy," La Rochefoucauld breaks with the humanist tradition and received opinion and destabilizes accustomed ideologies of self-identification.[3] The next step for La Rochefoucauld was to identify taste with a noble class. One behaves according to the conventions and unspoken regulations of one's class, which in turn produces itself by these very elements of social discourse. As Michael Moriarty argues, by helping to establish once and for all the subject position of *les honnêtes gens*, La Rochefoucauld allows the honest man to escape from charges of self-love. Moriarty writes: "If one has well and truly identified oneself as a subject, limited to a certain space of legitimate desire, the risk of wrongly identifying a particular object as good because it appeals to one's *amour-propre* is much diminished."[4]

Père Dominique Bouhours (1628–1702) published *La manière de bien penser dans les ouvrages d'esprit* in 1687, with many reprints to follow in the seventeenth and eighteenth centuries. The work is a dialogue between Eudoxe and Philanthe, who quote from various authors and texts (generally unnamed) on taste. One author to whom they refer has it that taste is "une harmonie, un accord de l'esprit

et de la raison." Eudoxe and Philanthe object to this notion of a harmony or accord between the spirit and the intellect because it merely replicates or extends the metaphor that already underlies taste (figurally extending the social and aesthetic concept of taste from sensations on the tongue or palate). Multiplying metaphors is the first sin of *conceptismo/concettismo/*conceit, and therefore should be avoided at all costs. Philanthe proposes a definition in which (to paraphrase his speech) taste is a natural sentiment attached to our soul, one that is independent of any sciences that we could acquire. Taste is nothing other than a certain rapport that one finds between our soul and its ability to perceive on one hand objects that are presented to it and the percipient faculty on the other. Finally good taste is a prime mover, or one might say, a space of instinct and right reason.[5] Up to a point, I agree with Moriarty that what Bouhours's dialogue produces is not so much a definition of taste as a "judgment of taste in action," "the play of a free-moving discourse," and finally "the vindication of a classical as against a baroque stylistics, and, more generally . . . the celebration of literary conversation and the production of a harmonious discursive spectacle."[6] Where Moriarty and I part company is in his reference to the classical–baroque dialectic. There can be no question that Bouhours has targeted the baroque for eradication, but not for the purposes of a return to a "classic" language; Bouhours intended nothing less than a stepping away from tropes, *topoi*, figuration, allegory, metaphor, conceit – in short, the entire tradition of rhetoric from Isocrates to his present day. Of equal importance (to Bouhours and his colleagues, at least) is the manner in which the dialogue sacrifices Spanish and Italian literature to the interests of the French. Perhaps it is true, as Moriarty asserts, that if Bouhours really wanted to define taste, he could have found a less narratively oblique and playful way to do so than a dialogue between his fictional characters. But part of Bouhours's strategy of dismantling the edifice of the Italian humanist tradition was to use play and dissembling.

Bouhours's text stirred up a hornet's nest in Italy, as we shall see when considering Giovan Gioseffo Orsi's extensive and vituperative response to the French Jesuit. Even Voltaire was to comment years later in a letter to Cardinal Domenico Passionei that Bouhours's contempt for Ariosto and Tasso was unjustified. Not that Voltaire would ever side with Italian literature, but he understood the extremes of Bouhours's polemic and showed little sympathy.[7]

Before looking to the Italians, however, I want to discuss in brief detail the contribution of Nicolas Boileau – the "Lawgiver of Parnassus" – to a European-wide debate that makes the Quarrel of the Ancients and Moderns seem like nothing so much as prelude to larger issues (although Boileau, always spoiling for a fight, waded into that squabble more than once). He also succeeded in shifting the authorizing agency for taste from a small aristocratic class to the much larger republic of letters.

Nicolas Boileau-Despréaux (1636–1711) was born into a family of clerks to the Parisian Parlement and was destined himself either for the priesthood or law. But his brother, a writer, encouraged him in a literary career. Ever the eager

learner and quick study, Boileau started off by publishing a book of satires and moved swiftly on to weightier matters, such as the art of poetry and defense of antiquity against the so-called moderns. He was something of an establishment figure, as royal historiographer (along with Racine) and member of the *Académie Française*, but was just the same drawn to polemics. From his satires to his art of poetry and finally and most viciously to his diatribe against women, Boileau was never far from some of the most fractious intellectual and social issues of his day. He was known for his dramatic presence and theatrical manner and could be called on to read aloud from his "poetics." Although no one these days sees him as the Voice of French Classical Poetics, his place in history is secure and his role in the foundations of taste pivotal.[8]

Following Longinus's *Art of Poetry*, Boileau wrote a smooth and tightly organized critique in verse. His four cantos range from somewhat more than 200 lines for I, II, and IV, to 428 for Canto III (with its rules for tragedy, epic, and comedy). He chose, of course, the Alexandrian line with its twelve syllables and midpoint caesura, the type of prosody that was as popular in early modern France as the iambic pentameter was in England or the hendecasyllable in Italy. His rhyme scheme is in couplets, a simple sequence of aa/bb/cc/ and so on. The tone he adopts is one of *bienséance* – decorum, decency, delicacy, and quiet reasonableness – and *le bon sens*.[9] He cloaks, in other words, his argumentativeness in a language that would have struck his audience as proper, utterly unexceptional, and sensible. Although he is not folksy, he is reassuring, sociable, and familiar. Reason, propriety, and common sense go hand in hand. The fixed medial caesura works to Boileau's advantage in his use of parallel structures, repitition, and paradox, which help to bring his message home. The Alexandrine meter can lead to such breathtaking periodic sentences as:

> *Telle qu'une bergère, au plus beau jour de fête,*
> *De superbes rubis ne charge point sa tête,*
> *Et, sans mêler à l'or l'éclat des diamans,*
> *Cueille en un champ voisin ses plus beaux ornemens;*
> *Telle, aimable en son air, mais humble dans son style,*
> *Doit éclater sans pompe une élégante idylle.*[10]

Early in his first Canto (lines 39–48) Boileau launched his attack on those whom he wanted his listeners or readers to see as the long-winded and obscure purveyors of *concettismo* (in the Soame–Dryden translation):

> Most writers mounted on a resty muse,
> Extravagant and senseless objects choose;
> They think they err, if in their verse they fall
> On any thought that's plain or natural.
> Fly this excess; and let Italians be

Vain authors of false glittering poetry.
All ought to aim at sense; but most in vain
Strive the hard pass and slippery path to gain;
You drown, if to the right or left you stray;
Reason to go has often but one way.

Boileau elevates the French style to the level of paradigm and justifies it with an appeal to good taste. In other words, the style in which he composes his poetics is not defended in normative, rational, logical terms, nor does it derive its legitimacy from the approval of noble connoisseurs (as La Rochefoucauld deemed appropriate), but rather from the synthetic judgment of the reading public. Boileau wrote in the preface to his 1701 edition of the *Art of Poetry*:

> As this is probably the last edition of my works that I shall prepare for publication, and as it is not likely that at my age of more than sixty-three years, and bowed under many infirmities, I can have very far to go, the public will approve of my taking leave of it in the customary way and thanking it for its kindness in so often purchasing works that are so little worthy of its admiration. Such great good fortune I can attribute only to the care I have taken always to comply with its feelings and, so far as I could, to acquire its taste in all things. This really is the one thing, it seems to me, that writers can never take too much pains with. There is no use in a work's being approved by a small number of connoisseurs; if there is not something markedly pleasing about it, and if it has not a certain salt capable of tickling the general palate of mankind, it will never pass for a good piece of work; and in the end the connoisseurs themselves will have to admit that they were mistaken in giving it their approbation.[11]

In this his valedictory statement on his art of poetry, Boileau makes clear his position on several important matters. First of all, he breaks with La Rochefoucauld and others who associated taste with a precise elite, *la noblesse d'épée*. At the time in which Boileau was writing, the old nobility had lost much of its independence, privilege, and power. The kings of France had for some time been battling against the aristocracy, and none had done a better job than Louis XIV. As Georges Lefebvre has shown, the nobles may have reasserted their power in the eighteenth century, but in the autumn years of Louis's reign, they, along with the clergy, had been kept in check. Boileau cast his lot with the reading public, a social phenomenon he may not have understood in any great detail, but he recognized that it was one that could offer him a certain freedom from the weakest and the oldest part of the aristocracy.

Of course, Boileau had a position at court, was, as we have seen, a member of the *Académie Française* (although he sometimes belittled it), and in the aristocratic

tradition did not wish to earn money from his books. Indeed, he accepted royal patronage so as not to soil his hands with sordid gain while maintaining his connections to high society with its systems of clientage and privilege. And despite his indifference – indeed, abhorrence – to earned income, he hoped that the burgeoning book trade would sell substantial numbers of his *Art of Poetry*. In other words, Boileau had no intention of freeing himself from the court, *les gens d'esprit* – whether of Paris or Versailles – connoisseurs, the nobility, or the Church. Just the same, he wished to cast his lot with the emerging phenomenon of a public taste, especially because it was one that he himself defined. Boileau seems to suggest that he is aware of a kind of natural truth that abides in each of us, the natural light of natural reason, a *consensus gentium*.

But what was this public, and how did Boileau learn his taste from it? Although I am not entirely in sympathy with Moriarty's search for the "locus of repression of the discourse of taste," I find his discussion of Boileau's commitment to the public to be useful.[12] He concludes that Boileau's investment in the public produces a shift that first of all liberates culture from "aristocratic hegemony" and second parallels, in general, a development from feudalism to capitalism.[13]

Another point of view suggests that Boileau's reader was none other than Boileau's own invention. In a clever and persuasive reading of *L'art poétique*, Selma A. Zebouni argues first of all that Boileu's polemic is anything but poetics; it is, in fact, a rhetorical text of the first order.[14] She demonstrates how Boileau writes in an injunctive mode that means to establish his own voice as an authority. His rhetorical mode of address also attempts to establish collusion between reader and writer, narratee and narrator. Boileau pretends to address a would-be poet, but he asserts that poets are born not trained, which suggests, as Zebouni points out, that no poet need read this book. There is, in essence, no reader, merely a fictitious character who is "a prop, a pretext in Boileau's enterprise."[15]

In addition to Bouhours's and Boileau's promotion of French culture and literature at the expense of the Italian and Latin rhetorical tradition, they do add something to the concept of taste, if not to any kind of real definition. We can infer from these writers that taste is aphoristic and epigrammatic rather than rational and definitional. It is, indeed, what they say it is. Of course Bouhours and Boileau never did say precisely what good taste is. Perhaps this is because, by its nature, taste – as the French understood it – escapes definition: it is intuitive, a possession of an elite class of writers, a phenomenon of gnosis.

THE ORSI–BOUHOURS POLEMIC

Le Père Bouhours began his quarrel over literary language and rhetoric in *Les entretiens d'Ariste et d'Eugène* of 1671, which was the first round in the most fundamental cultural and literary fight of the later seventeenth century (in 1714,

it appeared in Italian translation by the Jesuit Domenico Jannò).[16] But the dialogue that caught the Italians' and Arcadians' interest and enmity was his *La manière de bien penser dans les ouvrage d'esprit* of 1687. The *Colonia Renia* – Bologna's branch of the *Accademia degli Arcadi* – reacted in 1703 when Gian Gioseffo Orsi, a marchese of the old school, published (under his Arcadian name Alarco Eurinidio) *Le considerazioni sopra un famoso libro franzese intitolato La manière de bien penser dans les ouvrage d'esprit*.[17] Eustachio Manfredi, Pier Jacopo Martelli, and Lodovico Antonio Muratori supported him in the fray. Bouhours, whose new language was of the court and academies, set out for the reading public of France and Europe in lexical, grammatical, and rhetorical terms the new way of thinking about and writing literature. The very nature of the dialogue between Philanthe and Eudoxe is, as we have seen, courtly in its conversational and jousting mode. But make no mistake; Bouhours was not just advancing polite conversation; he dethroned Aristotle and completed the work begun by Jean Baptiste Colbert and Louis XIV in the service of monarchic and linguistic absolutism.[18] Lying not far in the background of Philanthe and Eudoxe's dialogues is an attack on the provinces, the *noblesse d'épée*, and Spanish and Italian literature to the benefit of the *les honnêtes gens*, Racine, St. Cyran and Port-Royal, and – just glimmering on the horizon – the republic of letters and the emerging, Habermasian "public sphere." Although the Arcadians were thrown immediately on the defensive, in the long run, they probably benefited as well from Bouhours, Boileau, and the new *bon goût*. But first we must follow the arguments and counterarguments in the Bouhours–Orsi dispute.

Bouhours's first concern was with *lingua* – national language, especially French and Italian – and only secondly *linguaggio* – literary language in general. He provided a few anecdotes to demonstrate how widespread was the conception that differing European languages had their unique qualities. For instance, a common joke of the time told how in Heaven the serpent speaks English, women Italian, men French, and God Spanish. And then there is the story of Charles V, who declared he spoke Italian with women, French with men, German with his horse, and Spanish with God.[19]

Using the voice of Philanthe, Bouhours called for a language that does not adapt to the various literary genres but is appropriate for any manner of writing, whether in prose or verse, or in polite conversation. It is, as M. Grazia Accorsi points out, a homogenous and ductile language, one that is linear, marked by brevity, clarity, the avoidance of long sentences, synonyms that add anything whatsoever to the original meaning, ambiguity, double meanings, long parentheses, superlatives, and epithets.[20] As Bernard Lamy wrote in the seventeenth century, language, like a pencil, makes pictures of our thoughts, using words for color.[21] Visual language should be like an utterly transparent window giving onto the world of thought.

Orsi correctly saw that the whole Renaissance–baroque structure of poetics and rhetoric – indeed, rhetoric itself – was under attack. Recognizing that

the French assault did not limit itself to several points or to individual literary works but extended to the whole system of literary language and the Aristotelian notion of imitation as a critical guide to literary creation, Orsi appreciated the epochal significance of this new "antiprecept" attitude. So as to erect ramparts against this "infranciosamento" – this frenchifying of language – Orsi recuperated one of the great models of the Italian tradition, Petrarch and the *petrarchisti* of the cinquecento. Orsi and all the Arcadians saw Petrarch as the reviver of elegy, ode, and pastoral; in addition, he was the developer of highly imagistic *concetti* and improviser of Latin rhythms in Italian. Orsi could not conceive of giving up Petrarchism; he hoped that because of the great poet's prestige, the Italian tradition that he represented was unassailable. The Bolognese marchese also insisted, as did all the Arcadians and specifically Lodovico Antonio Muratori, Eustachio Manfredi, and Pier Iacopo Martello, that the distinction between the lyric and the dramatic must be maintained just as the prosaicizing of literary language was to be resisted.

Marchese Orsi also conceded that a degree of naturalness was not a bad thing, although he either did not understand the French *sensible naturel*, or he simply wished to confute it. Orsi's appeal to rhetoric's middle way was as close as he wanted to come to Bouhours's nature.

All of this is not to say that the Italians were uninterested in reform, nor can one agree with Guido Tagliabue that the Italians simply did not "get it."[22] Those Italians who participated in the Orsi–Bouhours debate were not going to adopt good taste on the terms of Boileau or Bouhours, whom they judged to be essentially anti-Italian. One of the core issues in the quarrel of good taste and bad taste was, after all, national identity. With some justification one can assert, as Benedetto Croce has done, that the roots of the *Risorgimento* are to be traced to the founding of the Accademia degli Arcadi.[23] By repudiating Bouhours and Boileau while making their own use of *buon gusto*, the Arcadians were also struggling with their Italian identity and their place within a largely heterogeneous grouping of scholars, gentlemen, ladies, Church officials, lawyers, teachers, reformers, librarians, poets – in short, intellectuals who were trying to organize and make sense of various strata of culture.

When Camillo Ettori, Dominique Bouhours's *confratello* in the Society of Jesus, published his *Il buon gusto ne' componimenti retorici* in 1696, he, like Orsi soon after him, perceived the importance of the new French discourse on taste. Ettori is probably the first Italian to use the phrase "good taste" in print, although we know that Queen Christina had already advocated *buon gusto* in her academy. Also like Orsi, Ettori put the concept of good taste into terms that his fellow Italians could understand by (as the title indicates) contextualizing good taste within the traditions of rhetoric and more or less intentionally misinterpreting Bouhours's terms. He translated *sentiment nature* into *naturale giudicio*, displacing the phrase's meaning from sentiment to judgment.[24] When Ettori wrote that taste

is "il giudicio regolato dall'arte," he limited the concept of judgment by subordinating it to art, and therefore tradition and established rhetorical precepts. By so doing he made the concept more Aristotelian and less antirhetorical. He also translated *la noblesse, l'agrément,* and *la delicatesse* as *il sublime, il bello,* and *il delicato,* thereby building on his apparent desire to come up with a new aesthetic based on old rhetoric.[25] As Graziosi demonstrates, Ettori and his fellow Bolognese critics and intellectuals were not in tune with the language used by Bouhours (despite the fact that the francophone Orsi had been in Paris in 1686 and would have attended the theater and known something of the intellectual climate of the city and the court). She cites the example of Bouhours's use of the French words *coeur* and *esprit* and shows how the Italians tended not to see the affective and emotional on one hand and reasonableness and good sense on the other. Rather, the Italians translated *esprit* as *ingegno,* which gave rise to the kind of rhetorical opposition between *ingegno* — cleverness, intelligence, ingenuity, inventiveness — and *arte.*[26]

Despite all the cues that the Italians missed in Bouhours's and Boileau's disquisitions on good taste, the Bolognese — and soon enough, nearly all the Italian intellectuals — saw the need for cultural, literary, and artistic reform. Although Italian poetry still followed certain Latinate phrasings and depended on hyperbole and inversion, discursive Italian largely gave up Latinate phrasing and, like the pastoral, substituted paratactic as opposed to hypotactic constructions, preferring relatively straightforward declarative sentences.

The Orsi–Bouhours debate was at the core of the intellectual ferment and growth of the Academy of Arcadians, the excitement of Muratori, Gianvincenzo Gravina, Scipione Maffei, Eustachio Manfredi, and Aptostolo Zeno. The Italians became more conscious of their own literary tradition, the fact that the baroque and *marinismo* had become passé, and the Italian reading public had become part of and highly aware of European-wide literary, intellectual, and (eventually) political changes, all of which were soon enough to be understood within the cultural context of *illuminismo.* We can lay at the doorsteps of Bouhours (and after his death, the so-called Jesuit Journalists who published the *Mémoires de Trévoux*) and Boileau the almost frantic search for an Italian literary tradition that was to manifest itself swiftly in Crescimbeni's fourteen volumes of the *Rime degli Arcadi,* his *L'istoria della vulgar poesia* (Rome, 1689), and the four volumes of Italian Petrachism edited by Manfredi, *Scelta di sonetti e canzoni de' più eccellenti rimatori d'ogni secolo* (Bologna, 1709–11).

In the immediate aftermath of the Orsi–Bouhours debate, Scipione Maffei and others founded in 1710 the *Giornale de' letterati d'Italia,* which with its relatively widespread circulation dependent on a literate and cultivated public became the Italian mouthpiece for good taste and literature as well as the instrument for the Italian republic of letters.[27] One of Maffei's early tasks was to publish the most important treatise on good taste, Lodovico Antonio Muratori's *Reflections.*

MURATORI ON *BUON GUSTO*

As we have seen, good taste is not in and of itself any one thing; it is, rather, a variable concept that derives its meaning from differing contexts and usages. Outside of Italy, taste had come to be associated with intuition, insight, and empiricism. Within Italy, good taste remained attached to precepts of art and rhetoric, functioning as another word for the beautiful. In a sense, then, the Italians never let go of their Renaissance–baroque basis for the judgment and theory of art. Although not abandoning the humanistic traditions of Italy, the *eruditi italiani* nonetheless engaged the term *buon gusto* in the Enlightenment spirit of seeking reform and clarity. Lodovico Antonio Muratori (1672–1750) wrote his reflections on good taste as a direct result not only of the Orsi–Bohours dispute but also as a rectification of Camillo Ettori's essay.

Muratori, whose *Opere* run to more than thirteen volumes and 9,000 pages, was one of the intellectual giants of his age.[28] After Muratori's death, Voltaire appended a note to one of his odes voicing the usual, chauvinist cliché that until the time of Muratori and his eminent contemporaries, the Italians had been in a state of decline.[29] Just the same, Voltaire here and elsewhere made it clear how much he esteemed his near contemporary in Italy, even if he did not always give Muratori credit for those rich ideas he adopted from him. Near the end of the nineteenth century, the German historian of literature, Marcus Landau wrote that "Italian literature at the beginning of the 18th century . . . could show extensive and fundamental works on the theory and critcism of literature. Long before Burke and Hume, before Lessing and Mendelssohn, before Batteaux and Diderot, even before Addison, Shaftesbury, Dubos and Baumgarten, the first great work of poetics appeared in Italy, Muratori's *Perfetta Poesia*."[30]

Muratori was born into a poor family near Modena but received an excellent early education with the Jesuits. At the University of Modena, he followed a fairly standard and well-prescribed curriculum in law, theology, and philosophy. He also read widely in literature and history. After Muratori received his *laurea dottorale in diritto civile e canonico* (degree in civil and canon law – a common and important degree for an intellectual in the seventeenth and eighteenth centuries), Giovan Gioseffo Orsi and Felice Marsigli recommended him to Count Charles Borromeo, who brought the young jurist to Milan to take up a post at the Biblioteca Ambrosiana.[31] Arriving in 1695 at the age of twenty-three, having just been ordained a priest, he worked as a paleographer in the Ambrosiana's archives of unedited medieval manuscripts; it was there that he found an important eighth-century fragment now known as the Muratorian Canon. This text, based on late-second-century sources, lays out the order of the Christian New Testament.

In 1700, Duke Rinaldo d'Este appointed him the official librarian and archivist in Modena. During the complex negotiations relating to the so-called Dispute of Comacchio (having to do with the War of Spanish Succession and

conflicting feudal claims on the principality controlled by the d'Este family), Muratori played a subtle and significant role.[32] He produced documents that countered Clement XI's claim of papal jurisdiction of Comacchio, thereby siding with Imperial claims. Muratori's loyalty to the Este was to cost him crucial papal support, as we shall shortly see, in his call for an Italian republic of letters.

In his literary career, Muratori turned his attention to science, theology, aesthetics, and philosophy; most of all, he promoted ecclesiastical, literary, and political reform. Along with his colleague in the republic of letters Antonio Conti (1677–1749), Muratori championed the writings of Newton, Galileo, and Descartes (although he always held some reservations about pure Cartesianism).[33] Through Conti's influence he became a member of London's Royal Society in 1716.[34] Muratori also has passed down to us the most comprehensive definition and defense of good taste in the Italian language.

Even in the early years, well before the schism of 1711 (see Chapter 5), he became impatient with the Arcadians, complaining about the inanity of their bagatelles of pastoral poetry (what he called the *bagatelle canore*[35]); yet he stuck with them until Gravina led the final revolt, with the two of them and a host of like-minded intellectuals escaping the Arcadians' camp en masse. Muratori wrote those essays so crucial to our study of the politics of taste in eighteenth-century Rome (*I primi disegni della Repubblica letteraria d'Italia* [The First Designs on the Italian republic of letters] – and *Riflessioni sopra il buon gusto* [Reflections on Good Taste]) under the pseudonym Lamindo Pritanio.[36] I turn to Muratori for a working definition of good taste not because he succeeded in enunciating the way art should look (he writes far more about poetry than the visual arts, and, after all, there is no single source for an artistic style) but because of his earnest and systematic integration of taste with cultural and religious renewal as well as his conscious employment of both Galileo's experimental method and Descartes's arguments from doubt, these being the most "advanced" forms of dialectic and ratiocination in the early eighteenth century. Like so many of the others in Italy's growing cadre of *illuministi*, Muratori was an Augustinian, a rationalist, and an ally of the *gassendiani* and *malebranchiani*. He was as well sympathetic to and in touch with the Maurists in France.

Barely into his thirties, Muratori must have been relishing the heady atmosphere of the erudite and cosmopolitan company that he was keeping. He perceived that like-minded Italians hoped for a new kind of academy, one that would be free of princely control, not tied to the curia or a particular city; one that was scientifically and culturally based, that would address ecclesiastical reform, issues of Italian civic identity, and the modern state of letters and language. In short, he sensed a desire for something beyond the Accademia degli Arcadi, however attractive and genteel Crescimbeni and his shepherds may have been. Those intellectuals of the day who desired more than an opportunity to recite verses turned toward the more cosmopolitan and diffuse "republic of letters."

The republic of letters is a title well chosen because it invokes the public character of gatherings of literary men and women. The phrase itself probably can be traced to the early fifteenth century,[37] but the loose social organization of scholars gathering together or corresponding with one another became common and crystallized as a social phenomenon by the end of the seventeenth century, when there were journals and societies that took up the name. Because scholars believed that their concerns were separate from those of other members of society or the Church (although many churchmen considered themselves scholars and wished to be included within the republic of letters), they felt the need to fashion themselves as equals in a society dedicated to higher ideals. Crescimbeni wrote that the Arcadia "collects every science, and every genre of literature: and regards them all equally, and cultivates them so as to bear fruit for the republic." The republic to which he referred was the one of letters, not of Italian society in general (a distinction that led eventually to strongly expressed differences of opinion).[38] Of course, its egalitarianism, whether in terms of the members or of its putative catholicity of interests, was something of a smoke screen, a mystification of the hierarchical nature of the organization and the restriction of its interests.[39]

Muratori sat down to develop his ideas on the republic of letters (buttressed by good taste) in the dark days of the War of Spanish Succession when Modena was occupied by Imperial troops. His republic was not addressed simply to a loose and widely flung community of scholars and men of taste, as we shall see, but also to the immediate reality of the cultural and political crisis within Italy. He knew early on that the Accademia degli Arcadi was not an adequate model for the republic of letters. His first designs on the Italian version of the republic (dated 2 April 1703) are relatively (and remarkably) short and succinct.[40] The reflections on good taste, which soon followed, sprawl across a much larger discursive territory.

Muratori appealed to "i generosi letterati d'Italia,"[41] exhorting them to throw off their torpor and join his campaign for more enlightened studies. He expressed an acute and impatient awareness of the failure of Italy's many academies to address the crucial issues of the day. Every Italian city, he observed, had two, three, and more literary academies, and every day there were meetings and recitations of poetry, occupations that were interesting enough in themselves but that benefited the public relatively little. He observed that, like the delicate appreciation of a flower, poetry does not engage the intellect nor promote either the fame of *letterati* or that of the Italian nation. He saw his audience and himself – an eighteenth-century Italian clerisy – as representing and promoting a new kind of nationalism, one that had inherited much of its cultural identity from ancient Greece and Rome. In one of those asides that may strike us as a bit peculiar (but which probably found ready agreement among many of his readers), he recalled that (for reasons he could not fathom) Italy in the previous century had allowed its cultural leadership to slip away (I am paraphrasing his argument here). This happened not as a result of civil wars, an invasion of barbarians, a lack of

a good system of education, the failing genius of the people, or even because of tyranny; rather, Italy had somehow lost her way, wandering from the path of virtue, beguiled by sloth, her best minds poisoned by the baroque monster.[42] This reification of an artistic and literary style into a ogre of such proportions that it could sap the strength of an entire culture strikes me as very strange; yet Muratori found ready agreement to this view of things from a broad segment of European intellectuals. Then, Muratori goes on, just thirty years previously (he must be referring to Queen Christina's academy) the pernicious, maleficent influences of the baroque abated. He believed that the time was ripe in these opening years of the eighteenth century for a grand Italian republic of letters, one that would perfect the arts and the sciences by correcting abuses and by teaching the True and the Good. His repeated calls for "la fama dell'Italica Nazione" must have rung with a somber but fierce insistence in a peninsula caught in the crossfire of a brutal and confused war over Europe's balance of power.

Muratori precisely detailed his proposal. His general organization centered on an aristocratic model with democratic features. He proposed dividing Italy into five provinces (conforming more or less to contemporaneous political arrangements), each of whose heads was well suited to be a patron or protector of the Italian republic of letters. These were the Kingdom of Naples, together with the papal states under Pope Clement XI; the Most Serene Venetian Republic; Tuscany under the Grand Duke Cosimo III, dei Medici; and finally, the "Lombard Province," which covered the rest of Italy. The authority then would devolve from the great protectors through *arconti, consiglieri*, and *censori*. Clement XI would be the first to lead the republic of letters (and, in a sense, a politically unified Italy), with a three-year term. The leadership next would switch to Venice, and on down through the rotation, so that after all the other leaders had completed their terms, the pope once again would find himself in charge. Muratori had in mind specific duties for the various *responsabili*, all of whom would promote "Buon Gusto d'Erudizione," the *ragione d'essere* of the *Respublica*. He also outlined an elaborate and comprehensive curriculum for the republic.[43]

Muratori wrote his *Riflessioni di Lamindo Pritanio Sopra alcuni punti del Buon Gusto nello studio delle Scienze, e dell'Arti, per servigio della Repubblica Letteraria d'Italia* (as it is titled in his *Opere*) in the summer of 1705, soon after he gave up on his original proposal for an Italian republic of letters. In the summer of 1703, Rinaldo d'Este, duke of Modena, had withdrawn to Bologna to avoid the French troops occupying the *Stati Estensi*. That summer, Muratori, along with Eustachio Manfredi and Pier Jacopo Martello, stayed with Giovan Gioseffo Orsi in his Bolognese home. Rather than discuss his ideas for a new republic of letters with his immediate circle of friends, Muratori contacted the Venetian Bernardo Trevisan, whom he had never met but who was one of Orsi's correspondents. Trevisan quickly agreed to assist him in distributing the early texts on his "designs." In what appears to have been an ill-conceived scheme for generating interest and excitement in his plans for the new republic, Muratori's first essays sometimes

bordered on the satirical and comical. Anna Burlini Calapaj suggests that it was at Trevisan's insistence that Muratori proceeded in this manner.[44] She also advocates the position that Muratori objected to Trevisan's suggestions, but to no avail. The tone of "burla e commedia" put off some of Muratori's correspondents and in all probability undermined "Lamindo's" position, keeping the pivotal intellectual and scientific figure Francesco Bianchini from taking him too seriously. It soon enough became clear to Muratori that, despite the interest his *Primi disegni* stimulated, it was going to be nearly impossible to put his plans for a new republic into place. With a sense of resignation and despair, he commented: "I never believed Italian intellectuals, greatly divided by geography and differences in ideas, could be united."[45] Although he had brought Clement XI around to his way of thinking on the republic of letters, Muratori's pro-Imperial position on the d'Este principality of Comacchio cost him decisive papal support.[46]

Just the same, his proposals made something of a splash, impressing themselves on the community of scholars in the unofficial and scattered republic of Italian letters. Apostolo Zeno requested a joint publication of the "First Designs" and Part One of the "Reflections" in a 1710 edition of the *Giornale de' Letterati*. Once Muratori conceived of his plan for a republic of letters, he immediately set out to define the critical method he would have wanted for his organized republic, which is the discourse of *buon gusto*. Muratori's introduction to the matter of good taste begins with a recollection and defense once again of his proposal for a highly structured literary republic. Here he hoped to smooth out some of the potential problems, address those *studiosi* who had raised opposition, and develop his thesis on how to approach good taste and define a structure of the human psyche.

I write "discourse" when characterizing Muratori's "reflections" on good taste not because he is being rigorously philosophical (his employment of *riflessioni* suggests something different), but because the discussion of good taste seems to create its own kind of language, a genre almost (in the sense that pastoral poetry is sometimes thought of as a genre). Most twenty-first century thinking on taste suggests that it is forever an elusive concept, one that is more adept at expressing desire and power than it is in describing anything useful. But as an historical concept, taste (and specifically *good* taste) can tell us a great deal about how the leading thinkers expressed themselves. Muratori believed that *buon gusto* had replaced "il non so che"; how, he was not sure, but he believed it to be a good thing.[47]

Muratori launched his essay with a working definition of good taste: "We intend by good taste the understanding and the power to judge that which is defective, imperfect, or mediocre in the sciences and the arts."[48] How different this seems at first blush from Kant's assertion that "[a] judgment of taste requires everyone to assent; and whoever declares something to be beautiful holds that everyone *ought* to give his approval to the object at hand and that he too should declare it beautiful."[49] Muratori begins with the negative, Kant with the positive.

Yet Muratori would appear to anticipate Kant in some ways. Both men wrote about judgment and beauty; Muratori's and Kant's men of taste recognize beauty and demand agreement.[50] Both the German and the Italian tended to speak in general terms about the beautiful, with Kant in the main (although not invariably) restricting himself in his discussions of the purity of taste to perceptions of nature, whereas Muratori encompassed all of the arts and sciences under the rubric of *buon gusto*. Like Aristotle, who believed that poetry contains a higher coefficient of truth than history (which merely records specific events and therefore is true in but a limited fashion), Muratori tried to address the maximum level of generality. Rather than discussing *"il buon gusto particolare,"* he attended to *"il buon gusto Universale."*

In a penultimate move – that is, before providing us with his definition of taste – Muratori turns to the human mind and what he calls his commitment to first principles. He set out a model of human understanding that owes much to tradition and especially to St. Augustine's *On the Trinity* (book X, chapter 1), which in turn became part and parcel of the Enlightenment. The rational soul, he states, has both cognitive and appetitive (or willing) capacities; further, one can observe that our cognitive or intellectual potential is served by memory. The Trinitarian imagery continues with Muratori's assertion that there are three primary virtues of which we avail ourselves when approaching the arts and sciences: these are intellect (*ingegno* or *intelletto* – he seems to use the words interchangeably), memory (*memoria*), and will or desire (*volontà*). We can already see how different these are from Bouhours's use of such terms as *sentiment, esprit, délicat, naturel,* yet they are not so far from Kant's parsing of the human mind into cognitive power, feelings of pleasure and displeasure, and desire. For the memory or the imagination (*fantasia* – which is that capacity that allows us to overcome the real and participate in works of art) to do their work, Muratori insisted that intellect and desire must be sound, robust, and fit. "Neither a vivacious imagination nor a fortunate memory is able to unite with an unhappy intellect or a mean desire; neither one nor the other can create heroes of the republic of letters."[51] A happy intellect is a powerful force when it is joined with an acute, tenacious memory and a decided, determined will. With these capacities performing in harmony, we are ready to do the work of the intelligentsia or *letterati*. We are capable of producing, in other words, an immortal text, painting a perfect picture, and penetrating to the source of things. By alluding to an Augustinian model of the mind, Muratori anticipates Kant's argument that humans are capable of understanding the structure of the world because there is a kind of "fit" between the laws of nature and the structure of the human mind. Kant also paralleled Muratori's thinking in his assertion that the harmony and accord of our cognitive faculties achieved during the free play of the imagination is a necessary precondition for the experience of the beautiful. Is it possible that we should look *not just* to Hume, Wolff, Leibniz, Baumgarten, and Meier in our search for Kantian antecedents?

As I have already mentioned, Muratori's general assessment of human understanding also owes a great deal to seventeenth-century (and anticipates later eighteenth-century) debates on the functioning of our cognitive faculties. The epistemological issues of the time required that philosophers turn their attention to the study of the one who knows, not just to the issue of knowledge.[52] I have already suggested that Muratori based his model of the mind on St. Augustine, but in a more general sense, he was drawing on a tradition of human understanding, the origins of which predate by three-quarters of a millennium Augustine's writing on the Trinity. From the time of Aristotle on, we find fairly widespread agreement that sense, imagination, intellect, and will are our primary cognitive faculties. The question that arose over and over again had to do with the connection between mind and body: can there be a pure intellect that knows things (such as mathematics or geometry) that were not first of all in our senses? Should we agree with Aristotle that the rational and sensible souls are inseparable, that both intellection and the senses are unitary powers?

From my reading of Muratori, I feel confident that he ascribed to Descartes's solution to the mind–body debate. In his *Meditationes*, Descartes started with skepticism but was able to move to essences known by the intuition separated from the senses. So rather than leading him away from it, skepticism got Descartes to certainty. He did not need a metaphysical basis for his method, which relied essentially on conceptual clarity, sound empirical data, and the breaking of complex ideas into their constituent elements. Descartes drew from the traditional notion (used by the scholastics) that the senses bring to us images or "phantasms" that must always be present in our minds for there to be any real thinking. But his arguments from doubt and his assurance that thinking precedes being (I think therefore I am), convinced him that we can can form ideas without images.

Muratori had a method, too. His clarion call for the well-balanced man (and mind) finds an echo in Joseph Addison's journalistic conjectures on the man of taste. Addison (a bit later than Muratori) asserted that one's capacities should be balanced and in harmony: "to have a true Relish, and form a right Judgment of a Description, a Man should be born with a good Imagination, and must have weighed the Force and Energy that lie in the several Words of a Lanugage. . . . The fancy must be warm, to retain the Print of those Images it hath received from outward Objects; and the Judgment discerning."[53]

Addison used the word imagination, as we see, but the British – and especially Hume – often employed the term "fancy." Thomas Hobbes sometimes made a distinction between the Latin *imaginatio* and the Greek *phantasia*, although he was just as capable of conjoining them.[54] Muratori, like many others in the eighteenth century, associated imagination with memory but saw that they were not identical, that one in a sense served the other. We can know the past through memory, but to tie the past, present, and future together requires imagination, as Samuel Johnson remarked. John Locke saw the imagination as the synthesizing force in the association of ideas. The imagination, as I have already proposed, is

that which shapes our minds to art, is that extra facility and power that gives us a push into the realm of painting, sculpture, and literature. Certainly it is, according to Muratori, an accessory faculty, a kind of inferior one, in fact, that permits us to apprehend the world. But without a balancing intellect, the fantasy cannot know truth.[55] For Herder, the imagination brings together body and mind; for Hume, it is a "magical faculty" that defies understanding. Indeed, there were those who saw imagination as a double-edged sword, one that facilitates the memory, the intellect, the will, but which also can turn on itself. The imagination has an anarchic character, deriving its inspiration from the muses, from beings and places outside of history. Imagination's danger, Muratori believed, was best thwarted by a smooth running mind, one where checks and balances prevail, where harmony rules, and the intellect corrects our sensations.

Just the same, even smart, reasonably balanced people can go astray. Muratori sounds a cautionary note when he reminds his readers that we have all witnessed men (have we not?) of powerful and felicitous intellect, will, and memory veering off into dangerous territory, dedicating their lives to useless or pernicious studies, committing heresies, becoming atheists. One needs wisdom, and that is produced by *buon gusto*.

Good taste is our guide when studying the arts and the sciences. Muratori had highly utilitarian ends in mind when enjoining his readers in the republic of letters to practice *buon gusto*. Whatever one studies, it must lead him back to the True and the Good. The archetypal forms of erudition were, for Muratori, Christian theology and moral philosophy, the only absolutely necessary pursuits. These in turn are based on the scriptures, and, so, when reading the Bible, one should value the literal above the allegorical, analogical, and tropological. *Buon gusto* and the republic of letters serve Christian theology, and moral philosophy, and therefore pave the road that leads us to an image of Truth. Any sort of erudition that does not serve these ends is so much hot air, sterile pomposity (*sterile pompa*). He writes that "Finally if these arts or sciences serve human ends, making us good theologians and ethicists, not just in theory but also in practice ... then the price we pay will be justified, and the profit will be singular."[56] How different this is from Boileau's investment of good taste in *les hônnetes gens* and the reading public – not to mention Bouhours's derivation of good taste from the court and the salon.

Muratori was guarded and conservative in applying his precepts to theo-logical matters. Good taste might help with needed reforms within the Church, but it finally would not lead to any profound insights into the essential questions of the faith; we should not be tempted to use this generally useful tool for an understanding of that which is beyond its (and our) ken. In other words, Muratori was assiduous in his separation between the arts and sciences on one hand and theology and the mysteries of the faith on the other. For the latter, we should rely on the authority of the Church Fathers and Scripture. Why should we try, he asks, with our poor, human intellect to untie that most intricate and difficult

of knots, predestination, which caused St. Paul to tremble, and St. Augustine, the Holy Fathers, Church Councils, and sagacious writers to lower their eyes in submission and forbearance. One who in naïve temerity attempts to tackle such ineffable mysteries as the Trinity and the Incarnation is likely to end up befuddled, mired in error, trapped by heresy.[57] In Muratori's metaphor, one will inevitably become shipwrecked on the shoals of these mysteries.

Just the same, *buon gusto* is the lynchpin of Muratori's ethical criticism, and as such it serves many masters and achieves many goals. Good taste is the big engine that could and that now can direct our understanding of human production and creation. In fact, *buon gusto* can distinguish between the merits of the arts and sciences and the "demerits" of those who treat them. Who has not come across one of those "flycatchers" who deals in poetic minutiae, going on endlessly about nothing.[58] Muratori does not provide us with an example of trivial poetry, but he did so with history. *Buon gusto* would militate against a history that merely recounts the habits of antiquity, their games, food, buckles, spurs, handles, rings, shoes, and so on (this kind of thing, of course, was to be enormously interesting a century later to Jacob Burckhardt). What style of clothing did such-and-such a saint wear, what was the name of the father of Hecuba, who was the mother of Anchises? In Muratori's estimation, these interminable questions are of little moment and can try one's patience.[59] Historical study can be important, but not all who practice as historians have something important to say. He wanted there to be some meat on the bare bones of historical inquiry; he expected the historian to say something about why things were the way they were and to draw some lessons from the investigation. He was, indeed, *un historien engagé*, as Eric Cochrane has described him.[60]

Ethical criticism of this stripe has a long history, tracing its origins to a time well before Plato, who himself fulminated against the Sophists and their love of tropes (not unlike the *concettismo* practiced by Marino and his followers), which could so easily deceive gullible readers. Ethical criticism gauges the effects of cultural productions – whether in the arts or sciences (which is how Muratori consistently framed the issue) – and judges whether the effect is deleterious or beneficial. Plato's famous arguments for excluding many of the arts in his republic demonstrate the principle of "gatekeeping": The voices and influences we allow into our lives have an impact on the individual and the society. He who guards the portals of knowledge and experience can shelter us and keep us safe. Muratori had his contemporary republic of letters (his immediate audience), Catholics, and Italian "citizens" very much in mind. His audience (in a sense, his "choir") also included those whose thinking, whereas doctrinal, tended toward enlightened attitudes associated with democracy, anti-Scholasticism, and anti-Aristotelianism.

But he was not just a shepherd bent on protecting his flock; he hoped to produce rational and independent thinkers, souls not subject to authority (except in religious matters). It is on the point of revered authorities and independent

thinking that Muratori reflected some of the values of the Frenchmen with whom he was always – in his mind at least – arguing. In his *Reflections*, Muratori censured received opinion (*anticipate opinioni*), one of the great impediments to the search for truth.[61] He blamed our strong tendency to trust the ancients to how easily we are bedazzled by fame, the human ego, and our zealous reverence for the past. Plato, Socrates, Aristotle, and Epicurus were men of merit, but they were, after all, merely men. St. Thomas, Duns Scotus, Occam, Roger Bacon, and Raimondo Lullo were too dependent on Aristotle (as were, according to the Jansenists, the Jesuits) for their philosophy on one hand and Peter Lombard for their theology on the other. In youth it is important to follow a master, but finally one needs intellecutal independence. Muratori invoked that by now familiar notion that, beginning with the Italian Renaissance in the middle years of the fifteenth century, there was more questioning of the "Schools" and more reassertion of the importance of Plato at the expense of Aristotle. Pico della Mirandola, Francesco Patrizio, and Galileo taught us the faults of the antique philosophers. Erasmus, Juan Luis Vives, Gassendi, and Descartes railed against our cowardice in the face of worthless ideas; they understood the veneration of Aristotle, Galen, and Ptolemy, but they had no compunction about moving beyond them.

Buon gusto seeks the middle way (even in rhetorical terms), makes judgment the child of Prudence, and abjures antiquity and authority for their own sakes. Prudence has a role to play when studying moral theology, for instance. The sensible scholar who understands universal good taste will be neither too restrictive nor too inclusive when assigning a role to human consciousness (for which, read "free will"). Here as elsewhere Muratori eschewed the controversies between Jesuits and Jansenists; it is an error to be too rigorist or certain (the Jansenists) or too probablistic, indulgent, and benign (the Jesuits).[62] Muratori was a follower of Galileo and his school and he tried to shun the most severe tensions of his age and avoid taking sides in the Jansenist–Jesuit controversies. However, his sympathies were with the Jansenists. He made a similar case for taste in rhetoric and poetry: one should steer a steady course between the Scylla of brevity and acuity and the Charybdis of the excessively ornate, between the pungent and the fantastic, the natural and the sententious. As much as he worried about the truth quotient in imagination, he returned to *fantasia* again and again. He found irresistible that which he could not entirely trust. Trying to reconcile some of his own ambivalent attitudes, he suggested taking the middle way. Muratori would not specifically identify the great debates of his own age, but he addressed them just the same, all under the aegis of good taste. To extend these comments to artistic styles, we can see that Muratori would have found the Jesuit baroque style too ornate and yet probably would have judged a severe classicism as too dry and economical, too acute, perhaps even harsh. Muratori in a sense heeded the judgment of Milton's St. Michael in Chapter XI of *Paradise Lost*, that one must observe "the rule of not too much, by temperance

taught." I think he must have liked the paintings of Francesco Trevisani, for instance.

Buon gusto has counsels and precepts that address what we can perceive and judge with our senses under the tutelage of reason (rather than authority), and it admonishes us to avoid that which lies beyond our intellectual capacity. Muratori paraphrases Aristotle by saying that there is nothing in our mind that was not at first in our senses. Can one speak of whether privation or absence is a principle or property of things, whether color or smell are actually in objects?[63] Not really. Nor should one take on the finer issues of faith. The Holy Church has resolved those issues once and for all. We need only accept.

It seems clear to me that Muratori was doing his best to be an enlightened thinker, a forceful and efficient reformer, a good Catholic, and, to a degree at least, a Cartesian. He moved adroitly to avoid the difficulties of his age. Whereas Muratori was championing the new science of Gassendi, Newton, and Galileo, and the new philisophy of Descartes (with, as I have suggested, misgivings), the Office of the Inquisition was doing its best to brand as atheists those who followed, in scientific and religious terms, the same thinkers and their systems of beliefs. At the end of the seventeenth century, the Inquisition went after followers of Cartesian philosophies, for instance. A consultant to the Inquisitorial Tribunal, the Jesuit Antonio Baldigiani, wrote about the climate in Rome at this time: "All Rome is in arms against the mathematicians and physico-mathematicians. The cardinals have staged and are staging unscheduled meetings before the pope, and there is talk of making general prohibitions against all authors of modern physics. They are drawing up very long lists, and among those at the top of them are Galileo, Gassendi, [and] Descartes, as those most pernicious to the literary republic and to the sincerity of religion."[64]

Despite the Jesuit's comments on the literary republic, the Church's fears were directed toward theories that questioned the transubstantiation of the Host (in this case, Descartes was seen, because of his corpuscular theory, as one of the hated atomists). According to Cardinal Barberini, atomists "might claim to prove how the accidents of the bread and wine remain after the consecration, [while] the substance of the said bread and wine changed into that of the body and blood of our lord Jesus Christ." Such an assertion would be, in Barberini's mind, anathema.[65] Muratori seems to have been bent on isolating the literary republic from the witch hunts of the Holy Office.

Muratori marshaled the intellectual tools of the republic of letters when he commented that wise men use "grammar, [foreign] languages . . . rhetoric, poetry, logic, philosophy and other sciences" for the arts of persuasion. Because he was interested in universal rather than particular (that is, discipline-based) good taste, however, Muratori wished to comment on general approaches. If one hopes to escape from error and find the true, then one can do no better than to follow the works and methods of Descartes and his "illustrious" disciples. There are, as well,

general methodologies and curricula for studying and teaching that, Muratori declared, were well enough known for him to pass on to other matters.[66]

Certain types of rhetoric and eloquence annoyed Muratori. He disdained luxuriant styles, the excessive caprices typical of he literature of the mid-seicento – even in the best books and best writers – and the horrid, graceless manner of the Scholastics. All things should be expressed in a style that is neither too rustic, sordid, and deformed, nor adorned with inappropriate rhetorical flourishes. One should observe decorum and dignity; but, he warned, do not follow a certain Frenchman (he probably had in mind Bouhours) who repudiated rhetoric altogether. Do not blame rhetoric; condemn its abusers. By refusing to abandon the traditions of rhetoric, Muratori closed forever the path that would lead to an understanding of taste that would resonate throughout the European eighteenth century.

In the end, Muratori declared his hopes for his century, the settecento. He trusted that Italy would be the peer of every other country, promising great things, encouraging everyone's talents, awakening those who slept, cultivating the laws of good taste both general and particular, and heartening scholars not just to plod along with their work but to come to true understanding. He especially promoted the study of Latin, Greek, and Hebrew, because Latin is, simply put, *necessary*, the language of the Church, widely known and practical; Greek is the language of erudition; Hebrew is holy. Just as the rediscovery of the Latin and Greek traditions in the fifteenth century helped to launch the Renaissance, Muratori believed that Italian culture could once again find its true glory in the name of good taste.[67]

Judgment, the child of Prudence, begets good taste, and *buon gusto* was for Muratori the key to the balanced and healthy human mind, to all of the arts and sciences, the hoped-for republic of letters, a unified Italy of renewed glory, the precincts of the True and the Good, and a road map for the rational, balanced, prudent, human mind unfettered by authority or received opinion. He entered the quarrel of Italian versus French literature launched by Orsi and Bouhours as an Arcadian believing that the *Accademia degli Arcadi* and especially the poetry of Maggi and Lemene overthrew what he called the "Monarchy of Bad Taste."[68] As much as he admired Marino's poetic acumen, he found it necessary to attack the baroque and *marinismo* in the interests of his ethical criticism. There are numerous places in *Della Perfetta Poesia Italiana* where Muratori reveals his admiration of Marino; in the end, of course, he had to abandon him, but with some regret. In several short letters housed in Rome's Arcadian archive from Muratori to Crescimbeni, Muratori beseeches the *custode* to send him a copy of Tommaso Ceva's new text on the life of Lemene.[69] Once he got his hands on the book, he must have been entranced by Ceva's argument against "loud" poetry. Ceva solicited from his contemporary *letterati* a poetic diction that sounded like a soft instrument – say a lute – playing in a small room with few people. Ceva also

warned against unbridled fantasy – uncontrolled by reason, that is – that has the power and the danger of a runaway horse.[70]

It is not unparadoxical that taste, whose origins are indubitably in the senses – taste *is* one of the senses – can be transformed into pure intellection. Muratori seems to have believed, like Leibniz, that sense, imagination, and memory occupy one plane of intelligence, and pure understanding exists on another and higher. He was, in short, a rationalist, but one whose debt to the empiricists is undoubted. His search for the middle way led him into thickets of contradiction, ones he refused to acknowledge. Perhaps Muratori would have agreed with Georges Bataille, when he wrote that "truth has only one face: that of violent contradiction."[71] Yet focusing on truth and contradiction, paradox and the critical double may in fact lead us down the wrong path, or at least a road not taken in Muratori's reflections on good taste. What Muratori accomplished was to further a certain discourse on institutions, power (an "enabling" – to which I have already alluded), and knowledge. Muratori did not define good taste nor did he explain why good taste was necessary. Not really. But his insistence on good taste tells us the direction things were going in the cultural currents of his time and place. Things were going away from the baroque and toward the pastoral, away from an art and culture of metaphysics to one of self-articulation and ways of knowing, from early modernism to modernism.

TREVISAN ON *BUON GUSTO*

Muratori chose the Venetian philosopher Bernardo Trevisan (1652–1720) to assist in the publishing of his first designs on a republic of letters, perhaps because in La Serenissima he was least likely to be censored. Although Muratori's first attempt to garner interest among Italian intellectuals for a new and more universal kind of academy failed, he did not give up his project. Trevisan was there to help him publish his methodological tract, *Reflections on Good Taste*.

Trevisan was ideally placed to lend Muratori a hand. He came from a family of doges, was a senator and a member of the XL (the Council of Forty, or Quarantia, Venice's court of appeals), was rich and had wide-ranging philosophical interests.[72] He may have been somewhat chastened by his failed attempt to help Muratori advertise his designs on a republic of letters, which could explain the alacrity with which he jumped into publishing the essay on good taste, even adding his own introductory remarks; these, however, differ somewhat in tone and detail from Muratori's philosophy. Perhaps we have here once again a certain obtuseness on Trevisan's part; just the same, his philosophical position on *buon gusto* is instructive.[73] He took for granted that readers of Muratori's text – most of whom would have considered themselves fellow *letterati* and *eruditi* – had an intimation of *buon gusto* and had at least heard or read the phrase many times. In the event that they may have been vague on some of the particulars, it was his

intention to provide an overview of Muratori's philosophy and to introduce the basic premises of the idea of good taste. Trevisan's notions of the True and the Good derive from neo-Platonic and Christian traditions, which he then melds into a form of cultural studies appropriate to the republic of letters.

He states that "we" (meaning the human soul in its most universal sense) may have known the True and the Good when we were in a state of purity – that is, before the Fall – but, in our encumbered, contaminated, and impure state (I am paraphrasing Trevisan), we contemplate the reverberation of the divine attributes in things and, by means of our fallible suppositions and through dubious comparisons, investigate what those particular and distinct characteristics may be.[74] We seek to know the True and the Good, seeing them, as we are wont to do, through a glass darkly. Our tendency to doubt makes it hard to recognize them.[75]

Like Muratori, Trevisan argued from an ontological position on the nature of the True. Things are true insofar as they correspond to their idea, which exists both as a Platonic exemplar and, in a Christian sense, in the mind of God. Knowledge of the True must begin with the effect or sensation in us caused by the thing that we are to know. As an eighteenth-century man of taste, Trevisan affirmed that it is our nature to receive impressions of an object, idea, or experience by way of our senses and that this capacity is universal in our species. Unlike Muratori (who shunned such singularity), Trevisan located the sensuous origin of taste in food and drink: The particles that compose these liquors and comestibles penetrate our tongue and palate, activate nerves, and, as they circulate through our system, "push" on the spirit (borrowing some of his language from Descartes) to create pleasure or displeasure. Taste is a fundamental concept that molds our perceptions and allows us to understand with our minds that which is outside of us. He goes farther and asserts that good taste constitutes a God-given disposition and predilection to perceive the Good and the True. By associating taste with a particular human sense, Trevisan naturalizes the concept of good taste, pulling it out of the rhetorical and literary matrix that had held it for millennia.

Trevisan asserts (rather than demonstrates) that we have this capacity; it is, in philosophical terms, an a priori postulate. From this premise, he argues that we can either fall into error, through misapprehension of reality (as a result of – in Nicolas of Cusa's phrase – an *infirmitas gustus*[76]), or recognize the True and the Good through our inner capacity for good taste, which remains in conformity and correspondence with reality. Thomas Aquinas expressed this correspondence between the intellect and reality in the following terms: "*Veritas logica est adaequatio intellectus et rei*" (*Summa*, I:21:2). *Buon gusto* depends on nature, the perfection of our organs, and the temperament of our humors; with these all kept in proper order, our sensations remain uncontaminated and operate at their best. Perceptions can be fortuitous or haphazard, of course, so our reason must correct the inevitable errors of our impressions and therefore guarantee a kind of intersubjective validity.

In other words, we as human beings *must* all respond to beauty in a way that is fundamentally similar.

Trevisan wrote about how the human mind is endowed with intellect, memory, and will – borrowing his terms from Muratori (and ultimately the many discourses of the sixteenth and seventeenth centuries on our cognitive capacities) – but he played with these attributes, powers, or potentialities (*pontenze*) as if they had sprightly allegorical "potential." He creates metaphors of a more than usual metaphoric nature to demonstrate mind–body interrelations and the infinite malleability of our inherent potencies: memory, he writes, is the ear of the soul, whereas the ear is the memory of the senses; intellect is the eye of the mind, whereas the eye is the intellect of the body; will is the mouth of reason, whereas the mouth is the will of all that constitutes these powers.[77] Although each of these potentialities can play handmaidenly roles, they are not to be confused with one another. Just the same, they all do come into play, and constitute a more variegated – if still carefully differentiated – systems of senses than one often finds in the eighteenth century. The usual view is that the eye is for painting, touch for sculpture, and the ear for music. Trevisan demonstrates the mind's overall unity by insisting, in the manner of a metaphor, on the interrelations of such things as intellect–eye–mind.

Being somewhat more systematic than Muratori, Trevisan organizes the "art of good taste" (*L'arte del buon gusto*) into three things that are indispensably necessary for the human mind. The principle potentialities or powers (intellect, memory, will) must be arranged so that each has its appropriate parts and does not arrogate to itself functions of the others. All the powers treat subaltern faculties – those that serve the primary potentialities – in a disciplined and moderate manner as becomes their ancillary status. Finally, our potentialities or powers control the more riotous emotions, which tend toward insubordination.[78] If the memory tries to be the intellect by confusing images for facts; if the intellect spends time in idle speculations prompted by an unmoored memory; and if the will chooses to act on these confused, comingled, impressions that are neither the direct information of the memory nor the good counsel of the intellect, the results will be precipitous, immature, and defective. In short, nothing good – especially no good taste – will result from the confusion of our potentialities. This farraginous situation can only result in caprice, deceit, and concocted, counterfeit figures.[79]

One occasionally finds references to classicism and neoclassicism in the cultural products (in this case, philosophy and the visual arts) of the early eighteenth century. But both Trevisan and Muratori, for all their seeming rationalism, abjure the objectivist position of classicism for a methodical consideration of the subject position. Long before the British and German writers on taste, they emphasized the power of the mind to shape experience, but they did it so as to emphasize the disinterested nature of our intellect, our power to recognize and project the necessity of agreement among disparate subjects who nonetheless share mental powers that can find agreement. Descartes, Hobbes, and Locke established the

philosophical basis for dualism, for subject/object positions, for the separation of the mind and the body, reason and feeling. Certainly one can find in Locke a concern over the dangers of the imagination, a fear undoubtedly shared by Muratori and Trevisan.

Trevisan poses the following rhetorical questions (I am once again paraphrasing): How often has one not been deceitful in making pictures of chimera or things that never were, by proposing impostures of things that never are? He admonishes his readers that these appearances, which are mixed up, confounded, dispersed, and transformed, do not represent things as they had been or as they might become. When representing abstract ideas, one should do so at least with natural proportions (reflecting the Aristotelian idea that a probable impossibility is better than an improbable possibility). It is bad taste to end up with equivocations, fallacies, errors, monstrous proportions, deceit and falsehood. When things that are not supposed to be intermingled are mixed together, it gives rise to fear, jealousy, apprehension – and these promote distortion, an impropriety of *concetti*, and absurd opinions.[80]

Trevisan seems almost to have a fear of miscegenation. He writes that "A talented architect invented the Corinthian capital, that gracious ornament, by [adapting the appearance of] several plants displayed on a tomb. Others believe that by multiplying in every order and every part the same leaves, one thereby multiplies attractiveness, but they fall into the graceless confusion of the barbarian centuries, or the barbarism of our century." In one sense, he attacks the idea that "if some is good, more is better," but in fact he makes oblique references to the "barbarism" of the baroque and the *bel composto*. He argued against radical approaches when he wrote "often in excessive ardor; often when incautious; always when one falls into extremes, one is removed from the True, distant from the Good, and alienated from good taste."[81] This, too, is a condemnation of the baroque.

In Trevisan's hierarchy, the intellect, memory, and will must remain in good working order and must restrain those lesser tendencies of the human character toward prejudice, affect, and appetite. In the memory, prejudice tends to contaminate truth. The *affetti* or emotions bestrew a mist that confounds the intellect, and the appetites have a way of shaking off or pushing away the will.[82] We must remember that taste may begin on the palate, but it ends in the mind.

He went on to counsel his readers on the proper understanding and use of our appetites for knowledge, power, and pleasure.[83] The search for knowledge is, of course, natural and not in itself a bad thing, but to search always for the unusual and the novel, for that which glitters and is not useful, constitutes not the vileness of wanting to know, but wanting to know the vile. Also, given our fallen, human state, the will to power, however natural, is futile. The appetite for pleasure is profoundly human and is often one that seeks praise, glory, or unconditional acceptance. One should not luxuriate in a misguided sense that one is godlike, deserving of heavenly bliss; nor, on the other hand, should we put

too much stock in praises sung by the masses. Trevisan cautions us that "there can be no doubt that universal praise is best; but that which results from the majority of men is not universal if the majority does not contain the best men. The vulgar cannot understand those actions that they are incapable of performing. The worst of all is the imperfect ear of this strange animal [the undiscerning man] that cannot apprehend anything beyond the superficial. His dull ears do not have the ability to recognize any sound other than the tumultuous and the strained. He who seeks praise from [this vulgar man], or studies only superficial appearances with the deceitful purpose [of receiving that praise], is never in accord with good taste."[84]

Although Trevisan was loath to propose a theory of good taste, he was happy to propose certain preliminaries to a theory. He lectures us on our potentialities, warns us about our "subaltern" faculties – with special admonitions about jumbling things together – and gives us sundry advice and warnings. Be vigilant about our emotions and our appetites, for although natural, they can easily lead us down the primrose paths of happy dalliance and bad taste.

Because Muratori sought a high level of generality, he made infrequent references to specific arts and sciences and mentioned the visual arts hardly at all. Trevisan, on the other hand, saw the application of *buon gusto* to *le belle arti* and went so far as to assert that the visual arts can aid our sense perceptions and convey *buon gusto*. The novice will still prefer a painting that is merely filled with vibrant colors, but an expert judges the design, perspective, and the force of *sbattimento* – how it strikes the eye.

In general, when he wrote about our potentialities and how they should dispose themselves in such a way that everything is in its own place, he was making an argument about form and composition. He created an antibaroque polemic. His argument runs pretty much as follows: each part should be in its proper place, and there should be no confusion between or among our various primary and secondary mental and psychological characteristics, nor any arrogation by one power or potential of another's functions. There is no good taste if the memory acts without the mind – or usurps the functions of the mind – and vapidly or wanderingly produces images. One should proceed rationally. There is no good taste if the intellect (which has need of facts and a solid grounding) absorbs itself in idle and subtle speculations. So if the memory multiplies its images and the mind iterates or imports those images, there is an impediment to the will. The will without the information of the memory or the counsel of the intellect tends to behave in a precipitate (and therefore unthinking) manner. Certain parts observe a subaltern position, so that they serve as ministers and as ancillaries. We should not allow our *affetti* to excite us, because that creates a risk of obstinacy and resistance to rules, which undermines the dignity of the potentialities of our innate propensity for good taste.

Trevisan's language is consistent, even punctilious. He valued order, consistency, discernment, discrimination, differentiation, clear disposition, coherence,

hierarchy, and subordination. He feared confusion and disorder, heterogeneity, complexity, variegation, imbroglio, and discord. The strongly pejorative overtones to such words as deceit, caprice, falsehood, fallacy, impropriety, ardor, extremes, confounding, transformation (and the list can be extended) that pepper his introduction to Muratori's *Reflections* demonstrate that he was no friend of the *bel composto*. He must have shaken his head in dismay over Filippo Baldinucci's praise of Bernini: "The opinion is widespread that Bernini was the first to attempt to unite architecture with sculpture and painting in such a manner that together they make a beautiful whole (*bel composto*). This he accomplished by removing all repugnant uniformity of poses, breaking up the poses sometimes without violating good rules although he did not bind himself to the rules. His usual words on this subject were that those who do not sometimes go outside the rules never go beyond them."[85]

Muratori's reflections on good taste succeeded in dismissing the Bouhours–Boileau anti-Italian and anti-rhetoric stance while maintaining the need for reform and a new conception of the arts and the sciences, culture and literature, the practices of religion and philosophy. He argued powerfully against received opinion and in favor of the empirical sciences. For all of Crescimbeni's endorsement of *buon gusto*, he and his Accademia degli Arcadi with its insistent pastoralism, lyricism, and sonneteering found no favor with Muratori. Finally, by dedicating good taste to the Italian republic of letters, Muratori defined his audience in far more comprehensive terms than Boileau had succeeded in doing.

AESTHETIC AND CLASSICAL SANCTIONS OF PASTORAL AND ARCADIAN LANDSCAPE PAINTINGS

Having established the position of good taste in contemporary discussions, I would like to pause here and ponder, in terms of *buon gusto*, the position of the Arcadian topos – the *locus amoenus*, the pleasance, the Arcadian garden, the place of love – in short, the landscape, especially as it appears in painting. When the Académie Royale made its determinations on the classification of landscape painting, whether pastoral or any other kind, it was anything but generous. One of art history's most important theorists of the seventeenth century, André Félibien, published the annual conferences for the French Royal Academy; in the 1667 edition, he established a ranking of pictorial types, beginning with the most "noble" of arts – history painting – and proceeding to the lowest echelons of landscape and still life. Félibien had an orderly mind and understood in his own terms what was decorous and dignified, what was not, and how it all should be arranged. He gave voice to widely held ideas about the *grand goût*, the classical doctrine of painting, and the status of landscape painting.

The general attitude toward landscapes in the early modern period is not difficult to divine. The painting of nature had emerged as a separate category by

the middle of the sixteenth century, when Giovanni Paolo Lomazzo in his *Trattato dell'arte della pittura* (Libro VI, vol. lxii; Milan, 1584) came up with an appealing, if somewhat incoherent system of landscape types. He wrote about landscape paintings that showed "fetid" places and "privileged places," or places of "fire and blood," and "places of delights."

As Ernst Gombrich has suggested, the emergence of various genres in Renaissance painting probably had something to do with the specialization that existed in late medieval workshops, especially in the North, and with the fact that Renaissance theorists took particular note of landscapes.[86] Undoubtedly, artists who worked for an open market and found themselves forced to specialize saw that there was a fairly strong market for landscape paintings. Although Leon Battista Alberti judged landscapes not to be so majestic as history painting, he nonetheless expressed the widespread enjoyment of such scenes when he commented in his *Ten Books on Architecture* that "[o]ur minds are cheered beyond measure by the sight of paintings depicting the delightful countryside, harbours, fishing, hunting, swimming, the games of shepherds - flowers and verdure."[87] Building on Alberti, Leonardo went on to praise the painting of nature in terms that emblazon the landscape artist's abilities with the stamp of genius. When painting landscapes, one enters into nature's generative forces and thereby creates something divine.

Notwithstanding Alberti's and Leonardo's esteem for landscape painting, the classical doctrine in literature and the visual arts found little to praise in nature descriptions. By the later seventeenth century when Félibien ranked pictorial genres, it had become increasingly difficult to accord any real degree of seriousness to landscape painting. Views of nature were understood as something supplemental – a parergon – to the main action. So even though landscape had a role in painting, it was auxiliary.

The classical–humanist tradition in literature and the visual arts promoted the kinds of painting and sculpture that instruct as well as delight, that are based on allegories or narratives of general significance and moral weight, which spring from human character and action. Giovan Pietro Bellori put it succinctly when he wrote that "[p]ainting is simply the imitation of human actions, which properly speaking, are the only actions worthy of being imitated."[88]

Although collectors seemed not to care very much about the status of landscape paintings, theorists did. Because nature imagery plays an important role in pastoral painting, and the pastoral–Arcadian is tied directly to *buon gusto*, the philosophies of *buon gusto* had to come to terms with landscape painting. But how?

In Muratori's formulation, *buon gusto* provides the basis for judging what is defective, imperfect, and mediocre. If good taste can tell us what is flawed, it also can judge that which is perfect and beautiful. Muratori's and Trevisan's insistence on the True and the Good as the very substance of *buon gusto* incorporates the beautiful. The problem then becomes one of how to judge a landscape as beautiful. In 1794, when Friedrich Schiller published a short essay on the landscape

description in Friedrich Matthisson's poetry, he grappled with the problem of how to make disparate forms of nature into something that contains classical unity. Schiller was not alone among eighteenth-century thinkers who thought about what makes a landscape beautiful, but he was one of the more systematic of those thinkers, and his reasoning bears on the issues of taste and Arcadianism even in the earlier part of the century.

Schiller by this time was familiar with Kant's critique of aesthetic judgment. Liking something may be subjective in the narrowest of senses; that is, we like something because it fulfills an interest or even a need that we have. But if we feel that our response is unrelated to self-interest, is not peculiar to us, then it is a disinterested aesthetic judgment and should hold true for others. We mean something by beauty, and in principle others *ought* to agree with us about what is beautiful. Schiller had to come to terms with the way that nature poetry and landscape painting bring about a synthesis, the joining together of reason and imagination, nature and its idea or concept, fragments of experience and an enobling human wholeness – all in the service of creating the ideal, and specifically the ideal of beauty, which for our purposes is indistinguishable from *buon gusto*. One needs to go beyond what Denis Diderot called the *agréable*, the merely agreeable or attractive. Kant, too, distinguished between the agreeable (*angenehm*) and beauty (*Schönheit*), although he set himself the more difficult task of wrestling with judgments of taste unrelated to concepts (like classicism or the pastoral). Schiller seems less inclined to take that step, the one also not taken by Muratori and his Italian cohort. But first let us follow Schiller's argument.[89]

Schiller feared that the pleasure one takes in the enjoyment of landscape description may not derive from the existence of a unity nor the quality of the ideal that underpin a *necessary* and intersubjective experience of beauty. Jason Gaiger's take on Schiller's position is that "[v]iews of natural scenery . . . offer no objective rule by which the poet can ensure that the path taken by his imagination will be in accordance with the imagination of his audience."[90] In other words, Schiller's familiarity with Kant (he had taken up study of the philosopher in the 1780s when he was on his decade-long "sabbatical" from playwriting), even his occasional use of Kantian language, does not extend to his compatriot's view that natural scenery may give rise to an archetypal experience of beauty. Schiller found himself in the classical humanist camp, believing that only things human can rise to a level of universality necessary for agreement on matters of beauty: "The realm of *determinate* forms does not extend beyond *animal bodies* and the *human heart*; consequently these two alone allow of an *ideal*. Above man (as appearance) there are no longer any objects for art, but only for science; for here the domain of the imagination comes to an end. *Below* man there are no objects for *beautiful* art, but only for the agreeable, for here the realm of necessity is closed."[91]

Athough the preceptless version of taste came to be the one touted by Hume and Kant, others were not so easily convinced that the old anthropocentrism

should be severed from beauty. Schiller agreed with Bellori's position that things human occupy the artist to the exclusion of pretty much everything else. Just the same, he could not help but be moved by Claudian landscape paintings and Matthissen's landscape poetry, sensing that others should also respond in kind. He was in a quandary. Accepting Kant's distinction between the beautiful and the agreeable and his assertions that all subjects – all percipient humans – must assent to the necessity of beauty, Schiller nonetheless could not make out how the bits and pieces of nature – nature in its fragmentary, diversified, and diffused state – could ever rise to a higher, harmonious condition. Repudiating any hope of understanding the noumenal, but recognizing the phenomenal and pinpointing beauty in human feeling, Kant did not really have to worry about the status of nature. It was simply a given.

Admittedly Kant saw that there was a difference between free beauty and fixed or accessory beauty. Beauty in the fine arts is fixed because the category of art secures things and establishes intentions. A judgment of fixed beauty results from applying rules – the rules of art – and so one makes intellectual judgments. Just the same, beauty in art is like beauty in nature, except for the fact that it is restricted in art by the concept or category of art. All of this is to say that Schiller was not so much reacting to Kant's distinctions between free and fixed beauty as he was indebted to the oldest of rhetorical traditions in the West, specifically the one that requires of beauty an infusion of *idea* (or, as it came to be called in the eighteenth century, the "ideal").[92]

Schiller's direct and powerful response to Claude was, he was sure, a reaction to beauty, but he did not know where it came from or how it arose in the painting. "Whoever," he opines, "still feels fresh and alive within themselves the impression made by Claude Lorrain's magician's brush will be difficult to persuade that it is not a work of *beautiful* but only of *agreeable* art which has so delighted him."[93] He senses that the realm of the ideal, of the necessary and demonstrably intersubjective – in other words of the beautiful, which normally does not exist outside of human nature and classical narrative – can be found in Claude's paintings. I believe that (although he did not yet make this point) the concept of the pastoral prompted him in his sympathy with Claude.

To justify his readings of Matthisson and Claude, Schiller tested an analogy to music. The claim that music models the basic structures of our universe and, by necessity and analogy, our souls, is as old as the Pythagoreans. Schiller makes a formal argument that the harmony and accord one finds in music and that is the stuff of beauty also undergirds the compositions of Claude Lorraine and Friedrich Matthisson. He asserts that the inner movements of our souls work themselves out according to our nature and therefore are set and unalterable. Insofar as music can mime or pantomime our inner lives with its outer structure, it attains the same necessity and universality as human nature. There are problems with Schiller's position, however, as Jason Gaiger points out. Schiller's "defense of landscape as an appropriate subject for 'beautiful art' ultimately devolves on

reinscribing landscape painting and poetry back into the domain of human ideas and emotions. Outside of this 'symbolic' connection to the human sphere inanimate nature remains trapped in that contingency of form and organization which, for Schiller, deprives it of any higher significance."[94] Despite Schiller's attempt to associate landscape poetry and painting to the condition of music, he ultimately had to face the fact that an appeal to form without a human content fails.

Schiller needed something, some point of view or rhetorical device, to rescue landscape description from the merely agreeable or likable and bring it into the honored realm of the beautiful. His music analogy failed, so he turned to poetry. In his famous essay *On the Naïve and Sentimental in Literature*, Schiller bemoans the modern condition of humankind, estranged both from the natural world and from nature within us. At the same time, our redemption may come with sentimental poetry, from satirical, idyllic, and pastoral emotions.

Schiller's short study of the naïve and sentimental grew out of his decade-long struggle with the foundations of his art and poetics, as well as from his fruitful correspondence with Goethe.[95] His understanding of what constitutes the sentimental poet sprang from the same soil that nurtured the Arcadians and Arcadianism, not to mention (in a somewhat lesser but still significant degree) Muratori's articulation of the concept of *buon gusto*. Goethe, who seemed to work best as an intuitive poet, remarked to Eckermann that, "It wasn't Schiller's way to proceed with a certain unconsciousness and as though by instinct; he had rather to reflect on everything he did."[96]

Schiller was one of those pre-romantics who believed that when the world was young, artists and poets were part of nature, untainted and naïve. His reading of Winckelmann put him in touch with life "under a Greek sky," a phrase he used again and again. The naïve poet dealt with external and human nature in the most "natural" fashion, unaffected and spontaneously. The roots of the Western tradition in ancient Greece and Rome formed the childhood of our own time. "We" (that is, Western man in the later eighteenth century) live in modern times, inexorably separated from that state of innocence. It is the gap between nature and the human that shapes modern humanity and leads to one's need to reflect on and contemplate the ideal.

Rousseau's *retour a la nature* held no appeal for Schiller; it is our fate, he argues, to accept who we are and turn to good account our ability to be meditative, introspective, pensive, and so to create aesthetic values. It is the gift and responsibility of the modern poet and artist to fashion beauty through a sentimental (he took over more or less intact the English word) act of creation.[97] The naïve poet was part of nature and simply presented to us natural things: "In them [the natural things] we love the calm, creative life, the quiet functioning from within themselves, the existence according to their own laws, the inner necessity, the eternal unity with themselves."[98] Because he no longer *is* nature, the modern poet *seeks* nature, and "*reflects* on the impression which objects make on him, and

the emotion into which he himself is transposed and into which he transposes us is based only on that reflection."[99]

There is in this reflection an inevitable sense of loss and lament. Schiller sees that we come to terms with our inevitable incompleteness and separation from nature by working through such sublimated paths as the satirical and the elegiac. The satirical leads us away from the state of nature, whereas the elegiac way forces us to confront it.[100] Within the elegiac tradition (he refers not to poetic form or praxis but to modes of perception and feeling), there exists also a slightly different refinement – the idyllic.[101] If the loss of nature and unattainability of the ideal are greeted with sadness, then we are in the elegiac tradition; if, on the other hand, both nature and the ideal (the former naïve and the latter sentimental) are seen as regained and attained, then we are given the joyous and the idyllic. Schiller's distinctions and categories sometimes seem to sink into one another, sometimes to pull apart. Nor are they always consistent. The architecture of his arguments has not the clarity and consistency of Kant's; just the same, his poetics provide us with insights into some of the difficult aesthetic and rhetorical issues of the eighteenth century. His pondering of the idyllic (and pastoral) undoubtedly plays on centuries' worth of pastoral poetry and drama and can enlighten us on attitudes toward landscape painting, good taste, and the Arcadian in the earlier part of the eighteenth century, especially in Rome.

For Schiller, innocence and happiness did not fit into his complex society, nor can these primal states of the naïve age exist in an era marked by refinement and education. This does not mean that modern poets avoid the pastoral, but they have to remove "the scene of the idyll from the bustle of bourgeois life to the simple pastoral state" and locate it in "a place *before the beginning of culture* in the childlike age of man [Schillers emphasis]."[102] The man who lives the life of culture must be reminded of the possibility of the pastoral state, and the only way to do that is through art, because it can no longer happen in reality.

Every culture has its Golden Age, and every individual has one, too. Insofar as we have a poetic capacity within us, we each can experience a time of innocence and paradise. This time of innocence is regained through art, even if it is in fact a time before art. Therein lies a paradox. The poetic fiction of the pastoral idyll (or the idyllic pastoral) is in conflict with what culture has to offer, because, as Schiller insists, its value lies in an existence preceding culture. In theory, then, these idylls "lead us back whereas *in practice* they are leading us forward and ennobling us." Idylls "can fulfill their purpose only by the suspension of all art and only by the simplification of human nature, so, although they have the highest value for the *heart*, they have all too little for the *mind* and their monotonous sphere is soon exhausted."[103] Schiller spots an obvious limitation in the idyll. The fairly widespread enthusiasm for the pastoral could be attributed to a need for peace and tranquillity, which taints it somewhat as an interested rather than a disinterested taste. Writing pastoral poetry is like trying to combine the naïve and the sentimental; one drains the other, making both less rich and piquant.

The degree to which that pastoral form is natural is the degree to which it is not ideal. The poet "cannot stand the test of strict good taste which in aesthetic matters can forgive nothing half-baked."[104] However, one does not have to be half-baked, shilly-shallying between the naïve and the sentimental; indeed, the poet should go forward with the sentimental:

> Let [the poet] not lead us back into our childhood in order to have us purchase peace and quiet with the most precious attainments of the intellect, a peace and quiet which can last no longer than the slumber of our intellectual powers, but lead us on to adulthood in order to let us feel the higher harmony which rewards the fighter, which blesses the conqueror. Let him take as his task the creation of an idyll which would put into effect that pastoral innocence also among culture's subjects and under all the conditions of the most sturdy, most vibrant life, of the most extended thought, of the most subtle art, of the highest social refinement, which in a word leads man who cannot go back to *Arcadia* as far as *Elysium*.[105]

It seems clear enough, then, that the naïve poet remains in Arcadia, whereas the more sophisticated poet of the modern age, of ideas and beauty, can bring us to Elysium, a place of sentiment and more complex feelings than are to be found in the vales of Arcady. If we are in need of succoring, we turn toward Arcadia, but the fit and the strong move forward, away from Arcadia.

One of the upshots of Schiller's theorizing on the naïve and the sentimental (nature and culture, the primal and the civilized) was his finding of a place for landscape description within the compass of art and what Muratori thought of as the rhetorical tradition. Like those who considered and promoted *buon gusto*, Schiller tried to come to grips with a theory not just of literature but also of criticism, a poetics that rises to the level of what in recent years has been called metacriticism. Inside his somewhat belabored construction, Schiller located the pastoral, an unsure but still artful hybrid mode and set of emotions that could not make up its mind whether to pursue the naïve or the sentimental. But it was sufficient to make art, to raise a landscape painting by Claude Lorrain to the level from which one could avow an "intersubjective" necessity, and genuinely agreed-on concept of beauty. The pastoral concept suffices to buoy up landscape painting and give it a classical, artful, beautiful dimension. The pastoral may in its origins have been tied to *un sentiment naturel* – what Bouhours had touted as the basis of *bon goût* – but in the Arcadian discourses of the eighteenth century, it actually sprang from a poetic imagination forged in that bittersweet loss of innocence. The modern poet should know, Schiller maintains, that an unbridgeable gap separates him from the original pastoral world that had burgeoned "under a Greek sky." Although Schiller does not return to Claude's landscape paintings, he provides us an aesthetic justification for accepting them as something more than agreeable and

likable. I assume that he would have characterized Claude's accomplishment as enacting "pastoral innocence . . . among culture's subjects." Just the same, Schiller nearly anticipated Erwin Panofsky's description of Jacopo Sannazaro's Arcadia as that which is "a realm irretrievably lost, seen through a veil of reminiscent melancholy."[106] He differs from Panofsky in valorizing what he called Elysium at the expense of Arcadia.

How does this work for the kind of pastoral landscape painting of the late sei- and early settecento? As we shall see (Chapter 3), there is an apparent artlessness in Francesco Trevisani's landscapes, a naïveté that has been associated with oversophistication, a certain aesthetic fatigue or ennui. I have also brought up Schiller's sometimes conflicted readings of the sentimental idyll. Lying in the near background of all of my discussions are the discourses on good taste and the institutional presence of the Arcadian Academy.

THREE:

ARCADIA, PASTORALISM, AND

GOOD TASTE

There are two Arcadias, as most critics point out: the one in Greece and the spiritual Arcadia. It is this latter form that grew out of Virgil's knowledge of the historian Polybius, who was in fact born in the geographic Arcadia. Polybius reported that the shepherds of Arcadia from time immemorial had lived in simplicity, practiced the musical arts, and instituted musical contests. The tradition that Arcadia was the home of Pan (inventor of the syrinx) was established by Virgils' time. That it represented the Golden Age, something hazy and far-off yet intensely desirable, also became apparent by the early Roman period, especially in Ovid's introduction to the *Metamorphoses*. Virgil did not share Ovid's sense of a bygone and irretrievable era; in fact, he remained an optimist and believed that there could again be a Golden Age (with the advent of Augustus). Nonetheless, it is Ovid's melancholy sense of something regrettably past that fires the imaginative longing of so many later views of Arcadia as a landscape or island of dreams and wishes.

I have already made references to Schiller's writing on the naïve and our persisting human longing for a Golden Age. Here I want to review in somewhat abbreviated form, the time-honored lore of Arcadia as topos or place.

Arcadia is a persisting human idea and yearning, a state of mind, a mythological, or psychological, belief as powerful as any of Freud's basic drives. Arcadia is embedded in our Western consciousness and springs from the most fundamental mythopoeic activity. To sort out this remarkable state of mind, Bruno Snell looked back to its historical and literary origins and made the surprising but perfectly reasonable assertion that Arcadia was discovered in 42 or 41 B.C.E. (Snell's date for Virgil's *Eclogues*; the more accepted date is now in the 30s B.C.E.).[1] As mentioned earlier, Virgil drew his ideas of Arcadia from earlier sources; yet he was the one who fleshed out the bare bones of an earlier tradition. The epitaph on his supposed tomb in Naples reads *Mantua me genuit, Casabri rapuere, tenet nunc, Parthenope: cecini pascua, rura, duces*. The first lines tell of his birth and life, the last what he did: cecini pascua, rura, duces ("I sang of pastures, of cultivated fields, and of rulers"). The pastures are the *Eclogues*, the cultivated fields the *Georgics*, and the rulers the *Aeneid*: this corresponds to a movement from pastoral to didactic to

epic. So the *Eclogues*, being pastoral, creates more than does the *Georgics* a domain in which humankind accompanied by the poet can find solace in withdrawal.

The world of Virgil was in chaos in the early thirties; lands were being taken away from their rightful owners and given to military officers, civil war disrupted life, and the poet Tityrus, Virgil's alter ego, needed to find some leisure and shade in which to sing. This shady, bucolic world that Virgil created was that of the herdsman.

But before looking in on Tityrus, we need to go back to the place that inspired Virgil's Arcadia, Theocritus' Sicily. In the heady, epicurean atmosphere of Ptolemy Philadelphus' Alexandria, Theocritus entertained his audience with stories of love and death, singing contests, and rough-hewn shepherds living in the land of his own childhood. The whole is, appropriately enough, suffused with a sense of reminiscence and wistfulness, although, despite the obvious nostalgia and desire for returning, we have no evidence that Theocritus ever went home again. As often happens with thoughts about childhood and a Golden Age, we nonetheless prefer our comfortable and cosmopolitan existence.

It was Virgil who transferred the bucolic from Syracuse and the island of Cos to Arcadia. Some scholars trace the origins of Arcadia through the descriptions of Polybius (as mentioned earlier), whereas others follow from Sannazaro's contention in his tenth *Eclogue* that the god Pan introduced Arcadia. Because it is certainly beyond the scope of this study to review all of the arguments of Arcadian etiology, let it be sufficient to consider Virgil's Arcadia. Why choose a land further afield than Theocritean Sicily as the *locus aemoenus* for his poetry? As Virgil was more Italian than Theocritus, it seems odd that he chose a land in the Peloponnesus to be his "spiritual" landscape. Thomas Rosenmeyer explains that ironically Arcadia more than Sicily is Italic. Arcadia is, of course, not geographic in the literal sense, but appropriately disconnected to the actual historical events in Italy in the first century B.C.E. It is like a land before time, a place of extreme primitivism whose people were autochthonous (Pelasgus, the ancestor of the Arcadians, grew out of the ground like a tree) and therefore were closely connected to the Golden Age. Rosenmeyer summarizes Virgil's need of Arcadia: "The more openly the political reality of his day is admitted into the otium of the pleasance, the greater the need for a 'spiritual' landscape, to lift the experience above the mundane level of party strife. Arcadia is Italy writ large, a spiritual Rome, a primitivist conception of the blessed land, remote and exotic, hence ideally suited to accommodate and reconcile the incongruities of Virgil's pastoral vision. In such a land, expropriations, deaths of patrons and the worship of princes can innocently consort with plaints of love, catalogues of myth, and the miracles of a Golden Age."[2]

In the Arcadian landscapes of Virgil's *Eclogues*, shepherds find their tender feelings and dulcet voices; while lizards sleep in the noon heat and the herds lie in shadow, the shepherd sings. He has shed the vulgarity of the peasant and escaped the questionable sophistication of the urbanite: he is in Arcadia. This is

not a realm of heroic events, great deeds, or significant human actions. We do not know the shepherd's soul through the working out of events, actions, or his particular fate (*moira*). Our attention is drawn to the unremarkable, those normal things that do not usually command artistic scrutiny. Like still-life painting in early modern art or the *fête champêtre* of the eighteenth century, our emotional bond to the objects and sensations of ordinary experience is engaged. Norman Bryson has pointed out that the Greeks made the distinction in their painting between "megalography" – the depiction of things great – and "rhopography" – "the depiction of those things in the world that lack importance, the unassuming material base of life that 'importance' constantly overlooks."[3] This world of nature's remnants, a miscellany of rocks, tree, and streams, "odds and ends," as Bryson terms it when writing about the still life, is an unremarkable but highly communal setting for nonheroic events. But within this common world, there are, as Snell points out, mournful connections among lives and events. The pastoral is attentive to our losses and failures. The shepherd's "love for the familiar things is a longing rather than happiness." As John Ruskin was to formulate the literary topos of the pathetic fallacy – in which nature, robbed of autonomy, sympathizes with human emotion – Virgil believed all animals and nature participate in the shepherd's song (*Eclogue* V, 20–44). Usually the pain results from lost love; sometimes it is diffuse – the pain that is in the world, in being. Panofsky observes that "(i)n Virgil's ideal Arcady human suffering and superhumanly perfect surroundings create a dissonance. This dissonance, once felt, had to be resolved, and it was resolved in that vespertinal mixture of sadness and tranquillity which is perhaps Virgil's most personal contribution to poetry. With only slight exaggeration one might say that he 'discovered' the evening."[4]

Virgil's Arcadia was a place of refuge but not of escape. One could not go to Arcadia and build, through action, will and design, a better world; yet one could discover a better spiritual world, a world not of technology and government but of peace and tranquillity. Otium, the Latin word for ease, suggests that one take up a spot, languish, and sing. This is not the same as running away; it is, instead, a moment of release or respite from the world. The shepherd seeks succor, protection from trouble, and Arcadia offers the shelter (although, as Virgil makes clear right from the beginning, our toehold in the Arcadian turf is tenuous). The Arcadian shepherd "a nostalgic refugee from somber realities, . . . places his hopes, not on a just state, but on an idyllic peace in which all beings will live together in friendship and fraternity, a Golden Age in which the lion and the lamb will lie down side by side in harmony, in which all opposites are joined and tightly knit in one great love."[5] Shortly after this, however, Virgil found the miracle that could in fact transform the world into a place of peace and harmony: the Emperor Augustus. The *Georgics*, unlike the *Eclogues,* reflects this more utopian view.

The Arcadia of the *Eclogues* is not, strictly speaking, utopian, however; rather, it is the landscape of art. Because the poet discovers his soul and his feelings, he finds his unique identity and ability to express those innermost emotions through

song and word. This self discovery of the poetic imagination does not occur in quite the same way in Attic tragedy, according to Snell: Euripides was a great and inventive writer, but he operated mostly as a conscious thinker, seeking "to get to the bottom of certain matters, we might say 'problems'."[6] The Arcadian artist-poet finds himself immersed in something more pervasive and diffuse than conscious thought. He releases the restrictively rational and partakes of the world of dreams, wishes, feelings, fancies, and, in Snell's more ominous language "the darkly ebbing sub-conscious."[7]

I n his descriptions of the various locales for the convening of the Accademia degli Arcadi, the chief herdsman Giovanmario Crescimbeni most often identified the theatres. His garden was not the wood of Theocritus, Virgil, or Sannazaro; rather, it was the self-conscious playhouse in which the shepherds rehearsed the lives of the shepherds. Instead of the pastoral itself, the *Adunanze* (gatherings) were performances of the pastoral.

Crescimbeni's approach toward the pastoral was, in a sense, "metahistorical," but this is not to say he misunderstood or cared little for pastoral conventions. In the rituals performed in the Bosco Parrasio, he employed these conventions with a fascination and preoccupation that was remarkable. *Buon gusto* and pastoralism were somewhat different texts that, just the same, informed one another.

The Arcadians and other arbiters on taste probably had a greater sense of what they were against than what they were for. Especially in the visual arts, one looks almost in vain to find prescriptions for what good taste should look like. We must take an empirical approach to the paintings, sculpture, and architecture of the settecento to discover some of the rhetorical principles embedded within these artifacts. To infer their rhetorical strategies, we must *induce* the works to give up their tropes and figures.

PASTORAL AS GENRE AND MODE IN PAINTING

Pastoral painting did not spring forth full-grown like Athena from Zeus's forehead at the end of the seventeenth century. The pastoral endures the ages and adapts to countless cultural environments. As a literary mode, it derives from certain Greek and Roman poems of antiquity that deal with shepherds and country living. Leo Marx once famously said, "No shepherd, no pastoral." Yet this is not entirely true, for if we look at Emilian paintings of the earlier seventeenth century, and especially at the paintings of Francesco Albani, it becomes clear that mythological and allegorical paintings in general can be pastoral, too. Albani's panels of the *Loves of Venus and Diana* (c. 1617), painted for Scipione Borghese, are as much in the pastoral mode as are similar paintings by the Arcadian Maratti done a century later. Of course, Titian's bacchanals are not unrelated to the pastoral tradition, any more

than are some of the landscapes by Annibale Carracci and Domenichino. One can also mention Claude Lorrain, Nicolas Poussin, Gaspard Dughet, and Guercino – and these are just those who worked in Italy. Luba Freedman provides a valuable historical survey of the tradition of "classical pastoral" in painting, a tradition that does not necessarily center itself nor remain dependent upon those works produced in the ambit of the Arcadian Academy.[8] What I am asserting is that in the later seventeenth and earlier eighteenth centuries in Rome, pastoralism and good taste went hand in hand with the polemics of the Arcadians and, more generally, with some very important aspects of Italian learned culture.

ARCADIAN NARRATIVES IN FRANCESCO TREVISANI AND *ORIZZONTE*

Although he did not join the Accademia until 1712 (whose Arcadian name was Sanzio Echeiano),[9] Francesco Trevisani (1656–1746) had developed early on an Arcadian sensibility, one that has been pointed out by a number of scholars.[10] Frank DiFederico perceived an Arcadian presence in Trevisani's paintings in terms of a degree of rationalism – as in the setting out of perspectival spaces – and highly emotional *affetti* that anticipate a fairly typical eighteenth-century *sensibilité*. Andrea Zanella, on the other hand, dug a little deeper into the apparent consciousness within the narrative elements in Trevisani's paintings and discovered melodrama. Although it did not exist as a specific literary category before the nineteenth century, melodrama had been around since the beginnings of the history of stage and theater. Zanella's interpretation of Trevisani's Arcadian style focuses on such theatrical elements (Trevisani had written plays for Cardinal Pietro Ottoboni) as brilliant coloration and strong contrasts of light and shade, which lead inevitably to a sensational impact on the viewer. At the same time, there can be a sweetness and charm that has little to do with the putative subject matter.[11] The story moves, in other words, because of odd, unmotivated gestures, expressions, and dramatic visual effects. In Trevisani's religious works – such as martyrdoms or pietàs – Zanella correctly observes a lack of true anguish, struggle, and pain. Neither the figures within Trevisani's painted dramas nor the inner meaning of the stories themselves move viewers beholding them. Rather, the aesthetics of the painting depend on pure visualities or spectacle and sometimes cute, coy, idiosyncratic, or precious behavior on the part of the actors. At the same time, I would maintain (beyond what Zanella asserts) that because Trevisani's paintings are, in their essence – if not always in subject matter – pastoral, they are not just, or even primarily, objects of *aesthesis*. It is not that we apprehend them from the outside; rather, in a very real sense we *experience* them from the inside. I have more to say about relation between the inside and the outside of Arcadian paintings in my discussion of Jan Frans van Bloemen.

Zanella sees Trevisani's deployment of the elements of narrative painting as betraying a certain world-weariness and hedonism, self-conscious irony, and

perhaps loss of belief in the reality of the stories depicted. She associates these sophisticated and somewhat detached emotions with the Arcadians and their jaded attitude toward deep-seated human passions. Although she views Trevisani's painting style with a sharp eye, Zanella misses those archetypal elements of the Arcadian topos and the pastoral mode. The mask of the Accademia degli Arcadi is the mask of Pan, the genre is pastoral, and the setting is a spiritual landscape. What she refers to as melodrama might better be seen as pastoral simplicity. Trevisani's paintings often have a "way of being" (in the Heideggerian sense) that lacks what was an essential (for the seicento) connection between affect and narrative. The figures do not demonstrate the usual intention that one expects in Christian stories.

For instance, Trevisani's *Rest on the Flight into Egypt* (c. 1715, Dresden, Gemäldegalerie Alte Meister, Fig. 5) embodies *buon gusto* in the Arcadian–pastoral elements of the narrative, which in turn reveal a certain peculiarity in the ordering and logic of events. In the gentle turning of the road, we see a putto leading the ass away, probably for a drink. This is odd but perhaps linked to the way in which the escape into Egypt is treated in the *Infancy Gospel of Pseudo-Matthew*, where the Baby Jesus willed the palm tree under which the Holy Family sat to bow down and give its dates to Joseph (because the tree only leans here, Joseph is aided by angels gathering the fruits and dropping them into his cloak). The *Bambino Gesù* also caused courses of water to run (gathering perhaps in a pond down below from which the donkey can quaff) from the base of the tree. Two angels play with the infant, while Mary, with all the affectations of an aloof aristocrat, reclines at the foot of the tree. Nearly a dozen of these plump, winged babies romp and flit about like so many rather silly angelic servants. A naked, winged toddler leading a donkey to water and another shimmying up a tree are, after all, risible images; however, they are necessary for pastoral naïveté. Another angel, who is about to fly off to Paradise (again, according to the *Infancy Gospel*), holds a palm branch, which Jesus has just named as the prize for all victors and martyrs.

Contrasts of light and shade, sun-drenched fields in the far distance, and an atmosphere succulent with moisture and warmth create the perfect Arcadian pleasance. This is as much a *locus amoenus* as it is a way station for fugitives from corrupt justice. There are a few historical references, such the broken statue of a Roman god with a bucranium on his pedestal – suggesting the passing away of the old order, Isaiah's prophecy that "Behold, the Lord shall come on a swift cloud and enter Egypt, and all the idols made by Egyptians shall be moved from his face," and the anticipated death of Herod – but there is little here to suggest either the bloody context of the flight into Egypt or even the fulfilling of certain other prophesies ("Out of Egypt I have called my son"). The pleasance is a place of relaxation, of otium. Like Theocritus's and Virgil's shepherds, the Holy Family has no need to *negotiate* (negate the otium) in the world of work and affairs. Theirs is a sacred garden and refuge with blessed trees, flowers, streams, and habitations. Both before and after the establishment of the Bosco Parrasio in the mid-1720s,

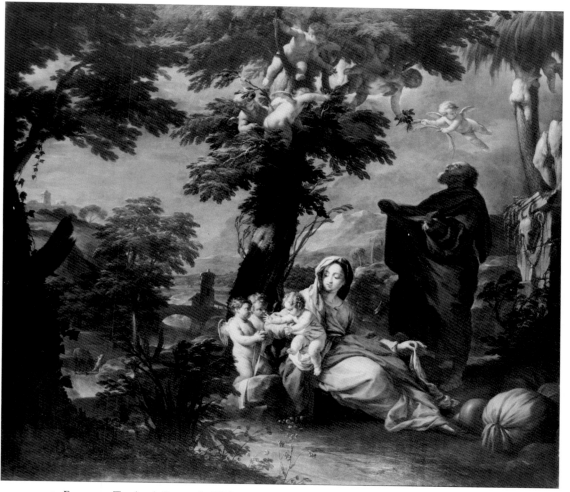

5. Francesco Trevisani, *Rest on the Flight into Egypt*, c. 1715, Dresden, Gemäldegalerie Alte Meister. Photo: Abt. Deutsche Fototek.

the academicians of Arcadia met in gardens that had been cunningly contrived to re-create this very type of setting. The realm of the Accademia degli Arcadi was as much a simulacrum as Trevisani's plush environment.

This fictional landscape is, as we have seen, the locus of pastoral elements that are rhetorical, modal (in the sense that pastoral is perhaps more mode than genre), and topographical. As a matter of rhetoric, we can point to the manner in which the pastoral usually does *not* observe decorum. In the early modern tradition of Italian painting, there had been an assumption that style and subject matter are synchronous and continuous, something Poussin called his theory of modes.[12] But this concomitance – in short, this decorum – is necessarily broken in the pastoral tradition, which seeks, among many other desires and motivations,

naïveté and simplicity. René Rapin in his discourse (1684) on Theocritus's idylls called for brevity and artlessness in pastoral poetry, so that there would be no conjunctions, no overall unity. The pastoral experience is one of gaps, fissures, and discrete elements – what Thomas Rosenmeyer phrases "internal asyntaxis."[13] Unlike the baroque universe, which was filled with meaning, the Arcadian topography is a place of little pictures (eidyllions) and short stories that really are extracts (eclogues). In Trevisani's painting, there are ruptures within the narrative that result in visual fragments, distinct and disunited vignettes, even if the entire scene is, in Leo Spitzer's terms, a *Stimmungslandschaft*.[14] That is to say, despite the overall atmosphere and pastoral ambience, the painting is, in sum, a series of discontinuities. We might say that the *Stimmungslandschaft*, the landscape of mood, is one of plenitude in which no matter where the eye rests, some detail of fictional nature presents itself.

There is a subtext, too, one that works against what might at first blush appear to be fullness and presence. Frederick Garber writes that "[w]here the surface promotes the wholeness of the bucolic condition, the subtext speaks for disjunction, lacunae, and breakings away."[15] As I have intimated, the subtext here has to do with the kinesics or *affetti*, the nonverbal communication achieved through gestures and movements of Jesus, Mary, Joseph, and the putti. The *Infancy Gospel*, which seems to stand as the pretext for this painting, refers to the fear, surprise, and, finally, gratefulness of Mary and Joseph. At first Mary wants figs, whereas Joseph wants water; they argue. He is astounded by Mary's suggestion that he climb the palm tree. But just then the infant Jesus commands the tree to bow down (or, as here, it leans a bit so that the cherubim can toss down the fruit) and the water to spring forth from the palm's roots. In the apocryphal Pseudo-Matthew, Joseph and Mary, weary and surely cross from their traveling in oppressive heat, are moved to joy at their son's miracles. In Trevisani's painting, they seem essentially unmotivated, a bit precious and certainly artificial, like actors who go through their paces, mug a little, but really care very little about "sending and receiving."

What poststructuralists call the transcendent referent or transcendental signified has a place in art history, especially in the general notion of iconography as that which "images *represent*," in Hubert Damisch's formulation.[16] In the age of *buon gusto* and pastoralism in painting, we lose that connection between iconography (the escape into Egypt) and what the painting represents or declares. Semiosis still operates, but not in terms of an authoritative source (a religious text), stable meaning, or unity.

These splits in the pastoral "space" derive not just from naïveté and simplicity, they are, as Garber asserts, essential to the pastoral mode, helping to shape a number of pastoral events. Pastoral space is shot through with holes; pastoral topography "works with all sorts of gaps that can never be bridged."[17] Garber accepts Schiller's judgment that moderns are separated from the state of nature because we have become sophisticated, self-aware, highly conscious – in short,

sentimental. We cannot follow Rousseau back to nature. Schiller may have said that the inhabitants of the naïve world "*are* what we *were*; they are what we *should become* again,"[18] but his use of the conditional voice makes clear that we will not become naïve, ever again. This is why there are those clefts in the pastoral world. Certainly one desires to go back, but it is impossible: There are no bridges across that space. Our nostalgia, our *pain* over the possible return, arises because we can never go home again.

The irruptions in Trevisani's painting are not just in the narrative, in the tellingly affected gestures of Mary, the darkening of Joseph's person, the improbableness, illogicality, and ludic nature of the putti, but in the very being of Trevisani's world. The pastoral carries with it particular codes, as Alistair Fowler insists all modes convey, and those codes or signs depend on the irretrievable world of the past, our irreparable break with it, and the coactive *Empfindungsweise*, by which Schiller meant types of feelings and modes of perception.[19] These feelings, Schiller tells us, are tinged with regret and lamentation, disappointment and sorrow. For all of Trevisani's sweetness, there is something sad about these old pastoral pictures with their vision of a lost world.

Another painter whose Roman works fit into the pastoral mode is Jan Frans van Bloemen (1662–1749).[20] Bloemen arrived in Rome in 1688, just before the founding of the Arcadia. Although he was never a member of the Accademia degli Arcadi, he certainly would have been familiar with the Arcadians and their tastes (his patron, Niccolò Maria Pallavicini, was the famous Arcadian Salcino Elafio). The Romans referred to him as *Orizzonte* (horizon), presumably because of his speciality in panoramic landscape paintings. He was more interested in the Campagna than in the city itself, although many of Rome's monuments appear in his paintings. He was not much of a figure painter (he often used Carlo Maratti and Placido Costanzi to staff his landscapes), nor were his pleasances always for trysts and titillation, love and loss, music and musings in the same way Watteau's were, for instance. Yet that difficult-to-define pastoral ambience, the *mythos* so important to the Accademia degli Arcadi, certainly saturates his painting of an *Arcadian Scene with Roman Buildings* (Fig. 6). The *pastori* – shepherds – in the foreground seem to have lost their sheep, but they have their staffs. Or perhaps they are swains rather than herdsmen. Somewhat altered version of several Roman buidings – San Giorgio in Velabro, the Colosseum, and Santa Trinità dei Monti – nestle themselves into the landscape. Using fairly standard scenographic techniques, van Bloemen gives us repoussoir trees and rocks in the foreground, while a carefully arranged sequence of planes brings the eye into the far distance. We have the pleasance, ambiguous in its semiotic significance, with associations about a Golden or (as Schiller would have it) Naïve Age.

In an essay for a symposium on the pastoral landscape held at the National Gallery of Art in 1988, David Rosand observes that when looking at a pastoral painting and "focusing on thematic iconography, we readily surrender to the invitation of the images; projecting ourselves beyond those framed and matted surfaces

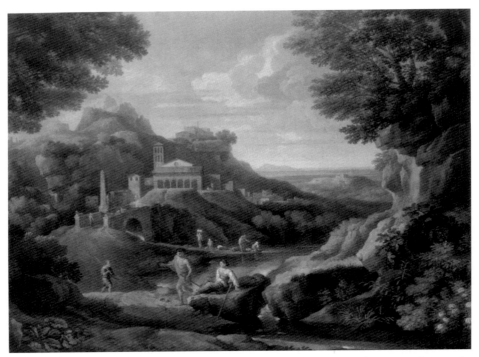

6. Jan Frans van Bloemen, *Arcadian Scene with Roman Buildings*, c. 1690s, (location unknown, in a private collection, Berlin, in the 1960s).

into the subject matter, we willingly enter the imagined landscapes of a fictive Arcadia."[21] This is not just some banal response to a painting; Rosand strikes right to the center of the pastoral mode, both in visual and literary terms. Roman pastoral painting of the later seventeenth and early eighteenth centuries almost seems to solicit us to practice Heidegger's "being-in-the-world." What could be more inviting than Orizzonte's Arcadian scene with Roman monuments? He even brings the picture world closer to our existential space by painting vivid plants and flowers just inside the frame, images that nearly bridge the two worlds. We live in being, as Heidegger teaches us, but sometimes the background or milieu of our existence is veiled, or not already discovered. Things need to be articulated, even if they are not deeply disguised: for instance, in Bloemen's painting, we see some recognizable buildings, acknowledge a landscape that is similar to Rome's Campagna, and observe shepherds gesturing to one another. What need to be more manifest are the pictorial conventions, such as the repoussoir trees, the compositional devices, formal qualities, and so on; these I take to be fairly obvious to anyone trained in formal analysis and other such traditional art historical practices, and not very difficult to uncover for those who are not.

We do not so much live *in* our world as live it, so enveloped are we in existence, as if we were wading in a stream, being swept away by it, wetted by it,

chilled by it, caressed by it, immersed in it. This painting, too, lived its Roman world of the 1690s (as it lives today's world). The role of the art historical critic, as I see it, is to get into the painting and its worlds, both then and now, and attempt to interpret what he or she uncovers.

BEING-IN-THE-WORLD AND CROSSING BOUNDARIES IN VERNET'S LANDSCAPES

In his *Salon of 1767*, Denis Diderot wrote tellingly of Claude-Joseph Vernet (1714–89), a member of the Roman colony of the Arcadians.[22] The French critic approached Vernet in a roundabout fashion, by beginning with vivid accounts of landscapes he professed to have visited.[23] Only toward the end of Diderot's delightful peregrinations did he reveal that he never left the Salon: He simply was describing paintings by Vernet as if they were sites actually inhabitable. This unusual narrative sleight-of-hand reveals the peculiar character of the pastoral – its ability to propel the viewer into the work, to absorb him, and to make him a real part of a fictional space. When Michael Fried in his study of embodiment in Courbet's painting considers Diderot's famous ekphrastic expedition, he remarks, "for Diderot the aim of such works [Vernet's pastoral landscapes] was not to exclude the beholder, as the dramatic conception required, but on the contrary to draw the beholder into the representation – a feat that would equally have denied his presence before the canvas (and of course, again paradoxically, would equally have transfixed him precisely there)."[24]

In addition to citing Fried's comments on Diderot (to which I will return), I want to bring up here, as I do later in Chapter 6 on the Bosco Parrasio, Wolfgang Iser's remarkable study of the fictive and the imaginary.[25] Iser thinks of the fictive as an aspect, attribute, or power of consciousness, what he calls an "operational mode"; it is not just a trait of literature, it is that which "makes literature possible."[26] And that which makes art possible, too. Further, this fundamentally human capacity for and urge toward the fictive (which is why Iser refers to "anthropology" in his subtitle) is not dependent on the old dichotomy of fictive–real, which derives from Greek philosophy; instead, Iser characterizes the fictive in terms of boundary crossing. The fictive text "knows" that it has in some way transgressed a borderline, has crossed over from something similar to, but not necessarily, the same as the "real." The sentient being who makes the crossing possesses a knowing faculty that understands what he or she has done. "In this way, the fictive becomes an act of boundary crossing, which, nonetheless, keeps in view what has been overstepped. As a result, the fictive simultaneously disrupts and doubles the referential world."[27] The referential world – or what Iser also calls the sociohistorical world – is the one in which we usually live. But this also, as Diderot would qualify it, is the "theater of the world," by which I take him to mean that even in our world, Iser's "referential" world, we strut on our stage; everyday life has its simulacral side.[28]

I would like to explore how it is that Diderot crosses an existential boundary, taking his reader along. His reviews of Salon exhibitions (named for the Salon Carré in the Louvre, where these biennial exhibitions were held) had been contracted by Melchior Grimm, who published them for a handful of Europe's crowned heads in his *Correspondance littéraire*. When dealing with such an exceptionally elite group, Diderot felt he had the freedom to experiment. He wrote to his mistress Sophie Volland that he could try out various tones, subjects, ideas, and voices.[29]

Diderot sets the stage for viewing Vernet's pastorals by writing in the *Salon of 1765* that these paintings cannot be described, but must be seen (a point he repeats several times in the *Salon of 1767*). To put that into the terms that I am trying to develop here, Vernet's paintings make worlds that we must visit. Although their realm is fictive, it is in a sense as present to the beholder as the so-called real world. In other words, Diderot goes beyond the old "indescribable" topos, seeking something more absorptive, compelling.

Claude-Joseph Vernet spent his early years in his native Avignon and near by Aix-la-Chapelle, learning the rudiments of painting from his father and, in his teens, in the studio of another local painter, in all likelihood Philippe Sauvan (1697–1792). It seems probable that the young Vernet knew paintings in the tradition of Salvatore Rosa and Claude Lorrain, for he used these styles in the decorative landscapes he painted for the chateau of the marquis de Caumont. Caumont subsequently sponsored Vernet's trip to Rome, requisite for an aspiring artist in the early years of the eighteenth century. Vernet was fortunate in his French and Roman connections, for although he could not attend lessons at the French Academy in Rome, he was given studio space there and was introduced to such an important figure as Cardinal Neri Corsini, the pope's nephew (and himself an Arcadian), who asked to see some of his paintings. One of his best friends among the French artists in Rome was Pierre Subleyras (1699–1749), another member of the Arcadian Academy and fellow countryman, who hailed from Saint-Gilles-du-Gard, near Avignon. Other of Vernet's contacts in Rome were Gian Paolo Panini, Jan Frans van Bloemen, Sebastiano Conca, and Placido Costanzi – to name but a few. He learned his pastoral painting from the current masters of *buon gusto*. After nearly twenty years in Italy and upon being recieved (*reçu*) in the Académie Royale in Paris in 1753, Vernet returned to France and thereafter exhibited regularly in the *Salons*.

Now let us return to Diderot's narrative and its deceptive levels in the *Salon of 1767*. Just before introducing Vernet, Diderot waxes in a very formalist vein in his discussions of Jean Siméon Chardin's still-life paintings. He says of them that they "have a colorsitic vigor, an overall harmony, a liveliness and truth, beautiful massing, a handling so magical as to induce despair, and an energy in their disposition and arrangement that's incredible."[30] We could be reading the evaluative criticism of a Michael Fried, Clement Greenberg, or Harold Rosenberg of the fifties and sixties in New York, but Diderot shifts the tone somewhat when

he comments that "[o]ne stops in front of a Chardin as if by instinct, just as a traveler exhausted by his trip tends to sit down, almost without noticing it, in a place that's green, quiet, well watered, shady, and cool."[31] This is the kind of simile that one often disparages when reading art criticism, for it seems to confuse art with life, to create an odd and unconvincing synaesthesia, one in which the observer confuses (or synthesizes) the sensation of a painting by Chardin with that of a rest stop along Interstate 70 in Nebraska (for instance). But indeed what Diderot has in store for us is an embedded narrative: we are, unbeknownst, about to go on an outing.

The next thing we see is Vernet's name, followed by the comment that, in effect, Diderot was getting ready to write about Vernet but decided instead to leave town and head out into the countryside. Of course, his journey need not impose itself on the narrative, but the fact that it does should tip us off to something out of the ordinary.

In the countryside to which he betook himself, Diderot tells us, one could lounge on the green lawns, take up the rifle and hunt, or simply wander aimlessly (the approved mode of pastoral locomotion – see Vittorio Giovardi's description of Rome's Bosco Parrasio, Chapter 6). There also are those who drink, eat, and discuss art, philosophy, and politics, eventually heading off to bed in a drunken stupor. Diderot chooses to join with a tutor and his two charges, children of the landowner and occupants of the local chateau. Off they go. Our narrator moves ever so craftily from the primary text, which is one of criticism, to storytelling, from the salon to a fabula, all the while commenting breathlessly on what exactly he is doing.

Diderot and his cicerone thrash out between themselves any number of reactions to the landscapes, especially those responses bearing on art and nature. The scenery appears to both Diderot and the abbé as beautifully composed, with just the right massing of rocks, ruggedness, and "breaking up the continuity of this embankment with a clump of trees"[32] – creating what we might call a compositional asyntaxis. We are more astonished by the works of man than of God, says Diderot, because human weakness promises less, and yet when an artist of Vernet's ability astounds us, we are moved. Vernet teaches us to see nature better (and what could be better than inhabiting the work?). The abbé eventually gets something in his eye and so cannot see very well; he worries about his charges, whom he would just as soon leave at home (Diderot, on the contrary, the wizard who makes all of this possible, likes having them run about). Diderot describes not just vistas in front of him, but all around him. His sense of space is continuous, absorptive, ingurgitive. There is a "feeling into" (as in the way the term *Einfühlung* – empathy – was used by Theodore Lipps in the nineteenth century) that is indeed part of the sublime experience of kinesthesia and absolute union. Diderot feels a kind of psychic overload when he first glimpses his second site, which leaves him "astonished and mute, my voice broken and my ideas thrown into confusion."[33] He alternately becomes silent, gape-mouthed, motionless, enchanted, lost in his

world, a world he calls alternately nature and art, evaluating it in terms of half-tints, aerial perspective, vertical planes, "exquisite taste," and coloring. Diderot's guide thinks him mad, for if he goes around judging nature by the standards of art, he will have great difficulty finding paintings that please him (but when he does, Diderot retorts, they will indeed be superb).

After visiting his third site, Diderot falls into a deep, delicious sleep, awakening refreshed and commenting to himself that "this is the real life."(!)[34] He surprises the reader by commenting that this nonsimulacrum, this "real" life in the forests and countryside can never be adequately summoned to us by the paintings of Wouverman, Ostade, or Vernet. This is a doubly remarkable statement, falling in the midst of an imbedded narrative that comments on the primary text of Salon reviews. Why this paradox here? His brilliant demonstration shows just how a painting can accomplish what his assertion denies is possible. Then he turns bitter, commenting that "we are devoured by ambition, hatred, jealousy, and love, and burn with the thirst for honor and riches, while surrounded by scenes of innocence and poverty, if that to which everything belongs can be described as impoverished. We are unhappy souls around which happiness is represented in a thousand different forms. 'O rus! Quando te aspiciam?' the poet said; and it is a wish that emanates from the depths of our hearts a hundred times."[35] Diderot's crossing over into the pastoral romance is tinged with the sadness of return, the pain of knowing that he does not belong there.

But the question arises, where is he? If he is in a painting, why would he say that no artist could stimulate in him his present rapture? With his narrative he proves that art can indeed lead him to know himself, to give him the "pleasure of belonging to myself," to achieve a kind of perfect self equilibrium, an aseity in which the awareness of self-existence precedes any analytical understanding of it. This is not the way of Descartes, who proposed a subject separate from what he perceives, the object, of the division between *res cogitans* and *res extensa*. Thanks to Vernet, Diderot is in the world in a more or less unconscious and unremarked way. Somewhere in the midst of the pastoral romance of Vernet's painting, Diderot asks, "Where am I at this moment? What is all this surrounding me? I don't know, I can't say. What's lacking? Nothing. What do I want? Nothing."[36] This comes close to Heidegger's *dasein*, his "being there," although there is no special place, just everyday human existence. Long before Husserl, Merleau-Ponty, or Heidegger, Diderot understood what it was to be like god ("If there is a god, his being must be like this, taking pleasure in himself").[37] Diderot's fictionalized doubling (and there are times when he takes the fictive to higher powers – tripling, quadrupling) challenges our cognitive ability to orient ourselves in terms of time and space, to know what is going on. Although what Heidegger calls being-in-the-world is for Diderot being-in-the-picture, the results seem to be similar enough. In the fictive mode, we question whether we have any real essence; in fact, essence is preceded and indeed supplanted by self-interpretation; Diderot is what he, in his fictive, pastoral, aesthetic existence, interprets himself to be.

But I would not want to force Diderot into a Heideggerian or Iserian mold; what interests me is how Diderot uses painting and the pastoral as natural, almost inherent, fictionalizing forms for criticism and for expounding on taste (the word *goût* comes up often enough in his Salon reviews, especially with regard to Vernet's painting).

So many other remarkable shifts in points of view turn up in his long discourse on Vernet that I can do no more here than indicate some of the other things that seem to happen within paintings that supposedly hung on the walls of the exhibition hall. Diderot remonstrates with the abbé on the nature of beauty and necessity for aesthetic distance, telling him that things that happen on the stage are different from but just the same related to (in the sense that fiction exists where we are as well) that which occurs in the "theater of the world."[38] All the world is a stage. Inside of Vernet's paintings, Diderot wonders (as he does elsewhere in his writings), what is the role of custom, what is a good citizen, what do we mean by such grand abstractions as good and bad, beautiful and ugly, true and false, and what in fact does it mean to be a man? Words were images to us when we were young, but as we become accustomed to their use, we lose sight of their vividness, of their connection to things, and so we treat them like coins, to be dispensed with as necessary in the contractual relations of men.

Finally, the curtain comes down on Diderot's pictures within pictures within a critical discourse. He and the abbé bundle their sleepy young charges into a carriage and walk wearily home, as the mountains' shadows grow longer. In a state of near exhaustion, Diderot leaves his fictive world, crossing the boundary again to the Salon reviews: "My secret is out, it's too late to repair the damage. Carried away by the charm of Vernet's *Moonlight*, I forgot that up to this point I've been spinning you a tale, imagining myself in nature (and the illusion was easy to sustain), all of a sudden I found myself in the landscape of the Salon once again." And then, just so that we do not believe that there has been some return to "reality," Diderot's friend responds to him, "What? Are you telling me that the instructor, his two young students, the picnic on the grass, the pâté, all were imaginary?"[39] And who is this speaker? It is we, the reader. How does Diderot answer this and other queries? In Italian: "É vero. Tu l'hai detto. A maraviglia. Bravo, ben sentito." Diderot drops one mask only to put on another, and cunningly enough, he chooses a mask from the *commedia dell'arte*.

I want to say one more thing about an observation made by Michael Fried. He points out that Diderot throws us into a picture as a way of keeping from simply standing in front of it in the Louvre gallery, while, paradoxically, requiring us to do just that – stand in front of the picture, that is. We as readers sit in front of Diderot's text and simultaneously, now in a slightly more fictive manner, rivet ourselves to the floor in front of Vernet's paintings. We are both beholders and visitors, audience and actors. Fried aligns himself with Iser by showing how the going and returning, the crossing and the recrossing, are twin poles framing an existential and aesthetic space.

As much as we art historians want to bring our objects of study to full consciousness, we realize how difficult that is. Perhaps it is not so hard to do this with the pastoral; after all, it holds a mythic place fundamental to human consciousness. Ontological investigation is about interpretation, of excavating and presenting what Heidegger sometimes refers to as the "background" of the *dasein*; in other words, our study involves making overt the common and everyday of pastoral being. Because of its mythic status, we can with some ease see ourselves in that world. It is, as Northrop Frye points out, a world rife with analogies of innocence, from shepherds to laundresses to an edenic world mixed with ancient and medieval Rome, shown in the vespertinal mood of late afternoon. There are no subject–object relations in Arcadia; we understand ourselves in the same way that others understand us. But of course neither Bloemen nor Vernet gives us an unmediated Arcadia. Instead we have paintings, and so there are gaps and disappointments.

The analogy to innocence and the representation of Eden form part of the background to the pastoral, but we should keep in mind what Schiller says about this pictorial world, that no matter how independently and fully realized it may seem, we know even as we enter it that we must soon again leave. By its very loveliness, this painting betrays our separation both from the being of the painting and the being of unspoiled, originary nature. What we have here, in other words, is a poetic lament, however unexpressed the *tristesse* of our eidetic image, this idyll or eidyllion. We are not just concerned with the being of the painting but how our being is always already superimposed on it. We interpret from within our own existence, and for us there is that sharp pain of homecoming beautifully expressed by the word and concept of nostalgia, which Charles W. Hieatt calls "the universal symptom of the pastoralist."[40] Like neuralgia, nostalgia is about hurting. The *nostos* of homecoming joins with the *algos* of sharp pain.[41]

Following Garber, I see a separation between the wholeness of Bloemen's bucolic experience and the existential world. Indeed, the spaces that open between Vernet's countryside and the Louvre's exhibiton halls, between Bloemen's painting and Rome's streets, palaces, academies, *eruditi*, and artists of the sei/settecento lead to a pain that constitutes a pastoral subtext. It is something buried much deeper in the background than those shepherds lolling about in the foreground.

TOMBS AND *BUON GUSTO*

Because of the intricate and indissoluble links between the sculptural tradition of the Roman eighteenth century and that of the baroque, I first discuss tombs of the seicento so as to establish some of the elements of the funereal genre in Italian sculpture and to indicate how it connotes death, commemoration, identity, power, religion, tradition, authority, and artistic style.

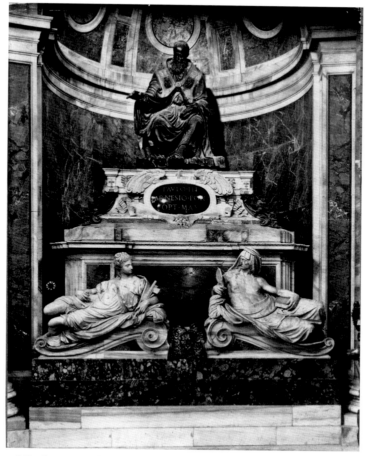

7. Giacomo della Porta, Tomb of Paul III, Farnese, 1551–1575, St. Peter's, Rome. Photo: Art Resource, New York.

Beginning with Giacomo della Porta's Tomb of Paul III Farnese in St. Peter's, we recognize the familiar pattern already established in the sixteenth century by Michelangelo in his Medici tombs: there is the image of the deceased seated at the summit of a pyramidal composition, with allegorical figures arranged below and to either side (Fig. 7). This is the kind of tomb that appropriates its own aedicula-like setting; that is, its strongly plastic quality would make the work something of a nuisance if it were set on a floor. In fact, were della Porta's tomb of Paul III erected outside of its niche, it would become an almost mausoleum-like architectural structure. There certainly are examples of such freestanding tomb sculpture, but it was not the normal baroque way. Tombs in St. Peter's, for instance, are usually framed within an arcosolium (a word deriving from arcus "arch" and solium, throne – and by extension sarcophagus). The effect of these large, deep, arched openings on the semiotics of tombs is quickly told: they isolate

the tomb, separate outside from inside, create a hallowed space by recalling the earliest Christian tombs cut out from tufa, and allude to tombs that also functioned as altars. In short, the arcosolium sacralizes the tomb, attaches it to ancestral time while keeping it disconnected from normal time. The ontology of the tombs is one of being and existence, not one of unfolding moments or becoming. The niche gives birth to, in Gaston Bachelard's poetics, "eulogized space."[42]

Monuments of the ecclesiastical hierarchy, and especially papal tombs, convey the magisterium, which refers to the Church's teaching authority. Protestants believed that only Holy Writ had authority; Catholics countered that the Church is the organ authorized by Christ to transmit divine truth. The papal tomb carries in hieratic terms both traditional and revealed truth by perpetuating the pontifical identity and by extension his infallibility and indefectibility. The Council of Trent had reaffirmed the living magisterium as part of the unwritten traditions of the Catholic Church. A tomb is not itself tradition; rather, it bears and conducts tradition and authority. Nonetheless, as a vessel of conveyance the tombs possesses – according to Catholic beliefs – truth, value, and authority.

The visible tomb was not invented in the baroque era, nor was immensity of scale. Yet the poetics of both the Counter-Reformation and the Jesuits encouraged that intimate connection between the traditions and artifacts of the Church and the minds and hearts of the faithful. It encouraged them through an awareness of scale and grandeur. There was at least an implicit sense that one prays, dreams, and contemplates in a world of immensity. The baroque experience was that paradoxical one of "intimate immensity" (once again borrowing a phrase from Bachelard).

In della Porta's tomb (1551–75), we have an early example of the Counter-Reformation or Tridentine assertion of Catholic authority in the person of the pope. The Roman pontiff reigns as the successor of St. Peter in his See and in his primacy. Paul sits enthroned on a pedestal gesturing mildly in the form of benediction. Reclining on their scrolls, Prudence and Fidelity gaze at one another in apparent indifference. These instantiating agents of abstract ideals perform or act out a kind of awareness or consciousness but without the "will" to do much else. Notwithstanding their passivity, the pope, allegorical figures, and architectural elements of sarcophagus, plinth, and throne represent the institution of the Church, Christ's Vicar on earth, and truth. This is a powerful mix.

Gianlorenzo Bernini changed the terms of the baroque papal tomb by distending the rhetoric of allegory. Coming alive, his figure of charity from the Tomb of Urban VIII tugs at its own *idée fixe* and compromises its universality (Fig. 8). Justice swoons as a putto tries to steal away with the fasces. The skeleton is like an editor trying to finish an article, unsure which version to use, either the one that's in its original place or the one that he holds in his hands. The tradition of allegory takes a beating here, because Bernini makes his figures both alive and historical: things are diachronic and unfolding, so that this chain of linked events is closer to our cosmos than allegory's. I do not wish to be sidetracked here into

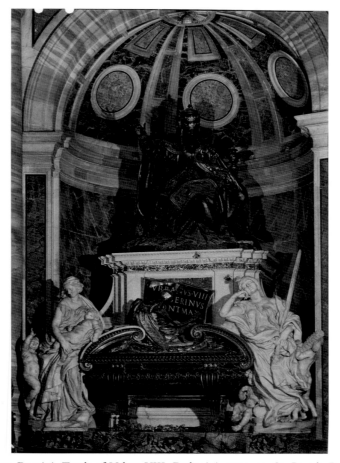

8. Gianlorenzo Bernini, Tomb of Urban VIII, Barberini, 1623–45, St. Peter's, Rome. Photo: Art Resource, New York.

reflections on the changing nature of allegorical representation in the baroque; just the same, it is worth noting how the usual egoless stand-in for an abstract idea can be narrativized.[43]

Bernini created an odd tension in the decorum of tomb sculpture by challenging traditional frames of meaning. To explain the source of this tension, let me jump ahead a century and quote from the chevalier de Jaucourt who wrote the entry in the great French *Encyclopedie* on the word "monument": "*Monument*: an architectural term, this word means in particular a tomb *quia monet mentem*, because it informs the mind."[44] The monumental tomb informs the mind by making the absent present, by enacting a sculptural prosopopoeia. Bernini's tomb of Urban VIII refers to the past and recovers the dead, but it also presents the dead and the past as living and present. There is something wonderfully unsettling about Bernini's monument because it does more than "inform the mind." He

represents the historical pope with a small cast of personifications as if in a the-atrical production. Louis Marin writes in his provocative *Portrait of the King* that "[t]o 'represent' . . . is to show, to intensify, to duplicate a presence. . . . to exhibit or show him in the flesh to those who ask for a reckoning."[45] There is here some-thing both exegetical (God communicating with human) and rhetorical (human speaking to human).

The official mode of representation in papal tombs affirms the place of the pope in the Church's magisterium, and his magistracy underlines his dominant spot in the hierocracy. The mystique or aura of the pope's prestige draws on the aesthetics of the marvelous and the power of epiphanies. All of the pope's power is played out or sublimated through signs and representation. The persistence and prolongation of memory and fame – and all the fireworks that go with it – has the effect, as articulated by Roger de Piles, to *frapper les yeux*.[46] One is *struck* by the image and inspired to believe in what that image simulates. In a sense, the imagery of a baroque tomb is a powered-up version of that which is found in the Renaissance. It is theatrical in the sense in which Aristotle writes about spectacle, that is, the visual aspect of tragedy.

Let me pause here for a moment for a digression on Aristotle. A favorite source for Renaissance and post-Renaissance critics, Aristotle listed spectacle as one of the elements of tragedy: "Every tragedy, then, must have six parts, because of which the tragedy is of such a sort as it is. These are plot, character, diction, thought, spectacle, and music."[47] He saw spectacle not as that which is imitated but as staging or "the manner of imitation" – in other words, style, but a style of particular dimensions and characteristics. Because he was writing about a literary genre – tragedy – Aristotle endorsed the linguistic at the expense of the visual. He warned the playwright that although "Pity and fear . . . may be aroused by the spectacle" it is preferable "and the mark of a better poet" to gain pity and fear from the audience through the "arrangement of the events." As Aristotle commented, the excellent poet appeals to our ears rather than our eyes ("it is necessary for the plot to be so put together that, without seeing, one who hears what has been done is horrified and feels pity at the incidents."[48] In the visual arts – especially those of the baroque style – the situation is precisely reversed, and one is to keep his or her eyes open at all costs; what was marginal at best in Aristotle's scheme becomes central to tomb sculpture in the baroque.

As we have seen, the two words – good taste (*buon gusto*) – may be the controlling characterization and authorization, affirmation, or sanction for eighteenth-century Roman art and poetry. Because I have already discussed *buon gusto* at considerable length, here I limit the discussion of good taste to the follow-ing general remarks. In short, we find that notions of *buon gusto* in the Roman set-tecento are both proscriptive and prescriptive. The hatred of Jesuit poetics and the dramatic baroque leads the list of prohibitions. "Esterminare il cattivo gusto!"[49] was a rallying cry of the Arcadians much as Voltaire's "Écrasez l'infame!" later spurred the *philosophes*. For the Arcadians, the baroque departed from reality – or

at least verisimilitude (*verosimile*), from classical traditions, and from reason. It was a fallen style. The Arcadia hoped for redemption, for a restoration of *buon gusto*, and a recovery from the "barbarism" of the baroque. There is a long tradition, as pointed out by Michael Everton, of the pastoral critiquing the status quo.[50] *Buon gusto* attempted to capture the sensibility of a class of aristocrats, artists, poets, and gentlemen who hoped to promote Italian culture, assert the power of an academy, and surreptitiously denounce Jesuit poetics. Through the agency of the Arcadians, the so-called excessiveness of the baroque was to be replaced by just measure; the marvelous by the true (or at least the ordinary); the surprising by the expected; the chimerical by the mimetic; the polysemic by the literal; the conceited by the self effacing; and the dramatic by the charming.

Although closely allied with good taste, Arcadianism with its literary and pastoral overtones is a phenomenon of another order. I try here to demonstrate what that is and how it operates on works of art – in our case, tomb sculpture.

My examples will be by Filippo della Valle. In the eighteenth century, tombs and funereal monuments were a sculptor's bread and butter. Della Valle's monument to Innocent in St. Peter's (Fig. 9) shows a far more tentative pontiff than we see either in Bernini's tomb of Urban VIII or della Porta's of Paul III. Della Valle, a member of the Accademia degli Arcadi, reveals his sensitivity to the antibaroque polemics that were being bruited about Rome at this time. The figure of Innocent gives the benediction with a hesitancy that seems to rob the figure of intention, as if he is a poor, even occluded conduit for expression of magisterium. The delicacy with which della Valle sculpts the fringe of the pope's cloak and creates intricate facets everywhere the eye looks suggests a near-sightedness, a work of sculpture that asserts its own existence despite the poor visibility that it suffers because of its position above a door and outside of commanding lines of sight. There is almost something reclusive about the tomb and about Pignatelli.

Della Valle's work sometimes enacts a kind of semiotic abjuration. What I mean by this is a tendency for the traditional action of semiosis to collapse: The relation between signifier and its signified breaks down primarily because the signifier does not do what we expect it to do, which is to generate enough energy to make the pope a genuine force in the Church. For all of della Valle's skills as a stone carver, he seems to have cared very little for the beholder, the one who stands below and off to one side of a dark passageway in St. Peter's. Everything is about surface, detail, even fussiness – but in an attractive way. The degree to which our attention is drawn to the surface of the work (insofar as we can see it, which, given the situation of the tomb, is no easy task) takes away from our reading of Innocent. As Marin has said, to represent "is to show, to intensify, to duplicate a presence." The self-absorbed imagery that della Valle gives us does a poor job of representing in Marin's sense and therefore of playing in the traditional visual game of signification. This tomb does little by way of *constituting* Christ's Vicar on Earth and the Church's magisterium. That which is imitated should have priority over the act of imitation, or at least that is the usual idea; it is in fact, as

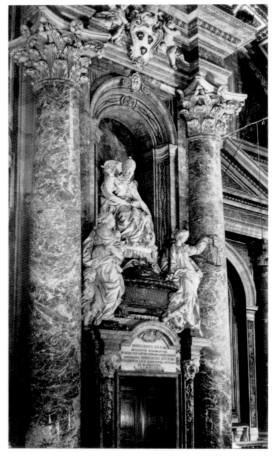

9. Filippo della Valle, Tomb of Innocent XII, Pignatelli (with design provided by Ferdinando Fuga), 1743, St. Peter's Rome. Photo: Art Resource, New York.

Jacques Derrida puts it, "not just *one* metaphysical gesture among others; it is *the* metaphysical exigency, the most constant, profound, and potent procedures."[51] Heidegger has said that the truth of a work of art dwells in the struggle between "clearance" or "opening" (*die Lichtung*) and concealment. It is in that tension between signification and the subversion of signification that one can find – and here the Arcadians would have given at least implicit agreement – art.

Another tomb by della Valle also demonstrates what I mean by the draining away of traditional meaning and the assertion of a kind of temperate, benevolent, and mild aestheticism. Della Valle's tomb of Thomas Dereham in the Roman church of San Tommaso di Canterbury (Figs. 10 and 11) presents in a fairly conventional format an image of the deceased, a coat of arms, and allegorical representations of religion and fidelity. An anthropologist might call a participation mystique any sustained panegyric, whether as a song, oration, or in visual terms

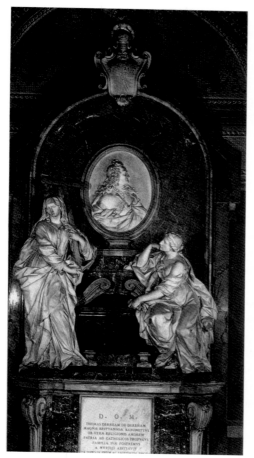

10. Filippo della Valle, *Tomb of Thomas Dereham*, 1739, S. Tommaso degli Inglesi, Rome. Photo: Vernonitzde Minor.

11. Detail of Figure 10. Photo: Vernon Hyde Minor.

a tomb. With the physical tomb, a sympathetic viewer is enabled to participate in the acclamation of heroic deeds and to witness fame and identity as they are projected into the future. Della Valle's elegy on Dereham stands above his epitaph, that personal lament on his bravery, loyalty, and exile – his *laudatio funebris*.

Dereham was a secret agent. He maintained that he knew the thinking at the Court of St. James (he translated the popular political journal the *Craftsman* for the papal court) and proved himself a loyal supporter of the Old Pretender, James III. Neri Corsini tolerated him; Neri's uncle Clement protected him. He fought with another of the notorious spies in eighteenth-century Rome, Baron Philip von Stosch of Küstrin. His epitaph, which he apparently wrote, in the English church in Rome gives a succinct accounting of his life.[52]

Despite the appeal of the epitaph, one is hardly led to profound bereavement or lamentation when gazing on the tomb figures themselves. The allegorical

representation of Religion betrays not a little apathy, as if in her petulance she wonders how long she must stand here as a "character witness" (Panofsky's term) to the conspiring and conniving Dereham. Ever thoughtful of herself and neglectful of the overarching idea she has been employed to instantiate, she protects her beautiful hands from splinters by wrapping a bit of her garment around the cross. Perhaps she is merely despondent; but in no way does she mourn or "speak" to her "other" – that is, the abstract idea of Religion (allegory = Greek, *allos*, "other," and *agoreuein*, "to speak"). Fidelity, idly holding a key in one hand and staring with pensive gaze on the *imago clipeata* of Dereham, has sunk to her seat with, we might imagine, a sense of ennui. Her dog Fido, in apparent indifference, peeks out from behind her skirts to see if anything interesting is going on. Like other artists in the Roman settecento, della Valle drains meaning from allegory as if it were an inconvenient, even awkward transmitter of significance. Anthony Ashley Cooper, third earl of Shaftesbury, objected to allegory on the grounds of good taste; he wrote that allegorical representation has no "manner of similitude or colourable resemblance to any thing extant in real Nature; whereas a rhetorical work, as we have seen, must deceive the eye."[53] Jean-François Marmontel (1723–99) also found little of interest in allegory, primarily because of its insistence on a correspondence between an abstract idea (such as religion or fidelity) and a physical form. For Marmontel, the truth of poetic (and pastoral) expression lay in the form itself and in the representation of a sweet, tranquil, and innocent life.[54] Arcadian aesthetics had the effect of focusing interest on the necessary pleasure of art and the erotics of pastoralism (Fidelity inexplicably leaves her garment unfastened). In Arcadianism, both allegory and narration collapse into lyricism.

It is my assertion that the Accademia degli Arcadi (for which I provide a brief history in Chapter 5) made the pastoral mode ubiquitous by promoting its penetration into nearly every cultural production in settecento Rome. *Buon gusto*, with its reputed rationality and pellucid mimesis was inevitably and fundamentally altered by Arcadianism. If *buon gusto* is the "text" of settecento aesthetics, then Arcadianism is the "subtext." As subtext it functions much like the unconscious; that is, Arcadianism boils beneath the surface of conscious debate and promotes deception and dissimulation against assertions of rationality and *buon gusto*. Arcadianism asserts the artifactuality of art – art intended for the cognoscento's appreciation – at the expense of an image's organic unity and self-contained meaning. As an intertext, it infects other texts and often works contrary to or against the grain of the host text. The monumentality of the monument – and therefore its ability to inform the mind – is compromised, indeed imperiled.

By its nature the baroque style – even with its sophisticated artfulness and testing of rules – countenanced the transcendental signified and enabled paintings and statues to function as polysemic texts (with literal, historical, allegorical, and anagogical levels of meaning) always reaching toward an outside

referent and meaning. Bernini's Tomb of Urban VIII asserts the power and legitimacy of the Counter-Reformation Church in a way that della Valle's Memorial to Innocent XII could never hope to do.

We find then a complicated situation in the cultural politics of eighteenth-century Rome. The Accademia degli Arcadi with its thousands of members and hundreds of colonies was the institutional tastemaker of the times. Its earliest members were the leading exponents of *buon gusto* as a utopian idea that would lead to rationality, simplicity, good sense, *il culto del vero*, and civic humanism. Good taste also would rid Italian culture of the baroque. Jesuit poetics and the superstitions of the masses also would fall victim to the *illuminismo* of Cartesian precepts. *Buon gusto* triumphed, but its victory was absorbed into the poetics of pastoralism and dreams of a Golden Age. Together although in a kind of semantic struggle, Arcadianism and good taste changed the terms of the monument and monumentality – because we can no longer be sure how it informs the mind.

CRESCIMBENI'S WORDS ON IMAGES

In his *Arcadia* (1708), Giovanni Mario Crescimbeni takes us on a walk with a group of nymphs led by Aglaura Cidonia (Faustina Maratti, daughter of the famous painter).[55] We set out from the Bosco Parrasio, happy and playful, to join in the Olympic Games at Elis, next to Arcadia in the Greek Pelopponnesus. Along the way, the nymphs visit both a scientific collection arranged by the Arcadian Epidauro (the medical doctor Giorgio Baglivi) and Nitilio's (Monsignor Leone Strozzi) museum of natural history and antiquities; our next stop is at an old shepherd's cottage, which turns out to be the studio of Disfilo – Carlo Maratti (1625–1713). The nymphs find an agile, spirited, even sprightly man, despite his advanced age. Now in his early eighties, the kindly painter greets his daughter with great affection and invites us all to peruse his paintings. What follows is a highly detailed portrayal of pictures in Maratti's studio.

Crescimbeni here demonstrates his skill at ekphrasis, the rhetorical tradition of offering vivid descriptions of paintings, statues, and other artistic images within a poetic (or, in this case allegorical and fabulous) setting. In a manner that strikes me as typical of the Arcadian discourse, Crescimbeni combines what Plato called the *icastic* with the *phantastic*, descriptions of things that exist (Maratti's paintings) with poetic caprice and fancy (the nymphs and their delightful peregrination). As narrative modes, the *icastic* and *phantastic* are at odds with one another, suggesting that here in the *Arcadia* they retain some mutual antipathy and rest uncomfortably together.

We can trace the ekphrastic tradition back to earlier pastoral writers. Theocritus, one of its first practitioners, described in his *Idylls* handsome cups given as prizes in pastoral singing contests; Sannazaro wrote hauntingly beautiful descriptions of painted friezes in his *Arcadia*, which of course Crescimbeni

had very much in mind. So we see that Crescimbeni entered into a tradition of considerable antiquity, summoned a popular Arcadian and pastoral trope, and celebrated the style of Carlo Maratti as the quasi-official representative of Arcadian *buon gusto*. More than that, he harnessed together differing discourses that both oppose and reflect one another. These are literature and painting (two general forms of representation), history and fable (two forms of literary narration), and – related to these last two – icasm and phantasm, which, as we have just seen, is descriptive versus fantastic mimesis. The word for such a blending of genres is syncretism, which refers not just to the mixing of modes, but also to the inconsistency, difficulty, and disruption in doing so.

With his detailed recounting of Maratti's paintings, the *custode generale* interrupts the flow of his narrative of these gamboling nymphs so that the temporal becomes spatial, images become words, and words become images.[56] Crescimbeni bodies forth pictures within a fable and within an Arcadian tradition of Arcadian texts. Nesting within these narrative boxes lie pictures that represent, *di ogni buon gusto*, Arcadian themes.

By putting pictures into a text and into words – "La Penna interprete del Pennello" as Stella Rudolph characterizes it – Crescimbeni not only demonstrates once again the Horatian "Ut pictura poesis" but intensifies his rhetoric by doubling his means of representation and expression.[57] As was to be true in the Bosco Parrasio, his text *Arcadia* accentuates the proposition that art and nature (as well as painting and literature, poetry and history) mirror one another, are indeed interchangeable as signs for one another. Although he states that he expects his readers to distinguish between "history" and "fable" in his narrative, there really is no such separation in his text.[58] We descend into an Arcadian realm of infinite specularity; that is, when falling into *Arcadia's* narrative, we lose our orientation. Narrative becomes visual, and pictures stand in a line to be read and pored over. Crescimbeni introduces the second picture with the following portrayal of the nymphs' progress: Quindi di seguitando a scorrere intorno intorno coll'occhio, si fermarono innanzi ad un'altra tela ("Continuing on, roaming around and around with their eyes, they stop before another painting"). This shows how the nymphs move temporally – indeed, at a leisurely pace – from one picture to the next; they are now about to look at another painting with the same attention that they would devote to reading a poem. The looking will last at least as long as a reading. With Crescimbeni's help, the painting (pace Simonides), is a *speaking* rather than a *mute* poem; the words themselves go beyond *showing* us the paintings – which is one of the traditions of ekphrasis – by offering through their representation of these paintings an attitude toward them, Maratti, and the Arcadian journey.

A significant element in ekphrasis is *enargeia*, what Quintilian elucidated as the brilliant use of description so as to appeal to the emotions and, as Longinus argued in *On the Sublime*, the *fantasia* of the reader. Because of its appeal to sight, *enargeia* holds a particular power that, when effectively employed by a poet,

penetrates deeply into our sympathies and emotions and therefore bypasses our more immediate need for persuasion by logical means (Longinus recommended that the orator restrict himself to the more descriptive form of *enargeia*, leaving to the poet the kind that promotes sublime experiences). In a remarkably fluent and subtle argument developed over the length of an entire book, Murray Krieger traces two versions of *enargeia*: "What we are seeing in the difference between what I am terming *enargeia I* and *enargeia II*, is the difference between the cool aesthetic based on distance between audience and object and the heated aesthetic based on fusion, or empathy, between audience and the object into which they enter (feel themselves into) as imaginary subjects."[59] Crescimbeni's ekphrasis tends toward the "warm" emotional rather than the "cool" mimetic. Whether or not he was familiar with Joseph Addison (I assume he was), the British essayist's words give us a good characterization of what it is that the Arcadian accomplishes here: "Words, when well chosen, have so great a force in them, that a description often gives us more lively ideas than the sight of things themselves. The reader finds a scene drawn in stronger colors, and painted more to the life in his imagination, by the help of words, than by an actual survey of the scene which they describe. In this case, the poet seems to get the better of nature; he takes, indeed, the landskip after her, but gives it more vigorous touches, heightens its beauty, and so enlivens the whole piece, that the images which flow from the objects themselves appear weak and faint, in comparison of those that come from the expressions."[60]

Let us, by way of Crescimbeni's text, draw close with the nymphs as they ponder Maratti's *Venus Tinting the Rose* (Fig. 12), painted for the Florentine collector Marchese Alessandro Capponi.[61] As Ovid relates in the *Metamorphoses*, Venus suffered great pangs of love for Adonis after she experienced a serious brush with one of Cupid's arrows. She took to dashing about the woods with her skirts hitched up to her knees as if she were Diana the Huntress rather than the goddess of love. In a rush to save Adonis (not shown in the drawing) from the wild boar, the unshod Venus (this part of the story appears in the anonymous *Pervigilium Veneris*) steps on a thorn, and from her wound spouts the blood that dyes the white rose red. This story of mixed pain and "painting" (of the rose) anticipates the more desperate gouting of Adonis's blood after the boar impales him. Venus assuaged her grief by sprinkling nectar onto her beloved's spilt blood so that, after only an hour, the red anemone – the delicate wind flower – sprang up from the blemished earth.

Crescimbeni describes for us how Venus gazes on the thorn just pulled from her heel with the kind assistance of an *amorino*. By throwing this entire critical enterprise into the discourse of a fable, Crescimbeni renounces the "authorizing" of his own voice; instead of *imposing* the picture on us, he seems to allow the painting with its surrounding tableau of the audience of nymphs to speak for itself. Crescimbeni disdains the role of teacher, master, or even chief herdsman; rather, steeped in fellow-feeling, he is a companion who wishes to converse with the reader, recounting an interesting tale. After commenting on the white

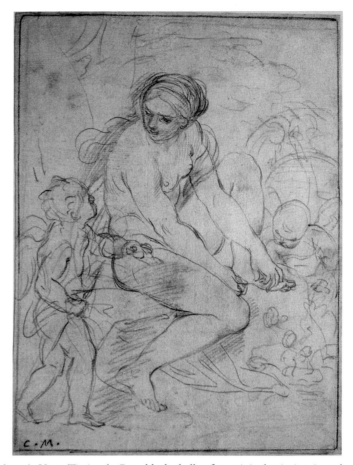

12. Carlo Maratti, *Venus Tinting the Rose*, black chalk, after original painting (now lost) Belgium, private collection. Photo: Stefan Kekko.

linen drapery that twists about Venus's body with a "judicious gracefulness,"[62] Crescimbeni describes the goddess as troubled and hurt, with her face averted. The gleeful *amorino* proudly shows her the offending thorn that he has just plucked from her heel. By giving us the bow and quiver at the putto's feet, the shrewd old Maratti (the characterization is Crescimbeni's) tips us off as to how the whole thing came about. To the left of Venus is another putto who holds and teases one of the doves that pulls her phaeton; another dove, disporting with a third putto, has just broken free from the silk ribbon that had held its leg. In the middle distance a clear stream flows between the trees and among the rocks. Adonis cuts a sorry and irresolute figure in the far distance. His leashed dogs pull him toward the woods, while Cupid takes him by the hand and points out Venus, who awaits him and with an inviting gaze implores him to return to her. She has sent off two putti as ambassadors to Adonis, but along the way they drop into

the limpid river for a swim.[63] All these figures, according to Crescimbeni, exhibit such animation that one could almost say they have real souls. Pausing with just a semicolon, Crescimbeni makes a smooth transition from the animated figures within his landscape painting to the framing story (or frame narrative) and the desire of the nymphs to dally longer before this picture. But because of their avid desire to see other paintings in the studio, they move on.

Before attempting to isolate some of the elements of Crescimbeni's ekphrastic technique, I want to return to his use of the verb *favellare*. Although *favellare* may mean simply "to tell a tale" or "to carry on a discourse," its primary sense is tied to the Latin noun *fabula* or, in English, fable. From the time of Hesiod (and most famously with Aesop, a supposed author of the sixth century B.C.E.), tales of beasts and personifications were told so as to elicit a moral lesson or some other hidden meaning. Often the message is made explicit (as when Crescimbeni gives away the "code" of his fable by identifying in footnotes all of the Arcadian names), sometimes it is left to the critical acumen of the reader to find the latent message in the surface or manifest story. Drawing on the Epicurean tradition of La Fontaine (1621–95), Crescimbeni seems bent on creating in his *Arcadia* a philosophy; yet insofar as the chief herdsman never makes his philosophy explicit, his allusions and sometimes mock-heroic narrative remains, to a degree at least, problematic. He does not divulge his meaning. It strikes me that his fable is like other pastoral recountings in that there is no real distinction between surface and depth, as we are used to, but rather a relationship of endless specularity between text and meaning. In his essay on Ariosto's use of the *locus amoenus* in *Orlando Furioso*, Eduoardo Saccone has come up with a system that he likens to the Möbius Strip: it is "a system according to which you don't move from the surface to what is under (thus understanding), from mask to naked face, but rather from one surface to another, from one mask to another, that normally complements, modifies or corrects the preceding one: offering usually what is not necessarily the orthodox, the right perspective, but certainly an alternative one."[64] As I commented earlier, art and nature along with text and meaning are signs for one another, with neither explicitly manifest nor latent. At the same time, Crescimbeni mixes together the art of the rhetorician, what appears to be a fairly straightforward description of paintings in a mimetic and sensible fashion, with fantasy and fabulation.

Aside from a few comments about rocks, trees, and dense vegetation, Crescimbeni says little about nature in Maratti's painting, concentrating instead on the *affetti* of various inhabitants within the painting and the denizens of the frame narrative itself. Indeed, much of Arcadian poetry, from Theocritus to Virgil and on to Sannazaro, sheds little light on the landscape and its picturesque qualities. Crescimbeni, like his forebears, projects an understanding of the emotional disposition of his characters. Venus is *dolente* (aggrieved, aching) and *affanosa* (distraught, gasping); the *amorino* pulls a *temeraria spina* (impudent or temerarious thorn) from Venus's foot; the putto gamboling about the sky *vezzosamente scherzava* (charmingly plays with) the dove; Adonis is *irresoluto* (irresolute, hesitant)

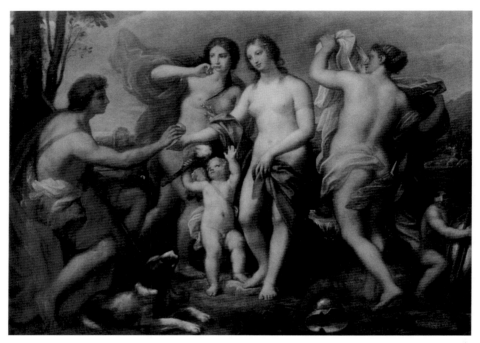

13. Carlo Maratti, *The Judgment of Paris*, Ekaterinisky Palace, Pushkin (Tzarskoje Selo), Russia. Photo: Ilya V. Tychkov.

and *penoso* (troubled, pained). In Addison's words, Crescimbeni "heightens" and "enlivens" the painting, giving words to what we experience in our "feeling into" (Krieger's phrase) the personae of Maratti's and Crescimbeni's little drama or fabliau. Crescimbeni in his *commiseratio* with the audience, the nymphs, Venus, and Adonis creates a pathos that is finally not very stirring; one might even say that rather than *pathopoeia* one finds *ethopoeia*.

This painting shares certain things with pastoral rhetoric, such as a sense of "internal asyntaxis" or parataxis – a rhetorical term that means, literally, side by side – a narrative and compositional device that separates and isolates various elements from one another, creating a coordinating rather than subordinating (typically baroque) composition. As I have mentioned: hypotaxis is baroque; parataxis is Arcadian *buon gusto*. The drama is suspended rather than suspenseful, with Venus giving every appearance of enjoying a pedicure. The sense of otium, of utter relaxation in verdant fields, in no way intimates the struggle and loss that lie at the core of the Ovidian tale.

As already mentioned, the nymphs, in no great hurry (although with an eagerness to see more of Maratti's paintings) drift over to the next canvas, *The Judgment of Paris* (Fig. 13). Crescimbeni must have had a good copy of the painting in front of him, because he makes perceptive color notes. Once again in his embedded narrative – the ekphrastic treatment of Maratti's pictures – the Arcadian

herdsman describes the color of the drapery across Paris's lap as *pagonazzo* – a mixture of bluish and purplish tints – and characterizes it as *vaghissimo* – graceful, even sweet. The mantle that descends from Paris's shoulder is vermilion, which accords beautifully with the other colors. He also admires the fantastic, spotted lynx pelt that serves as the cinch crossing Paris's other shoulder. In her modesty as well as delight at having won the prize, Venus pulls a blue garment about her hips, in a manner that can be translated as "light and diverting." Juno (obviously a poor loser) is "vexed" with Paris and casts a "turbid," even "sinister" eye on him, while she bites her finger in a fit of "spitefulness." Her capricious, fluttering drapery is highlighted with yellow and gold. She must be in an extraordinary hurry to get away from Paris, because we see her hips from the side with legs in full stride, whereas her torso still faces Paris and the viewer. Horace Walpole saw this painting at Houghton Hall and commented that Maratti made it "when he was 83 years old, yet it has none of the Rawness of his later Pieces. The Drawing of the *Juno* is very faulty, it being impossible to give so great a Turn to the Person, as he has given this figure."[65]

Crescimbeni refers to the "ferocious" Pallas Athena, who also turns away from Paris, grasping in her two hands her rose-colored mantle, which, in her headlong and angry haste, gets caught up with her shirt. Moving from this turbulent foreground scene, Crescimbeni's eye seeks a more tranquil spot in the middle distance, where he espies "a pleasant landscape" in which there is a shepherd watching his herds. In all, Crescimbeni judges this to be a "most noble painting" worthy of the one who painted it and the one for whom it was painted (the Arcadian shepherd Salcindo, Niccolò Maria Pallavicini).

Crescimbeni reads *The Judgment of Paris* in more excited terms than *Venus Tinting the Rose*, as if he were warming to his task, feeling more assured in his assessment of the states of mind of the three goddesses and clearly fascinated by Maratti's brilliant use of local colors.

Crescimbeni mostly abandons color descriptions in his brisk and encomiastic ekphrasis on Maratti's *Apollo and Daphne* (Fig. 14).[66] Claiming that the painting is destined for the court of Louis XIV (actually it had already been at Versailles for more than a quarter of a century), Crescimbeni assures his readers that from the point of view of attractiveness and expression of the passions the *Apollo and Daphne* is in no way inferior to the *Judgment of Paris*. The *stupenda* figure of Daphne, perched perilously on the steep banks of the river Peneus, expresses both her terror and the precipitous manner of her flight from Apollo. Crescimbeni's rhetoric here is clearly in the pastoral tradition as he builds up tension (unresolved, albeit) and a sense of headlong rush with the repetition of the word *che*, which functions as an anaphora, and, because it is the only connective term in a long sentence, also creates that Arcadian sense of disconnection – parataxis. He strings together his phrases and clauses with *che contemplarono, che ... è situata, imperciocche ... esprime, che vi sarebbe*, and so on. As we have seen, both of these figures of speech – anaphora and parataxis – are part of Arcadian rhetoric and the discourse of good

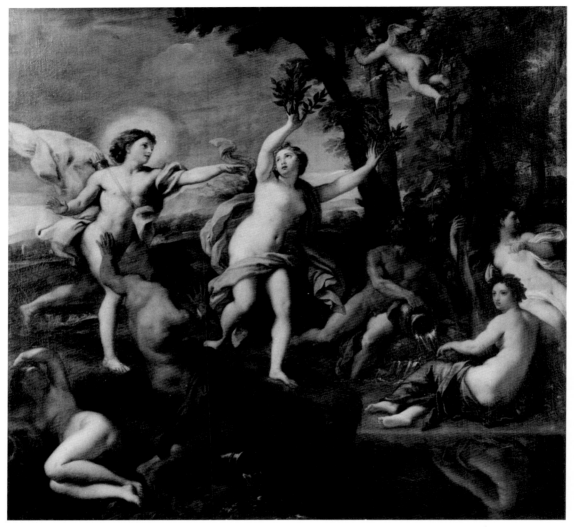

14. Carlo Maratti, *Apollo and Daphne*, 1681, Brussels, Musées Royaux des Beaux-Arts de Belgigue. Photo: IRPA, Bruxelles.

taste. Daphne is on the lip of the precipice, and if not for the "assistance" of her metamorphosis, would surely tumble into the torrent; Crescimbeni adds that the sagacious Desfilo also has planted her just at the right place (on a precipice, at the instant of her transmogrification, and smack in the middle of the composition) for the delight of the viewers. Crescimbeni is, in other words, highly sensitive to the importance of the gaze (he frequently uses the verb *rimirare* – "to gaze" – and refers specifically to *i riguardanti* – "the beholders"). By thematizing the act of looking, Crescimbeni engages his implied readership – his friends – in the warm terms that (we recall), Krieger associates with *enargeia II*.

Crescimbeni knows a performance when he sees one. He tells us that the amazed Apollo points with his index finger at Daphne's "unexpected" metamorphosis (how, indeed, could one "expect" such a thing anyhow?). Is this, we might wonder (entering into the game of interpreting Apollo's motivations) a spontaneous reaction on the god's part, or is he performing, in terms of visual narratology, his dramatic role as the "internal focalizer" with Daphne as the "focalized"? Of course, such an indexical move on Apollo's part provides absolutely no assistance to the reader and viewer. How could we help but see what is going on, after all? Just the same, Crescimbeni, the external focalizer, doubles the indexicality by pointing out Apollo's pointing. By telling us that Daphne is strategically placed in the middle of the painting, Crescimbeni draws our attention to Maratti as another focalizer, positioned intermediately between the putative figures within the painting and the voice of the chief herdsman.

Our narrator also emphasizes the performativity of drapery patterns, when he refers to "these two figures, greatly enamored [with one another] by the play of their picturesque drapery" (*Queste due figure, molto invaghite dallo scherzo de' pittoreschi panneggiamenti*). Then, in a surprise move, the chief herdsman pulls back from the embedded narrative to the frame narrative and tells us how minutely the nymphs are studying this picture; so attentive are they, he relates, that one (whom he names Nosside) observes among the river gods a figure whose hands are above his head and who has dropped his urn, allowing the water to spill out. Because this is contrary to the normal allegorization of river deities carrying water jugs under their arms, Nosside cannot restrain from asking why he is shown this way. Disfilo answers that he represented Sperchio in this way so as to express a precipitously running river with many rapids. Within this frame narrative, then, we have two figures in discussion over an image in the imbedded narrative. Crescimbeni simultaneously builds up layers of narrative while creating an abyss of texts.

Passing over several other pictures in Disfilo's exhibition, I want to go straight to the last in line, which offers an Arcadian allegory and presents self portraits of Maratti and one of Arcadia's most prestigious collectors, Marchese Niccolò Maria Pallavicini (the original owner, as we have seen, of *The Judgment of Paris*). Crescimbeni, adopting a quiet and contemplative tone, has relatively little to say about Il *Tempio di Virtù* (Fig. 15). Because the way to virtue is so long and arduous, one is unlikely in a single lifetime to view this stunning temple up close. It is enough to say (to quote Crescimbeni) that the nymphs lose themselves in the vista and their thoughts, remaining in front of the work until the middle of the night. Finally Aglaura summons them, along with her indefatigable father, to dinner.

One of the anonymous contributors to the 1732 edition of Bellori's *Lives of the Artists* describes this painting in somewhat more detail than we can glean from Crescimbeni.[67] Besides naming the two protagonists, the author writes that Maratti is in the act of painting a portrait of Pallavicini, whereas it seems that the three graces behind him are helping the painter deepen the sense of dignity,

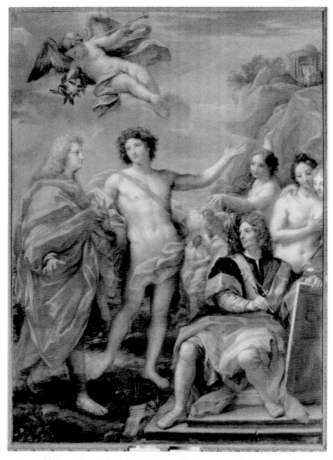

15. Carlo Maratti, *Self-Portrait with the Marchese Pallavicini* (Il Tempio di Virtù), Stourhead, Wiltshire, The National Trust, Hoare Collection. Photo: Bridgeman Archives.

decorum, elegance, and gracefulness that cannot be acquired by study alone. The flying allegory of fame brings the laurel crown to the marchese, while Genius points out the steep road to the temple of virtue.[68] Although both Bellori and Faustina Maratti identify the figures behind Maratti as the Three Graces, the way in which Crescimbeni describes the meditative mood of the nymphs, this group could in fact contain several of the nymphs, magically projected (*internate*) into the vista of the painting.

The depiction of virtue in general (*virtus generaliter sumpta*), rather than as the seven cardinal virtues, recalls the theme of Hercules at the Crossroads, which was recalled by Petrarch as displaying manly virtue. He even speculated that the concept of virtue derives from the Latin root *vir* – male – emphasizing the way virtue and virility conflate with one another.

In general, the frame narrative tells of nymphs on a journey. By the time we get to Book IV of *Arcadia*, we encounter an embedded narrative (there are others) describing Disfilo's hut and his informal exhibition of paintings. If we move farther into this hierarchy of tales we get to the paintings themselves and observe the ways in which the nymphs study and move among the canvases. Next come mythological events – now in visual rather than literary form – represented in paintings that are caught up in complex webs of intertextuality. Tying together these various tales is the narrator's (Crescimbeni's) voice, which never abates, never hesitates in taking us deeper and deeper into fabulation. Like a herculean puppeteer, the chief herdsman has strings going to and maneuvering all sorts of characters and tableaus. He brings along Maratti's daughter, establishes emotional relationships among the characters, names a nymph, and has her speak to the fictional Maratti, who answers. He imputes emotions and excitement to the characters within the paintings and offers short critiques of composition and coloration.

Crescimbeni weaves his various kinds of narrative into intricate ornamentation, not unlike the Möbius strip, that turns in on and often mirrors itself. As we shall see in the discussion of the Bosco Parrasio (Chapter 6), elements of performativity are important in the Arcadian version of *buon gusto*; here the spinning of Crescimbeni's tales brings forth many performative utterances. Benjamin Lee observes that J. L. Austen's development of the concept of performativity "reverses the priority held by language as truth and correspondence over language as action and creation."[69]

But Crescimbeni does more than offer up frame and embedded narratives, skits, paintings, vignettes, focalizers, scientific, geological, and artistic exhibitions, and things that I have not even touched on in this essay, such as fantastic images of Roman aqueducts made from trees, large obelisks bearing statues, primitive huts galore, trees with engraved translations from the Greek, and so on. He bundles this entire assortment of tales and presents the package under the title *Arcadia*, which is the Accademia degli Arcadi, a landscape and garden, a *ricorso* (regeneration and renewal) of Rome achieved by a return to certain origins (pastoral poetry, fables, ancient Greece, Olympic Games, ancient Roman architecture), a kind of *habitus* or consciousness, and a complex form of rhetoric and good taste. And lest we forget, *Arcadia* (the text) *is* Giovan Mario Crescimbeni, *custode generale*.

Carlo Maratti was the Grand Old Man of Arcadian painting. One would be foolhardy to say that the Arcadians shaped his style, for it was well established long before the founding of the academy. Yet the spate of his mythological paintings produced after 1680 satisfied the tastes and sensibilities of the Arcadians as well as corresponded with the formative years of the Accademia's history. Such Arcadians as Livio Odeschalchi (Aquilio Naviano), Ferrante Capponi (Efestio Erimanteo), and Niccolò Pallavicini (Salcino Elafio) numbered among those later patrons who especially preferred mythological subjects from Maratti. Critics of Maratti's later

style have used such terms as graceful, subtle, and nuanced to describe the ways in which his manner relaxed somewhat from the more severe classicism of Andrea Sacchi; as he grew older, his compositions loosened, undercutting the earlier unity and hypotaxis of baroque composition. These general stylistic changes, along with his lightened palette, suggest that Maratti's style is inappropriately termed (as it sometimes is) neoclassical.

FOUR:

WHAT IS ARCADIAN ARCHITECTURE?

S andro Benedetti first announced his search for an Arcadian architecture in
1970.[1] Following on the heels of the exhibitions and symposia held in Rome
in 1990–1 marking the 300th anniversary of the founding of the Accademia degli
Arcadi, Benedetti published once again his belief in the existence of "architecture
in Arcadia." But what he intended by this designation never entirely crystallizes.
Benedetti certainly brings into play the Accademia degli Arcadi as an institu-
tion (or as a locus for tastemakers) but has little to say about the Arcadians and
their academy as promulgators of poetic ideas, modes, or motifs; in other words,
Benedetti does not write about pastoral – or, in a slightly different sense, Arcadian –
architecture. What, then, does he mean by architecture in Arcadia?

Benedetti claims to be doing for the eighteenth century what Paolo
Portoghesi did for the seventeenth; that is, he sorts through the historical and
architectural records to find what he terms the contrasting emotive and theoret-
ical positions of the time. When his second essay appeared, he was convinced
that his was a historiographical innovation, a new way of understanding Roman
architecture in and around the year 1730. These are, I believe, rather exaggerated
claims; at the same time, Benedetti's reading of the historical record is reliable and
useful.

Spotting past trends in the visual arts is part guesswork and part imaginative
reconstruction. In his desire to find a path through the architectural maze of the
early settecento (and identify some tendencies), Benedetti reviews eighteenth-
century reflections on architecture and style and focuses on two architectural
competitions (concorsi) held in Rome at this time, one for the façade of Giovanni
in Laterano, the other for the long-awaited completion of the Trevi Fountain. He
also follows Carlo Calcaterra's assertion that baroque rhetoric could still be found
in the settecento, even in the rime read by the Arcadians – sworn enemies of the
old concettismo though they believed themselves to be.[2] For instance, Calcaterra
tells of a certain Pompeo Rinaldi, one of the "most applauded" of the Arcadian
poets in the academy's early years, who recited a poem (all of these are collected in
the many volumes of the Rime degli Arcadi, housed in Rome's Biblioteca Angelica)
in which he recycled such threadbare baroque tropes as a calm sea standing for

"il mondo," a ship representing human life, and so on. The issue here is not the fairly low quality of some of these Arcadian sonnets, but that old habits in poetry die slowly, even when they are openly and continually repudiated. The same goes for architecture, as Benedetti correctly states. Francesco de 'Sanctis' Spanish Steps (1723–6), Giuseppe Sardi's façade for Santa Maria Maddelena (1735), Gabriele Valvassori's façade for the Palazzo Doria Pamphili (1731–4), Nicola Michetti's reconstructions of the Palazzo Colonna (1730), and various elements in the works of Filippo Raguzzini all fall within the late baroque style, according to Benedetti. One could quibble with the list (as well as disagree with his use of "late baroque" as a stylistic marker), but I am inclined to grant him his point. Despite my allusion to the "death of the baroque," it lived on in Rome and elsewhere, as is well known and documented in the histories of architecture. So we set aside for the time being a "baroque redux" and focus on what Benedetti refers to as the entourage around Neri Corsini, the competitions for the Lateran façade and the Trevi Fountain, and some contemporary writings on the arts.

Taking the last point first, we can turn to Benedetti's discussion of Lione Pascoli (1674–1744), who, in his *Vite de' pittori, scultori ed architetti moderni* (1730–6), did much to promote the Roman school of painting, sculpture, and architecture of the seicento and early settecento.[3] But what Pascoli praises in the first volume – fancy, caprice, invention – he condemns in the second.[4] In plain words, between the publication dates of the two volumes Pascoli learned the gospel of *buon gusto*. Benedetti's interest, just the same, restricts itself to Pascoli's few comments on architecture, specifically when he defends contemporary palace design against accusations that modern edifices were less beautiful than ancient ones. Pascoli brings a utilitarian argument to bear when he argues that the exigencies of modern palaces were such that architects needed to build numerous stairways to join in a servicible fashion the various apartments contained in a single building. Pascoli asserts that modern architecture – commodious, versatile, and convenient – is in no way inferior to that of the ancients. He also trumpets the magnificence of Rome, calling for its continual renewal and declaring the need for splendor and (of course) comfort, which would be profitable to the shopkeepers (Pascoli was an economist) and beneficial to the "nation."[5] Pascoli also voices his ideas on town planning by recommending the placement of manufactories and shops in certain areas of Rome where their common clientele and markets could be more efficiently exploited. He was a rationalist, a careful planner, a practical man. There is nothing in Pascoli's writings on architecture that explicitly supports the idea of an Arcadian architecture, but there is little doubt that he had been swayed by antibaroque/pro–*buon gusto* arguments. Just the same, his rationalism embraces neither aesthetic nor poetic ideas to any significant degree. Pascoli's call is the usual one in these years for order, utility, and clarity.[6]

Then there were the Florentine Pope Clement XII (Lorenzo Corsini), his nephew Neri, and their Tuscan cohorts and retainers. As Filippo Juvarra famously

and bitterly announced, with the advent of Clement's papacy, in Rome "Tuscany exults and laughs."[7] For nearly a decade, artists from anywhere but Tuscany were, for all intents and purposes, shut out. The Florentines may have rejoiced in their good fortunes, but they bewailed *concettismo* and things *alla romana*, condemning baroque conventions and hoping for at least the old ambience of "l'aria cinquecentesca." In general, the circle of intellectuals around Clement XII aligned themselves with those who taught at the University of Pisa, maintained the tradition of Galileo, supported erudite historical research, and promoted Florentine art and criticism, especially that of the cinquecento. They rejected popular and religious superstitions, believing that baroque rhetoric in some ways supported irrational beliefs and that Jesuit – inspired emotive images (Neri's circle of intellectuals was on the whole anti-Jesuit) appealed to the *incolti*, those uncultured souls given too quickly and easily to credulity.

One of the Corsini family's most trusted retainers, the Arcadian Giovanni Gaetano Bottari (1689–1775), librarian and professor of ecclesiastical history, had an abiding interest in *le belle arti*, and published his *Dialoghi sopra le tre arti del disegno* because (he believed) these dialogues, filled with good lessons, would be useful.[8] The dialogues between Bottari's alter egos (critic Giovanni Pietro Bellori and painter Carlo Maratti, both long dead by the time Bottari penned his dialogues) point out that although architects should learn the basics of geometry and statics (the mechanism of equilibrium), they tend, alas, to rely on their foremen rather than on their own knowledge – with predictably bad results. Bottari's Bellori complains that young architects only learn about ornament, missing the intrinsic or first principles of architecture. We can extrapolate from Bellori's sentiments that Bottari sees ornament as something supplemental, inessential, adjunctive, extrinsic; in fact, he is generally dismissive of the ("merely") decorative.[9] He deplores those ostentatious buildings – whether sacred or secular, public or private – that cost one so dearly and that are covered with arabesques – as if they were made by woodcutters more practiced in decorating mirrors than in designing edifices.[10] Convinced that a painter or sculptor could do a better job in designing and constructing a palace, a garden, or a casino, Bottari had no dealings with the average young architect. In fact, he believed that solid grounding in perspective and *disegno* served both painters and sculptors well when they ventured into the architect's and builder's *cantiere*. Some of the best buildings and gardens were made not by architects, but by those painters and sculptors (not surprisingly, mostly Florentine) who had a sense of order in their eye, who had an intuitive understanding of design, and who employed principles of the perspicuous, clear, and concinnous.[11] From the mouths of Bellori and Maratti issue allusions to a kind of artistic invention that cannot readily be taught, one that is instinctive, spontaneous, and nondiscursive.[12] Bottari's Maratti says that he who studies architecture does not profess it, nor – in point of fact – really even studies it. Undoubtedly enjoying the irony, Maratti avers that the architectural vocation in his day (although he had been dead more than 40 years by the time these

dialogues were published) was not just impoverished (*decaduta*), but was utterly lost (*perduta affatto*).[13]

These artistic intuitions, much praised by Bottari, arise from good training in, as we have seen, perspective and *disegno*. Architects who dabble in ornament (Bottari believes that many architects of his day did just that — practiced their profession superficially) may not understand the importance of balance, symmetry, the ability to divide and subdivide two-dimensional spaces with an eye to the rational aspects of design, which is, of course, a Tuscan principle. He is quite explicit in his belief that ornament is just so much child's play.

As is well known, Paolo Pino, Ludovico Dolce, and Giorgio Vasari made a point of the distinction between line and color (*disegno* and *colore*). Dolce championed Titian's color, and Vasari boasted of the intellectual underpinnings of Tuscan *disegno*, better anchored in our cognitive faculties than the more diffuse *colore*, which appeals to the "lesser" senses. It is only through design, Vasari contended, that the artist's idea can take on tangible form.[14]

Through his personas, Bottari defends a severe, wise, and rational architecture, one not given to mystical transport. Because of the ways in which young architects slavishly copy ornament and are indifferent to design, Bottari judges the baroque style plebian. He thinks that the *intenditori* should support a more intelligent and controlled architecture, like that of the cinquecento. He calls for "giusto stabilimento," which means for him a study of equilibrium, the distribution of weight, and the appropriate arrangement of formal elements.

We as twenty-first-century critical historians of art run into the same problems with Bottari as we do with Muratori, Gravina, Crescimbeni, and a host of other Arcadians. They tend to stake out ethical positions on the visual and literary arts, generally attacking what they do not like rather than making explicit the status, appearance, and meaning of contemporary painting, sculpture, architecture, poetry, drama, literature, and philosophy — to mention only the main categories. They draw a Plimsoll line of condemnation just the other side of the baroque, *secentismo*, and *concettismo*; make some general statements about order and just measure; then go about their business. We need to find their critical posture by studying their ways of proceeding, how they go about their business in ways that are caught up in their cultural values, principles that often remain unspoken.

We have the difficult task of looking to the Italian late-seventeenth- and early-eighteenth-century religious, intellectual, literary, and visual cultures to see how discourses (specific kinds of language use) in one area critique discourses in another. We try to pull from our investigations something that helps us to understand, account for, and describe the way things were and looked. With Bottari we have an intellectual who was a prolific writer, although he almost always published his works anonymously. It is only after the fact that his contemporaries and later historians have been able to identify his writings. Bottari adopted certain stances in relation to ecclesiastical history, libraries, language (he was director of the Accademia della Crusca), works of art, Jansenists and Jesuits, and the affairs

of the Corsini family. Polemicist though he was, his positions were slippery and subtle, nuanced yet assured. His pride in his Tuscan heritage shines through these exchanges between his second selves Bellori and Maratti.

Does this mean eighteenth-century Roman palaces should, in his estimation, look like Palazzo Strozzi in Florence (Bottari especially admired the palace's bold cornice)? Perhaps they should. In so far as Bottari gives at least lip service to "l'aria cinquecentesca," might we expect Ferdinando Fuga's Palazzo della Consulta to resemble the Lateran Palace? It was indeed Fuga's master Giovanni Battista Foggini's practice to train his students in the art of such cinquecento artists as Michelangelo, Ammanati, and Buontalenti. But Filippo della Valle (another student – and nephew – of Foggini) made statues that look no more like Michelangelo's than Fuga's architecture looks like Ammanati's and Buontalenti's. At this point, we have gained little ground on conceptualizing Arcadian architecture, and so we turn to the principal competitions of the day.

The key competitions in 1732 were for the rebuilding of San Giovanni in Laterano and the completion of the Trevi Fountain. Here once again all the important players gathered. Eight members of the Accademia di San Luca pored over models and drawings submitted by a host of architects for the new façade of San Giovanni.[15] The top vote-getters were Alesandro Galilei (with a plurality of four votes), Ludovico Rusconi Sassi, and Luigi Vanvitelli. The judges wanted to hold a second competition among the three finalists, but Clement XII, naming Galilei the winner, overruled them. There were storms of protests among the architects in Rome, strong rumors that Vanvitelli had really been the choice of the academicians, and complaints that Galilei's design was too severe. Sebastiano Conca, one of the judges, protested that the Tuscan's proposal was "very pedestrian and poor, and not in accordance with the best tradition of Roman architecture which demands the use of columns and more projections."[16] Reflecting Conca's judgment, Elisabeth Kieven points out that Vanvitelli's proposal both ameliorates Galilei's starkness and provides swags and fluted pilasters more in keeping with the Roman style. Another judge, Giovanni Paolo Panini, criticized the foursquare design with its unemphatic projections.[17] Benedetti puts Galilei squarely in Bottari's camp because of his attention to *proprietà* and *convenienza* – that which is fitting and proper – vague characterizations derived from superficial readings of rhetorical commonplaces on decorum. Interestingly enough, Bottari disliked Galilei and worked unsuccessfully behind the scenes for Ruggieri.[18] The French architect Antoine Dérizet also championed Galilei's solution as the one best suited to the architecture of the Lateran and, refreshingly for him, far from the "good" Roman tradition, which was about the "wild and unreasonable compilation of pilasters and columns and unnecessary projections."[19] Neri Corsini, who paid for Galilei's elaborate model, chimed in with the observation that his compatriot's design was noble, majestic, and in the best tradition of buon gusto antico.[20]

This typification of *gusto antico* was often associated with the Trevi Fountain in Rome. Kieven describes the Trevi as a successful combination of *buon gusto*

and *gusto alla romana*.²¹ Her celebration of the fountain's design would find wide agreement today from the thousands who daily choke the Piazza di Trevi as well as from those who study Roman architecture of the eighteenth century. But despite this (apparently) successful combination of Florentine and Roman architectural conventions and innovations, those Arcadians attached to the Corsini family probably would have been tight-lipped in their expression of approval, if not breaking into bursts of outright anger and dissatisfaction. For instance, Bottari comments on the Trevi Fountain in a footnote to Maratti's discussion of the proper ornamentation of a fountain. Here Bottari lets loose with some strong words in his favorite place – the footnote – to do just that. By refusing to put these imprecations into the mouths of his fictional henchmen – his doppelgangers – our Florentine *erudito* demonstrates his wish to speak directly to us, the readers, in his own voice.²² He condemns this unfortunate admixture, even adulteration, of architectural elements, despite the fact that Nicola Salvi was reputed to be one of the most "expert" architects in Rome (adding to a sense of dismissal, Bottari fails even to name him). Bottari would brook no concessions to the Roman tradition, notwithstanding the strong dose of *gusto antico* that most commentators find present in the Trevi. Bottari writes that the Trevi is an enormous congeries of broken rocks piled one on top of the other, creating a vast space impinging on a relatively small piazza, leaving only room enough for a narrow street. Above this rocky and irregular foundation rises a façade that employs what Bottari judges to be the most inappropriate, disadvantageous, and disproportionate order – the Corinthian. By choosing the Corinthian order for the colossal pilasters fronting the Palazzo Poli, Salvi has, according to Bottari, elected the most refined, elegant, and graceful order, a terrible mismatch for the outsized jagged rocks. How unsupportable, dissonant, ridiculous! He writes with some acerbity that the Trevi had been praised to the stars and ranked with the works of *buon gusto* (a judgment and characterization that must have sent shivers up and down Bottari's spine). He claims that the other errors of the Trevi are simply too numerous to list (which is a nice preterition).

In sum, Benedetti's argument leads us to the conclusion that "architecture in Arcadia" is antibaroque and anti-Roman, that it follows in some general way the Tuscan style of the fifteenth and sixteenth centuries and that it is spare in its ornamentation, understated in its projections and recessions, conservative in matters of equilibrium (even if many judge the façade of San Giovanni in Laterano to be top heavy) and mass, and sensitive to the teachings of Vitruvius and Vignola. Benedetti's application of the word Arcadian (or, alternately, the phrase "architecture in Arcadia") makes sense only in the fact that many of those who were the tastemakers in early eighteenth-century Rome belonged to the Accademia degli Arcadi. Even though I strongly believe in and argue for an Arcadian sensibility in painting and sculpture, its application to architectural style, at least in Benedetti's presentation, strikes me as tenuous at best.

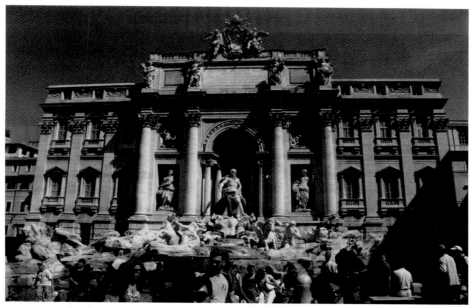

16. Nicola Salvi, Trevi Fountain, 1732–62, Rome. Photo: Vernon Hyde Minor.

AN ARCADIAN FOUNTAIN: THE TREVI

But that is not to say there is no such thing as Arcadian architecture. I believe, for instance, that the Fontana di Trevi is indeed Arcadian in a sense deeper than Benedetti uses in his discussions of architecture in Arcadia (Fig. 16). That is not to say that the Trevi Fountain is a pastoral eclogue in architectural form, but it does have an Arcadian sensibility. Benedetti was right, of course, to consider the Trevi as Arcadian, even if he made a very different argument from mine.

With the appellative *buon gusto* hovering above them all, the phrases *alla romana*, *gusto antico*, and *gusto moderno* appear with some regularity in discussions of settecento architecture in Rome, especially in the thirties and forties. As I believe is fairly evident, the debates over and ponderings of these terms by students of the settecento have not always led in the direction of clarification or agreement. In this matter, I tend to follow John Pinto's explanations: *gusto antico*, as we can imagine, describes an architectural taste deriving both from the writings of Vitruvius and from specific ancient Roman buildings.[23] Further, like Bottari (although with some important divergence as well), Salvi built his taste in part on cinquecento architecture, specifically the work of Michelangelo (whom Salvi mentions specifically) and Palladio (to whom Salvi alludes). We recall that Bottari's insistence on *disegno* grew from his Tuscan roots, and although he would indeed have supported Salvi's listing of Michelangelo as a potent ancestor, he may have been less moved by either Palladio or Salvi's deliberate quotation of the Arch

of Constantine. Just the same, without trying too hard to discriminate among antecendents (which, nonetheless, is a game played by Bottari and his contemporaries), we can at least say that *gusto antico* takes within its purview the architecture of imperial Rome and the Italian cinquecento.

When the phrase *gusto alla romana* was used by Bottari and others in the settecento (more often than not in a pejorative sense), it undoubtedly called to one's mind what we call the Roman baroque – specifically the architecture of Bernini, Rainaldi, and Cortona (but perhaps not quite the architecture of Borromini). *Gusto moderno* was employed in much the same sense and disdainful manner. Bottari cared little for Roman *grandezza* (essential to *gusto alla romana* and *gusto moderno*), preferring Tuscan strength and simplicity, along with the straightforward modular style of the Bolognese-educated Giacomo Vignola. Good taste prized buildings bereft of ornament, an architecture reduced to framework, panels, and cornice.

Now we can distinguish the architectural implications of *buon gusto*. I think it is fair to say that the prevailing architectural idea of good taste tended to reject *gusto alla romana* and *gusto moderno*. *Buon gusto* could relate to *gusto antico*, but only so long as antiquity was cleansed of emphatic ornament and projections (the hated "ornato di colone e maggiori aggietti," as Sebastiano Conca described it – albeit affirmatively).[24] But understanding the implications of *buon gusto* primarily in terms of the disposition of architectural mass and surface articulation is something of a bare-bones approach. Again, John Pinto leads us into more verdant terrain, that of Arcadian literature. As I have already said, if *buon gusto* is the text of much of the cultural, literary, and artistic production of the Roman early eighteenth century, then Arcadianism is the subtext. I return to a discussion of the ways in which Arcadianism as subtext threads together with, as well as obstinately destabilizes, the primary text of good taste.

I begin with and elaborate on Pinto's excellent introduction of the *Rus in urbe*, an important pastoral theme. I also consider other aspects of the Trevi that we can associate with Arcadian topoi.

Rus in urbe – bringing the country to the city – is a commonplace of much ancient literature, including the pastoral. The city of Rome hardly intrudes on the Piazza di Trevi, which is enclosed on all four sides by surrounding buildings. Creating this space for nature in the midst of the urban archetype – Rome – seems to play against the standard pastoral topos of conflict between city and country. As we shall see later in the discusson of otium (Chapter 6), however, one can rail against the sins of the city, while at the same bemoaning the boredom of the country. The best synthesis is to have both – *rus in urbe*. Just as the Bosco Parrasio (another of Salvi's projects) is in (or at least at the edge) of the city, so, too, did the political realities of eighteenth-century Rome surround the Piazza di Trevi. This is an inescapable situation, one not to be scorned.[25] As Frank Kermode states, "The first condition of Pastoral is that it is an urban product."[26]

From classical antiquity through the early modern period (and beyond) nature had been invoked for her beauty and her sympathy to the suffering or prayerful human. In Sophocles' play *Ajax* (412 ff.), the eponymous hero in flight from Troy calls out to the rivers, thickets, foam of the sea, waves, streams, and caves. Salvi's extensive inventory of nature and her creatures in the Trevi Fountain derives from a similar tradition in medieval and Renaissance poetry.[27] There are more than thirty species of fauna present among the *scogli* and along the base of the façade of the Palazzo Poli, all carefully planned by Salvi.[28] In addition, an attentive observer can spot a snail on one of the ledges and a salamander basking in the sun, survey the huge Tritons or sea horses and, until the nineteenth century (when they were broken off), watch the water running into one of the basins from the heads of two snakes.

This listing or enumeration of elements shows up not just in ancient, medieval, and early modern literature, but specifically in pastoral texts and scientific enquiries. The herdsman (or perhaps here the idler by the shore) loves to inventory what he can see of God's flora and fauna. The cataloguing of these delights is known rhetorically as the priamel, favored, for instance, by Theocritus. The pastoral invites paratactic compositions, those that occur when things are itemized, specified but not necessarily employed as similes. They contribute to pastoral otium, the joy of the stream, the wood, the field – those places favored by Petrarch in his love of the solitary life.

The fountain is also a stage set, an orchestra, and a cavea. A few years before his planning of the *Fontana di Trevi*, Salvi assisted Antonio Canevari in the design of the Bosco Parrasio, where there is a theater at the top of the Arcadian wood (see Chapter 6). The setting of the Trevi is not so different from the Parrhasian Grove's theater, with circling seats (like a reduced *cavea*), orchestra or chorus space (taken up by water at the Trevi, and probably used by some members of the audience at the Bosco Parrasio to stretch out in an appropriately pastoral way), and a fairly elaborate *scenae frons*.

The rhetorical figure of the *theatrum mundi* has been around since Plato wrote in the *Philebus* (50b) of the "tragedy and comedy of life."[29] John of Salisbury and later Shakespeare (in *As You Like It*) explicitly state that the world is a stage, the human comedy being played out for the pleasure of God and the angels. Or the audience may be more earthbound, as when members of the Accademia degli Arcadi sat on their benches or sprawled on the ground while listening to the shepherd-poets reading their verses. Here at the Trevi, water and its attributes (fecundity, abundance, salubrity) hold the stage and move into the orchestra, while visitors take seats elegantly arranged around the grand basin. The populace can watch the mythic and allegorical figures reflect both the grand scheme of things and the history of the original aqueduct, the one that still feeds the Trevi – the Aqua Vergine. We watch not an Everyman play, but the myths of ocean and streams and the allegory of fructification.

Paul Alpers writes on pastoral literature and the importance of convention, by which he means a "coming together."[30] When the word convention is used as part of literary and artistic discourse, it often indicates not just the formal agreement among participants and purveyors but suggests something arbitrary and unyielding. Convention gainsays individuality. That is what Samuel Johnson disliked so much about Milton's *Lycidas*. As Alpers develops *convenire* in pastoral poetry, he emphasizes not the subordination of an individual to a prescribed practice or custom, but instead revisits the opening scene of Theocritus's poem, in which the shepherds gather to sing elegies to the departed Daphnis. The citizens of Rome convene at the Trevi also to recall those absent popes now present by virtue of their munificence and their epitaphs and inscriptions. Not unlike pastoral shepherds, Rome's denizens congregate to idle away the time, to rest a while and gossip; Salvi's Trevi is a small pool in Arcadia, a pastoral spot and artificial setting free of grievance. We gather here for the pleasures of the contemplative life, the life of retirement. One may look to the past (the narrative of the original aqueduct) or to the promising future, where (it is hoped) the complex will become simple, where Anita Ekberg may once again wade into the fountain. Sannazaro in his guise as Sincero found in Arcadia the possibility of a joyful future and his self-discovery as a poet.

Salvi wrote a lengthy description of the program for the Trevi, emphasizing the animating power of the dynamic figure in the very center of the fountain, Oceanus, who rides on a shell drawn by sea horses. The horses in turn are accompanied by Tritons.[31] In what is essentially an encomium, Salvi represents Oceanus as the source of great natural powers, a wellspring. Water, which Salvi describes as "the only everlasting source of continuous being," gushes from beneath Neptune's shell.[32] The architect wants to show the sea horses as identical in their forehoofs to land horses, while their piscine nature is revealed by haunches transforming into fish. By representing them this way, Salvi shows that water is as important on the land (where horses live) as it is in the great oceans, where marine steeds glide almost effortlessly across the waves.

The rearing sea horse, the Triton sounding his conch, the water surging over the *scogli*, the pilaster on the far right crumbling and sliding off the façade of the Palazzo Poli – all these attest to the power of the ocean (Fig. 17). It nurtures and it destroys. John Pinto relates the power of the sea, the foaming water on irregular rocks, and the picturesquely "crumbling" architecture to the topos of metamorphosis.

The architecture of the fountain appears to grow organically from the living rock. A rusticated basement level articulated by drafted masonry is partially obscured by the rougher texture of the naturalistic *scogli* that rise from the fountain basin. The colossal order of Corinthian columns and pilasters tying the façade of the fountain together rises directly from the basement, which provides a transition between the polished sophistication required of an urban edifice and the rustic simplicity appropriate to a grotto. In several instances, this transition is blurred by

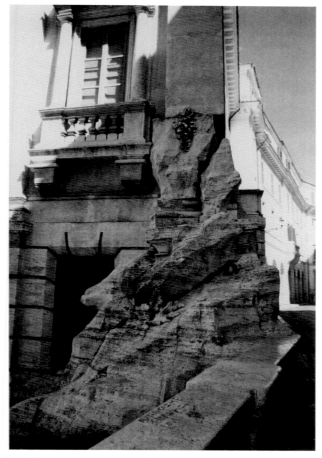

17. Nicola Salvi, Trevi Fountain, detail of slipping pilaster. Photo: Vernon Hyde Minor.

the intrusion of sculptural features – like the oak tree growing at the base of one of the columns – which visually bind the world of nature to the world of man.[33]

We are reminded that artfulness comprises an important part of pastoral values, despite the usual insistence on the natural.[34] We may see this artifice as having a certain rhetorical value as well: Bottari, as we know, hated the way Salvi plumped down the elegant Corinthian pilasters atop graceless piles of rocks. But for all of Bottari's scowling and disapprobation, there certainly would have been those who recognized and enjoyed the architectural *adynaton*. This rhetorical figure, a kind of impossibility stratagem, presents the unfeasibility or absurdity of a luxurious palace arising from the waves, supported only by the boulders of the sea. One might think of the Theocritan "may order turn disordered, and the pine grow pears" – but that is an appeal for nature to mourn the death of Daphnis. Here we have, I believe, a species of Golden Age longing, one that fired Salvi's imagination, creating an architectural panegyric for both Augustus's

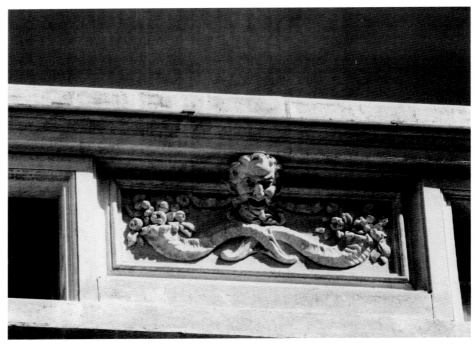

18. Nicola Salvi, Trevi Fountain, detail of grotesque masks, c. 1735, Rome. Photo: Vernon Hyde Minor.

deputy Marcus Agrippa and the modern popes – Clement XII, Benedict XIV, and Clement XIII (all Arcadians) – who brought water from afar to refresh the Roman populace, to find abundance and health in the midst of a great but nearly waterless city.[35]

The Arcadians loved playing games of an oracular nature in which questions lead to seemingly fanciful responses, answers that give the impression of being utterly out of place. For instance, Susan Dixon recounts the game of "Oracle" played by the lovely Aglaura Cidonia – Faustina Maratti Zappi (Carlo Maratti's daughter, whom we met in Cresimbeni's fable *Arcadia*). To the question "Is love necessary to make a perfect soul?" she responded "crystal."[36] Three contestants improvised explanations for her answer; the one who came closest to her intention won.

Designs of the oracular, death and decay, metamorphosis, arbitrary change (adynaton), and the employment of the ancient topos of the grotesque fit with Arcadian fabulation and the sometimes obscure associations generated by the Arcadians' beloved "Olympic games." Salvi's comic subversions, such as his crumbling pilaster, in which it would appear that an essential support for the façade has given way (leading us to worry about the structural integrity of the entire architectural pile), along with his grotesque heads (Figs. 18 and 19) – which in fact are masks – in the attic story and at the corners of the façade, probably would

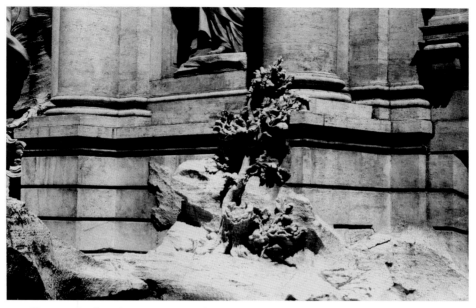

19. Giuseppe Prodi and Francesco Pincelotti, *Oak Tree*, 1742–4, Trevi Fountain, Rome. Photo: Vernon Hyde Minor.

have earned the contempt of (in addition to Bottari) no less an authority than Vitruvius: "But these paintings, which had taken their models from real things, now fall foul of depraved taste. For monsters are now painted in frescoes rather than reliable images of definite things. Reeds are set up in place of columns, as pediments, little scrolls, striped with curly leaves and volutes; candelabra hold up the figures of aediculae, and above the pediments of these, several tender shoots, sprouting in coils from roots, have little statues nestled in them for no reason, or shoots split in half, some holding little statues with human heads, some with the heads of beasts."[37]

As I have been painting a picture of and interpreting the Trevi, it should be fairly obvious that there are many departures from *buon gusto*. I have already observed that pastoralism and good taste are uneasy bedfellows. Here plants, humans, animals (both mythological and not), and architecture become mixed up with one another. Salvi carved a small oak tree out of the travertine, having it cling to and become enmeshed with the base of a grand Corinthian column, just at the feet of Filippo della Valle's *Salubrity* (Fig. 20). A luxuriant weed spills over the dislodged base of the collapsing pilaster on the far right of the façade. The power of laughter, for which the Trevi cries out, is the laughter of folk culture, the pastoral, of masks and performances, of Rabelais, Shakespeare, and Cervantes.

This mixing of forms, species, and genuses – this cutting across taxonomic classifications, in other words – springs as we have seen from a love of the

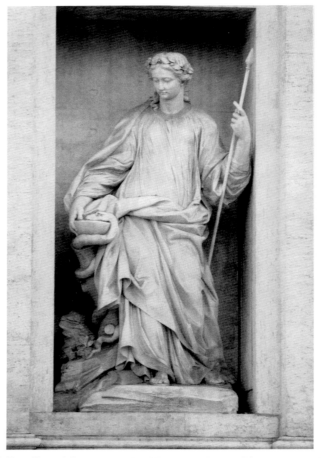

20. Filippo della Valle, *Salubrity*, 1762, Trevi Fountain, Rome. Photo: Vernon Hyde Minor.

grotesque. Strict adherence to good taste probably would prohibit such an address, of course; but the pastoral delighted in the hybridizing of animal and human, the environment of grottoes, the nostalgia for those half-human, half-animal figures found in ancient Roman (and sixteenth-century) frescoes.

Mikhail Bakhtin in his celebration of the grotesque in Rebelais's world – the world of the "flesh" and the "belly" as Victor Hugo dubbed it – sees the grotesque as potentially hostile to classicism and the enlightenment. The grotesque was "[t]o a certain degree . . . a reaction against the elements of classicism which characterized the self-importance of the Enlightenment. It was a reaction against the cold rationalism, against official, formalistic, and logical authoritarianism; it was a rejection of that which is finished and completed, of the didactic and utilitarian spirit of the Enlighteners with their narrow and sacrificial optimism."[38] It was, in short, an abomination to the principles of *buon gusto*. No wonder Bottari could hardly contain himself in his disdain for Salvi's designs.

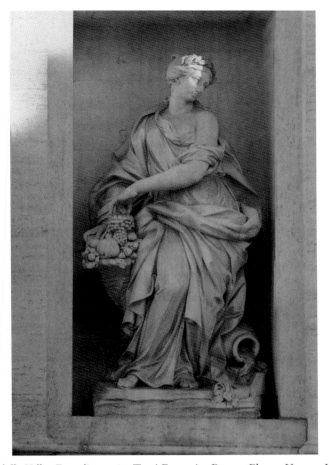

21. Filippo della Valle, *Fecundity*, 1762, Trevi Fountain, Rome. Photo: Vernon Hyde Minor.

Bottari worried about the congeries of rocks in the Trevi, but there are as well narrative aggregations that add up to a miscellanea of voices. We have angels trumpeting the fame of a series of popes, inscriptions on how Clement XII adorned the Aqua Vergine with great care and commended its wealth and healthfulness. Allegorical figures of salubrity and fecundity (Figs. 20 and 21) pose like pageant queens in the great niches on either side of Neptune, who – according to an unkind but not inaccurate characterization by Rudolf Wittkower – looks like a dancing master, while reliefs show the discovery of the source of the Aqua Vergine (Figs. 22 and 23). A remarkable series of masks, as we have seen, spread themselves across the frieze and around the corners of the *scenae frons*. These sham personae suggest shifting identities and personalities, change and reincarnation. They are adversaries of uniformity, promoters of heterogeneous reality, defiers of boundaries, celebrators of mockery, obscurers of the distinction between reality and image, the actual and the represented. For all of Bottari's animadversions,

22. Andrea Bergondi, *Agrippa Supervising the Construction of the Aqua Virgo*, 1760, Trevi Fountain, Rome. Photo: Vernon Hyde Minor.

Crescimbeni (had he lived long enough) probably would have been delighted to invite these personalities into his fabulous text *Arcadia*.

No one proclaimed the importance of *buon gusto* more than the Arcadians; and yet, as I have mentioned, good taste and pastoralism remain somewhat estranged from one another – "uneasy bedfellows" to be sure. The style of good taste, accoding to Muratori, is pure, natural, and unstudied, free of false wit, conceit, immodesty, ingeniousness, ornament, and childishly luxuriant rhetoric.[39] Although Muratori did not wish to eliminate the grander forms of rhetoric, he clearly admired the bare-bones, even taciturn style of Descartes.[40] In the general spirit of *buon gusto*, pastoralism may turn the complex into the simple, as William Empson said. It certainly is not a mode in the baroque manner of conceit and wit.[41] Just the same, the Arcadian-pastoral – whether as poetry, painting, or architecture – departs from the strictures of good taste willfully and often. We have

23. Giovanni Battista Grossi, *Trivia Pointing Out the Source of the Aqua Virgo*, 1760, Trevi Fountain, Rome. Photo: Vernon Hyde Minor.

seen how Bottari threw up his hands at the misalliance between the unruliness of rocks and the refinement of Corinthian pilasters fronting the Palazzo Poli.

What I mean by "text" and "subtext," not just in Arcadian architecture but in the grander avenues of good taste, needs some explanation. By text, I intend something fairly broad, like a cultural production constituted by a system or corpus of signs. I have tried, when discussing *buon gusto* in the early settecento, to locate certain invariants – or, better yet, paradigms – among multitudes of texts. Following Bakhtin's notion of the dialogic, I think of a text as an utterance, one which always leads to a response. So if *buon gusto* is a text, it is the fruit of many dialogues. Text is always "interindividual," always on the borderline between or among idiosyncratic declarations. In that sense, all text is intertext, with subtext as a special variation. David Danow has said that a subtext is "ontologically dependent on an incorporative text."[42] Despite its reliance on its parent text, the

subtext may not be in harmony with it. This is how I see pastoralism, which is a long-lived literary mode or genre of much greater complexity than good taste. It agitates within the text or discourse of *buon gusto*, frequently upending it with a panoply of rhetorical devices, narrative strategies, and subtle critiques.

Pastoralism would never let stand the commonplace that *de gustibus non est disputandum*. The history of taste is, of course, long and multifaceted. By the time we find Hume trying to establish the standards of taste, pastoralism is a thing of the past. Whether Hume ascertained the rules of *buon gusto* is not the issue; the fact that he leaves out the Franco–Italian debate on rhetoric and the Arcadians' love of the sonnet and pastoralism gives evidence to the necessity of getting rid of a troubling and distracting subtext.

FIVE:

A SHORT HISTORY OF THE ACADEMY
OF THE ARCADIANS

"ARCADIA TRIUMPHANS"

The Arcadians were a curious lot.[1] There was no lack of academies in the Roman settecento, and yet this one with its extravagant history and practices seems to have packed more punch, to have dominion over all. Its ties to leading intellectuals were strong, which helped to make Arcadianism a cultural fact of primary importance in the settecento.[2] The air everyone breathed came from a hoped-for past, a past that would deliver Roman art and poetry from the so-called barbarities of the baroque, establish a new cultural institution – one tied to that emerging phenomenon of the "republic of letters" – and launch a new sense of taste. The extreme conceits of baroque art and poetry – especially in the hands of Giovanni Battista Marino – seemed to attract contempt like some powerful magnet drawing toward itself shuddering filings of iron, particles of abuse motivated by obscure forces.

In the middle years of the seventeenth century Queen Christina of Sweden invited Vincenzo Leonino's group of anti-Marino poets into her entourage.[3] There were eleven members nominated in 1674 into her "Royal Academy"; this group, which existed until Christina's death in 1689, was dedicated to *buon gusto* and comprised, among others, Giovanni Francesco Albani (later Pope Clement XI). There also were members of the Curia, archbishops, bishops, the secretary of the Society of Jesus, along with other Jesuits and Franciscans. By 1679, the *custode* of the Vatican Library had joined the group.

The story of the founding of the Accademia degli Arcadi has the shape of a legend and the image of a spiritual landscape. After the death of Queen Christina, those intellectuals in her entourage found themselves without a patron and without an ideology.[4] At least one of them, Giovan Mario Crescimbeni, was in search of a new academy. In 1690, the Abate Crescimbeni and a number of poets (none of whom, however, were from Christina's inner circle), all self-consciously "purist," were searching for a gathering place behind the Castel Sant'Angelo. They came on a grassy area known as the Prati di Castello, and there, to the general satisfaction of the gathered poets, each practiced and improvised his verses. As we read in the early histories of the *Arcadia*, one among them (probably Agostino

Maria Taja, who had once been imprisoned for quietism[5]) thrilled the others with the exclamation: "It seems today as if Arcadia were reviving for us!"[6] And so the Accademia degli Arcadi was born in the shadow of Hadrian's tomb.[7]

The Arcadi documents the sensibility of, among many others, Gian Francesco Albani, Francesco Bianchini, Filippo Buonarotti, Ludovico Segardi, Metastasio (Pietro Armando Domenico Trapassi, 1698–1782), Giovan Mario Crescimbeni, Gianvincenzo Gravina, and Lodovico Antonio Muratori, figures who were as important in eighteenth-century Rome as Marsilio Ficino, Lorenzo de' Medici, Cristofero Landino, and Pico della Mirandola were in fifteenth-century Florence.[8]

As Maria Pia Donato has demonstrated, in her study of the history of Italian academies, by the end of the seventeenth century the lay nobility and professional bourgeois classes in Rome were "struck dumb" and marginalized by the prelature (who had their academies); they needed a place to meet in civil conversation.[9] The Arcadians were among the very first to offer such an opportunity.

By the middle years of the eighteenth century, many artists of note belonged to the Arcadia.[10] The Accademia di San Luca remained the official organization of artists, and one had to be a member to receive commissions from the Sagri Palazzi Apostolici, which was the arm of the Vatican that oversaw the refurbishment and redecoration of Roman churches and papal palaces. The Arcadian Pope Clement XI invited the Accademia degli Arcadi to enlist in the festivities of his annual prize giving to artists held on the Capitoline Hill. Thus were joined the major literary and artistic academies of eighteenth-century Rome.[11] Belonging to the Arcadia taught these artists what the San Luca did not: what one's art should look like, and what it should not look like; what taste is; and, finally, what that has to do with a modern Italian and Roman (as opposed to a baroque or an ancient Greek or Latin) cultural identity.

Although the bibliography on the Accademia degli Arcadi is fairly large, the academy's treatment in English language texts appears in circumscribed terms. Generally, a brief overview is given, with a few remarks made about its putative program. The usual treatment of the Arcadia in books is no more than a dozen pages, in articles, a few paragraphs. The Arcadian Academy surfaces in Italian surveys of literature as a significant but limited organization of poets. Although there was an important exhibition devoted to the Academy of the Arcadians in Rome in 1991, its more general role as a cultural and artistic association that fomented debate on the politics of taste in the early eighteenth century has yet to receive the attention that it deserves.[12] As we have seen, in the catalogue of *Art in Rome*, a watershed exhibition of eighteenth-century Roman art at the Philadelphia and Houston Museums in 2000, there appears an important and detailed discussion of the Arcadians and their role in eighteenh-century Roman art and culture.[13]

I was drawn to an investigation of the Accademia degli Arcadi by way of my studies of Roman sculpture of the eighteenth century. Filippo della Valle, about

whom I have written, held the foremost position in eighteenth-century Roman sculpture, yet he is a virtual nonentity in the "great man" sequence of Italian sculpture.[14] Why? Is it that he simply was neither as innovative nor as good as Michelangelo, Cellini, Bernini, and Algardi? That is not so easily determined – although I would not want to argue for his inclusion in this sort of pantheon either. There is something remarkably unassertive about his style; there is, as I have discussed already, something nigh onto (what I call) semiotic abjuration in his rhetorical strategies. That is not say that his art has no "meaning," it is just that its significance lies elsewhere than in traditional iconology. The passivity of his style, its softness and sense of reclusion, explain (in part at least) his low profile. The discourses of art history have not been markedly interested in his kind of art, or indeed in the Roman art of his period.[15]

I have suspected that there is a missing text, some cultural and political organization, as well as some cultural stance – a kind of cultural poetics – that might flesh out the bare bones of settecento criticism. I believe that the Accademia degli Arcadi is that institution, that "text."[16] In a broader sense, there was a significant movement for reform in Rome in the first half of the eighteenth century. What interests me are the Arcadians' own inscriptions on the visual and tasteful culture of the settecento, on values and meaning. There is an apparent (but perhaps not true) paradox that a polemical organization asserting rationality over authority, soundness of judgment over "capricious" baroque *concettismo*, good taste over bad taste, would take on the masks and the games, the allegories and dissimulations of Arcadian shepherds. But the landscapes of the mind – whether in terms of landscape thematics, cute, plush, and coy rhetorical moves (as with the sculpture of della Valle) or the feints and negotiations of Crescimbeni and the Roman Curia – may lead to some interesting observations about the cultural history, visual culture, and history of taste in eighteenth-century Rome.

On October 5, 1690, the original fourteen members of the Academy of the Arcadians met a second time, now in the garden of the Franciscan *Frati minori* next to the church of San Pietro in Montorio (in an area belonging since the nineteenth century to the Accademia di Spagna di Belle Arti). They drew up their preliminary guidelines and quickly made a list of pastoral names for each member of the group. Gian Mario Crescimbeni became the custode generale d'Arcadia – the chief herdsman. Gian Vincenzo Gravina, the jurist and classical scholar, was also among the original group.[17] They adopted the pan pipes (or syrinx) as their impresa and chose the Bambino Gesù as their protector. They even took up their own calendar, based on Olympiads.

Vernon Lee ungraciously and unjustifiably describes Giovan Mario Crescimbeni as having "all the disadvantages of ugliness, stupidity, pedantry, and poverty."[18] Crescimbeni on the contrary was a clever, even an extraordinary man, one bent on creating and controlling an institution that was to have its tentacles creeping throughout the cultural network of eighteenth-century Rome and the

Italian peninsula. A man of his times, he conceived of the Academy of the Arcadians as similar in structure to the ecclesiastical–monarchical model.

Born in Macerata, in the Marches region of Italy, on October 9, 1663, Crescimbeni was the son of Giovan Filippo Crescimbeni, a professor of jurisprudence at the local university.[19] He received a rigorous and traditional education, being tutored in grammar, religion, rhetoric, as well as Italian and Tuscan eloquence. He took his degree in law in 1679 and moved to Rome, where, instead of a juridical career, he joined the republic of letters in the form of whatever academies were available at that time. He quickly enrolled in the academy of the humorists (Accademia degli Umoristi), of the "braiders" (Accademia degli Intrecciati), and the "infecunds" (Accademia degli Infecondi). All of this, of course, was in anticipation of his own academy, one dedicated as much to cultural politics and a way of life as it was to a particular literary form.

Soon after the founding of the Arcadia in 1690, Crescimbeni (whose pastoral name was Alfesibeo Cario) began the building of colonies. By the end of his life (in 1728), he had added thirty-six satellites, mostly in Italy, to the Roman academy. He approved every new member of every colony. By 1710, there were 1,163 members; by 1728, 2,619. The original rules of the academy restricted the number of shepherds; these, however, Crescimbeni blithely ignored. His ambitions were imperialist and grand. He expected to reform Italian literature by a return to taste, health, and just measure (*gusto, sano, convenevolezza*) and to revive national culture. He stated in *Breve notizia sullo stato antico e moderno dell'adunanza degli Arcadi* (1712) that it was the primary intention of the academy to "cultivate the sciences and to awaken the better part of Italy to good taste in humanistic letters and in particular poetry in the vulgar tongue."[20] He undertook the daunting task of arranging and surveying Italian literature in a series of books on poetry and prose.[21] He wrote several tomes on the Arcadia itself, as well as a fable that serves as a history of the Academy.

This fabulous romance *Arcadia*, which was begun in 1692 and published finally in 1708, is based loosely on the structure of Jacopo Sannazaro's *Arcadia* of 1502.[22] As noted in Chapter 3, Crescimbeni spins a densely allegorical tale of considerable length, detailing the founding of the academy, its early members, and, by implication, something of the social life of Rome in the early eighteenth century. Almost hermetic in its use of language, Crescimbeni's fantastic narrative, written partly in prose and partly in poetry, recounts the wanderings of shepherds and nymphs in and beyond the Bosco Parrasio (although as yet they did not have a permanent home). Revealing already his distrustful nature, he disclosed that he wished to keep his narrative arcane and removed enough so that it would remain inaccessible to those unfriendly with the Arcadians. He remarks that it was not really his intention to publish the history of the Arcadia but to leave it in manuscript form. As he reports, however, his colleagues from outside Italy so desired news of the Arcadia that he finally succumbed to their wishes. He trusted that his readers, through knowledge of his writings, would be able to distinguish

that which was history from that which was fable. Perhaps Crescimbeni already anticipated the coming crisis in the Arcadia, that there were enemies both inside and outside the Parrhasian Grove. With his secretiveness, he could maintain some sense of exclusivity, communicate with his friends, and (he hoped) mislead his enemies.

The first chapter is an account of the founding of the Arcadia.[23] In the second, he describes the habitations of the nymphs, writes of the "bite of the tarantula," and illustrates various medicinal cures. We visit the huts of the nymphs and experience many rarities. In one chapter, the nymphs admire the paintings of Carlo Maratti (Disfilo in the Arcadian nomenclature). Crescimbeni's ekphrasis strikes one as relatively straightforward, but the tone is one almost of a loving caress (see discussion in Chapter 3). There are also wanderings through woods, lessons in physics, and finally a musical party followed by a musical drama.

Among his many guises, one was as historian of Italian literature – and he was in a very real sense among the first historians of Italian literary history. His *L'istoria della volgar poesia* (Rome, 1698) was an attempt to catalogue poetry in the vulgar tongue (Tuscan rather than Latin) from Guittone d'Arezzo (mid–thirteenth century) to his present. A number of critics mirror the comments of Nicolò Tommaseo that this 400-page opus is "without criticism, without novelty, without grace, but with an abundance of facts, of citations: wonderful material!"[24] He neither sings the praises nor recounts the biographical details of the poets; rather, as he wrote, "it is sufficient to . . . present the state of poetry in the vulgar tongue in every century up to our own."[25]

In *La belezza della volgar poesia*, which appeared in two editions (the second somewhat longer), Crescimbeni examined the different genres of poetry, from the lyric to the sonnet, from tragedy and comedy to epic. This he accomplished in a series of eight (nine in the second edition) dialogues, each of which considered a particular poem. He concentrated on formal elements, ignoring to a large extent the narrative component, and favored Italian over Latin and Greek examples. As a result of his literary production, he was admitted to three of Florence's great academies, *La Fiorentina, la Crusca*, and *gli Apatisti*.

In addition to his writings on literary history, the lives of the Arcadians, the history of the Accademia degli Arcadi, books of his own poetry and prose, he wrote fully detailed histories of three Roman churches, Santa Maria in Cosmedin, San Giovanni a Porta Latina, and Sant'Anastasia. These last are known for their seriousness, rigor, and – in an archeological sense – authenticity. In 1709, he became a canon of Santa Maria in Cosmedin, rising to archpriest (or dean) in 1719. Just before he died on 8 March 1728, he asked to be admitted to the Society of Jesus. The vote was close, but he was received.

M. G. Morei, the *custode generale* in the middle years of the eighteenth century, wrote in his history of the Arcadians that Crescimbeni composed the statement of purpose. It reads in part: "We Arcadian Shepherds assembled in the midst of the Parrhasian Grove, which we have elected as our eternal meeting

ground, wishing to maintain the peace among ourselves, declare this our Arcadian domain, where all of our possessions are to be shared one with the other."[26]

Although the Arcadian "domain" was in Rome, the Accademia degli Arcadi existed throughout the peninsula. Soon after its founding, the Academy spread to the Kingdom of Naples, the Grand Duchy of Tuscany, other papal states, and eventually throughout Italy. As we have seen, thirty-six colonies were founded between 1690 and 1728. Of the approximately 2,600 members accounted for in this early period of the *Arcadia*, about seventy-four were women. Those who wrote for the *Rime degli Arcadi* (eight volumes) and the *Prose degli Arcadi* (thirty-two volumes) were mostly of the clergy.

Amadeo Quondom has used the archives at the Biblioteca Angelica in Rome to study the early enrollments in the *Arcadia*.[27] The membership of the *Arcadia* consisted mostly (about 46 percent between 1690 and 1728) of members of the "Terzo Stato" – those who were neither nobility nor clergy. Although the majority of the members of the third estate had no title, there were those who did: 212 *dottori* (this term refers not to medical doctors, but to those with a fairly high level of education), 72 *avvocati* (lawyers), 55 *cavalieri* (nobility), 15 *burocrati*, 7 *senatori*, 4 *professori*, 4 *pittori*, 3 *architetti*, and 2 *musicisti*. Next in numbers (33 percent), but probably more potent in influence, were members of the church hierarchy: cardinals, bishops, monsignors, Vatican bureaucrats, members of religious orders, canons, and *abate*. An *abate*, who may have been the fundamental intellectual figure of the Italian eighteenth century, was anyone receiving an ecclesiastical benefice, even if he belonged only to a minor order.[28] Among the foreigners in the *Arcadia*, nobility and clergy formed the largest part. Just a listing of the membership and size gives some indication of the importance of the academy.

The heavy involvement of the clergy (and high-ranking ones at that) bears evidence to the place of the Roman Congregations, the tribunals, and the offices of Curia in the Accademia degli Arcadi. As the judicial body that took its shape from the reforms of the Counter, Reformation and Sixtus V, the Curia assisted the pope as the "absolute" or primatial ruler of the Church. In a sense, the Curia had been for several centuries the cultural arm of the papacy, but in fact its obvious and primary role moved in other than cultural directions. What was needed in Rome was an academy that united many of the other academies already existing, one that was to promote taste and culture. In other words, Rome (and the Curia) was ripe for that new phenomenon, the *Respublica Letteraria* or republic of letters.

Indeed, the tradition of the "parrhesian" conversation – frank, friendly, collegial – so important to the republic of letters, failed to prevent (perhaps even gave rise to) the first of the academic disputes in the young academy.[29] As Michel Foucault has demonstrated time and again in his analyses, every discourse – every form of writing, reading, and exchanging – has expressed or implied limits.

We recall as well that there were such publications as the *Arcadia* by Crescimbeni that purported to be secret and inaccessible, but which was published by

Antonio de Rossi, the Arcadians' "in-house" press. Crescimbeni offers *postille* throughout, which are not marginal glosses but footnotes, identifying each of the characters in his allegory. The allegory itself is not particularly complicated because he follows the general outline and format of Jacopo Sannazaro's *Arcadia*.

Free speech was encouraged unless that speech interfered with Crescimbeni's own program for the academy. The Arcadian Academy's original rules, known as the *Leges Arcadum*, were ten in number, with two sanctions, all translated into archaic Latin by one of the original members and a classical scholar of considerable reputation, Gian Vincenzo Gravina. They were dedicated to Pope Innocent XII in 1696. Then the trouble began.

THE SCHISM OF 1711

In his inaugural lecture to the Arcadia, Gravina (Opico Erimanteo) asserted that not only had he translated the laws, he had indeed written them (he probably did). His gesture of translation became one (or so he was accused) of appropriation. With the backing of the Collegio of the academy, Crescimbeni, doubtless furious (for he professed to have written them), demanded that Gravina retract that statement before the inaugural addresses would be published.[30] Gravina seemed to agree, but when the publication appeared, his speech remained as had been. This dispute between Crescimbeni and Gravina was the worm at the center of the apple, a quarrel in this new academy dedicated to the *aurea mediocritas* that was to lead to the schism of 1711.

After years of squabbling, the dust settled and the Arcadia split. Gravina left with about seventy others (mostly "young Turks," some of the cleverest of the academicians), hoping to found a rival academy, which he succeeded in doing, but only for a short time. His Arcadia Nuova lasted a scant three years, first under the protection of Livio Odescalchi and, after his death, that of Lorenzo Corsini (the future Clement XII). Corsini mediated between the two academies, and the schismatics signed a document in 1714 that ended the hostilities. The Arcadia Nuova became the Accademia dei Quirini, and afterward had less of a presence in the republic of letters than did the Arcadians, although it continued to be supported by the Corsinis.

There was a growing sense throughout the eighteenth century that the Arcadians had lost their intellectual integrity, in part at least because of the exodus of the Graviniani. In 1767, Charles Duclos wrote about Rome in general that it was "greatly in need of regeneration. Literature, the sciences and arts, with the exception of music, are languishing. . . . The Arcadian Academy, with its deluge of sonnets, is a mere parody of true learned societies."[31]

The dispute certainly turned on more issues than a debate over the rightful authorship of the original rules. Although the members of the academy were of that species known as *amici della domenica* – men who felt that their association

with one another was largely occasional (as if they only met on Sundays) and friendly, free of rivalry and antagonism – battles of will inevitably arose.

Crescimbeni, a supporter of *buon gusto* and *chiarezza*, was, in his dispute with Gravina, up against a man of some substantial intellectual power. Gravina, born in 1664 in Roggiano (a small town near Cosenza in Calabria), came from a distinguished family.[32] His maternal uncle Gregorio Caloprese, one of the foremost intellectuals of his day, saw to his early education as a poet and philosopher. Believing that literature was the foundation of all knowledge, Caloprese taught his disciple the classics. But in the interest of developing a well-rounded individual, Caloprese also insisted that the young Gian Vincenzo know philosophy, science, even medicine (attacking the presuppositions of Galen), and moral theology. He instructed his pupil also to take exercise in the evening, either swimming, running, or, if the weather were bad, calisthenics. He then sent him on to Naples, where he studied civil and canon law. He arrived in Rome just at the founding of the Accademia degli Arcadi.

It is worth pausing here for a brief review of Gravina's philosophical position, for it tells us much about the intellectual and theological ferment of this period of spiritual (and political) crisis. Throughout the middle years of the seventeenth century, ascetic and severe religious practices were garnering attention throughout Europe, but especially in Italy. The Spanish priest Miguel de Molinos (1628–96) had advocated in his small book the *Spiritual Guide* that one's most intensely religious experiences come from an emptying of personal will and a consequent filling of the spirit by God. His quietism caused significant vexation among the Jesuits in particular, because of its dependence on a personal and intimate connection between human and God that was in no way subservient to the priesthood, religious orders, or the Church. He eventually was tried, condemned, and imprisoned (as much for his apparent licentiousness as his purported doctrine). In France, Blaise Pascal (1623–62), a youthful prodigy in mathematics, experienced a religious conversion (and later on, a "night of fire") that brought him to the community around Port-Royal and Jansenist theology. Sympathetic to Jansenism and in defense of Antoine Arnauld, who was being tried for his Jansenist proposals by the faculty of theology at the University of Paris, Pascal drafted and published (as we have seen in Chapter 1) *Les Provinciales*, a hugely popular tract, written in an acerbic, lucid, and tightly drawn prose. His attack on Jesuit laxity of morals landed some telling blows. Innocent XI condemned as heretical a number of propositions that were closely associated with the Jesuits (and denounced by the Jansenists).

Gravina's *Hydra mystica*, one of his first pieces of sustained writing, was a Latin text in dialogue form between allegorical representatives of Heresy and Casuistry. The actual Hydra-headed monster was probabalism, the very foundation, according to Pascal and Gravina, of the Society of Jesus. The dialogue fulminated against certain kinds of philosophical thinking that sought to develop a new religion, leave behind Christianity, or bask in obscuritanism, seeking to

confound rather than to explain. In short, Gravina's target was Jesuit teaching, practice, and custom.

Gravina was attuned to the intellectual currents of his times (and especially *Les Provinciales*) and the needs of the Counter-Reformation Church to reform its own indecisive stand on grace and sin.[33] Indeed, Alexander VIII had condemned casuistry, *il peccato filosofico* (the philosophical sin), on 24 October 1690. By the time Gravina skewered the Jesuits, they already had been weakened somewhat on matters of faith. Gravina was not so much an anti-Jesuit agitator as he was one who called for reform in moral and daily life.

Consistent with that sense of reformation were Gravina's philosophical positions on received opinion (outside of Scriptures) or dogma. Like others in the philosophical revolution in Naples in the second half of the seventeenth century, Gravina was anti-Curial, anti-Scholastic, anti-Aristotelian (or at least a revisionist on the Greek philosopher), and virulently antibaroque. As a sign of his accomplishments (and recommendations from Francesco Pignatelli (later Cardinal), the pope's nephew, in Naples), on Gravina's arrival in Rome, Innocent XII appointed him to the chair of civil law at La Sapienza in 1699, and in 1703 he was awarded that of canon law. In his protected position within the Curia (where his anti-Curial attitudes certainly increased), he reported back to his patron Pignatelli in Naples on the political intrigues at court.[34]

Crescimbeni's strength, on the other hand, lay in his institutional position and his maddening way (or so at least it must have struck Gravina) of refusing to understand the deeper consequences of his rival's position. Despite their urbanity and much touted self-awareness, those Arcadians who divided themselves between the *crescimbeniani* and *graviniani* (as the camps came to be known) argued at cross-purposes with one another. As they contended for leadership in an institution that promised to – and in fact already did – provide a secure vantage point from which to determine and control social and cultural practices, as well as religious ideologies in Rome, the need for rational forms of argumentation gave way to jockeying for position. Rarely if ever had there been such an opportunity for an organization existing outside of the Vatican, religious communities, or universities to seize so much power, to become a dominant institution. The stakes were high.

Gravina, stung by the reaction of the Collegio of the Academy of the Arcadians, wrote several defenses of himself. He published a "letter to a friend"[35] in which he tried to explain in the most reasonable of terms why he had to disagree with Crescimbeni and, along with many of his disciples, leave the Academy of the Arcadians. There is bound into Manoscritto 19 in the Arcadian archives (Biblioteca Angelica, Rome) a published version of *Della division d'Arcadia: Lettera ad un'amico* (Naples, 1711); immediately following is a seventeen-page manuscript in which Crescimbeni copied out Gravina's text in the right column and placed his *postille* or marginal notes on the left. He breaks up Gravina's text every few sentences, allowing his own annotation to overrun Gravina's space. Not only was Crescimbeni reproachful in his vociferous denials and denunciations, he enacted

a kind of chirographic aggression against Gravina. Their debate seems to have known no bounds, with the dispute being carried on both silently and clamorously. In addition, there were satires sponsored by the rival camps.[36]

Gravina, in his letter "to a friend" (Scipione Maffei), introduced his topic in a somewhat oblique fashion by bringing up the need for classical theatre in Rome (he had earlier expressed great disdain for baroque spectacle in the popular theatre). This would be a theatre, he hoped, that not only staged the classics of Greek and Roman drama, but that also functioned as a school for teaching young people eloquence and moral virtue. It appears that Gravina wished right from the start to ground his arguments in "classicism," a concept of culture and philosophy that was emerging in European discourses on literature, history, art, value, and moral judgment. Among other intellectuals of his generation, he shuddered at the way in which contemporary culture had declined from ancient ideals. He found the theatre in Rome at the turning of the eighteenth century to be benighted, corrupt, and trivial. In Crescimbeni's counterattack, he addressed Gravina's concern for new theatres but did so in a superficial way, niggling over details without taking the suggestion to task. He did comment that theatrical presentations could have a salutary effect on the populace of Rome, teaching them about the consequences of bad habits and sinful behavior. But apparently he could not see where Gravina was going with his arguments.

The sober-sided Gravina simply would not abide what he saw as the frivolousness of the Arcadians. He complained bitterly about the *sonnetini* and the *cicalate pastorali* – the little "sonneteers" and yammering, endlessly chattering shepherds.[37] In his austere judgment, lyrical poetry had its beginning and end in Petrarch. Crescimbeni blustered in response that if anyone doubted either the full range of Arcadian poetry – its treatment of themes beyond those of love poetry (what he referred to as philosophical, ethical, and historical poetry) – then one should simply come to the *serbatoio* or depository of Arcadian sonnets and judge for himself (perhaps a dangerous invitation).[38] Crescimbeni was also quick to point out that Gravina had written love poetry. Gravina, certainly no enemy of poetry in all of its genres, nonetheless felt that the Arcadian Academy should choose literary classicism, preferably in the tragic and epic vein, as a way of going beyond three centuries of Petrarchism. For all of his animadversions and pronouncements on what makes poetry good, Gravina's own versifying was not well received. Even two centuries later, the Italian national poet Giosue Carducci accused Gravina of being the most disgraceful of Italian poetasters.[39]

Gravina's hostility to the baroque caused him to judge ever more severely Arcadian poetry; for, despite the Arcadians' ostensible *antimarinismo*, Gravina saw their academy leading merely to a *barocchetto*, or "little baroque." Gravina's dry and resentful tone – in short, his scorn – masks some of his own ideological concerns over the baroque style and more precisely the Jesuits and their probabalism. At some unconscious level, perhaps, Gravina sensed that Crescimbeni and Arcadian poetry were soft on casuistry.[40]

Calling on his own background as the chair in both civil and canon law at La Sapienza in Rome, Gravina made a number of juridical observations. He protested that the rules of the Accademia had been thrown over willy-nilly. For one thing, no single member was to be given continuous service on the executive board of the academy, known as il Savio Collegio, until others in the membership who were fit and desired to serve had also been given the opportunity. The rules of the academy stated that every year, six of the twelve members of the Collegio were to be replaced. In 1711, one of the new members had already served a two-year term on the board, although there were others who had yet to be enlisted. Gravina remonstrated with the entire membership of the academy, but to no avail. Further, the original rules also called for a restriction on the number of members and that the members be *letterati*; as things turned out, however, Crescimbeni had flung open the gates and admitted anyone willing to pay a *piastra*, so that now (according to Gravina) the *letterati* were in the minority.[41] Gravina averred that law is the very soul of civil society, and without it the people become a simple herd, a disordered throng.[42] Of course, he was trying to smash a flea with a big stick when he argued against Crescimbeni's manipulation of Arcadian policies and procedures. Nontheless, Gravina went on in what we can only imagine were stentorian tones to argue that just as every society differs, so, too, do their laws; indeed, a society is identified and given its very character by its laws. As evidence that Gravina's comments on civil law carried significant weight in the eighteenth century, one can point to Montesquieu, who in his *Esprit des lois* affirmed Gravina's importance.[43]

Gravina was also interested in the social and republican implications of taste and poetry. In part because he conceived of the poet as a jurist of sorts, Gravina wanted the morality of poetry and art to be firmly based in certain legal, theoretical, and republican ideologies. Dino Carpanetto and Giuseppe Ricuperati write that Gravina "saw in the jurist not only the ideal legislator of ancient times and the founder of civil society but also the only rational curb on the abuse of absolute power and the interpreter of a need for democracy and liberty which underlay the foundation of states."[44] Gravina wrote in his *Opere* that "The poet [and when he mentions the "poet" we can understand that, within the limits of public discourse in early-eighteenth-century Rome, that all humanists – including artists – were addressed] should have that regard for people that the prince has, and whereas the prince should not place all his faith in the affection and inclination of the people – for popular opinion changes with the wind – yet he should not hope to reign securely without it: "thus the poet should not hope to sit comfortably on the throne of glory neither only with the help of the people, nor without the people."[45] Gravina also saw the poet as scientist-philosopher when he gave his definition of poetry as a "science of both human and divine things, converted into a fantastic and harmonious image."[46] Beyond that, the poet is magician, as we know from Gravina's description of Homer as the "most powerful magician and most wise enchanter" (because he could turn poetic language to the effects of

naturalism).[47] One can indeed mine the writings of Gravina to find any number of statements that seem ambiguous or even paradoxical within the context of his self-proclaimed Cartesianism. On the whole, however, he remained fairly systematic and consistent in his call for an art grounded in verisimilitude, morality, normalcy, naturalism, rationality, and didacticism. These characterizations I use are, of course, not absolute values in and of themselves, but rather constitute a strategic position by Gravina in the cultural, literary, and artistic polemics of the early settecento, especially as they helped to define the terms of contention within the Arcadia itself. He wanted to sustain a memory and exalt a myth of an unchanging set of values that had been discovered and brought to perfection in the Greco–Roman tradition. Despite his interest in science and progress in society, Gravina also was attracted by the myth of an enduring, pastoral past.

The Arcadians' preoccupation with poetic as opposed to civic values disappointed Gravina, for whom civic virtue was necessary to national and cultural identity. Private virtue, with its emphasis on the capricious and the individual smacked too much of *secentismo* and the "dangers" of the baroque. Although the Arcadians were no friends of the baroque or of the *concettismo* and *meraviglia* of the archetypal baroque poet Giovanni Battista Marino, their obsession with idylls, eclogues, and the pastoral experience kept them (or so their detractors would argue) insulated and isolated from some of the larger issues of taste in the eighteenth century. Indeed, when Gravina gave the idyll brief attention in his *Ragion poetica*, he saw that it attended to tastes and feelings, reflected human virtues and vices, and held up a mirror to our most private moments. But it could not hold a candle to epic and drama.[48]

SIX:

THE PARRHASIAN GROVE

Today there is something forlorn about the Bosco Parrasio, the Arcadians' old garden on the slopes of Rome's Janiculum Hill.[1] It is overgrown and only indifferently tended. One hardly notices it, just up the street from the church of the *Sette Dolori*. More than a century ago, the British writer Vernon Lee (Violet Paget) also kept passing it by. She clambered up and down the Via Garibaldi, in search of this "Italian Parnassus," discovering, even within yards of its gates – which for some reason she failed to see – that "no one had ever heard of such a place as the Bosco Parrasio, nor of such beings as the Arcadians." She finally came on a priest and asked him what he knew. "The priest, as jolly, slovenly, and demonstrative a one as could be found, turned with alacrity towards us – 'The Bosco Parrasio? This is it.'"[2] He also was an Arcadian, so invited her in to look around.

Her visit left her "with the most dismal impressions of the Bosco Parrasio – of muddy paths, dripping bushes, flower-beds filled with decaying ilex-leaves, lichen-covered benches, crumbling plaster, and mouldering portraits – grim specters looking down on the final ruin of Arcadia."[3] But in its heyday, during the early decades of the eighteenth century, carriages arrived at its gates to let down cardinals and bishops, lords and ladies, high Vatican officials – even the occasional pope – priests, and jurists of canon and civil law. Artists and poets probably arrived on foot, but they came nonetheless. Here members of the Accademia degli Arcadi on special occasions witnessed or participated in "Olympic games," listened to or recited lyric poetry, strolled about in what a contemporary described as an "insensible" fashion. One laughed, gossiped, played at living in Arcadia, and shared in the Italian version of the Respublica Letteraria.

From its beginnings, the Academy of Arcadians transfigured the landscape so that its shepherds could "live" in Arcadia. They understood that to make one place another, to make a plot of ground in settecento Rome into an area of ancient Greece or a spiritual landscape, a site and spectacle created and described by Theocritus, Ovid, and Sannazaro, they would have to make a garden, one whose pleasures matched the attitudes and manners of the pastoral, from innocence and

simplicity, to passivity, serenity, quietude, and repose. The spontaneous association of ideas that is prompted by a garden setting allowed the Arcadian shepherds to declare their garden as "our Arcadian domain."[4]

The Arcadian – named Laufilo Terio – Giovanni Battista Vico – asserted that poetic language creates knowledge with its corollaries, primary among them being the metaphor, which "confers sense and emotion on insensate objects."[5] The world in which the Roman Arcadians chose to live at the turn of the eighteenth century was teeming with metaphor and figuration (if not, perhaps, of the despised "conceited" stripe), rife with pastoral conventions. As we have already seen, Paul Alpers calls attention to the fact that the common perception of convention (and especially pastoral convention) is that voiced by Samuel Johnson in his distaste for Milton's *Lycidas;* Johnson observed that the pastoral mode is "easy, vulgar, and therefore disgusting; whatever images it can supply are long ago exhausted, and its inherent improbability always forces dissatisfaction on the mind." Of *Lycidas*, he commented specifically that "there is no nature, for there is no truth; there is no art, for there is nothing new."[6] But one can see the notion of conventionality in a different light, as Alpers argues, by referring back to the Latin root of the word: *convenire* – coming together. The opening of Theocritus's *Idylls* describes the coming together of shepherds to hear the lament before Daphnis's tomb. The pastoral is not just elegiac, of course: it is about fellow feeling and companionship in the face of life's trials and sufferings.[7] As such, it is far from the individual and heroic traditions established by the tragic and the epic. The conventionality of the garden emphasizes as well its mythic quality. This Parrhasian Grove embodies a process of returning to certain stories and conventions basic to the history of Western literature and art; at the same time, the employment of pastoral conventions and topographies (in the form of a garden) results both unconsciously and cunningly in the establishment by the Arcadians of a set of discursive practices with an accompanying mentality that reveal the sensibilities of a time and a place qualified by a socially constructed group with intellectual, cultural, and political objectives. The Parrhasian Grove possessed and made use of a complex stratigraphy of rhetorical devices. I intend to unpack and dig up (the mixing of metaphors is both intentional and pointed) as many of these devices and strategies as I can.[8]

The Bosco Parrasio, wherever its location, was "immutable" in its role as a gathering place for songs and recitation; on important occasions, the Arcadian shepherds performed games during their "Olympiads" (their calendar, carefully coordinated with the Julian calendar, was arranged in Olympiads; considering the fact that in the ninth year of their existence the Arcadians had already celebrated 620 Olympiads, they must have occurred with astonishing frequency).[9] These "Olympic Games" were not just for physical exercise, as the first *custode generale* Giovan Mario Crescimbeni explained, but constituted mental workouts as well. Shepherds would take turns proceeding through five poetic games (*Giuochi Poetici*), commencing with a brief discourse on or demonstration of logic,

followed by recitations of eclogues, songs, sonnets, and madrigals or epigrams.[10] There also were Olympic games in memory of deceased Arcadians. Crescimbeni described one such event that took place in July 1705 at the garden of Prince D. Vincenzo Giustiniani (this was before the construction of the present Bosco Parrasio) in memory of the deceased. There was a lovely but ephemeral theater in the form of a rotonda made with intertwined benches covered by green tapestries. These seats were surrounded by wooden pyramids enclosed in vegetation, erected to the height of twenty *palmi* (five meters), within which were plaques commemorating *gli uomini illustri defunti* (the dead worthies).[11] Special publications in honor of the Oympiads contain detailed descriptions of the ceremonies.[12]

The Bosco Parrasio was not in its early years any single place. The academicians met first of all in 1690 at San Pietro in Montorio, then at a series of locations – the villa of the duca di Paganica at San Pietro in Vincoli, the villa of the Princes Mattei Orsini on the Esquiline, then in 1691 back to the gardens of the Palazzo Riario alla Lungara (Queen Christina's home). Also they were hosted by Ranuccio II Farnese in the Orti Farnesiani on the Palatine, precisely in that place, according to ancient tradition, chosen by Evender, king of Arcadia, for his own home. They built a little theater there. Afterward, the Arcadians moved to the garden of the Palazzo Salviati, where Duke Antonio Maria Salviati had constructed an oval theater. After his death in 1704, they removed to the Villa Giustiniani on the Flaminia, with again a richly decorated (but, as we have seen, temporary) theater constructed for their purposes. In 1707, they went to a garden on the Esquiline owned by Prince Francesco Maria Ruspoli. Next, in 1712, they were on the Aventine, in the gardens of Cardinal Ginnasi. It was not until 1721 that John (Jão) V, king of Portugal, provided them the funds to build their temple and their theater.[13] Not only did the Arcadians in their early years have entrance to some of the choicest gardens in Rome, the chief herdsman Crescimbeni was able to assemble an impressive circle of patrons.

The current garden was erected in 1725–6 and became both the site of the Accademia's cultural production and a place where rituals associated with the pastoral and the discourses on good taste could be played out. It was conceived as a literary landscape, a topos for the traditions of pastoralism and Arcadianism.[14] Before returning to a discussion of the ways in which the Bosco Parrasio figures in the engendering of good taste and a pastoral hermeneutics, I want to document the building of the garden and provide an outline of its iconography.

The Bosco (or wood)was opened each year on the first of May by the chief herdsman and closed on the seventh of October. There were six regular meetings during the season in which shepherds could read aloud their own verses, or – if a shepherdess, cardinal, or noble – have them read by others.[15] There were also numerous other, "extraordinary" meetings in the palaces of the nobility and the ecclesiastical hierarchy throughout the winter months.

THE BOSCO PARRASIO IN CANEVARI'S PLANS

With funds from the king of Portugal in hand, Antonio Canevari (whose Arcadian name was Elbasco Agroterico) along with his assistant, Nicola Salvi, undertook the responsibility for building the last home of the Accademia degli Arcadi, laying the cornerstone on 9 October 1725, just after the close of the pastoral season. The inscription on the cornerstone was *DEO NATO SACRUM*, referring to the infant Jesus and *Natale*, or Christmas.[16]

Canevari's career was by no means brilliant (Francesco Milizia referred to him as "il povero Canevari"), yet he was employed on some important commissions throughout his considerable span of life (1681–1764).[17] In 1703, still in his early twenties, he had won the Academy of St. Luke's *concorso* with a design for an unexecuted papal residence (he was not to join the Academy of St. Luke until 1724). He submitted designs for the Sacristy of St. Peter's and the façade of San Giovanni in Laterano, but without success. With Cardinal Paolucci's assistance, he was hired for renovations at the church of SS. Giovanni e Paolo on the Celian Hill, and he also made significant contributions to the façade of the church of Ss. Stimmate di S. Francesco in 1721. After his completion of the *Bosco Parrasio*, he left Rome for Portugal, where he soon became an architect in the service of John V, building the Royal Palace (which was destroyed by the great Lisbon earthquake of 1755), and contributing to the Basilica in Mafra. Caneveri was the chief architect for King John's most important public work, the building of Lisbon's aqueduct, the *Aguas Livres*, but was dismissed because of his incorrect calculations for grading the conduit (the water ran backward). Milizia reports that Canevari returned to Italy with "his tail between his legs."[18] His next stop was Naples, where in 1737 he collaborated with the architect G. A. Medrano on the construction of the Capodimonte palace for the Bourbons; there was, however, a dispute between the two architects. Madrone got hold of Canevari's model, passed it off as his own, and received the final commission, squeezing out his hapless rival. Despite his failure to convince Charles III of Naples of his authorship of the plans and model, Canevari was able to secure the commission for Charles's summer palace in Portici (1742–59). Canevari died in Naples in his eighty-fourth year.

In a general sense, Canevari based his plans for the Bosco Parrasio on the chief herdsman Crescimbeni's requirements and sketch (Fig. 24).[19] Although no artist, Crescimbeni nonetheless had fairly clear ideas about the layout of the Arcadian garden, which was to be an extended metaphor for the Academy of Arcadians and those topics of central importance to his own position of leadership and power. The garden was to incorporate most of the *topoi* of the pastoral in its simplicity, as pleasance, and place of otium; it also would convey his own position as chief herdsman as well as the situation and idea of the Accademia degli Arcadi in Rome.

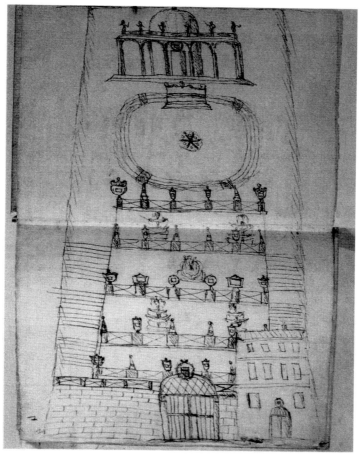

24. Giovan Mario Crescimbeni, *Plan for an Arcadian Garden*, 1725, Biblioteca Angelica, Rome. Photo: Mario Setter, Biblioteca Angelica.

Crescimbeni's sketch shows a large, gated entranceway, with terraces ascending the hill; within each promenade or lawn were either one or two fountains. A series of obelisks (in reference to deceased Arcadians) and other *imprese* were lined up to delimit the spaces and to force one to either side, where straight staircases allowed access to the next highest section. An amphitheater (vaguely reminiscent of Bramante's Tempietto just up the hill from the Bosco) stood at the top, with a podium in the very center. Surmounting the entire complex was a loggia of five bays that screened a small rotunda. In its general outlines, Canevari's plans do follow Crescimbeni's drawing.

The earliest description of the garden is that found in Vittorio Giovardi's *Descrizione dell' nuovo teatro degli Arcadi*, which, because the garden remained unfinished at publication (1727), relied on Canevari's plans.[20] I follow Giovardi's

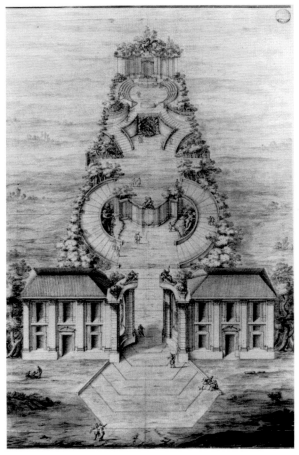

25. Antonio Canevari, *Project for the Bosco Parrasio*, 1725, drawing, Accademia di San Luca, Rome. Photo: Accademia di San Luca.

description, but we must keep in mind that certain economies were necessary in the final execution.

According to the original plan (Fig. 25), one entered the garden by a polygonal staircase lying directly before the grand entrance gate. To either side, two-story edifices were to rise, each three bays wide, united in their elevation by pilasters surmounted by capitals in the form of the lyre. Here one would be able to step in out of the rain. Reclining on the entablatures that frame the entrance gate were plans for four statues, with Pan and Syrinx to one side, Pallas and Mercury on the other. As Giovardi informs us, these were part of the iconography or allegory of the garden and alluded to the Arcadians – with Pan and the nymph Syrinx – and the *letterati* – with Pallas (Athena?) and Mercury. On entering one encounters two curved staircases to right and left, forming an ellipse; these are bounded by laurel,

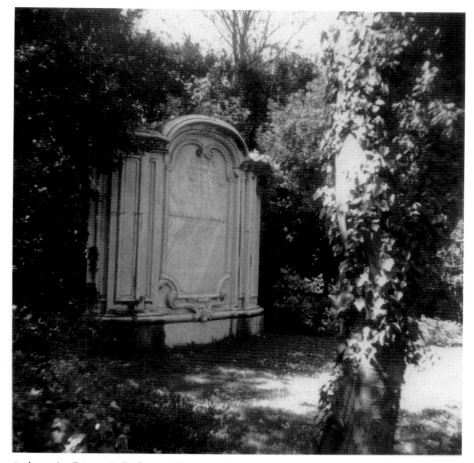

26. Antonio Canevari, *Dedicatory Plaque, with Inscription to John V of Portugal*. Photo: Georgina Masson, Fototeca, American Academy in Rome.

which is essential to the Parhassian Grove and which was used to crown poets. There is a tablet centered between the entrances to the staircases that bears an inscription to King John V of Portugal, celebrating his generosity to the Arcadians (Fig. 26). A statue of the young Apollo, perched atop the tablet, points with one hand to the inscription, while holding in the other a crown of laurel. Nestled within the curves of the bottom ramps are two fountains with river gods, one representing the Tiber and the other the Arno.

The first landing of the garden's staircase offers a spacious area for strolling among the vegetation, which, according to an early account by an Arcadian who carried out a survey of the property, was made up of fruit and nut trees, scrub, and vines.[21] Giovardi describes as well the thick growth of laurel, and the grassy alleyways that lead to plaques (*Lapide di Memoria*) of the Arcadian *defunti*, and in the back a grotto with a statue of Alpheus.

27. Antonio Canevari, *Stairway*, Bosco Parrasio, Rome. Photo: Vernon Hyde Minor.

The next set of steps (Fig. 27), arranged on opposite sides of the grotto, curves away, and then at a sharp angle arches backward and inward, continuing the ascent to the next level. On this *platea*, just above the grotto, one could turn and take in the greater part of Rome, and even the closer precincts of the Campagna. If one wished to hear the recitations of the Arcadian shepherds, he or she could remain on this landing or enter, from two small openings, into the rounded theater (Fig. 28). The usual manner of listening to Arcadian performances was to find a spot on the ground or on a bench, stretching oneself out so as to achieve the appropriate appearance of languor and comfort. This pastoral seating had a certain random quality to it (*"sedendo . . . come è costume degli Arcadi, sparsi e alla rinfusa fra gli uditori"* – sitting, as is the Arcadian custom, scattered in an irregular manner among the listeners[22]).

Crescimbeni instructed that the seating in the oval theater not rise so high as to block fresh air from circulating freely among the shepherds, carrying scents of herbs and grasses. Just in front of the architectural backdrop to the theater and to the entire garden, Carnevari arranged a long bench with a backrest, appropriate for the "eminent" cardinals in attendance.

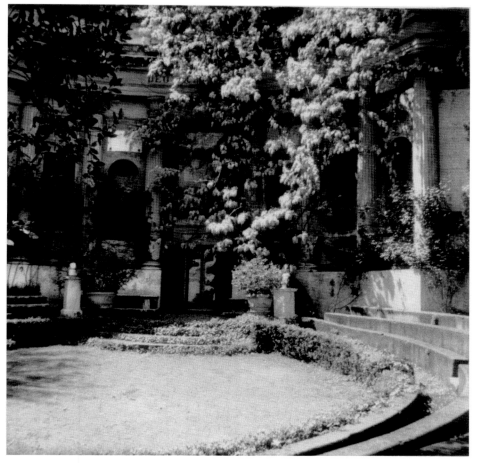

28. Antonio Canevari, *Skene and Paraskenia*, Theater, Bosco Parrasio. Photo: Georgina Masson, Fototeca, American Academy in Rome.

Behind this bench rises the *skene* in the form of an exedra, with its noble proportions, freestanding columns, and plaques that carry the ten laws of the academy.[23] Careering above the architectural backdrop of the Bosco Parrasio was the flying horse Pegasus.

Except for the stage area, which has two unevenly shaped rooms (one of which was known as the *serbatoio*), and the entrance gate as originally planned, the home of the Arcadians was out of doors. This *serbatoio* (literally, a reservoir or archive) contained, among other things, portraits of the members, the numerous publications of the academy (especially of poetry), and, along with the other room, provided another place into which the shepherds could withdraw when it rained.[24]

The Bosco as it stands today differs in many ways from Canevari's and Crescimbeni's intentions. Even in its original construction, the two pavilions at

the bottom of the hill had to be abandoned because of cost overruns. Virtually none of the sculpture survives (and we cannot be sure how much – if any – of it was executed); the plaques honoring the deceased Arcadians are now to be found embedded in a wall like a *paraskenia* adjacent to the architectural backdrop to the theater (Fig. 28); and generations of trees and shrubs have grown to substantial height, obscuring all views of the city of Rome. A wall separates the garden from the adjoining Orto Botanico behind the Corsini palace. In the early nineteenth century, a house was added at the top of the garden, behind the façade of the *skene*, and remains occupied as a private residence today (Fig. 29).

DIPLOMACY

The land falling between the gardens of the Riario Palace (which became the Corsini Palace in 1736) and an area belonging since the nineteenth century to the Accademia di Spagna di Belle Arti (the location of San Pietro in Montorio and Bramante's Tempietto) was paid for with funds from John V of Portugal, who hoped to win the favor of Pope Innocent XIII (who had been an Arcadian from 1719 with the name Aretalgo Argireo) through this act of generosity.[25] The Arcadians, shrewd in their forethought, had elected by acclamation the king of Portugal as an honorary member ("accademico d'onore") of the Arcadians. His response was swift and gracious. On 29 February 1722, his letter accepting membership (he assumed the seat previously occupied by Clement XI) was read to the Arcadians during one of their winter sessions. The king rejoiced that it gave him pleasure to take under his protection such an esteemed and celebrated academy, one famous throughout Europe.[26] A year and a half later (24 September 1723) Crescimbeni announced to the assembly that John had bestowed on the Arcadians the (somewhat less than princely) sum of 4,000 scudi.

Earlier in the century, during the reign of John's father Pedro (1683–1707), and continuing with his reign, the Portuguese crown had a difficult history with the papacy. Under the good offices of John Methuen, a commercial treaty was signed with England. On the death of Pedro, John V married the archduchess Marianna, sister of the archduke Charles, thus strengthening alliances with Austria. The Lusitanian monarchs remonstrated with Clement XI over the continuation of the Chinese Rites, which they strongly supported. As was the case with many such quarrels, the satellite issues of who controlled the Chinese missions and the status of the French and the Jansenists in their conflict with the Jesuits were of paramount importance. The Jesuits, in favor at the Chinese court and vigorously supported by John V (with the assistance of their mission at Macao), had established Chinese Rites that acknowledged both Confucianism and ancestor worship. The Dominicans and their allies forcefully opposed these hybridized ceremonies. Finally, amid much wrangling between the Jesuits and the French mission (with Jansenist influence), the Holy Office came down against the Portuguese and the Jesuits, publishing a decree prohibiting the Chinese ceremonies

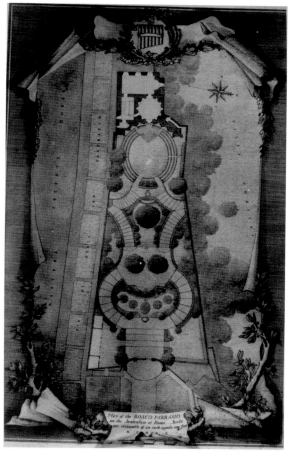

29. Ernst Lawson, *Plan of Bosco Parrasio*, 1920, Library of the American Academy in Rome. Photo: Fototeca American Academy in Rome.

(20 November 1704). Clement XI then appointed as *legatus a latere* Charles Thomas de Tournon, Patriarch of Antioch, to go to China. The Chinese emperor K'ang - hsi did not much like him, preferring the better-educated and more sympathetic Jesuits. Not to be denied his assignment, Tournon issued a mandate supporting the decree of the Holy Office in Nanking in 1707 but found himself jailed by the Portuguese garrison when he reached Macao. Despite Clement's insistence that John V release Tournon, he remained incarcerated and, after three years, died in prison. The papacy and the Portuguese crown were locked in conflict.

With the Portuguese ambassador (and Arcadian) Andrea de Mello's assistance, the church and John V attempted to smooth things over. Everyone knew that the king could draw on his enormous wealth from the Brazilian gold mine at Matto Grosso and the diamond mine at Minas Geraes to assist in his diplomatic initiatives with the papacy. When the king sent ships to aid the Venetians against

the Turks in 1716, Clement XI was very pleased; soon thereafter, in response to a petition from John, the pope conceded to Lisbon the status of a titular Patriarchate.[27] The patriarch of Lisbon (an archbishop promoted to cardinal) has honors and privileges that allow him to maintain a court similar to the pope's; indeed, his coat of arms is like the pope's, with a tiara (but minus the crossed keys of St. Peter).

Pope Innocent XIII (reigned 1721–4), papal nuncio to John during the pontificate of Clement XI, understood the political overtones of John's gesture to the Arcadians, thanked him, accepted his protectorship of the academy, but did not accede to the Portuguese king's new request for a "nunciature of the first class" with a special court for ecclesiastical matters. The papacy had not been helpful when Portugal was seceding from Spain, so John undoubtedly read his second-class nunciature, which kept Lisbon at a distinctly lower standing in the diplomacy of the Holy See than Madrid, Paris, and Vienna, as a further affront to Portugal's influence and reputation. The Portuguese remained adamant in their desire for retaining their nuncio, and having a crown or patriarchal cardinal with the distinction that would thereby accrue to the Patriarchate (which, of course, is an honorific title that has little importance beyond that of status) of Lisbon. With a cardinal as Portuguese delegate, John V could have an important say in papal politics, even to the point of exercising a veto over the election of a pope not properly sensitive to Portuguese interests. But not until the papacy of Clement XII (1730–40) did John achieve his goals. In 1736, Clement, wearying of a protracted controversy that had become deeply quarrelsome, acceded to John's wishes and in 1737 granted him a crown cardinal, Tommaso de Almedia, with the pope's own nephew Cardinal Neri Corsini eventually becoming the cardinal protector of Portugal.[28] For his support of the Portuguese cause and from his salary as nuncio, Neri managed to wring from John V enough money to hire Ferdinando Fuga for the rebuilding and extending of the old Palazzo Riario (now the Palazzo Corsini), construct a grand staircase, and to fashion a huge new garden.[29] Neri was of that species of cardinal nephew who could expect no lucrative offices from his uncle the pope, for Clement took seriously Innocent XII's bull that effectively gutted the old practice of nepotism. John undoubtedly now realized that it was more rewarding to bribe a papal nephew than it was to curry favor with a pope's favorite academy.

It is interesting to observe, just the same, the position of an Arcadian grove and academy (Neri, too, was a member) in the complicated negotiations of political and papal power (Neri, who had directed a papal commission on this matter, certainly "helped" the elderly, infirm, and bedridden Clement to his decision). The Accademia degli Arcadi's regard was high among the European governing classes: With the respect that it commanded, the academy could play an important role in political negotiations, although in this instance it was, in effect, a pawn in a larger game that had no immediate consequence for the Arcadians. Innocent XIII felt no more of a compunction to grant John his request than had

Clement XI, who just the same requested (and received) from the Portuguese king a contribution for the figure of St. Thomas by Pierre Legros in the Apostle series at St. John Lateran.[30]

According to documents found in the academy's archives in Rome, even setting up the original Diploma di Protettore with John V involved some difficult exchanges between the academy and the Portuguese king's ambassador. Although the chief herdsman Crescimbeni wept with joy when John pledged 4,000 scudi for the purchase of the grounds and the erection of staircase, *skene*, lectern, seating, and landscape design, he resisted the designation of protectorship. As the leader of an institution that fashioned itself as part of the republic of letters, Crescimbeni worried over the suggestion of control by the Portuguese king. The ambassador de Mello reacted with surprise. He contended that Crescimbeni's response lacked proper reverence and obsequiousness to the king, and that, after all, the king had no desire to control the academy (he had, in effect, other fish to fry), lived far away, and only wanted the best for the academy. As the ambassador said, the phrasing was "a mere expression for the secretary to use, and not for any formal act of protection or subjugation."[31] After considerable debate, to which an entire assembly was dedicated, the academy acquiesced, but with the tacit understanding that they were not going to give up their independence. In the end, they got their money and their autonomy.[32] Crescimbeni always maintained that the academy had no temporal protector, only the spiritual protection of the Christ Child.[33] The Portuguese ambassador was now in a position to petition the pope for the retention of Bichi as head of the nunciature; Innocent's only response was that "Bichi must obey" – in other words, he was to return to Rome. At the insistence of John, however, he remained in Lisbon, and the papacy and the king of Portugal remained at loggerheads for more than a decade.

Crescimbeni feigned his disregard for such political entanglements as a way to maintain a political advantage. The Arcadians were implicated in papal and imperial politics, with Crescimbeni and other strategically placed Arcadians siding with Clement XI during the War of Spanish Succession, whereas Lodovico Antonio Muratori and Gian Vincenzo Gravina took positions sympathetic to the Imperial side.[34]

Crescimbeni knew the main chance when he saw it, and acted accordingly. He also understood the importance of masks and games (used skillfully in his allegorical text *Arcadia*) and the way in which dissimulation is enacted by virtue of one crossing the threshold into the Bosco Parrasio. How does the Acadian garden represent the real world? What relation does it have to the rest of Rome and how did it function as the *habitus* of churchmen, ladies, and intellectuals? The illusory world of the Bosco Parrasio informed the "real" world of papal, religious, academic, literary, cultural, nationalistic, and artistic politics. One world always doubled the other; but because the field of activity was rife with concealment, the kind of representation that went on was more of disfigurement and imitation, paradox rather than agreement. Crescimbeni undoubtedly understood that otium,

ever so essential to the pastoral experience, was prior to and in some ways in opposition to, or a covert form of, the "negating" of otium: "negotium" or negotiation, which involves overt political maneuvering.

This brings us to the question of how the pastoral mode (and the pastoral garden) figures in political events. When weighing the ideological quotient in any pastoral expression, moment, or place, we must keep in mind that Virgil's first Eclogue pits Tityrus, who has received pastures from Octavian, against Meliboeus, a victim of the same despotic transfer of land. The pastoral realm, in other words, despite its Edenic, idyllic setting, cannot escape the world of politics and power. The relation between Arcadia and "reality" is never simple, nor is it obvious. In other words, one can argue the impingement of Augustus's world on Virgil's Arcadia, but the link, however probable, is not secure. Arcadia figures or signifies many versions of the world, ones of play, contests, poetry, art, and even sometimes worlds that are historical. The received opinions of Platonic and Aristotelian mimesis – as Muratori suggested – lead not to simple truths or the "real," but rather to other myths and other stories.

In her study of neoclassicm and the *fête Chempêtre* in late seventeenth- and eighteenth-century pastoral poetry, Annabel Patterson asserts that pastoral authors "denote their ideological stance as writers in relation to their sociopolitical environment."[35] One of the complications of the "ideological stance" is that the two modes of discourse most commonly chosen by writers of the time, neoclassicism and pastoralism, were in fact cut from the same cloth; yet the former (which also could be called, with more historical justification, Cartesianism) would appear to be a theory "of containment, of rationality, of a benevolent or idealizing view of the social order," whereas the latter tends toward destabilizing those very standards.[36] Patterson's point – and it is one with which I agree – is that the issues involved in pastoral commentaries (and discourses on good taste, with which they were closely aligned) were greater than even individual writers were aware and seemed to warrant oblique turns of phrase. In general, writing *about* the pastoral in eighteenth-century Europe far exceeded pastoral writing itself; Patterson's take on this fact is that theorists wanted to use pastoral for purposes beyond the literary: "[T]he energy invested in writing *about* pastoral was symbolically displaced ... it signified the participation of intellectuals in bigger arguments otherwise beyond their intervention."[37] There are at least two important points here, it seems to me: one is that two (apparently) antithetical poses – the neoclassical/Cartesian and the pastoral – function together as the "critical double," energetically defying the law of noncontradiction; and the other is that the pastoral implies much more than it states, both in terms of poetics and politics. Arcadian references are multifarious, crossing boundaries among the sociohistorical, mythical, psychological, artistic, and pure play. All links, it seems to me, between the Bosco Parrasio and other worlds and other discourses are problematic, diffuse, intimated, and suggested. Wolfgang Iser's comment on the relation between signifier and signified in pastoralism is relevant here: "Departure

from traditional mimesis goes hand in hand with departure from the convention-governed relationship between signifier and signified by letting the signifier float, so that it may serve to produce hitherto unforeseeable significations, resulting ultimately in a fictionalization of established connections."[38]

The semiotic freight borne by pastoral discussions (and constructions, such as the Bosco Parrasio) tends to be as elusive as a whippoorwill, and sometimes as delicate. Patterson observes that "the presence of ideology in eighteenth-century pastoral discourse is more inferred and intimated than spoken."[39] When looking at texts (and, as a corollary, visual art) we have to "think in terms of incomplete if not false consciousness, and to deal with repressions (and admissions) that were perhaps not fully understood by their authors."[40] Whereas not so Marxist as Patterson's, my approach nonetheless draws on cultural criticism (as well as literary theory and hermeneutics), and, although I am not particularly interested in pursuing false consciousnesses, Patterson's references to repressions and that which is "not fully understood" by authors and artists (she also was making reference to paintings by Gainsborough and Constable) are consistent with my own attitude toward what might be called Arcadian semiosis. Along with Wolfgang Iser, I would maintain that "it is hard to trust any reading of pastoralism that, deliberately or otherwise, hinges on the traditional concept of mimesis."[41]

One instance of Arcadian semiosis can be found in Crescimbeni's text on the academy. His *Arcadia*, published in 1708 (but written more than a decade earlier), was composed, as we have seen, with Sannazaro's *Arcadia* (1498) in mind. He expressed the belief that the academy's friends would be able to see the doubleness of his language and would be able to lift the masks, so to speak, to find the hidden meaning. He presumes – indeed, he absolutely needs to be so assured – that there are those who hold the key to his enigmatic prose; otherwise, he could not play his *giuochi*, put on and take off his masks, dissemble and at the same time speak frankly, engaging in a Parrhasian conversation.[42] There is a process in Crescimbeni's writings on the academy (and in his *Arcadia*), as well as in his various negotiations with the worldly powers of his time that enfolds politics into the mythic–poetic–cultural work of the Arcadians. All of these worlds of thoughts, poetic and political constructions, these discourses and microcosms seem to exist simultaneously and interchangeably as wheels within wheels. Crescimbeni's search for power remained cloaked in pastoralism and stealth.

But before exploring the polysemy and the imperspicuity of the discourses and hermeneutics in the Bosco, let us return to the more nearly manifest text of the Parrhasian Grove as represented by its iconography.

ICONOGRAPHY

In my discussion of Giovardi's narrative and Canevari's plan, I have given a brief description of the iconographic elements in the garden. Here, in an attempt to

show how they contribute to a reading of this site as a literary landscape, I revisit the various mythological characters and assess their role in the meaning of the garden. Then I return again(pastoralism is about returning, after all) to offer an analysis in more general terms on ways to interpret the pastoral experience in the Bosco. Given the well-documented and nearly dictatorial control of the academy by Crescimbeni, I am attributing the allegorical program to him. Daniele Predieri in her text on the Bosco Parrasio bases her observations on similar grounds, maintaining that Crescimbeni's garden is a place dedicated to meditation, intimacy, and to the intellectual appropriation of arcane philosophical ideas. Studying the Bosco Parrasio, in her view, requires looking at humanist theory as much as garden theory. My reading of the iconography, whereas not inconsistent with some of Predieri's ideas, differs in many and significant ways from her text and other commentaries as well.[43]

The entire grove is named after Parrhasius, an Arcadian city in the Greek Peloponnesus, founded by the man of the same name, a son of Zeus (some say of Lycaon).[44] Arcadians were first known as Parrhasians. According to the story told by Plutarch, the nymph Phylonome bore twin boys by the god Ares and, fearing her father's wrath at her imprudence, forsook the boys, leaving them on Mount Erymanthe. There, a she-wolf nurtured them until the shepherd Tyliphus, who named them Lycastus and Parrhasius, took the pair in. In this version of the story, the connection to the legendary founding of Rome is unmistakable and serves to underline the intimate bond between the city of Rome and the Arcadian realm.

Within the Bosco, the god Pan and the nymph Syrinx live alongside the more literary figures of Pallas and Mercury (all described by Giovardi as statues over the entrance gate). Pan is the quintessential Arcadian figure, the chief herdsman (and therefore, associated with Crescimbeni), credited by Sannazaro in his Tenth *Eclogue* with the invention of the pastoral (just as Crescimbeni fashioned himself the refounder of pastoral and the savior of Italian literature from *cattivo gusto* – bad taste). According to Ovid's *Metamorphoses* (much cited by the Arcadians and the main text for the program in the Bosco Parrasio), "On the mountain slopes / Of cool Arcadia, a woodland nymph / Once lived, with many suitors, and her name was Syrinx."[45] Syrinx is the nymph (or, more specifically, an Arcadian Hamadryad – one who presides over forests and trees) whom Pan pursued. While still in flight, she was changed into a reed on the bank of the river Ladon. Pan, listening to the soughing and whistling of the reeds, said, "This much I have!" and thought to tie them together to make his panpipes. In the tenth chapter of *Arcadia*, Sannazaro describes Pan's sadness at Syrinx's metamorphosis: "i sospiri si convertirono in dolce suono" – his sighs were converted into sweet sound. These woodland minor deities balance the personages of Pallas and Mercury or Hermes who are atop the right-hand gate (said by Giovardi to represent *letterati*). If we assume that "Pallas" (*Pallade*) is Athena (it is her best-known epithet), then

the associations of the warrior goddess as well as the representative of science and wisdom are invoked. If, on the other hand, we see her as the more obscure Pallas, Triton's daughter, who was raised with Athena, Zeus's daughter, then the meaning becomes more complex and nearer to an Arcadian idea. Athena killed the female Pallas, daughter of Triton, over a petty quarrel, and afterward in her contrition the goddess carved a statue of Pallas to be placed on Olympus. The so-called Palladium then had the power to protect cities (it provided Troy safety for ten years). The masculine name of Pallas is even more Arcadian, however (the figure in Canevari's design that must represent Pallas – since the other figure seems quite clearly to be holding the caduceus and therefore is Mercury – is shown from the back and would appear to be male), and identifies a man who, like Parrhasius, was one of the sons of Lycaon, the king of Arcadia. He is reported by Dionysius of Halicarnassus to have given his son-in-law the responsibility of the Palladium, which, if we recall the female Pallas as the mythological figure that became the Palladium, brings us once again to the story of Troy and, eventually and by way of Aeneas, to the founding of Rome. Chances are – although we have no precise documentary evidence to prove this – Crescimbeni hoped to intimate all of these ideas, cementing the bonds between Rome and the Arcadians and demonstrating the ineluctable covenant that legitimized his academy.

One can turn again to an Arcadian interpretation for Mercury, recalling the traditions that he was the father of Evander, an Arcadian who came to Rome before Romulus and founded the Pallantium on the Palatine Hill (where, we recall, the Accademia degli Arcadi had one of its early homes). Elsewhere he was the father of the Lares, the Roman tutelary gods, and like his offspring was a guardian of crossroads and property, ensuring prosperity and safekeeping. But Giovardi specifically relates him to *letterati*, and it is once again in the *Metamorphoses* that we find him so presented. Hoping to lull the hundred-eyed Argus into sleep and then behead him, thereby freeing Io from his constant surveillance, Mercury, dissembling a shepherd, relates to him the story of Pan and Syrinx (as represented on the opposite side of the Arcadian gate). The caduceus then becomes not just a "wand of sleep," but a vicious blade that severs the watchman's head. Mercury is a teller of tales, one who feigns a pastoral guise, and does it to deceive and finally to murder another. The pastoral tradition in the hands of Theocritus, Virgil, and Sannazaro has far less of violence than does Ovid; yet the iconography of the Bosco Parrasio repeatedly suggests Ovidian tales, thereby calling into question the sylvan innocence and otium so often associated with this particular garden.

We turn next to Apollo, whose aspects and exploits are legion, nearly all of them in some way evoked by his presence in the Bosco Parrasio. He was a herdsman (making him a bucolic figure) whose flocks were stolen by the young Hermes (Mercury); rather than punishing the trickster, Apollo so loved the lyre invented by Hermes (which figures prominently in the *Bosco*'s architectural order

[Fig. 30]) that he let him keep the herd and gave him, in addition, the golden staff or Caduceus (as we see in Canevari's print). Apollo as the god of music and poetry lived on Parnassus (another association of the name "Parrasio") among the muses. He also was soothsayer, one who (like the Arcadians) conveyed his messages in verse or (like Crescimbeni in his early text *Arcadia*) in obscure allegories. He perhaps excites that oracular role by pointing to the dedicatory inscription to John V of Portugal, the "munificence of the benefactor and the gratitude of the beneficiaries."[46] His indexical relationship to the inscription (by pointing) puts him into an interesting semiotic position as one who *is* the frame, or indeed a superscription, of the laudatory text that exclaims both John's munificence and the Arcadians' gratitude. The Bosco Parrasio is rife with Peircean elements of semiosis – icons, indexes, and symbols. Here as a sign, signifier, or signatory, Apollo is "outside" suggesting some relationship to the inside, perhaps even as "author." Apollo of course is not just Apollo but becomes an indexical mode by which we know one of the origins of the garden. Crescimbeni's and Canevari's Bosco is filled with these clever semiotic elements which seem to caper about in specularity and self-referentiality; they are, in short, what I call "performatives."

Then the lazy river gods Tiber and Arno embody the Latin and Tuscan literary traditions. Giovardi applauds the way their waters mix together, joining the Latin and Tuscan traditions (although one notes that their basins remain separated). This "confounding" of literatures – in Giovardi's language – represents the Roman Arcadia as a melting pot or mixing bowl (the metaphors become hopelessly mixed); but to confound is also to confuse and perplex, to withhold or delay resolution and meaning, to leave us with impassive and massive statues, always recumbent, never changing their course.[47]

In his right hand, Apollo holds the laurel, a leaf he espoused when Daphne's father transformed her into a laurel tree; further, the Pythia, Apollo's oracle at Delphi, chewed it in her divinatory trances. We shake off, for the moment, however, the sense of Apollonian trance, detach ourselves from one narrative, so that we can ascend to another idyllic or eclogic moment (the pastoral is a mode given to disruptions and discontinuities).

Giovardi describes the next level of parkland, above and behind Apollo, as an area for promenading. More specifically, one wanders here "insensibly," as he describes it, taking the view of Rome and meditating on the dead; the experience has all the earmarks of a Kantian encountering (*insensibile* can also mean disinterested) of the beautiful, but here mixed with the elegiac. There are elements of *buon gusto*, for, as Kant later was to articulate taste as a matter of free pleasure, one contemplates this view of Rome with no expectation of personal gain. The delight is human and universal, shared with others simply because of our capacity for the free play of the imagination and understanding. In his *Critique of Judgement*, Kant insists that there is purposiveness to nature, and so it makes itself comprehensive to us; the source for that purposiveness is our uniquely human

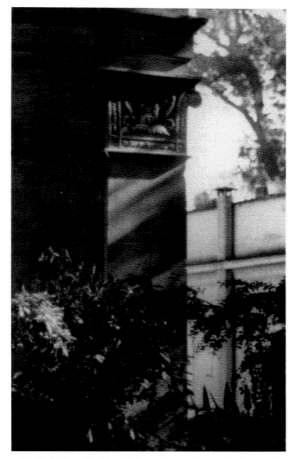

30. Antonio Canevari, Capital on Inside of Gate, Bosco Parrasio, Rome. Photo: Vernon Hyde Minor.

reflective judgment. The Bosco Parrasio is not nature (nor for that matter is the view of Rome), though, but nature made into a garden, and therefore other forms of judgment come into play. We are as apt to "read" the garden as to drink it in insensibly, and that brings us to the elegiac tradition, which is pastoral in its sources.

In his masterful study of pastoralism and variant readings of "Et in Arcadia Ego," Erwin Panofsky argues against a strictly grammatical interpretation of the Latin phrase, favoring instead an elegiac reading of Poussin's painting of the same name. What he maintains, in short, is that in Poussin's second and more classicizing version of the *Et in Arcadia Ego*, the "I" or "Ego" refers not to the presence of *death* (the tomb, in this instance) in Arcadia, but *someone* – a specific (Daphnis-like) personage inside the tomb. We are not confronted by the horror of death so much as we are remembering – in the elegiac tradition – one who has died.

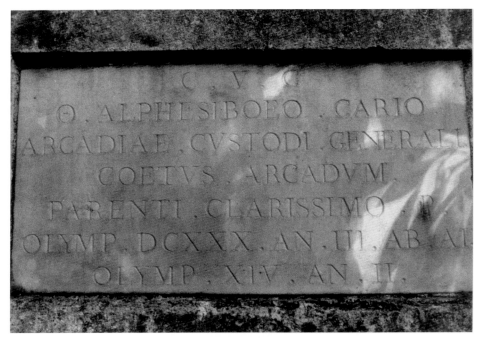

31. *Plaque Honoring Giovan Mario Crescimbeni*, Bosco Parrasio, Rome. Photo: Vernon Hyde Minor.

Elegiac sentiments contrast sharply with what we feel when we cower before the bleak, cold fact of death. Crescimbeni's desire to list Arcadian *defunti* sacralizes and memorializes illustrious men and women. In his evocative paraphrasing of "Et in Arcadia Ego," Panofsky touches on the sentiments undoubtedly favored by Crescimbeni: "'I, too, lived in Arcady where you now live; I, too, enjoyed the pleasures which you now enjoy; I, too, was hardhearted where I should have been compassionate. And now I am dead and buried.'"[48] The epitaph (a writing on a tomb) addresses the passerby to ponder the life of the one so described and thus to ponder on his or her own life. These plaques, which still exist, were, perhaps, the objects of threnodies, and remain brief forms of the pastoral elegy as commemorations and celebrations of the poetic abilities of past Arcadians (see Crescimbeni's plaque, Fig. 31).

Turning from the view of Rome and that pastoral sense of *agoraphilia* (which only improves with ascent), one faces at the back of the landing and beyond the epitaphs the opposite of a *veduta*, something that creates more of a *frisson* than the pleasurable if melancholic mood associated with an elegiac stroll. Here we see a grotto with water seeping from irregularly arranged blocks of tufa. Giovardi describes the effect of the grotto oxymoronically as at once horrible and delicious ("un orrido insieme e delizioso oggetto") – a *philia* and a *phobia*.[49] This calls to mind Leonardo's similar response: "And after having remained at the entry some time, two contrary emotions arose in me, fear and desire – fear of the threatening

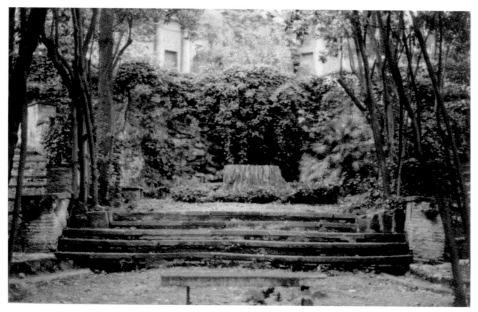

32. Antonio Canevari, Grotto, Bosco Parrasio, Rome. Photo: Vernon Hyde Minor.

dark grotto, desire to see whether there were any marvelous thing within it."[50]
The old Horatian *concordia discors rerum* or discordant harmony of things (used
repeatedly in Petrarchan and Arcadian sonnets) insists on the attraction of the
repellent, and, I might add, the tastefulness of the distasteful, the *buon* of the
cattivo gusto. As a rhetorical figure, the oxymoron affirms the paradoxical, which
never releases antithetical abstractions from one another: Art and nature cannot
pull apart, for each requires its opposite to discover its identity, and therefore is
forever subverted by its "other." The grotto, home of the grotesque, here begets
the poetic figure of Alpheus, referred to by Giovardi as "il celebratissimo Alfeo,
simbolo della Greca Poesia, e creduto principio delle altre maniere di poetare"
(the most celebrated Alpheus, symbol of Greek Poetry, and believed to be the
principle of other styles of poetry). For the Arcadians, Alpheus would have been
most celebrated as the god of the river that runs from Arcadia to Elis in the
Pelopennese. He was a lecherous spirit who pursued Artemis and the Nymphs.
Ovid's account, which seems to offer the best explanation for his presence in this
grotto, recounts the story from the Nymph Arethusa's point of view. At midday –
"the panic hour of noon" – hot and weary from a morning of hunting, she tells
(in Ovid's erotic language) of having hung her clothing on a "curved" reed before
slipping naked into a limpid pool.[51] But almost immediately she was terrified by
the hoarse yet stentorian voice of the river god, who threw off his watery shape
– for he was that very pool – and chased her as she fled, rocketing across the
countryside. Calling to Diana to save her, Arethusa found herself turned into a
stream of water, prompting Alpheus to give up his human shape once again and

become a river "to join me. My goddess broke the earth, and I plunged downward to the dark depths, and so came here."[52] In the statue described by Giovardi (the grotto remains, but without Alpheus [Fig. 32]), the sad nymph Arethusa is the water issuing from his urn. Here in the Arcadian garden is a natural marvel, a river and a nymph swallowed by the ground, only to reemerge again, with the river god shaking off his watery form (after having mingled with hers) to become once more, in a postcoital state, human like, while his beloved victim continues to issue like a fountain from his urn.[53] Peter Marinelli sees Arethusa as essential to the pastoral story: "The ancient myth of Arethusa, traditionally the source and patroness of pastoral poetry, is that of a spring which flowed underground from her home in Greece and emerged amid new surroundings in Syracuse; as an emblem of changeful constancy, the myth is especially fitting to the literature it inspires and to the idea central to its being. Constancy with change is precisely the history of pastoral as an informing idea."[54]

Crescimbeni and his learned *pastori* saw their own mythical realm mediated through the "natural *mirabilia*" of Ovid's tales; indeed, they often practiced the naturalizing of the miraculous, just as Ovid had done. The whole notion of the conflation of marvel and nature is part and parcel of the Ovidian tales and the Arcadians' poetry. For instance, it is at least the putative role of "Pythagoras" in Book 15 of the *Metamorphoses* to show how Ovid's explanation of the origin of streams, trees, flowers, and so on is consistent with Lucretian natural philosophy. The natural and marvelous are not just antithetical but are in every sense paradoxical (as in Giovardi's "un orrido insieme e delizioso oggetto"). In Pythagoras's haunting and arresting language, we are reminded of the eternal flux of things, their metamorphosis – the movement of the soul through various forms – the mutability of nature and time: "Nothing is permanent in all the world. All things are fluent; every image forms, wandering through change. Time is itself a river in constant movement, and the hours flow by like water, wave on wave, pursued, pursuing, forever fugitive, forever new."[55] The natural and Arcadian, the natural and marvelous, the natural and the artistic, the delicious and the horrid must live, however contentiously, together.

What was Delphic, Latin, and Tuscan below becomes aesthetic, elegiac, paradoxical, and grotesque at this level. Crescimbeni's trilogy of *gusto, sano, and convenevolezze* with their patinas of rationality, lucidity, and decorum are apt describers of good taste; but they barely scratch the surface of Arcadianisms, the pastoral, and the paradoxical – the real themes of the Bosco Parrasio. In this magically transfigured landscape, one that has the capability of metampsychosis (souls migrating into different living forms), the Arcadian poet is released from the restrictively rational and partakes of the world of dreams, wishes, feelings, fancies, and, in Bruno Snell's more ominous language "the darkly ebbing subconscious."[56] We recall that Giovardi sees Alpheus in his grotto with his beloved Arethusa as the "symbol" of Greek poetry and the source or beginning of all other manners of poetizing. We have, then, the birth of poetry in the bowels of the earth, where

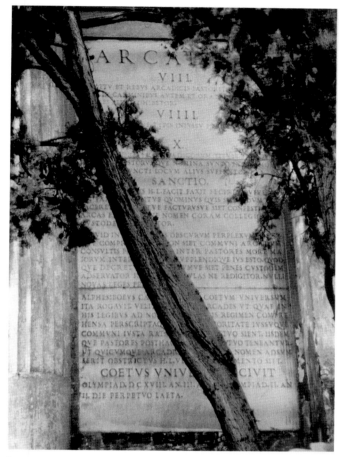

33. Antonio Canevari, Gravina's "Laws" of the Arcadia, Bosco Parrasio, Rome. Photo: Vernon Hyde Minor.

a god forever holds captive as seeping water a nymph who thought nothing of her own beauty and lived only for the joy of the hunt but who now spends eternity watering the underworld. This poses an interesting etiology of poetry as something that insinuates itself into life, undermining and oozing, dripping and transpiring, stealthily and destructively coming into the open. Can this be pastoral poetry?

The last elements in the iconography are the inscriptions on the exedra behind the theater and – above the theater's architrave – the statue of Pegasus. The inscriptions are of several types. First of all, *DEO NATO SACRUM* appears on a marble plaque just above the portal, and then there are tablets dedicated to the patronage and assistance of Benedict XIII and Alexander VIII. We have also the much vaunted and much disputed (in terms of authorship) *Leges Arcadum* (Fig. 33). Pegasus, whom Giovardi sees "in a certain sense" as a figure of Mount. Parnassus,

rears up among the greenery in full bloom behind the *skene*, while water gushes from the cuts made by his hooves.[57] By seeing him as a "figure," Giovardi makes an apt characterization of Pegasus, for he can become – if we are to take the notion of "figuration" seriously – the palpable site, the virtual repository for the values and systems of belief that circulate around Mount. Parnassus.[58] What drives this figuration is once again metamorphosis, the changing of one thing into another, which is after all the temper and tendency of metaphor, *figura*, and poetic–pastoral language and imagery. The winged-horse Pegasus, born of the blood from Medusa's severed head and proud mount of Bellerophon, returned after his master's death to the gods and was present one day during a typical pastoral singing contest, this one on Mount. Helicon. It was between the Muses and the Pierides (the daughters of Pierus). Mount. Helicon (an extension of Mount. Parnassus) swelled so with pride that it threatened to touch the heavens; Poseidon, dismayed by such conceit, instructed Pegasus to strike it with his hooves. When he did so, up spewed a stream, known henceforth as the Hippocrene (horse stream), and Mount. Helicon resumed its accustomed shape. I doubt that Crescimbeni fretted too much about the Arcadians' own overweaning pride; just the same, here we have a mythological check on haughtiness, presumption, and conceit. When she visited Mount. Helicon and the Muses (described once again by Ovid – and mediated by Crescimbeni and Canevari), Minerva admired the mythical version of the stream resulting from Pegasus's kick. When she landed on the mountain, Minerva "spoke to her learned sisters / 'I have heard of a new fountain, sprung, they tell me / Under the hard hoof of the wingèd horse / Medusa used to own. I have come to see it, / This miracle."[59] "and Minerva stood there, / Admiring long, and looked at woods and grottoes / And Lawns, bejeweled with unnumbered flowers, / And said that Memory's daughters must be happy / In both their home and calling."[60] One of the Muses responded that they would be happy were they safe. Without such a guardian as Minerva (perhaps in the text of the Bosco Parrasio, Crescimbeni in the guise of the storyteller Mercury fills that role), however, the Daughters of Memory feared themselves to be easy prey to brutal and powerful tyrants.

The overall iconographical plan is pastoral, poetic, Arcadian, self-congratulatory, assertive, performative, and rife with erotic and violent undertones. Hippocrene's reign over the garden makes explicit the allegorical association of the Bosco Parrasio with the Valley of the Muses. The recollection of metamorphoses (Pan and Syrinx, Apollo in several stories, Alpheus and Arethusa, Pegasus and the Hippocrene) demonstrates the importance of Ovidian imagery and language. The Latin poet's frequent references to *imago, simulcarum*, and *monumentum* when describing the results of metamorphoses, are visual and artistic. In other words, the iconography of the Bosco Parrasio constantly "figures" art and its production. The very use of iconography is a rhetorical strategy that confirms change, transformation, and mutability. The connection of the garden to settecento experience, to Rome and Roman taste, social and political reality, and to

literature and art is symbolic; the garden has, in other words, a speculative reality. The iconography and the garden are interwoven, even entangled and caught up with one another, so that iconographical meaning saturates the landscape to the point that a leaf on a bush is never just a leaf, it is apt to be laurel. The Bosco Parrasio is not filled with baroque conceits, however; it is a studiously literary garden, referring back to poetic modes and poetic ideas. It reaches not in some anagogic sense toward the divine and the mysterious, but has vectors of meaning that sheer sideways, as it were, toward language and certain kinds of visualizations. Perhaps this ever-present artfulness is demonstrated by Ovid's description of Thetis' grotto, when he says that "a cavern / Lies in the grove, made, possibly by nature / By art, more likely."[61]

Here nature, in the form of a highly constructed topography and carefully arranged iconographic display, imitates art, and art constructs nature. Art helps to constitute pastoral presence in the Bosco Parrasio and to make it an apt site of leadership for Crescimbeni and his associates in the Accademia degli Arcadi. It seems, in fact, that art and nature are perpetually confounded in the Acadian realm, with the Bosco often performing as a huge cyclorama. Crescimbeni wrote in Book VII of his *Arcadia* of an encountering by a group of shepherds and nymphs of a small wood that contained a natural fountain, which, he maintained, could not have been made more agreeable or genial by art.[62] There can be no question, however, that this "rustic fountain" was a product not just of Crescimbeni's own artfulness, for even within the frame of the allegorical and fictional account we are to read this fountain as constructed by human hands, not as if it were formed by geological forces. The working back and forth of artistic and natural elements is so dense and continuous, that we can no more identify which is which than we can see individual spokes of a fast-turning wheel.

Thomas Vaughan's (fl. 1771–1820) short lyric "The Stone" plays on the imagery used by Crescimbeni:

Lord God! This a *stone*,
As *hard* as any One
The Laws in Nature fram'd:
'Tis now a *springing Well*,
And many Drops can tell,
Since it by *Art* was tam'd.

THE BOSCO PARRASIO REDUX: PERFORMATIVITY

The riddles and endless Olympic games that one finds throughout Crescimbeni's fable *Arcadia* (and that were enacted in the Parrhasian garden) create that densely ludic experience in which the chief Herdsman seemed to revel. In his descriptions of the various locales for the convening of the Arcadians, Crescimbeni most often

identifies the theatres. His garden was not just the wood of Theocritus, Virgil, or Sannazaro; it was the self-conscious playhouse in which the shepherds rehearsed the lives of pastoral shepherds. Instead of the pastoral itself, the *Adunanze* (gatherings) were performances of the pastoral. Here a poet read his own verses (we recall that a poetess and more eminent shepherds – cardinals, specifically – often had their verses read by others) to an audience of poets. Indeed, the centerpiece of the Arcadian discourse was the ritualized recitations from the podium in the Bosco Parrasio of *rime*. These were performed for a closed fellowship, one that knew the rules and tropes of pastoralism, was initiated into the forms of disclosure and concealment that accompany performances not unlike those of the pre-Homeric rhapsodists. The communion of the shepherds was so precisely encompassed and the rules of such particularity that the content of individual recitations was prescribed and their duration limited to fifteen minutes. Apparently there was neither debate nor response of any kind.[63]

A common feat of poetizing was to speak extemporaneously. One of the most famous of the *improvvisatori*, Bernardino Perfetti (1681–1747) – Alauro Euroteo in Arcadia – was a professor of civil and canon law. The French magistrate and writer Charles de Brosses (1709–77) describes in his *Lettres familières* one of his improvisations: "We gave Perfetti, as subject, the Aurora Borealis. He thought, with bowed head, for a good quarter of an hour, while a harpsichord played softly. Then he rose, and began to declaim quietly in octaves, stanza by stanza, still accompanied by the harpsichordist, who struck chords while Perfetti was declaiming, and played continuously during the intervals between the stanzas. At first these followed each other slowly enough. Then, little by little, the poet's animation increased, and as he warmed to his task the harpsichordist played more loudly. Toward the end the poet was declaiming like a man inspired, poet and accompanist going on together with an amazing rapidity."[64]

This sort of text was composed as it was recited, requiring that the performer-poet rely on certain narrative conventions and metrical patterns, all of which correlated to the pastoral. The audience for this performance was Arcadian and had certain expectations about subject (which in this case was precisely given), diction, and prosody, ones that must have been met – given Perfetti's later crowning with laurel (as described later). The performativity was, in short, delimited by a certain calculation and anticipation on the part of the audience. This very nearly is a form of pure performance, a literary undertaking that arises out of the tradition of *furor poeticus*, generated by a declamatory or rhapsodic performance. It is a production that appears to have no prescribed text, even if there is a discursive tradition for such trumpetings. Perfetti made neither a literary proposition nor imitated a preexisting reality. The performance was, just the same, highly presumed, predicted, and even incited by the Arcadians. The notion that the mad poet inspired by the muses literally "breathes in" poetry suggests that he is a conduit for words that originate elsewhere – in this case, not with the gods or the muses but with the audience itself. Just the same, as I have suggested, the poet

escapes traditional notions of Platonic mimesis, seems even to inaugurate that which can be imitated by others. It is worth noting that le Président de Brosses, a somewhat skeptical observer of Italian ways, went on to say that there was more sound than sense in Perfetti's histrionics.

Nonetheless, because of this performance and his renown as a poet, Perfetti was given the laurel crown on the Capitoline Hill in 1725. A contemporary diarist, Francesco Valesio, recalls the scene for us in which Perfetti acts out the great Petrarchan event:

> (Sunday, 13th of May, 1725) At the hour of 21:30 [for the eighteenth century, this means 2½ hours before sunset], three carriages of the *Popolo Romano* in livery, along with twelve attendants carrying batons (and among these were five deputized *cavaliere*) went to pick up Cavaliere Perfetti, who awaited them at the Sapienza [the University] in the grand salon in which he had [just] conferred the doctorate of jurisprudence. The poet wore a large damask robe such as those worn by conservators over his city clothes and was placed in the first carriage. They arrived at the foot of the Campidoglio, where they got down and went together to the Palazzo Nuovo de' Conservatori, entering into the Salone. There the poet knelt before the Senator, who wore a golden toga, and received the laurel crown, part of which was real and part of which was artificial so that it would not wilt. This event was accompanied by the noise of firecrackers and the sounds of trumpets and drums. Afterward, there were recited by Marchese della Penna an oration in Italian, by Morelli a Latin Eclogue, another by Dottore Gasparri and several sonnets by members of the Arcadian Academy. The function ended with the poet in gratitude singing many octaves and accompanying himself on the guitar in honor of the people and the city. Assisting him were nine cardinals incognito. He went again to the Palazzo de' Conservatori and on leaving heard several cries of "Viva!" from his clack; ascending to the palazzo, he walked out to the balcony, and wearing his crown he bowed to the people, who filled the piazza. . . . And then he departed with the Canon Crescimbeni in the carriage of a Gran Principessa.[65]

As we see, Arcadian shepherds came to the Parhassian Grove (or journeyed elsewhere) for performances. As a place for declamations and recitations, the theater (nearly)-in-the-round, with seating, podium, stage, and *skene*, took over the entire upper level of the Arcadian garden. In addition to discussing the ostention or theatrical display in this prominent area of the garden, I also want to consider the "performativity" of the site itself and of Crescimbeni's iconographical program for the Bosco (for we should keep in mind that the iconography of the

Bosco is entangled with its natural setting – there is no separating of art and nature in the pastoral realm).[66]

The neologism "performativity" has been around in linguistic, philosophical, and literary studies since the 1950s when the Oxford philosopher J. L. Austin gave his lectures on *How to Do Things with Words*. Those presentations under that attractive and deceptively simple title have kept a variety of critics, philosophers, linguists, and historians busy since the mid–twentieth century. The importance of Austin's work depends to a certain extent on how he moved discussions of meaning (in literary or, by corollary and extension, artistic productions) beyond propositions of truth or falsehood. Austin's response to logical positivism created a shift in how we generally come to terms with meaning: not all utterances are about truth and falsehood; in point of fact, there are in Austin's original formulation two kinds of utterances, the constantive and the performative. The former can be true or false, but the latter is based on doing something, carrying out a promise or asserting a vow.[67] "I do" uttered in a "felicitous," non-"parasitic" context – that is, during a legitimate marriage ceremony – performs an action rather than reports on a state of affairs that may be fact or fiction, true or false. It does what it says. When we judge a performative statement, it should be carried out on "standards of success or failure," as Wolfgang Iser writes.[68] As I have already quoted Benjamin Lee, he explains how "Austin reverses the priority held by language as truth and correspondence over language as action and creation."[69]

I turn to Austin's emphasis on speech–act theory and performativity because, as I have already intimated, the Bosco Parrasio was from top to bottom a performative space. In addition, the interpretative strategies associated with performativity allow us to do something more than identify the iconographical elements within the garden and point out their connections to the interests of the Arcadians. We can, keeping in mind the implications of performativity, speculate in interesting and informed ways on how the shepherds, in taking their ritual and contemplative turns about the garden, created meanings as if they activated ideas simply by passing through the force fields surrounding Crescimbeni's statues, tripping wires, so to speak, that produced meaning out of the thin but charged Arcadian air. Because meaning depends on contexts and circumstances, there are shifts depending on how Crescimbeni's statues are experienced. For instance, because their meaning depends on how, when, and under what circumstances they were experienced, the allegorical presentations of the Tiber and Arno do not have stable subject positions. They have no core identity within the performative space of the garden. They enact themselves and generate meaning dependent on a whole host of circumstances of encountering and reading. The interpretant (in Peirce's semiotic model) is the image in the mind of the perceiver (who I often associate with an Arcadian shepherd), but once that image appears, it, too, generates other interpretants, and so the process spirals onward. Allegorical meaning can in fact be slippery, depending as it does on the supposed abstract idea and its uncertain relationship to its physical instantiation (or hypostasis) in a

statue. Add to that the elements of style (which, as I have mentioned, we cannot determine), the context of a piece of ground on the side of the Janiculum as microcosm connected with the Parrhasian and Arcadian macrocosms, the effect of pastoralism, the act of perceiving, the wearing of masks and the assuming of identities (through the adopting of pastoral names), and so on. Meaning does not disappear in these circumstances, but it does become nuanced and inflected.

This vitality of meaning – one that just the same has an evanescence, even a certain cloudiness – arises out of circumstances of time and place. Austin wrote that even with constative statements about indubitability, it "is not a matter of what *kind of sentence* I use in making my statement, but of what *the circumstances are in which I make it.*"[70] He makes a detailed argument for the necessity of considering context. I would maintain that "art acts" like speech acts are not just structures or symbols but depend on expectations and complex systems of (often unspoken) rules that give meaning to events based on the context in which they are performed and how they are experienced. Usually there is a convention of some sort involved, one that is understood both by the sender and the receiver. Then there is the context or situation, which must harmonize or connect up with the convention and the performance. When there is enough mutual understanding of the circumstances, the utterance can generate meaning and "effect the transaction."[71] Austin seems to think that we can come to some agreement when discovering a determinate meaning by being attentive to (in Iser's characterization) "conventions, procedures, and rules."[72]

Austin sums up and argues that constative and performative utterances can be further divided into three "acts":

> We first distinguished a group of things we do in saying something, which together we summed up by saying we perform a *locutionary act*, which is roughly equivalent to uttering a certain sentence with a certain sense and reference, which again is roughly equivalent to "meaning" in the traditional sense. Second, we said that we also perform *illocutionary acts* such as informing, ordering, warning, undertaking, etc., i.e., utterances which have a certain (conventional) force. Thirdly, we may also perform *perlocutionary acts*: what we bring about or achieve by saying something, such as convincing, persuading, deterring, and even, say, surprising or misleading. Here we have three, if not more, *different* senses or dimensions for the "use of a sentence" or of the "use of language."[73] [And, I would add, the "use of visual communication."]

Austin's system attempts to give some order and explanation to how meaning, in common and general senses of that word, is spawned and consumed. Austin insists that everyone involved in the transaction understand the circumstances of the utterance (the whos, whats, whens, and whys of the event) and the conventions

governing that utterance (the syntactical and grammatical use of language); in addition, he hopes that all participants will be sincere and act in good faith.

I am nearly ready to apply Austin's model in my general reading of the Parrhasian Grove's iconography, but first we must deconstruct a bit his construction (because a brief excursus on Derrida versus Austin is crucial to my overall argument about the circulation of taste in eighteenth-century Rome, I hope that the reader will indulge me for several paragraphs while I try to demonstrate how performativity also works in subtle and somewhat unexpected ways). Austin's disquisition on how to do things with words pursues and hopes to assure clarity of communication. His belief in the certainty of meaning in not just locutionary but illocutionary and perlocutionary utterances provides a huge target for the lion of deconstruction, Jacques Derrida, who nonetheless opts for something more akin to a sneak attack than a frontal assault.[74]

At first blush Derrida would appear to approve of Austin's attempt to shift meaning from the consciousness of a speaker to speech acts, from artistic intention to convention and rules. Austin's view of language as something other than outward expression of an author's inner thoughts does not necessarily hold up even in his own arguments, however. We recall that we interpret illocutionary (performative) utterances by understanding the circumstances in which they occur. If one says "I do" in a movie or stage production, its performance is not the same as uttering those words in a "genuine" marriage ceremony; in fact, Austin declares that the use of the "I do" in a theatrical setting is parasitic on the real thing.

In Derrida's niggling, even irritating way, he burrows into Austin's argument precisely at this point. He tugs at the "parasitic" thread until he unravels much of what Austin had to say. The problem has to do with traditional "logocentric" hierarchies, such as host–parasite, serious–nonserious, standard–nonstandard, and so on. Derrida argues that we cannot understand "I do" in a serious way if we cannot conceive of it in a theatrical or nonserious way; in other words, the very repetition of "I do" in nonstandard as well as standard contexts – its "iteration" in deconstructive terms – is what allows us to interpret it. Iteration is that which allows language, performance, or imagery to be transferred from one context to another and to carry along with it certain traces and meanings; it is the "always already" so popular with deconstructionists. When an actor *performs* "I do," his repetition and citation of that clause implants it in the wider context of language and speech acts and confers on it the possibility of having meaning, whether legally binding or not. In his review of the Derrida–Austin debate, Jonathan Culler argues that the "possibility of 'serious' performatives depends on the possibility of performances, because performatives depend on the iterability that is most explicitly manifested in performances."[75] He makes a strong case that variations on a standard performative ("I do") must precede it. Special cases make for the general case: " the iterability manifested in the inauthentic, the derivative, the imitative, the parodic, is what makes possible the original and the authentic."[76] Much of what Culler says here is pertinent to Arcadian shepherds reciting their

poetry in the Bosco Parrasio – but that is, for the moment at least, beside the point – the point being that Austin cannot rely on the priority of the standard use of certain phrases and linguistic turns over parodic, theatrical, ironic, or dissimulating uses. Derrida is quick to point out that Austin, when he appeals to the standard case and finally to the sincerity of the speaker as the ultimate test in authenticity, retreats to the very intentionality he set out to displace. Derrida has to kick Austin aside so as to get back to his own conception of meaning (which just the same relies on some of the core notions of performativity) as that which grows out of ever-widening contexts.[77] Derrida asks us to speculate on what it would be like if "the meaning of meaning . . . is infinite implication? the unchecked referral from signifier to signifier?"[78] Derrida's well-known (if not well-understood) pronouncements on the infinite deferring of meaning is not a recommendation for beating a retreat from interpretation, but rather a reasoned appeal not to close down meaning. We should accept the inevitable, chameleon-like shifting of meaning, its indeterminateness, even cloudiness sometimes.

I want to see the whole meaning of the Parrhasian Grove in performative and poststructuralist terms; I want to get at how the disseminating free play of language and artistic meaning operated (and perhaps operates still, but in a muffled and distant way) in the garden. In the production of the Arcadian garden, the putting on of performances in its theater, and the arrangement of sculptural figures, symbols were organized and effects created. In their long and useful article on the Accademia degli Arcadi for the catalogue of the show of eighteenth-century Roman art in Philadelphia and Houston, Liliana Barroero and Stefano Susinno argue for a specifically Arcadian iconography in the Bosco.[79] Beginning with a brief review of Giovardi's account of the Bosco's sculptural program, they quickly move to what they find to be the archetypal Arcadian iconography not just in the garden but throughout the Roman settecento. They cite numerous instances of allegorical representations of the practices of painting, sculpture, and architecture that pepper fresco cycles and show up in easel paintings with a remarkable frequency throughout the eighteenth century. The ubiquity of this theme, they reason, can only be understood within the sphere of the Arcadians' influence.[80] While finding nothing with which to object in their essay (and much to learn from it), I want just the same to do something different, to demonstrate not only that there were Arcadian themes but that they performed and generated meaning in a distinctive manner; I assert that there was a pastoral-Arcadian hermeneutics.

The Arcadians can be thought of as an interpretive community, one dedicated to the genre of pastoral and the concept of *buon gusto*; as such, the Arcadians would have interpreted and experienced, both consciously and unconsciously, the elements of their garden in terms of some incompletely formed yet recognizable worldviews, ontologies, and epistemologies. That is to say, the Arcadians had horizons of expectations, habits of mind, or in Bourdieu's narrower and more

specific semantics of taste, a *habitus*. Benjamin Whorf referred to something similar when he wrote, in less sociological terms than Bourdieu, about the "thought world," which is a "microcosm that each man carries about within himself, by which he measures and understands what he can of the macrocosm."[81] And we should not forget Michel Foucault's formulations on this very topic, which appear under various headings, such as "episteme" or "discursive formation."[82] As I have been arguing, what went on in the garden was a matter of performance on many levels, from those who dressed up as shepherds and shepherdesses and promenaded through the grounds of their Virgilian wood, to the way the iconographic elements performed certain aspects of political power for the Arcadians, thereby legitimizing the Academy and Crescimbeni.

The sculptural program was arranged in such a way that it could be perceived, experienced, and interpreted from points of view that were neither direct nor necessarily commanding, for these statues were sometimes obscured by trees and thickets of laurel, or inaccessibly placed on high, not in a position to give a standard performance per se, but to perform or influence in a more surreptitious fashion, to inveigle or entice, perhaps. Austin's perlocutionary utterances were those, we recall, that performed such acts as "convincing, persuading, deterring, and even, say, surprising or misleading."

In his original plan, Canevari seems to underscore a casual perusal of the Arcadian garden (Fig. 25). For purposes of scale and animation an architect will often "staff" an architectural view, but – the common assumption seems to hold – without giving a great deal of attention to inventing a significant narrative. I maintain on the contrary that even "casual" narratives have their meaning and are deserving of our attention. By typifying the visitors, Canevari in fact encapsulates precisely the kind of performance and experience that I am suggesting would have been common in the eighteenth century. The architect depicts outside the gates several groups of figures, with some men sitting and others gesturing. One of the two men just entering the garden points toward the statues of Pan and Syrinx reclining atop the left-hand gate. Our other guides or surrogates mime their way through the garden, alternately stopping in front of the colossal statues of the Tiber and the Arno, inviting one another to ascend the stairway, quietly conversing during their ascent, stopping at the first landing for further talk or gossip, looking directly on Alpheus and his grotto, climbing to the amphitheatre, and finally reclining contentedly on the benches beneath the skene and the colossal statue of Pegasus.

These allegorical figures (Tiber and Arno) and denizens of the *Metamorphoses* (all the other sculpture) perform nearly offstage, sometimes at the edges of the pastoral space, like ornament and backdrop, framing the experience for the Arcadian shepherds. As with the boundaries of their property, these statues form part of the perergon or frame of the pastoral realm. The shepherds and their guests at the *adunanze* or gatherings knew all or most of the Arcadians' captions, codes, and discourses, were certainly fully informed on pastoral conventions, recognized

the allegorical figures, and were primed to absorb meaning and sentiment, almost as if they were "inspiring" these from the heady Arcadian atmosphere in the Bosco.

One of the reasons that I am stressing the dissemination, diffusion, scattering (as Crescimbeni/Giovardi wrote: "*sedendo ... come è costume degli Arcadi, sparsi e alla rinfusa fra gli uditori*") – and even the distancing of semiotic elements from one another in the Parrhasian Grove – is that there is the tradition, observed by the Frenchman René Rapin (1621–87) in the later seventeenth century, of a disconnectedness within the pastoral form and the pastoral realm; that is to say, the pastoral mode is paratactic (whereas, we might think of the baroque as hypotactic, as I suggest later). In many languages, parataxis tends to be more typical of poetry than prose, because the elements of verse largely supplant the need for the logical use of conjunction. When used in the pastoral, parataxis – this relative absence of syntactic connecting terms or conjunctions; this avoidance of linkage between phrases and clauses – may create the effect of speed, briskness, a piling up, condensation, and even isolation of stylistic elements. Thomas G. Rosenmeyer has characterized Rapin's essay on pastoral naïveté (from his *Dissertatione*) as promoting a kind of "internal asyntaxis;" that is, much is left out in the writing of pastoral, whether it be connectives or explanations that might tie discrete elements together.[83] There is, in effect, a degree of incongruity and uncertainty in the pastoral. Here in the Bosco, the marginalizing of the iconographical program goes some way in creating these gaps or fissures, of maintaining the fiction of pastoral innocence, asyntaxis, and parataxis. It is worth pointing out that Rapin felt that the Italians, because of their propensity for the baroque mode in poetry and art, were constitutionally incapable of understanding the brevity and disjunctive quality of the pastoral (obviously the Arcadians showed that this was not the case). The baroque is, as I suggested earlier, hypotactic: as a syntactic form, it exhibits and emphasizes large, grandiloquent gestures that make use of subordination, correlation, and association – rather than simple coordination. The hypotactic, baroque style stresses unity, harmony, and complexity – the very opposite of *buon gusto*.[84]

I am drawing parallels between poetic or pastoral diction and the functioning of iconographic and structural elements within the Bosco (and, as we will see, within painting and sculpture) because I believe that they provide us with a way of getting at the *mood* and experience of the garden. A mood is something that steals over an individual in a way that (it strikes me) is semiotic in a noniconic sense. The mood produces meaning, but not just at the level of narratives or allegories. This literary garden, with its three parallel levels, creates a kind of rhetorical structure that contains rather than abets movement; certainly, one is led by the stairways from one level to the next, but the progress is anaphoric (rather than euphoric), similar to the ways in which anaphora is used in pastoral poetry to slow things down, cool the lovers' heat, calm their palpitating hearts. Rosenmeyer avers that with anaphora, "*kinesis* is arrested, continuity blocked, progression cut

off."[85] In the next section, I wish to look more closely at some fairly standard pastoral conventions, see how they operate in the Bosco Parrasio, and demonstrate how these produce further shades of meaning, enhance experience, feed into the cultural values of the age, color our retrospective interpretation of Rome in the settecento, and inform the Arcadian rhetoric of good taste.

THE PARRHASIAN GROVE AND PASTORAL CONVENTIONS: GREEN THOUGHTS IN A GREEN SHADE

As Paul Alpers has amply demonstrated, it is no easy task even to frame the question "what is pastoral?" – nor do I wish to provide an answer, any more than I believe that all pastorals are the same. I am mindful of Annabel Patterson's assertion that "it is not what pastoral *is* that should matter to us"; rather, we should heed "what pastoral since Virgil can do and has always done; or rather, to put the agency back where it belongs – how writers, artists, and intellectuals of all persuasions have *used* pastoral for a range of functions and intentions that the *Eclogues* first articulated."[86] I would like to discuss in further detail the ways in which Crescimbeni and legions of Arcadians used the Bosco as a pastoral experience that merged with their aesthetic (the promoting of *buon gusto*) and political interests.

Pathos

There are connections between human passions and setting; as J.- F. de Saint-Lambert in the "Discours Préliminaire" to his *Saisons* (1769) observed that if "the young and amorous are placed in a delightful grove, reclining on beds of flowers, in the midst of a happy country, and under a bright and serene sky, these beauties of nature will increase the pleasing sensations that arise from representations of love."[87] To investigate further the importance of the pastoral experience for eighteenth-century Roman art and culture, I want to explore various topoi, or standard rhetorical figures of Crescimbeni's Arcadian realm. The specific terms that I have chosen are the pathetic fallacy, otium, and the effects of anaphora and suspension

In *Modern Painters*, the eminent Victorian John Ruskin tries (as he sees it) to bring a little common sense to our experience of the world. He believes that it is not all that difficult to tell "the difference between the ordinary, proper, and true appearances of things...and the extraordinary, or false appearances, when we are under the influence of emotion, or contemplative fancy." He goes on to say: "false appearances [are] entirely unconnected with any real power or character in an object" and are "only imputed to it by us." This imputation he terms a fallacy, of which there are two kinds: "Either...it is the fallacy of

willful fancy, which involves no real expectation that it will be believed; or else it is a fallacy caused by an excited state of the feelings, making us, for the time, more or less irrational." All these irrational feelings "produce in us a falseness in our impressions of external things, which I would generally characterize as the 'pathetic fallacy'."[88] An example that he gives is from Coleridge's "Christabel": "The one red leaf, the last of its clan, that dances as often as dance it can." Whatever his misgivings about the pathetic fallacy (he committed them often enough himself, so we should not take his dismissals absolutely), he bequeathed to the study of literature and art a useful term for a phenomenon that has been around since the dawn of writing and painting.

Once inside the Bosco, which is a symbolic garden suffused with pathos, the shepherd has (supposedly) left behind the world of affairs and civilization, politics, and negotiation and begins to inhabit instead a realm of dreams and wishes, poetry and metamorphosis, performance and aesthetic disinterest, elegy and rusticity. This is, in Leo Spitzer's terms, a *Stimmungslandschaft*, a site in which the mood (*Stimmung*) "extends over, and unites, a landscape and a man." The Latin terms *temperamentum, consonantia, symphonia* suggest this connection.[89] The pathetic fallacy also can rest on dissonance, as often enough happens in Virgil's *Eclogues*; Theocritus' *Idylls* opens with both a soothing and a discordant nature.[90]

Crescimbeni's version of nature, Mount Parrhasius – transferred from Arcadia and plopped down on the slopes of the Janiculum – functions as a wood, a garden, a theater, and even a villa. As nature it is nearly always providential, succoring those shepherds who visit there, encouraging that mythic identification of human and nature and allowing the Ovidian personae to metamorphose and merge with the garden. Bernard Dick writes of the way in which the pathetic fallacy can rise beyond rhetoric to art: "The pathetic fallacy achieves artistic status when it is subtly worked through a poem, entering and leaving unobtrusively, and always standing for something more than mere ornament. When a poet imparts human feelings to natural objects, he is actually reverting to a mythical past where a bond of kinship existed between man and his environment. He is returning to a world where groves and springs were inhabited by intangible but real supernatural powers."[91]

Otium

Otium helps to shape the mood of the pathetic fallacy. Rosenmeyer associates otium with the garden or pleasance: "The more openly the political reality of his day [he is writing about Virgil's *Eclogues*] is admitted into the otium of the pleasance, the greater the need for a 'spiritual' landscape, to lift the experience above the mundane level of party strife. Arcadia is Italy writ large, a spiritual Rome, a primitivist conception of the blessed land, remote and exotic, hence ideally suited to accommodate and reconcile the incongruities of Virgil's pastoral

vision. In such a land, expropriations, deaths of patrons and the worship of princes can innocently consort with plaints of love, catalogues of myth, and the miracles of a Golden Age."[92]

As we have seen (Chapter 3), Arcadia is not a realm of heroes who perform famous deeds or participate in political machinations (at least not obviously). We do not know the shepherd's soul — either its eighteenth-century version or the Theocrtican or Virgilian "original" — through the effectuation of events or one's particular destiny. The shepherds luxuriate in this literary landscape, enveloped by a mood. As Theocritus wrote, *amat bonus otia Daphnis* — good Daphnis loves otium (5.61).

But how does the otium in the Bosco Parrasio work, what conditions does it fulfill, and what value does it lend to those things that went on in the garden? How seriously does one take this otium? Is it one more element in the garden's performativity?

As we have seen, the pastoral convention promotes the idea that shepherds idle away their time in sweet sympathy with nature, avoiding the coarseness of urban existence. In tranquillity and peace, the *pastore* sings his songs, free of stress, happy and content in his simplicity. The tradition of otium would seem to suggest that one's imagination and creativity are enhanced, even ennobled, by repose and inaction.[93] Michel de Montaigne wrote on the walls of his house that he had retired from the active life and was dedicating himself to "freedom, tranquillity, and leisure." One can almost imagine these words inscribed somewhere in the Bosco Parrasio, perhaps on a tree (although that was usually reserved for the name of one's beloved), for otium germinates calmness, serenity, *hasychia* (ease), those states of mind for which the Bosco seems to have been designed. In this Roman grove, one could enjoy a "pause in the process of living."[94]

The antipode for the place or topography of otium was traditionally the city of Rome, a metropolis that ancient writers posited as being far from the pastoral, a place where one was preoccupied by the rush of human events, unnerved by the clamor, squalor, buzz, diversions, cacophony, and stimulation of urban experience. The Roman epigrammatist Martial (c. A.D. 38/41–c. 103), active in the circle of Seneca and the younger Pliny (writers who also wrote about otium), retired to his native Bilbilis in Spain, hoping to enjoy there peace and quiet; alas, he found – as did many another writer of Rome's great age of literature – that retirement has its discontents. Like Ovid at Tomi, Martial awakened to loneliness and despair. Writing in his last book of *Epigrams*, he deplores the unexpected dreariness and wretchedness "in this provincial wilderness where, unless I work without limit my retirement is without consolation or excuse. I miss the ears of the town to which I had grown accustomed and I seem to be pleading before an audience of strangers. . . . I miss that refinement of taste, that inspiration of my themes, the libraries, theaters, social intercourse, through which one enjoys oneself without being aware that one is learning as well; in fine, all those advantages which I abandoned in pettish fashion I now miss as though I had been robbed of them."[95]

As Brian Vickers has exhaustively demonstrated, this ambivalence toward otium is widespread in the literature of antiquity.

There is an undoubted connection between good taste and otium, but there is also one, as Martial observed, between taste and an urbane, cosmopolitan center, filled with *letterati*, cognoscenti, and *dilletanti*, men and women of sensibility. It is hard to imagine Crescimbeni with any desire for the life of leisure. He worked assiduously throughout his life, tirelessly promoting his academy, establishing the discipline and discourse of Italian literary history, attacking his enemies, and protecting his titular church of Santa Maria in Cosmedin. He used rather than practiced otium.

Otium is very much part of the Arcadian package. Crescimbeni and the Arcadians employed the topos of the shepherd in an urbane manner, embracing in figurative terms the archetypal, pastoral, otium-soaked shepherd's life.[96] We remember that the Bosco was dedicated not just to Pan but also to the Baby Jesus. The Bible is rife with references to the simple, natural, undramatic life of the herdsman or shepherd. For instance in Genesis 4:1–5, we read: "And Adam knew Eve his wife; and she conceived, and bore Cain, and said, I have gotten a man from the Lord. And she again bore his brother Abel. And Abel was a keeper of sheep, but Cain was a tiller of the ground. And in process of time it came to pass, that Cain brought of the fruit of the ground an offering unto the Lord. And Abel, he also brought of the firstlings of his flock and of the fat thereof. And the Lord had respect unto Abel and to his offering: But unto Cain and to his offering he had not respect." Abel, the victim of Cain's wrath, stood for the Bedouin tradition, the homely and contemplative life. The great poet and singer of the Old Testament David was a shepherd; his twenty-third Psalm calls out: "the Lord is my shepherd and I shall not want." And one also finds a strong awareness of otium in the praise of monastic withdrawal from the affairs of the world. In the nineteenth century, John Henry, Cardinal Newman wrote that monastic life "was a return to that primitive age of the world, of which poets have so often sung, the simple life of Arcadia or the reign of Saturn, when fraud and violence were unknown. It was a bringing back of those real, not fabulous, scenes of innocence and miracle, when Adam delved, or Abel kept sheep, or Noah planted the vine, and Angels visited them."[97] Lodovico Antonio Muratori, as a representative (and Arcadian) thinker of the settecento, may not have had much sympathy with overpowerful religious organizations and their monastic communities, but he promoted clerical spirituality and the role of the priest as *pastor* rather than as *preacher*.[98] In the seicento, when all the preachers were brothers or *frati*, their importance, influence, and prestige were incalculable. They lived together, shared a common table, had a library near at hand, and were almost completely free of pastoral duties. Muratori saw there a kind of pride and sense of class; nor did Muratori find the same pastoral atmosphere to the monastic life that Cardinal Newman was to recall with such nostalgia a century later. But he did understand the importance of the priest as shepherd rather than polemicist

and orator. Muratori recognized the significance in the seventeenth century of the dynamic preacher who undertook apostleship, preaching, and evangelism, three interconnected vocations that he understood as a rhetoric of arrogance and pride.

Muratori's ideal parish priest – the pastor – lived more nearly a life of otium than did his seventeenth-century counterpart – the preacher. His was not a life of idleness but of *otium negotiosum*, defined by Brian Vickers as "leisure with a satisfying occupation" as opposed to *otium otiosum*, "unoccupied and pointless leisure."[99]

Otium is the condition, the mood, the topos and trope of Arcadianism and the Arcadian garden in Rome. But once again it is worth emphasizing that the seclusion sought by the Arcadians was not that of the hermit saint or the writer forced into exilic retirement; it was instead, a Petrarchan otium and withdrawal. Petrarch wrote in his *Life of Solitude* that "I mean a solitude that is not exclusive, leisure that is neither idle nor profitless but productive of advantage to many. For I agree that those who in their leisure are indolent, sluggish and aloof are always melancholy and unhappy, and for them there can be no performance of honorable actions, no absorption in dignified study, no intercourse with distinguished personalities."[100]

I have been emphasizing the way in which meaning spreads itself out, so to speak, in the Arcadian garden and environment, how *buon gusto*, otium, pathos, parataxis, anaphora, performativity, and the Arcadian iconography generate their implications, distinctions, nuances, rhetoric, and mood in a diffuse semantic field rife with the ambiguous and evanescent, capricious and transitory. We are in a world of fragile substance and insecure denotations. Not even the music of the pastoral world has a specific source – it is a kind of surround sound, as we hear from Andrew Marvell, who in "To His Coy Mistress" laments that "in thy marble Vault, shall sound / My echoing Song." Indeed, a stone vault creates echoes, but this hollow sound is part of the eternal present in which Tityrus pipes in Virgil's opening *Eclogue*: "as I idly play on my slender reed." Paul Alpers observes that this representation of otium and playing creates music with no source, music "that fills the space around him."[101]

An important aspect of otium is kinesis (or antikinesis). As I mentioned earlier, one could move about the Arcadian garden but certainly not at breakneck speed. The paired staircases transfer into three-dimensional space the rhetorical figure of the anaphora – the repeating of certain elements or forms for the purpose of creating a stuttering stasis. The anaphoric (rather than euphoric) motility encourages the passive – or, at any rate, relaxed – experiencing of the beauties of nature (these stairs are, of course, related to the contemporary Spanish Steps, that transfer the pastoral experience to a more specifically urban context). One ambles through the Bosco Parrasio, lost perhaps in idle gossip. It was well known, however, that this prattling away during a leisurely stroll was, in the opinion of Marcus Portius Cato – Cato the Elder (234–249 B.C.E.) – unworthy of the vigor

and industry of a Roman; it was, in his opinion, something typical of the softer and more "effeminate" ways of the Greeks.[102] Those in the Bosco Parrasio and the Roman republic of letters undoubtedly found in these soft ways something congenial to their expressions of ideologies, expressions in effect strewn about the magical landscape, communications that passed into the thick air, redolent of the sensuous, delicious, and cheering attitudes of good taste so casually borne by the members of the organization that had wrested cultural leadership away from the Vatican and the Curia.

Suspension

In pastoral experience, suspension is very nearly the opposite of suspense; the latter builds dramatic interest for the beholder because he or she consciously anticipates a resolution, the working out of a plot. In the kind of drama that is driven by a protagonist or hero, there is a narrative sequence that constitutes a sort of drive with logical, even inevitable, consequences. Not so in pastoral. Perhaps the best example of irresolution and therefore the tranquillity of the suspended moment or circumstance comes at the end of Virgil's *Eclogue* I. Tityrus, as we have seen, has been given land by Octavian, and there he lies "in the beech-tree shade," whereas Meliboeus, the victim of the same act of charity, has had stolen from him what Tityrus was given. Yet Meliboeus insists that he is not envious, rather he is "full of wonder" at this remarkable turn of events following the victory of Octavian over Brutus and Cassius at Philippi in 42 B.C.E. Just the same, his bitterness comes out at the end of the first Eclogue when he laments: "Have we done all this work / On our planted and fallow fields so that / Some godless barbarous soldier will enjoy it?" Tityrus, not unkindly and yet without any expressed sympathy, invites Meliboeus to spend the night with him, in deliciously pastoral language: "And rest yourself awhile on these green fronds; / The apples are ripe, the chestnuts are plump and mealy, / There's plenty of good pressed cheese you're welcome to. / Already there's smoke you can see from the neighbors' chimneys. And the shadows of the hills are lengthening as they fall."[103] Nothing is resolved (except, interestingly enough, the poetic meter); Tityrus does not even acknowledge Meliboeus's reversal of fortune. Yet the pastoral mood remains intact; indeed, Panofsky remarks that this kind of "vespertinal" moment is so touching as to suggest that Virgil "invented" the evening.[104] What would seem to be conflict is absorbed into the warmth and goodness of the rural twilight.

The Bosco Parrasio as Pastoral Romance

In his text on the fictive and imaginary (to which I have already made brief reference), Wolfgang Iser claims for pastoral a paradigmatic status.[105] Pastoralism foregrounds the fictive in ways that no other literary activity can match. Iser particularly favors the pastoral romance (as opposed to the more restrictive eclogue

format) for its ability to create a fictive world that has an intimate relation to the real world.

The real world and the world of the pastoral romance mirror one another. Iser's notion of escape seems to fit with what Vickers writes about otium, that the pastoral shepherd does not escape reality, avoid negotiation; rather, he steps away from reality by putting on masks and playing games. It is a way to gain perspective and distance from the sociohistorical world. The knowledge one gains from donning costumes can return with Crescimbeni's shepherds to their other existence. Therefore, our Arcadian shepherds did not search for a Golden Age, but retreated into fictionality for strategic reasons. When the shepherd returns to his world, he is empowered by his experience and understanding to bring about change. How one playacts in the Bosco Parrasio has no real consequences; on the other hand, what one does in the professional world of eighteenth-century Rome could have had very real results. It is not that one wants to hide in the Golden Age; it is that one can use the concept of the Golden Age to formulate responses to real issues in the real world. The historical world then can be restructured and rationalized in ways that relate to the mythical Arcadia. In some ways, Horace anticipated the need to be in both worlds in *Epode II*, when the Roman poet writes about the dreams of his character Alfius, who thought:

> Happy the man, who far from town's affairs,
> The life of old-world mortals share;
> With his own oxen tills his forebears' fields,
> Nor thinks of usury and its yields.

But soon enough Horace reveals that Alfius has not forgotten the city:

> Alfius the usurer, when thus he swore
> Farmer to be for ever more
> At the mid-month his last transaction ending,
> By next new moon is keen for lending[106]

Although it is axiomatic that pastoral movement requires both retreat and return, we should not assume that as we go back and forth we shift between unrelated worlds. Neither Crescimbeni's Rome nor the Arcadian realm can be complete in itself; they exist together and mirror one another perpetually. Iser writes that "neither is fulfilled simply by what it denotes, for only their interaction can unfold the implications of their references."[107] If we take Iser's assertion seriously, we are forced to look to the Arcadians to understand the social and historical significance of early settecento Rome. At the same time, to interpret the Bosco Parrasio, we must look beyond its gates.

The denotation to which Iser refers comes about by way of the Arcadians' crossing of the boundary, their walking into the Bosco, and then leaving again: "In crossing the border between a historical and an artificial world, the pastoral romance provides a vivid portrayal of literary fictionality that is lodged neither in the artificial nor in the historical world. Rather, it embodies an act that allows for worlds to be surpassed within the world."[108] Iser sees the pastoral romance as that which crosses the border; in the Parrhasian Grove, real people went in and came back out. They saw the unchanging "present" of a religiously dominated culture, of institutional and political plotting, deception, and scheming, set against the memory of a pastoral past, one made dissonantly present by the Bosco Parrasio.

Relatively few people on relatively infrequent occasions used this garden. Its sculpture program is gone – or may never have existed. Vernon Lee described her first impression of it in the late nineteenth century as an abandoned, overgrown, irregular wood inhabited by slatternly and bedraggled squatters.[109] Even by the middle of the eighteenth century (1760), and again in the early nineteenth century, the garden had fallen on bad times, and there were appeals for money to refurbish the grove.[110] The garden still stands, with its old gates and painted name; the words "Parrasio" and "Arcadi," stenciled in at different times, contend with one another in pentimental fashion to identify this overgrown, picturesque, and largely ignored wood. Here there was once a (feigned) innocence, not unlike that characterized by T. S. Eliot as "an undissociated sensibility."

Despite the garden's untidy and decayed appearance today, we should recall it in its original conception and in its heyday. The Arcadian discourse was about, among other things, a turning to "returning," and the Bosco assumed the masks of ancient pastoral and the shape necessary for functioning as a conduit through the Roman cultural and social centers of power and desire. Discourses are not necessarily about truth, as we have seen, but rather they express the authority of a particular entity, such as the Arcadians, to institutionalize ideas and styles. When Michel Foucault writes about "power" in relation to the actions and behavior of discourses, he does not refer to domination or repression; instead, he shows how discourses make things possible. As Arcadianism circulated throughout Italy and especially Rome and its institutions in the eighteenth century, it abetted and allowed certain things to happen. Through pastoralism, Arcadianism could regulate, adjust, arrange, manage, and order events in such a way that particular notions and abstractions – such as *buon gusto* – became fairly standard assumptions.

The Bosco is archetypal (as, perhaps, are most gardens) and is absolutely suffused by metaphor, so that everything means something else (one is reminded of Heidegger's "something else" – *ein Anderes* – that a work of art always reveals[111]). The Bosco not only figured a constellation of cultural attitudes, it assisted the Accademia degli Arcadi in its mission to wrench from the Vatican the cultural

leadership of Rome. It bears saying once again: who defines culture, controls culture; who defines taste, controls taste.

A kind of courtly society once gathered here to play out pastoral rituals and to assert its presence and position of power in a society of the sister arts and of good taste. Like many gardens, the Parrhasian Grove was replete with cultural meaning, an insistent, self-asserting, physical trope, rather than simply a background or setting for Arcadian events. One might say that this piece of nature is no longer nature per se but has been artificially transformed, as has any space rearranged by human hands; in other words, I am emphasizing the garden as a rhetorical strategy, an altered space, one that works to reprise a hallowed if sometimes denigrated literary mode and tradition and to give it symbolic and social meaning. In the Bosco Parrasio, nature and culture are signs of one another. The Roman settecento drew breath in the Arcadian garden just as the Bosco Parrasio existed in the Eternal City.

What is unique to this place is its exquisite pastoralism, the way it becomes a landscape of many things, one of which is tradition. The Arcadians, who constituted the "great writers, philosophers, or artists, all the noble lords, all the rich bankers, all the astute lawyers, all the well-known doctors, all the sainted priests, all the beautiful ladies" in Vernon Lee's memorable description, brought to this garden a wonderful life and invested it with a tradition of extraordinary amplitude and history.

Tradition is the handing down from one generation to the next of a certain set of practices and beliefs.[112] The uses made by the Accademia degli Arcadi of the Arcadian and pastoral traditions were both selective and opportunistic. Dating at least from the time of Queen Christina's academy in Rome in the mid–seventeenth century, there had been some diffuse but apparently resolute sense that Roman cultural life was in need of renewal, that artistic and literary practices – products of *secentismo* – were threatening to devolve into too much artfulness and self-referentiality, into isolated if proud practices, cut off from the larger truths that the past had established and that one now had to reach backward in time to retrieve. The growing differentiation and complexity of artistic and literary culture might have been seen as a threat to the simplicity and wholeness of things as they once had been.

But the very modernism and rationalism of the times meant that more and more thinkers (including Arcadians) were turning to Cartesianism and empiricism, modes of thought not necessarily supportive of old (and especially pastoral) traditions. Perhaps the Arcadian garden is something of a swan song for traditions that were venerated because of their antiquity; those who saw in Arcadianism a chance for renewal – especially Gravina and Muratori – despaired of the shepherds' absorption into the lyricism that the garden represented.

Like a poem, the Bosco Parrasio is a text and a performance that addresses the visitor (more then than now; but the address goes on) in ways that saturate

the very ground, vegetation, architecture, and air with sirens' songs that are both indistinct yet compelling and seductive. Every crumbling bit of travertine, every plaque denoting a dead Arcadian, every tree and bush – although many generations removed from the original theater – along with our memory of the first inhabitants and Crescimbeni's iconographic program enraptures us in this Valley of the Muses.

NOTES

INTRODUCTION

1 Vernon Lee (Violet Paget), *Studies of the Eighteenth Century in Italy* (Chicago: A. C. McCLurg, 1908), 15–16.

2 On artistic influence, see Vernon Hyde Minor, "Art History and Intertextuality," *Storia dell'Arte*, n. 92 (1998), 132–42.

3 Liliana Barroero and Stefano Susinno, "Arcadian Rome, Universal Capital of the Arts," *Art in Rome in the Eighteenth Century*, ed. Edgar Peters Bowron and Joseph J. Rishel (Philadelphia: Philadelphia Museum of Art/Merrell, 2000), 47–75.

4 These quotations come from Quatremère de Quincy, Francesco Milizia, and the *Dictionnaire de l'Académie*; see Renée Wellek, *Concepts of Criticism* (New Haven: Yale University Press, 1963), 69–127, with other quotations and a full bibliography.

ONE: *CATTIVO GUSTO* AND SOME ASPECTS OF BAROQUE RHETORIC

1 J. G. Robertson, *Studies in the Genesis of Romantic Theory in the Eighteenth Century* (Cambridge: Cambridge University Press, 1923), 5.

2 James V. Mirollo, *The Poet of the Marvelous: Giambattista Marino*, (New York: Columbia University Press, 1963), 103.

3 Mirollo, ibid., traces the idea of *secentismo* (as it is more commonly spelled) to the mid–eighteenth century and the critic Giuseppe (Joseph) Baretti, who claimed that the term was already in use.

4 See K. K. Ruthven, *The Conceit* (London: Methuen, 1969), 5–16, for an enlightening discussion of the contradictions built into the notion of "far-fetched". I have provided some of this background in my article, "What Is Buon Gusto? The Arcadian View," *Antologia di Belle Arti*, nn. 59–62 (2000), 72–84.

5 Francesco Algarotti puts Borromini together with Marino (and other seicento poets) in *Saggio sopra l'Accademia di Francia che è in Roma* (Livorno: Per Marco Coltellini, 1763); there is also another specific connection in "Saggio sopra quella questione perché i grandi ingegni a certi tempi sorgan tutti ad un tratto e fioriscano insieme," *Opere* (Venice: Per Giambatista Pasquali, 1757) (the dedication letter is dated 12 August 1754); reproduced in *Saggi*, ed. G. da Pozzo (Bari: G. Laterza, 1963), 354: "E quando venne poi il Marini a infrascare la poesia di concetti e di acutezze, quando fece quasi lo istesso il Borromini nell'architecttura.". Another Arcadian text that attacks baroque architecture is the unpublished manuscript *Del bello e del buono dell'architettura. Dialoghi fra Ariesteo Licaonio B.A. e Filena Tirrenia. Dialogo primo. Del modo di giudicare del bello dell'architettura. Letto in Arcadia dallo stesso Ariesteo il 3 di Maggio 1770* (Bibl. Vat. Cod. Chig., M VIII, LXXX-7). Giovanni Bottari's *Dialoghi sopra le tre arti del disegno* (Reggio: Pietro Fiaccadori, 1826; first published in 1754) was largely dismissive of architecture *alla romana* or of *gusto moderno* – both of which were code phrases for baroque architecture.

6 For ancient comments on the connections between poetry and painting, see Quintilian, *Institutio Oratoria*, trans. H. E. Butler (London and New York: Loeb Edition, 1921), vol. I, 295; Cicero, *De oratore*, tran. H. M. Hubell (London and Cambridge, MA: Loeb Edition, 1952), 359–61.

7 Samuel Johnson, *Lives of the English Poets*, ed. G. B. Hill, vol. 1, *Cowley–Dryden,* (Oxford: Clarendon Press, 1905), 19.

8 See especially Tommaso Stigliani, *Del mondo nuovo* (Piacenza: 1617) and *Dello occhiale* (Venice: Carempello, Sandro Bazacchi, 1627). Especially in *Dello Occhiale*, Stigliani laments Marino's many "failures" in the poem *Adone*. Marino refused, Stigliani indignantly points out, to follow Artistotle's unities, ignoring the need for a proper beginning, middle, and an end. The poem is overwhelmed by superfluities, enthusiasms, and disproportion. In chapter 6, Stigliani regrets the way Marino "stumbles" through the episodes of Adonis and Venus. And so on, for more than 500 pages (there are tables at the end that list all of Marino's "errors").

9 For a persuasive argument on the existence of Jesuit poetics, see Anthony Raspa, *The Emotive Image: Jesuit Poetics in the English Renaissance* (Fort Worth: Texas Christian University Press, 1983). Although his discussion focuses on Donne, Crashaw, and Revett (among others), Raspa's formulation of a Jesuit poetics depends on the *Spiritual Exercises* and a great deal of Continental writing. Also see Evonne Levy, *Propaganda and the Jesuit Baroque* (Berkeley: University of California Press, 2004).

10 For a discussion of the impact of Pascal's *Provinciales*, see Richard Parish, *Pascal's Lettres provinciales: A Study in Polemic* (Oxford: Clarendon Press, 1989).

11 Alba Costamagno, "Agesia Beleminio (G. G. Bottari) e L'Accademia dell'Arcadia nel Settecento," *Miscellanea* (Quaderni sul Neoclassico) no. 3 (Rome: Bulzoni, 1975), 43–63.

12 Hanns Gross, *Rome in the Age of Enlightenment: The Post-Tridentine Syndrome and the Ancien Regime* (Cambridge: Cambridge Univesity Press, 1990), 270.

13 Mieke Bal, *Quoting Caravaggio: Contemporary Art, Preposterous History* (Chicago: University of Chicago Press, 1999), 16.

14 Paul de Man, "Semiology and Rhetoric," in *Allegories of Reading: Figural Language in Rousseau, Nietzsche, Rilke, and Proust* (New Haven and London: Yale University Press, 1979), 16.

15 Ibid., 6.

16 De Man does not accept that what is being conveyed converges with how it is being conveyed. He demonstrates again and again that just when a poem seems to be asserting that its content and form are united, it betrays – deconstructs – itself.

17 *Rettorica e Barocco: Atti dell III Congresso Internazionale di Studi Umanistici*, ed. Enrico Castelli (Rome: Fratelli Boca Editori, 1955).

18 Giulio Carlo Argan, "La 'rettorica' e l'arte barocco," *Rettorica e Barocco*, 1955, 9–14.

19 Kenneth Burke, *A Rhetoric of Motives* (Berkeley and Los Angeles: University of California Press, 1969), 54.

20 Robert J. Clements, *Michelangelo's Theory of Art* (New York: New York University Press, 1961), 16–29; David Summers, *Michelangelo and the Language of Art* (Princeton: Princeton University Press, 1981), 203–33; Erwin Panofsky, *Idea: A Concept in Art Theory*, trans. Joseph J. S. Peake (New York: Harper & Row, Publishers, 1968), 118–21.

21 "[Q]uella meditatione che lo spirito fa sopra alcuno obietto che se gli offerisce di quello, c'ha da scriuere." Quoted and translated in Bernard Weinberg, *A History of Literary Criticism in the Italian Renaissance*, 2 vols. (Chicago: University of Chicago Press, 1961), 235.

22 Ibid., 236.

23 Ibid., 243.

24 Ibid.

25 Frank J. Warnke, *Versions of Baroque: European Literature in the Seventeenth Century* (New Haven and London: Yale University Press, 1972), and *European Metaphysical Poetry* (New Haven: Yale University Press, 1961).

26 Warnke, *Versions of Baroque*, 32.

27 Ibid., 38.

28 Elizabeth Cropper and Charles Dempsey, *Nicolas Poussin: Friendship and the Love of Painting* (Princeton: Princeton University Press, 1996), 253–78.

29 Anthony Blunt, *Nicolas Poussin* (New York: Bollingen Foundation, 1967), 7.

30 Barbara Maria Stafford, *Visual Analogy: Consciousness as the Art of Connecting* (Cambridge, MA: MIT Press, 1999), 9: "Most fundamentally, analogy is the vision of ordered relationships articulated as similarity-in-difference. This order is neither facilely affirmative nor purchased at the expense of variety. Analogues retain their individual intensity while being focused, interpreted, and related to other distinctive analogues and the prime analogue. We should imagine analogy, then, as a participatory performance, a ballet of centripetal and centrifugal forces lifting gobbets of sameness from one level or sphere to another. Analogy correlates originality with continuity, what comes after with what went before, ensuing parts with evolving whole. This transport of predicates involves a mutual sharing in, or partaking of, certain determinable quantitative and qualitative attributes through a mediating image."

31 *The Institutio Oratoria of Quintilian*, trans. H. E. Butler (Cambridge: Harvard University Press, 1959), vol. III, 301.

32 Erwin Panofsky, *Studies in Iconology: Humanistic Themes in the Art of the Renaissance* (New York: Harper Torchbooks, 1962), 3–31.

33 Howard Hibbard, *Caravaggio* (London: Thames & Hudson, 1983), 151.

34 Leo Bersani and Ulysse Dutoit, *Caravaggio's Secrets* (Cambridge: MIT Press, 1998), 45.

35 Ibid., 47.

36 Franco Croce, "Baroque Poetry: New Tasks for the Criticism of Marino and of 'Marinism,'" *The Late Italian Renaissance, 1525–1630*, ed. Eric Cochrane (London: Macmillan 1970), 377–400; translated and abridged from "Nuovi compiti della critica del Marino e del Marinismo," *Rassegna della letteratura italiana* LXI (1957), 456–73.

37 Francesco Flora, *Storia della letteratura italiana*, 7th ed. (Milan: Mondadori, 1955), 240, quoted and translated by Cochrane, 1970.

38 This is a point made by Cochrane in his discussion of Flora.

39 Paul de Man, *Blindness and Insight: Essays in the Rhetoric of Contemporary Criticism*, 2d ed. (Minneapolis: University of Minnesota Press, 1983), 136.

40 Conrad Rudolph and Steven F. Ostrow, "Isaac Laughing: Caravaggio, non-traditional imagery and the traditional identification," *Art History* 24, no. 5 (November 2001), 646–81.

41 Stanley E. Fish, *Self-Consuming Artifacts: The Experience of Seventeenth-Century Literature* (Berkeley: University of California Press, 1972).

42 Stanley Fish, "Literature in the Reader: Affective Stylistics," *New Literary History* II (Autumn 1970), 123–62.

43 Fish writes about literature, but there can be no doubt he borrows concepts from art history.

44 Fish, *Self-Consuming Artifacts*, 1.

45 Ibid., 3.

46 Fish, "Rhetoric," in *Critical Terms for Literary Study*, ed. Frank Lentriccia and Thomas McLaughlin, 2d ed (Chicago and London: University of Chicago Press 1995), 205.

47 W. K. Wimsatt, Jr., and Monroe C. Beardsley, *The Verbal Icon: Studies in the Meaning of Poetry* (Lexington: University of Kentucky Press, 1954), 21.

48 Filippo Baldinucci, *The Life of Bernini*, trans. Catherine Enggass (University Park and London: Pennsylvania State University Press; 1966), 74.

49 For a discussion of the Christian church building as a "model" of the Heavenly Jerusalem, see the classic study of the subject, Otto von Simson, *The Gothic Cathedral: Origins of Gothic Architecture and the Medieval Concept of Order*, 3d ed. (Princeton Princeton University Press, 1988).

50 *The Spiritual Exercises of St. Ignatius*, trans. Anthony Mottola (New York: Image Books Doubleday, 1989), 140.

51 Ibid., 72.

52 Giovanni Careri, "The Artist," in *Baroque Personae*, ed. Rosario Villari (Chicago and London: University of Chicago Press, 1995), 292–4.

53 *The Spiritual Exercises*, 82–3.

54 Ibid., 54.

55 Svetlana Alpers has brilliantly distinguished these two modes of visual rhetoric in "Describe or Narrate? A Problem in Pictorial Representation," *New Literary History* VIII, no. 1 (Autumn 1976), 15–41. Her notion of the descriptive received further development in *The Art of Describing: Dutch Art in the Seventeenth Century* (Chicago: University of Chicago Press, 1983).

56 Stafford, *Visual Analogy*, 23.

57 Vernon Hyde Minor, "Art History and Intertextuality," *Storia dell'Arte*, no. 92 (1998), 132–42. Other sources for his figures are given in *Luca Giordano 1634–1705*, exh. cat. (Naples: Electa, 2001), 122.

TWO: *BUON GUSTO*

1 Still the best discussion of the Italians' philosophical position within the broader European context is Guido Morpurgo Tagliabue, "Note sul concetto del "gusto" nell'Italia del settecento," *Rivista critica di storia della filosofia*, Anno XVII (1962), Fasc. 1–3, 41–67, 133–66, 288–308. Tagliabue, however, dismisses the Arcadians as purveyors of *cattivo gusto*, no matter how earnestly they promoted precisely the opposite.

2 One of the best surveys of taste remains Giorgio Tonelli, "Taste in the History of Aesthetics from the Renaissance to 1770," *Dictionary of the History of Ideas*, ed. Philip P. Wiener, vol. IV (New York: Charles Scribner's Sons, 1973), 353–7. See also "Goût," by Voltaire, Montesquieu, d'Alembert *Encyclopédie, ou dictionnaire raisonné des art, des sciences et des métiers*, Vol. VII (Paris, 1757); E. N. Hooker, "The Discussion of Taste, from 1750 to 1770, and the New Trends in Literary Criticism," *PMLA* 49 (1934); R. G. Saisselin, *Taste in Eighteenth-Century France* (Syracuse, NY: Syracuse University Press), 1965; Alexander Gerard, *An Essay on Taste* (London: A. Millar, 1757); Rene Wellek, *A History of Modern Criticism: 1750–1950*, vol. I (New Haven: Yale University Press, 1955), 38–42, 107, 109, 95; W. C. Booth, *Critical Understanding* (Chicago: Chicago University Press, 1979); B. H. Smith, *Contingencies of Value* (Cambridge: Harvard University Press, 1988); M. Moriarty, *Taste and Ideology in 17th-Century France* (New York: Cambridge University Press, 1988).

3 Moriarty, *Taste and Ideology*, 121, writes of how La Rochefoucauld uses the term *goût* to break down tradition and "to demolish the moral authority of the ancient philosophers, the Stoics particularly, and their modern epigoni, and beyond them a whole scheme of categorical morality."

4 Ibid., 139.

5 Dominique Bouhours, *La Manière de bien pener dans les ouvrages d'esprit* (Paris, 1674), 516–17: "Le goust . . . est un sentiment naturel qui tient à l'ame, & qui est indépendant de toutes les sciences qu'on peut acquérir; le goust n'est autre chose qu'un certain rapport qui se trouve entre l'esprit & les objets qu'on luy présente; enfin le bon goust est le premier mouvement, ou, pour ansi dire, une espèce d'instinct de la droite raison qui l'entraisne avec rapidité, & qui la conduit plus seûrement que tous les raisonnemens qu'elle pourroit faire." Quoted in Moriarty (1988), 18.

6 Moriarty, *Taste and Ideology*, 19, 21.

7 "Il y a longtemps que je connois les méprises du Père Bouhours, et l'injuste sévérité de M. Despreaux à l'égard de l'Ariosto et du Tasse. L'un et l'autre ne connoissoient que superficiellement ce qu'ils critiquaient." This letter, along with others in Italian, are published in Voltaire, *Correspondance*, texte établi et annoté par Th. Bestyerman (Bibl. de la Pléiade, vol. II, Paris, 1963), 893–4, 907–8, 933–4, 947. See also Alphonse Dupront, *L. A. Muratori et la société européenne des pré-lumières* (Florence: Leo S. Oslschki, 1976), 10–11 (where the letter in French is quoted).

8 Many years ago, René Bray (*La formation de la doctrine classique en France* [Lausanne: Payot, 1931]), 363, commented that classicism had been in the air for quite some time before Boileau arrived on the scene: "Boileau ne lá point inventée. Il lá reçue déjà constitueée de ses devanciers."

9 Antoine Gombauld Méré, *Æuvres complètes*, ed. Charles-H. Boudhors (Paris, 1930), III, 126: "la bienséance est si delicate, qu'elle ne souffre rien de mauvais goût," quoted in Moriarty, 86; Boileau, *Art Poétique*, canto I, ll. 27-8: "Quelque sujet qu'on traite, ou plaisant, ou sublime, / Que toujours le bons sens s'accorde avec la rime."

10 Canto II, 1-6:

> As a fair nymph, when rising from her bed,
> With sparkling diamonds dresses not her head,
> But without gold, or pearl, or costly scents,
> Gathers from neighboring fields her ornaments;
> Such, lovely in its dress, but plain withal,
> Ought to appear a perfect Pastoral.

Translation from Sir William Soane for John Dryden, ed. Albert S. Cook, *The Art of Poetry: The Poetical Treatises of Horace, Vida, and Boileau* (Boston: Ginn & Company, 1892), 173.

11 *Selected Criticism: Boileau*, Ernest Dilworth (New York: Bobbs-Merrill, 1965), 3.

12 Moriarty, *Taste and Ideology*, 180.

13 Moriarty (ibid., 185) states that a dependence on the old nobility is, in effect, a personal one, as in the feudalist relations between lord and vassal, but "Capitalist relations, speaking in the abstract, are impersonal: as long as someone buys this product, operates this machine, manages this plant, and does so competently where it matters, the system can work. Similarly, for Boileau, as long as his poems don't end up being read for the entertainment of lackeys hanging around the Pont-Neuf, it doesn't much matter who reads them."

14 Selma A. Zebouni, "Rhetorical Strategies in *L'Art poétique*, or, What Is Boileau Selling?" *French Literature Series*, vol. xix (1992), 10-18.

15 Ibid., 14.

16 *Trattenimenti di Aristo e di Eugenio*, trans. Domenico Jannò (Palermo: Antonio Pecora, 1714).

17 Gian Gioseffo Orsi, *Le considerazioni sopra un famoso libro franzese intitolato La manière de bien penser dans les ouvrage d'esprit* (Bologna: Pisarri, 1703). A later edition – Marchese Giovan-Gioseffo Orsi, *Considerazioni Sopra la Maniera di ben Pensare ne' Componimenti già pubblicata dal Padre Domenico Bouhours della Compagnia di Gesù, Modena, 1735 (s'aggiungono tutte le Scritture, che in occasione di questa letteraria Contesa uscirono a favore, e contro al detto Marchese Orsi, Colla di lui Vita, e colle sue Rime in fine)* (Modena: Soliani, 1735), combines a translation into Italian of Bouhours's text and various writings by Orsi and other *letterati* involved in the dispute.

18 In general, I will be following the arguments in M. Grazia Accorsi and Elisabetta Graziosi, "Da Bologna all'Europa: La Polemica Orsi-Bouhours," *La rassegna della letteratura italiana*, (September–December 1989), 84-137. The literature on the dispute is fairly extensive: G. Toffanin, *L'eredità del Rinascimento in Arcadia* (Bologna: Zanichelli, 1923), 59-109; G. L. Moncallero, *L'Arcadia*, vol. I, *Teorica d'Arcadia. La*

premessa antisecentista e classicista (Florence: Olschki, 1958), 188-231; V. Lugli, Il Muratori e la "placida battaglia" contro Bouhours, in *Miscellanea di studi muratoriani (Atti e Memorie del convegno di studi storici in onore di L. A. Muratori nel bicentenario della morte*, Modena, 14-16 aprile 1950) (Modena: Aedes Muratoriana, 1950), 135-41; Francesco Paolo Madonia, "Osservazioni in margine alla polemica Orsi–Bouhours," *Esperienze letterarie* XXIII, n. 1 (1998), 77-89.

19 Dominque Bouhours, *Les entretiens d'Ariste et d'Eugene* (Paris: Seb. Mabre-Cramoisy, 1671), 90-1.

20 Accorsi, "La Polemica Orsi–Bouhours" (who writes the first part of the article), 88.

21 Cited in ibid., 89; B. Lamy, *La rhétorique ou l'art de parler* (1670; reprint, Paris: A. Pralard, 1688), 53.

22 Tagliabue, 1962, 47: "Il problema metodologico si può dire che gli eruditi italiani nemeno lo afferrarono."

23 Benedetto Croce, *La letteratura italiana del settecento: note critiche* (Bari: Laterza, 1949), 5.

24 Camillo Ettori, *Il buon gusto ne' componimenti retorici* (Bologna, 1696), 4-5: "Un autor franzese che, senza nome ha stampato in materie di ben parlare, reca due definizioni del buon gusto (diciam così) rettorico. L'uno, che egli è armonia d'ingegno e di ragione: l'altra un naturale giudicio il quale risiede indipendentemente da' precetti nell'animo di alcuni; in vigor di cui reprimendo l'impeto dell'ingegno fa che si contegna nelle sue proposizioni entro i confini della ragione."

25 Graziosi, "La Polemica Orsi–Bouhours," 113.

26 Ibid., 122-3.

27 Brendan Dooley, *Science, Politcs, and Society in Eighteenth-Century Italy: The Giornale de' lettarati d'Italia and Its World* (New York & London: Garland, 1991).

28 Lodovico Antonio Muratori, *Opere*, vol. VIII (Arezzo: 1768). For Muratori, see G. F. Soli Muratori, *Vita di L. A. Muratori* (Venice, 1756). The most extensive treatment in English remains J. G. Robertson, *Studies in the Genesis of Romantic Theory in the Eighteenth Century* (1923; reprint, New York: Russell & Russell, 1962), 60-95. The literature in Italian on Muratori is vast. See bibliography for more references.

29 Voltaire, *Oeuvres completes*, nouvelle edit. Conforme à l'édit. Beuchot, II (1878), 472. Cited in Dupront, 1976, 12: "Les Italiens on dégénéré jusqu'au temps de Muratori et de ses illustres contemporains."

30 Marcus Landau, *Geschichte der italienischen Literatur des 18en Jahrhundert* (Berlin: E. Felber, 1899), 208.

31 L. Vischi, "Come L. A. Muratori fosse chiamato dottore all'Ambrosiana," *Atti e Memorie della R. Deputazione di Storia Patria per le provincie modenesi e parmensi*, vols. III, IV (1887), 414-15.

32 Sergio Bertelli, *Erudizione e storia in Lodovico Antonio Muratori* (Naples: Istituto Italiano per gli Studi Storici 1960), 100-74.

33 Vincenzo Ferrone, *The Intellectual Roots of the Italian Enlightenment*, trans. Sue Brotherton (Atlantic

Highlands, NJ: Humanities Press, 1995), 99–105. For Conti, see G. Gronda, "Antonio Conti," *Dizionario biografico degli Italiani*, vol. 28 (Rome: Istituto della Enciclopedia Italiana, 1983), 352–9.

34 Bertelli, *Erudizione e storia*, 217–18

35 Muratori, *Opere*, VIII, 2.

36 His original Arcadian name was Leucoto Gateate, according to *Le vite degli Arcadi* (1708). Perhaps the Lamindo Pritanio came from his membership in the Arcadia Nuova. He used the name to avoid detection as the author of the early sections of the *Primi disegni* that were sent around to Italian writers and intellectuals.

37 Anne Goldgar, *Impolite Learning: Conduct and Community in the Republic of Letters 1680–1750* (New Haven and London: Yale University Press, 1995), 2.

38 Giovan Mario Crescimbeni, *Prose degli Arcadi* (Rome: A. de'Rossi, 1718), preface: "accoglie ogni scienza, e ogni genere di lettere: e tutte egualmente le riguarda, e coltiva per rendersi fruttuosa alla repubblica." He is in effect coopting comments made by Lodovico Antonio Muratori in *Riflessioni sopra il buon gusto*.

39 Amadeo Quondam, "L'Arcadia e la 'Repubblica delle lettere,'" *Immagini del settecento in Italia: A cura della Società italiana di studi sul secolo XVIII* (Bari: Gius. Laterza & Figli, 1980), 198–211.

40 Alberto Vecchi, "La nuova accademia letteraria d'Italia," *Accademie e cultura: aspetti storici tra Sei e Settecento* (Florence: L. Olschki, 1979), 39–72.

41 Muratori, *Opere*, VIII, 1–35.

42 Muratori, *Opere*, VIII, 3: "Ciò che può sembrare alquanto strano, si è il sapere, che non guerre civili, non invasioni di barbari, non mancanza di Scuole, o d'Ingegni, non tirannia di Regnanti, non altre pesti furono cagione, che nel secolo precedente giacesse l'Italia alquanto dimenticata del suo valor negli studj. L'ozio solo per avventura fu quel mostro, che a poco a poco avvelenò le menti, e le distolse dal faticoso cammino della virtù, non lasciando luogo a quel nobile rossore, a quella generosa invidia, che dovea nascere ne' nostri maggiori al rimirar le proprie campagne vinte in fecondità dalle nostre vicine."

43 See the discussion of Muratori's plans in Ferrone, 1995, 90–2.

44 Anna Burlini Calapaj, "I rapporti tra Lamindo Pritanio e Bernardo Trevisan," *Accademie e Cultura: aspetti Storici tra sei e settecento, Biblioteca dell'Edizione Nazionale del Carteggio di L. A. Muratori, V* (Florence: Leo S. Olschki, 1979), 73–92.

45 "Io non ho mai creduto che si possano unire gli ingegni italiani troppo divisi di luogo e differenti di idée," quoted in Calapaj, 1979, 85; see L. A. Muratori, *Epistolario*, vol. II, 746–47.

46 Dooley, *Science, Politics, and Society*, 33–5.

47 Lodovico Antonio Muratori, *Della perfetta poesia italiana* in "Opere classiche italiane" (Milan: 1821), vol. III, 395. "Questo buon gusto è un nome venuto su nei nostri tempi; pare un nome vagante, e che non abbia certa e determinata sede, e che si rimetta al Non so che, e a una fortuna e a un Accerto dell'ingegno. Se vuol dire quello che gli antichi diceano, Giudizio, è buona cosa; e sotto un nuovo vocabolo dice il tutto."

48 Muratori, VIII (1768), 65: "Noi per buon Gusto intendiamo il conoscere ed il poter giudicare ciò, che sia difettoso, o imperfetto, or mediocre nelle Scienze e nelle Arti."

49 Immanuel Kant, *Critique of Judgment*, §19, Ak. 237 (section number and pagination of the Akademieausgabe); trans. Werner Pluhar (Indianapolis: Hackett 1987). Italics added.

50 Kant could have read Muratori's *Riflessioni sopra il buon gusto* in a German edition, *Kritische Abhandlung von dem guten Geschmacke inden schönen Künsten und Wissenschaften, Aus dem Italienischen ürbersetzt* (Augsburg: Matthäus Rieger, 1772).

51 Muratori, VIII (1768), 67: "Tuttavia potendo una Fantasia, sebben vivace, e una Memoria fortunata unirsi ad un infelice Intelletto, e ad una pessima Volontà, non è l'una, o l'altra capace di far, Eroi nella Repubblica delle Lettere."

52 Gary Hatfield, "The Cognitive Faculties," *The Cambridge History of Seventeenth-Century Philosophy*, ed. Daniel Garber and Michael Ayers, vol. II (Cambridge: Cambridge University Press, 1998), 953–1002.

53 *Spectator*, III, 561 (no. 416, 27 June 1712).

54 Wolfgang Iser, *The Fictive and the Imaginary: Charting Literary Anthropology* (Baltimore and London: Johns Hopkins University Press, 1993), 171–248, provides a short intellectual history of the notion of fantasia–imagination and also shows the complex interplay the imaginary has with the fictive. Iser discusses Hobbe's confusion on 173.

55 Muratori, *Della perfetta poesia* (1821), book 1, chapters 14 and 21.

56 Muratori, VIII (1768), 88: "Finalmente se queste Arti o Scienze si fanno ancora servire all'ultimo fine dell'uomo, cioè a far noi, o gli altri buoni Teologi, e buoni Morali, non solo in Teorica, ma eziandio in pratica . . . allora il prezzo e merito loro sarà eminente, e singolare sarà il nostro profitto."

57 Muratori, VIII (1768), 107: "Altrove però non apparisce cotanto la necessità di ben ponderare ciò, che vaglia l'Ingegno proprio, come nelle materie di Teologia oppur di Fede. Da che mai sgorgarono i più degli errori e dell'Eresie, se non da questa fonte: cioè a dire dall'umana Ambizione, e dall'immaginar se stesso più robusto e penetrante degli altri. Senza ben consigliarsi colle proprie forze; senza badare all'esortazione dell'Ecclesiastico. . . . Si figurarono alcuni di poter mirare apertamente ciò, che è conceduto di mirar quaggiù solamente confusamente e in enigma. Si misero pertanto a volere sciogliere a spiegare i difficilissimi nodi della Predestinazione, cosa che facea tremare San Paolo, e ha fatto abbassar le ciglia di S. Agostino, a tanti Santi Padri, Concilj, e Scrittori acutissimi. Con egual temerità altri vollero, (e stimarono, che il volere fosse un potere) pienamente capire gl'ineffabili Misterj della

58 Ibid., 90: "Tutte però le varie Arti e Scienze possono, per colpa o per elezione di chi le tratta, divenire e comparire sterili, o di poco momento, almeno in qualche lor parte. Quel disputare in esse di sole parole, quel ricercare si studiosamente le minuzie, quel muovere tante quistioni intorno al possibile, e far controversia e fascio d'ogni cosa, anche più minuta: è cagione, che ad alcuni riescano o dispiacevoli, o poco lodevoli infin le più nobili Scienze. Ma il Buon Gusto distingue il merito delle Arti e delle Scienze dal demerito di chi le tratta. In ciascuna sorte di letteratura noi possiamo contare qualche cacciatore di mosche; laonde è uffizio del suddetto buon Gusto il tenerci lungi da questo difetto col considerare la maggiore, o minore, o niuna utilità, che può trarsi dalle questioni, dagli argomenti, e dalle cose imparate o insegnate."

59 Ibid., 91.

60 Eric Cochrane, "Muratori: The Vocation of a Historian," *The Catholic Historical Review* LI, no. 2 (July 1965), 172.

61 Muratori, VIII, 1768, 93–105.

62 Ibid., 99: "Nella Moral Teologia sono due eccessi, il troppo ristringere, il troppo allargare la giurisdizione della Coscienza; cioè l'essere troppo Rigorista, come oggidì si dice di certi, o l'essere Probabilista, cioè troppo indulgente, e benigno: estremo senza fallo più pericoloso dell'altro a'Cristiani."

63 Ibid., 109: "Parliamo qui di materie nulla pertinenti all'Fede, e alla Religione, poichè di quelle, che v'appartengono, terremo ragionamento più abisso. Bene sta, che Aristotele dica: nulla essere nell'intelletto, che prima non sia stato nel sense; o che la privazione sia un de'principj delle cose; o che i colori, e i sapori sieno negli oggetti, e simili altre proposizione."

64 Antonio Favaro, *Miscellanea galileiana inedita: Studi e ricerche* (Venice: Antonelli, 1887), 155. Quoted in Ferrone, *Intellectual Roots*, 4.

65 Ibid.

66 Muratori, *Opere*, VIII, 115: "Solo diremo, che oltre a questi Metodi particolari ce ne sono altri due universali. Il primo tratta della general maniera, colla quale si dee investigare la verità, e fuggire l'Errore, e questo si può apprendre dalle opere del Cartesio, e de' suoi più illustri discepoli. Il secondo riguarda la general maniera di studiare, imparare, e insegnare, o in privato, or in pubblico, e di questo hanno eziandio trattato moltissimi altri eruditi. Ond'io rimettendo i Lettori a tali opere, passo avanti."

67 Ibid., 134–5.

68 Lodovico Antonio Muratori, *Opere del proposto Lodovico Antonio Muratori*, vol. IX, parts 1 & 2 (*Della perfetta poesia italiana*) (Arezzo: Michele Bellotti, 1769), 148: "Per anni parecchi è stata in gran credito la Scuola Marinesca. ma da molti anni in qua essendosi accordati i migliori Ingegni d'Italia per isbandir que' pensieri ingegnosi che non han per fondamento il vero s'è ridotta a pochi giovani mal accorti o vecchi tenecissimi dell'antico linguaggio la Monarchia del Gusto cattivo. O con isdegno o con riso s'intendono ora le agutezze, i Concetti falsi avendo finalmente la Ragione, la Verità e il buon Gusto riportata vittoria e trionfato nelle Accademie Italiane. Contuttociò, poichè il desiderio di giovare altrui mi ha fatto riprendere questa fatica, sarà parimenti lecito a me di perseguitar le reliquie di una peste letteraria che va ripullulando ne' versi e nelle Prose d'alcuni e massimamente perchè vivono ancora col beneficio delle stampe coloro che, o in Teorica o in Pratica, fondarono il barbaro Regno di questi falsi pensieri."

69 Biblioteca Angelica, Rome, Archivio Arcadia, *Manoscritti dell'Arcadia*, no. 23, 185–91r.

70 Tommaso Ceva, *Memorie di alcune virtù del signor Conte Francesco De Lemene con alcune riflessioni sulle sue poesie* (Milan: Bellagatta, 1706), 123–4.

71 Quoted by Paul Buck, *Violent Silence: Celebrating Georges Batailles* (London: Georges Batilles Event, 1984).

72 Carlo Frati, *Dizionario bio-bibliografico dei bibliotecari e bibliofili italiani* (Florence: 1933), 548.

73 Bernardo Trevisan, "Introduzione all'Opera del Pritanio cioè la Teorica del Buon Gusto," *Opere del Proposto Lodovico Antonio Muratori*, VIII, (Arezzo, 1768), 36–58.

74 Trevisan (*Opere* VIII), 37: "Allorchè la tracotanza dell'uomo, resa contumace al Divino precetto, cercò nella cognizione del bene, e del male il sapere, miseramente il perdette. Conoscevan nel suo primo stato felice con pure, ed assolute nozioni il Vero ed il Bene reale, e contemplando l'Ipostasi de'entrambi nell'essere incircoscritto d'Iddio, conosceva nello stesso l'essere delle cose verificato, e raccolto. Ingombro di specie contaminate, ed impure, dovette colo mezzo di congetture fallaci, e di comparazioni dubbiose investigare il modo, con cui, mediante gl'istessi attributi, le cose fossero ciò, che sono, e dal non essere fossero con caratteri, e proprietà particolari distinte. Quindi incominciò a dar nome di vero alla conformità attuale degli oggetti coll'immagine, che de' medesimi concepiva, non al concetto inessabile, ed assoluto del Creatore. Si avanzò a circoscrivere come Bene, non più la comunicazione, che hanno col Creatore le cose, ma la relazione, che le cose possono avere coll'esser suo."

75 Ibid., 37: "Conservò dunque l'uomo, quasi retaggio della prima sua Nobiltà l'inclinazione incessante a questi due grandi attributi, che dicemmo, di Vero, e di Bene; ma ne perdette in gran parte il buon'uso per gli equivoci, da cui restò tale inclinazione insidiata, e perchè mancò ad esso l'abilità di conoscerli."

76 Ibid., 38: "Incontra l'Uomo poscia nel pericolo, e cade, perchè non ben conosce l'Errore, nè lo conosce

per questi due gran difetti; L'uno è la mancanza di quelle similitudini, con le quali praticando il confronto si avanza nel raziocinio; L'altro, dice il dotto Cardinale di Cusa, è *infirmitas gustus*, la quale *rationem seducit.*"

77 Ibid., 40: "Come il Gusto, ed il Buon Gusto del senso, sebbene in quella recondita parte, che senso comune appelliamo, si ferma, tuttavia dimostra altresì di continuo i suoi effetti rispettivamente in ognuno de' suddetti sentimenti particolari; Così ancora, abbenchè il Buon Gusto della Mente nella più sublime parte della stessa le sue radici abbarbicate mantenga, pure in ciascheduna delle sue potenze sempre mai germoglia, e fiorisce. Queste possono anzi paragonarsi a' sopraddetti sensorj, o seguendo l'allegoria animosa, posson cangiar nome con esso loro. La Memoria può dirsi l'orecchia dell'Anima, come l'orecchia la memoria de' sensi; L'Intelletto l'occhio della Mente, come l'occhio l'Intelletto del Corpo; La Volontà bocca della ragione, come la bocca Volontà di questo materiale composto."

78 Ibid., 40–1: "I. Che queste principali Potenze si dispongano in guisa tale, che faccia ciascuna le parti, che faccia ciascuna le parti, che ad essa appartengono, nè si arroghi le funzioni dell'altre. II. Che tutte procurino di trattenere in disciplina, e moderazione quelle Facoltà subalterne, che a loro servono, come ministre, ed ancelle. III. Che mantengano in divozione, e soggette alcune tumultuanti affezioni, che spesso osano dimostrarsi contumaci a' loro comandi, anzi insidiare la medesima lor dignità."

79 Ibid., 42: "certo chè sempre ci discosteremo dal vero, fabbricheremo a noi stessi l'inganno, e potrem dire di giocolare più tosto, fingendoci figurette a capriccio, che di filosofare, ed intendere."

80 Ibid., 44: "Quante volte non mentisce, figurando chimere, che non mai furono, proponendo imposture, che non mai sono?. . . . E tutto in tal guisa mesce, confonde, disperde, o traforma, che o non più rappresenta ciò, che prima era, o il fa diversamente apparire. Ella applica Immagini particolari a cose trascendenti, ed astratte: Unisce proporzioni naturali, e finite a ciò, che oltre la natura si avanza, e dentro l'infinito s'estende: Innesta agli umani riguardi le cose, che sono Divine. Da corpo all'incorporeo, misura all'immenso, numero all'infinito: Ma poscia con quai consequenze; D'equivoci, di fallacie, di errori, e di opinioni mostruose, ingannevoli, e false."

81 Ibid., 47: "Spesso nell'ardire eccede; Spesso manca nella cautela; e sempre, che in uno di questi estremi s'abbatta, si scosta dal Vero, s'allontana dal Bene, e dal Buon Gusto s'aliena."

82 Ibid. 48: "I pregiudizj tendono nella Memoria a contaminare l'inclite specie del Vero. Gli Affetti vanno spargendo caligini per confondere l'Intelletto; Ma gli Appetiti sempre mai s'impiegano a scuotere, a rapire, ed a spingere in più modi la Volontà."

83 Ibid., 52: "L'appetito di Sapere è naturale ne' suoi principj, ed egualmente violento ne' suoi progressi; ma perchè naturale, non può condannarsi, benchè sia violento ed estremo. Da santa penna fu scritto, che l'uomo, il quale dee vivere, come sempre dovesse morire, debba imparare, come se sempre viver dovesse. Il male si è, che essendo più lo scibile di quello; che può sapersi, nè potendosi tutto apprendere, si sceglie spesso lo studio di ciò, che men giova, o che talvolta più nuoce. Alcuni cercano solo quello, che più risplende; Altri ciò che reca loro vantaggio; Diversi l'inusitato; Moltissimi il nuovo; Non pochi ciò, che serve a convincere gli altri, e non solo ci porta talvolta sapere lo male, ma ancora ci necessita a sapere male." And further, ibid., 53: "L'Appetito di Potere è ugualmente naturale nell'Uomo. Ogni cosa creata aspira a quella maggior perfezione, in cui possa più ostentare gli atti della propria natura; ma l'uomo, che riconosce in se stesso con l'anima una parte, che veramente è Divina, e che la simiglianza [sic] d'Iddio in sè contempla; per natura sempre cerca d'essercitar quegli atti, che ai Divini attributi convengono, e sempre aspira a poter riunirsi a quel Dio, da cui la sua prima origine trasse: Perchè nondimeno il peso di questa spoglia mortale è in tutti insuperabile ostacolo a così elevata intenzione, da ciò nasce, che non v'è alcuno, il quale, finchè in questa carne è rinchiuso, possa giugnere a questo fine."

84 Ibid., 56: "Non v'è dubbio, che la miglio Lode è quella, ch'è più universale; ma non è però più universale, quella, che è formata dal numero maggiore degli uomini, quando in questi non sieno inclusi ancora i migliori. Non può il volgo conoscere, e compensare quelle azioni, ch'egli è incapace ad eseguire. Il peggio nondimeno si è, che l'occhio imperfetto di questo strano animale non giugne nelle cose oltre la superficie, nè le sue stupide orecchie sono abili a raccogliere altro suono, che certo tumultuante, e sforzato; onde chi ricerca da lui la Lode, o studia solo nelle superficiali apparenze, con quell'ingannevole oggetto, che non mai col Buon Gusto s'accora."

85 Filippo Baldinucci, *The Life of Bernini*, trans. Catherine Enggass, foreword by Robert Enggass (University Park and London: Pennsylvania State University Press, 1966), 74.

86 E. H. Gombrich, "The Renaissance Theory of Art and the Rise of the Landscape," *Norm and Form: Studies in the Art of the Renaissance* (London: Phaidon, 1966), 107–21.

87 Book IX, chap. 4., translated and quoted in Gombrich, 111.

88 G. P. Bellori, *Le vite de' pittori, scultori et architetti moderni* (Rome, 1672), 460.

89 I follow pretty closely Jason Gaiger, "Schiller's Theory of Landscape Depiction," *Journal of the History of Ideas* 61, no. 1, (January 2000), 114–31.

90 Gaiger, "Schiller's Theory," 123.

91 Friedrich Schiller, *"Über Matthisons Gedichte,"* in ed. *Herbert Meyer Schillers Werke*, Nationalausgabe, XXII (Weimar, 1958), 269–70, as quoted and translated in Gaiger, 2000, 123. Italics in the original.

92 See Erwin Panofksy, *Idea: A Concept in Art Theory*, trans. Joseph J. S. Peake (New York: Harper and Row, 1968).

93 Schiller, "Matthisons Gedichte," 266; as quoted and translated in Gaiger, "Schiller's Theory," 123.

94 Gaiger, "Schiller's Theory," 126.

95 Friedrich Schiller, *On the Naïve and Sentimental in Literature*, trans. Helen Watanabe-O'Kelly (Manchester, England: Carcanet New Press, 1981).

96 Quoted in Watanabe-O'Kelley's introduction to Schiller (1981), 9.

97 Schiller, *Naïve and Sentimental*, 41, extends the notion of the poet to the artist (although he concedes that there are limitations to the parallel): "What has been said here of the poet can, with obvious modifications, be extended to any artist."

98 Ibid., 22.

99 Ibid., 42.

100 Ibid.: "the question arises whether he should linger more with reality or more with the ideal – whether he wants to depict the former as an object from which he turns away or the latter as an object which he turns towards. His depiction will, therefore, either be satirical or (in a wider meaning of this word which will be explained later) it will be elegiac; every sentimental poet will adhere to one of these two ways of feeling."

101 Frederick Garber, "Pastoral Spaces," *Texas Studies in Literature and Language*, 30, no. 3 (Fall 1988), 431–60, develops a reading of Schiller that understands his employment of the word *Empfindungsweise* as both "modes of feeling" and "modes of perception."

102 Schiller, *Naïve and Sentimental*, 62–3.

103 Ibid., 63.

104 Ibid., 65.

105 Ibid., 65–6.

106 Erwin Panofsky, "ET IN ARCADIA EGO: Poussin and the Elegiac Tradition," *Meaning and the Visual Arts* (Garden City, NY: Doubleday Anchor Books, 1955), 304; Panofsky also refers to the tradition of the actual Arcadia in Greece being wrapped in a " 'sweetly sad' melancholy" (297).

THREE: ARCADIA, PASTORALISM, AND GOOD TASTE

1 Bruno Snell, "Arcadia: The Discovery of a Spiritual Landscape" in *The Discovery of the Mind: The Greek Origins of European Thought*, trans. Thomas G. Rosenmeyer (Oxford: Basil Blackwell, 1953). For Arcadia also see Terry Gifford, *Pastoral* (London and New York: Routledge, 1999), especially 13–44; Luba Freedman, *The Classical Pastoral in the Visual Arts* (New York: Peter Lang, 1989), 103–52; Peter V. Marinelli, *Pastoral* (London: Methuen, 1971), 15–56; Erwin Panofsky, "ET IN ARCADIA EGO: Poussin and the Elegiac Tradition," *Meaning and the Visual Arts* (Garden City, NY: Doubleday Anchor Books ,1955), 295–320. Theories of the pastoral are legion and, in general at least, lie outside of the scope of this text.

Just the same, I have provided in the bibliography a number of references to the study of the pastoral.

2 Thomas G. Rosenmeyer, *The Green Cabinet: Theocritus and the European Pastoral Lyric* (1969; reprint, Berkeley, Los Angeles, and London: University of California Press, 1973), 238.

3 Norman Bryson, *Looking at the Overlooked: Four Essays on Still Life Painting* (Cambridge: Harvard University Press, 1990), 228.

4 Panofsky, "ET IN ARCADIA EGO," 300.

5 Snell, *Arcadia*, 294.

6 Ibid., 300.

7 Ibid.

8 Freedman, *Classical Pastoral*.

9 Biblioteca Angelica, Rome, Archivio Arcadia, *Il catalogo de pastori arcadi*, II, 52, no. 1301.

10 Frank R. DiFederico, *Francesco Trevisani Eighteenth-Century Painter in Rome: A Catalogue Raisonné* (Washington, DC: Deacatur House Press, 1977), 14–19; Andrea Zanella, "Francesco Trevisani e il Teatro Arcadico," *Carlo Marchionni architettura, decorazione e scenografia contemporanea*, ed. Elisa Debenedetti, *Studi sul settecento romano*, no. 4 (Rome: Multigrafica Editrice, 1988), 405–12; A. Griseri, "Francesco Trevisani in Arcadia," *Paragone* (1962), 28–37, and idem, "Juvarra e la pittura d'arcadia," *Studi Piemontesi*, 12 (1983), 332–8; Christopher M. S. Johns, *Papal Art and Cultural Politics: Rome in the Age of Clement XI* (Cambridge: Cambridge University Press, 1993), 197–201. Much of the discussion here of Trevisani and della Valle's tomb of Thomas Dereham is adapted from "What Is Buon Gusto? The Arcadian View," *Antologia di Belle Arti* (2000), 72–84, nn. 59–62.

11 Natalino Sapegno, *Compendio della storia della letteratura italiana*, II (Florence: La Nuova Italia, 1957), 429, uses the phrase "gran paese del tenero" in his reference to the arcadian poetry of Carlo Innocenzo Frugoni (1692–1768).

12 Anthony Blunt, *Nicolas Poussin* (London: Pallas Athene, 1995), 225–7.

13 See the translation of Rapin by Thomas Creech, *The Idylliums of Theocritus with Rapin's Discourse of Pastorals* (Oxford: Printed by L. Lichfield for Anthony Stephens, 1684), cited in Rosenmeyer, 1969, 53.

14 Leo Spitzer, *Classical and Christian Ideas of World Harmony; prolegomena to an interpretation of the word "Stimmung,"* ed. Anna Granville Hatcher, preface by Rene Wellek (Baltimore: Johns Hopkins Press, 1963).

15 Frederick Garber, "Pastoral Spaces," *Texas Studies in Literature and Language*, 30, no. 3 (Fall 1988), 440.

16 Hubert Damish, "Semiotics and Iconography," in Thomas Sebeok, ed., *The Tell Tale Sign* (Lisse: Peter de Ridder Press, 1975), 29. Damisch makes the distinction between iconography as used by Panofsky and in semiotics. In semiotics one "is intent on stripping down the mechanism of signifying" when employing the term iconography.

17 Garber, "Pastoral Spaces," 439.

18 Friedrich Schiller, *On the Naïve and Sentimental in Literature*, trans. Helen Watanabe-O'Kelly (Manchester, England: Carcanet New Press, 1981), 22, italics in original.

19 Alistair Fowler, *Kinds of Literature: An Introduction to the Theory of Genres and Modes* (Cambridge: Harvard University Press, 1982); see especially Garber, "Pastoral Spaces," 438, on the interpretation of *Empfindungsweise* as something more than what Poggioli in *The Oaten Flute: Essays on Pastoral Poetry and the Pastoral Ideal* (Cambridge: Harvard University Press, 1975), 51, simplifies as raw feeling: "the modes Schiller describes can in no sense be detached from the conditions of the sentimental state, especially the implacable spaces that define its ways of being. Subject and object are fused indissolubly in a state of absolute relation."

20 A. Busiri Vici, "Bloemen, Jan Frans van, detto Orizzonte," *Dizionario biografico degli Italiani*, vol. XX, 1968, 793–5; idem, *Jan Frans van Bloemen Orizzonte e l'origine del paesaggio romano del settecentesco* (Rome: Ugo Bozzi, 1973); Denis Coekelberghs, *Les peintres belges à Rome de 1700 à 1830* (Amsterdam: Uitgeverij Jimmink, 1976), 19–74.

21 David Rosand, Robert C. Cafritz, and Lawrence Gowing, *Places of Delight: The Pastoral Landscape*, exh. cat., National Gallery of Art and the Phillips Collection (New York: C. N. Potter, 1988).

22 Anna Maria Giorgetti Vichi, ed., *Gli Arcadi dal 1690 al 1800: Onomasticon* (Rome: Arcadia, Accademia Letteraria Italiana, 1977), 400. His Arcadian name was Venusio Nemeio. For Vernet, see *Claude-Joseph Vernet, 1714–1789*, exh. cat., ed. P. Conisbee (London, Kenwood House; rev., enlarged, Paris, Mus. Mar., 1976), and Philip Conisbee, "Vernet, Claude-Joseph," *The Grove Dictionary of Art Online*, ed. L. Macy. http://www.groveart.com. (Accessed 16 May 2003)

23 *Diderot on Art*, II, ed. and trans. John Goodman, introduction by. Thomas Crow (New Haven and London: Yale University Press, 1995), 86–128.

24 Michael Fried, *Courbet's Realism* (Chicago: University of Chicago Press, 1990), 8.

25 Wolfgang Iser, *The Fictive and the Imaginary: Charting Literary Anthropology* (Baltimore: Johns Hopkins University Press, 1993).

26 Ibid., 171.

27 Ibid., xiv–xv.

28 *Diderot on Art*, II, 101. This phrasing of the theater of the world comes from Diderot's notable exercise of "being-in-the-painting" (to put it in Heideggerian terms). In the middle of his fabulation on Vernet's painting (discussed later), Diderot explains to his companion that there are differences between the theater as a stage experience and the theater of the world. He insists, just the same, that, as Shakespeare also said, all the world's a stage.

29 See Thomas Crow's introduction to the English edition of the Salons, in *Diderot on Art*, II, ix–xix.

30 *Diderot on Art*, II, 86.

31 Ibid.

32 Ibid., 88.

33 Ibid., 91.

34 Ibid., 97.

35 Ibid., 97. The editor gives the following translation and citation: "Oh rustic home, when will I see you?"; Horace, *Satires*, II, 6, v. 60.

36 Ibid., 98.

37 Ibid.

38 Ibid., 101: "On the stage we prefer to see the good man suffering rather than the wicked man punished, while in the theater of the world, by contrast, our prerference is for the wicked man punished over the good man suffering."

39 Ibid., 119.

40 Charles W. Hieatt, "The Integrity of Pastoral: A Basis for Definition," *Genre* 5 (1972), 2.

41 Garber, "Pastoral Spaces," 444–5.

42 Gaston Bachelard, *The Poetics of Space*, trans. Maria Jolas (Boston: Beacon Press, 1964), xxxi.

43 Vernon Hyde Minor, "The Recollection and Undermining of Allegory in Eighteenth-Century Roman Sculpture," *Storia dell'Arte*, no. 57 (1986), 183–91.

44 Louis Marin and Anna Lehman, "Classical Baroque: Versailles, or the Architecture of the Prince," *Yale French Studies*, Issue 80, "Baroque Topographies: Literature/History/Philosophy" (1991), 175.

45 Louis Marin, *Portrait of the King*, trans. Martha M. Houle (Minneapolis: University of Minnesota Press, 1988), 5.

46 Thomas Puttfarken, *Roger de Piles' Theory of Art* (New Haven and London: Yale University Press, 1985), 55.

47 Aristotle, *Poetics*, 49b31; trans. in Allan H. Gilbert, *Literary Criticism: Plato to Dryden* (Detroit: Wayne State University Press, 1962), 76.

48 Aristotle, *Poetics*, 53b1; Gilbert, *Literary Criticism*, 87.

49 Giovanni Mario Crescimbeni, *Storia dell'Accademia degli Arcadi, istituita in Roma, l'anno 1690 per la coltivazione delle scienze delle lettere umane e della poesia* (London: Bulmer, 1804), 52 (Originally published in Vittorio Giovardi, *Notizia del nuovo teatro degli Arcadi aperto in Roma l'anno 1726* [Rome: Antonio de' Rossi, 1727]); Crescimbeni's comment that it was the duty of the academy to eliminate bad taste appeared originally in chapter 3 of book 3 of his *Stato della Basilica di S. Maria in Cosmedin in Roma* (Rome: Antonio dei Rossi, 1719), 111.

50 Michael Everton, "Critical Thumbprints in Arcadia: Renaissance Pastoral and the Process of Critique," *Style* (Spring 2001), 1–17.

51 Jacques Derrida, "Limited, Inc.," supplement to *Glyph*, 2 (Baltimore: Johnson Hopkins University Press, 1977), 236; see also Vernon Hyde Minor, "Filippo della Valle's Tomb of Innocent XII: Death and Dislocation," *Gazette des beaux-arts* CXII (1988), 133–40.

52 Thomas Dereham of Dereham, Baronet of Great Britain For the love of the true Religion, A fugitive from his Country to Catholics, The last of his family,

Abstained from marriage Lest Loyalty to God and to his lawful king, So faithfully maintained by himself, Should be endangered by his posterity. This constancy of his devotion. He willed should be attested by this sepulchral slab. (THOMAS DEREHAM DE DEREHEM/ MAGNAE BRITTANIAE BARONETTUS/ OVERAE RELIGIONIS AMOREM/ PATRIA AD CATHOLICOS PRONVGVS/ FAMILAE SVAE POSTREMVS/ A NVPTIJS ABSTINVIT/ NE FIDES IN DEVM AC LEGITIMVM REGEM/ SANCTE AB IPSO SERVATA/ POSTERIS IN DISCRIMEN VENIRET/ HANCE PIETATIS SVAE CONSTANTIAM/ SEPULCRALI LAPIDE TESTATAM VOLVIT./ OBIJT. VII NEBRV. A. S. MDCCXXIX./ VIXIT. AN. LIX. MENSES. X.DIES. XI.) Translation from N. Goldie, "The Last of the Norfolk Derehams of West Dereham," *Norfolk Archeology* XVIII, (1914), 1–22. Pier Leone Ghezzi drew a caricature of him (Rome, Biblioteca Vaticana, Ottob. Lat. 3115, f. 68) and scribbled some notes on the back to the effect that Dereham died from an insect bite he received when riding near San Giovanni in Laterano. Because his body was so swollen from his last illness, he was covered by a golden blanket at his funeral in St. Thomas of Canterbury.

53 Anthony Ashley Cooper, third earl of Shaftesbury, *Characteristicks* 3, 381–2, 385.

54 Charlotte Hogsett, "On Facing Artificiality and Frivolity: Theories of Pastoral Poetry in Eighteenth-Century France," *Eighteenth-Century Studies* IV (1971), 420–36.

55 Giovanni Mario Crescimbini, *L'Arcadia del Can. Gio. Mario Crescimbeni* (Rome: Antonio de' Rossi, 1708).

56 Murray Krieger, *Ekphrasis: The Illusion of the Natural Sign* (Baltimore and London: Johns Hopkins University Press, 1992).

57 It was common practice in the early years of the century to mount the phrase UT PICTURA POESIS on the Capitoline Hill during the awarding of prizes to young artists in the Concorsi Clementini (cosponsored by the Arcadians and the Accademia di San Luca). Also the title of the competition in 1706 emphasized the tie between poetry and the visual arts: Le belle arti in lega con La Poesia per L'Accademia del Disegno, Celebrata in Campidoglio il di 6. Maggio 1706 (Rome: Gaetano Zenobi, 1706).

58 In a sense, we can disentangle the "real" (historical figures and actual paintings by Maratti) from the fabulous and allegorical, but his narrative blends them together so that there are no sutures, no seams that separate one from the other.

59 Krieger, *Ekphrasis*, 94.

60 Joseph Addison, *Spectator*, 416, as quoted in Krieger, 99.

61 Stella Rudolph, in "Una visita alla capanna del pastore disfilo, 'Primo Dipintore d'Arcadia' (Carlo Maratti)," *Arcadia: Accademia Letteraria Italiana, Atti e Memorie*, ser. 3, vol. ix, fasc. 2, 3, 4 (Convegno di Studi, 15–18 maggio 1991) III, Centenario dell'Arcadia, Rome, 1991–4, 387–415, reestablishes the identity and histories of these pictures. She points out that the image of Venus was not made for Ferrante Capponi, as

Bellori tells us, but, according to the more reliable information in Francesco Saverio Baldinucci, *Vite di artisti dei secoli XVII–XVIII*, ed. A. Matteoli (Rome: De Luca, 1975), it was made for Alessandro Capponi.

62 Crescimbeni, *Arcadia*, 133–4: "La prima tela (questo quadro fu fatto per la Città di Firenze) che s'offerì al guardo delle Ninfe, esprimeva la favola di Venere punta dallo spino nel piede, per lo cui sangue, le rose, che il riceverono, di bianche, che in prima erano, divennero vermiglie. Rimiravasi in essa assisa sopra un sasso Venere ignuda, se non quanto sottil candido lino per le belle membra si vedea serpeggiare con giudiziosa vaghezza. Appoggiava ella tutta dolente, e affannosa, e smarrita in volto, il manco piede offeso ad un'altro sasso minore, presso il quale era locato un grazioso Amorino, che dopo averle dal piede tratta la termeraria spina, tutto lieto, e ridente, gliele mostrava, quasi in segno d'averlo guarita; e per indicare il proposito, col quale il fanciullo s'era messo ad operare, l'accorto Pittore gli aveva dipinto appresso, gettati appiè d'un tronco, l'arco, e la faretra. Al fianco di Venere, tra le rose già fatte vermiglie, v'era un'altro Amoretto, che recatasi fra le braccia l'una dlle Colombe use a tirare il carro di quella Dea, con essa vezzosamente scherzava, nel tempo stesso, che coll'altra, legata al piè con un nastro di seta, andava per l'aria, scherzando altresi, un altro non men leggiadro fanciullo. A tergo di queste figure, tra arbori, e sassi scorreva limpidissimo fiume, di là dal quale appariva in lontananza vicino a folta boscaglia il bellissimo Adone in atto irresoluto, e pensoso: perciocchè quinci i cani, che egli tiene per lo sguinzaglio, il traggono alla caccia verso la selva, quindi pel mano vien tirato da Amore, il quale gli addita Venere, che l'aspetta, e col guardo quasi l'invita, e tornare da lei, per compiangere la sua disgrazia, notificatagli col mezzo di due allegri Amorini, i quali, spedita la loro ambasciata, si erano rimessi al nuoto nel fiume, per far ritorno all'innamorata lor Dea. Ora queste figure tanto ne' loro atti erano espresse al vivo, che avresti detto, che avessero l'anima; e le Ninfe avrebbero molto più, che non fecero, indugiato sulla loro contemplazione, se non fossero state portate altrove dal vivo desiderio di goder della vista dall'altre maravigliose pitture, onde la stanza era adorna."

63 Not all of these details are visible in the version that is illustrated here. As Rudolph reports, in the inventories of Maratti's house made in 1712, one finds evidence of another copy of this painting, one which perhaps contained the fine detail reported by Crescimbeni: "Quadro d'una Venere a cui l'Amore leva la spina dal piede con altri amorini, E Adone in distanza, copia di quella che andiede in Firenze, e questa dipinta assai dal Sig.r Cav.e Maratti." Rudolph, "Una visita alla capanna," 395, n. 28.

64 Eduardo Saccone, "Wood, Garden, locus amoenus in Ariosto's *Orlando Furioso*," *Modern Language Notes* 112, no. 1 (1997), 12.

65 Horace Walpole, *Aedes Walpolianae: or, a Description of the Collection of Pictures at Houghton-Hall in Norfolk, The Seat of the Right Honourable Sir Robert Walpole, early of Oxford* (London, 1747), 54. Walpole saw the original, which left Houghton Hall in 1779 for the collection of Catherine II, eventually finding its way in the Hermitage Museum (which lent it to the Pushkin Palace). See Rudolph, "Una visita alla capanna," 398, n. 37.

66 Because the painting had been sent to Louis XIV many years earlier, Crescimbeni was working either from a print or from a copy; we know that Maratti received 1250 scudi from Louis and a patent as a painter to the French royal court; Rudolph, "Una visita alla capanna," 396–7.

67 Giovanni Pietro Bellori, *Vita di Carlo Maratti, Pittore, Scritta da Gianpietro Bellori fin all'anno MDCLXXXIX. Continuata e terminata da altri* (Rome: Antonio de' Rossi, 1732), 90: "ed uno molto grande al Marchese Pallavicini, nel quale rappresentollo in piedi in abito eroico, ed incontro se stesso finse a sedere, che il ritraea in pittura, avendo appresso le tre Grazie, donzelle bellissime, che pare gli assistano, per infondere nelle opere di lui la venustà, e la leggiadria, dono, che con lo studio non può acquistarsi. Intanto la Gloria spiega le ali in aria, e corona di alloro il Marchese a cui si fa avanti il Genio, che gli addita con la destra un monte scosceso in lontananza, su la cima del quale vedesi il Tempio della Virtù, e questo dipinto fu riputato un parto de' più insigni del suo pennello."

68 Rudolph, "Una visita alla capanna, 401, quoting from C. G. Ratti, *Istruzione di quanto può vedersi di più bello in Genova di Pittura, Scultura ed Architettura*, 2d ed., vol. I (Genoa, 1780), 142–3, recalls for us an octave, with a hendecasyllable (ababab) scheme culminating in a rhyming couplet, that describes this painting. Although the "voice" of the poem would appear to be Carlo's, there is no evidence whatsoever that he wrote poetry; as Rudolph argues, it is most likely written by his daughter Faustina.

69 Benjamin Lee, *Talking Heads* (Durham and London: Duke University Press, 1997), 23.

FOUR: WHAT IS ARCADIAN ARCHITECTURE?

1 Sandro Benedetti, *L'architettura del'Arcadia nel settecento romano* (Rome: Bonsignori Editore, 1997). This text contains (among other pieces) his two earlier essays, "L'architettura dell'Arcadia: Roma 1730," in *Bernardo Vittone e la disputa fra Classicismo e barocco nel settecento*, Atti del Convegno Internazionale, Accademia delle Scienze di Torino (21–24 October 1970), Turin Accademia delle Scienze, vol. I (1972), 337–69; "Architettura in Arcadia: poetica e formatività," *Atti e memorie. Convegno di Studi, III Centenario dell'Arcadia, Arcadia Accademia Letteraria Italiana* (Roma: 1991–4), 355–65 (this latter article is in substance a recapitulation of the earlier article on Vittone).

2 Carlo Calcaterra, *Il barocco in Arcadia e altri scritti sul settecento* (Bologna: Nicola Zanichelli Editore, 1950), 5.

3 Lione Pascoli, *Vite de' pittori, scultori ed architetti viventi, dai manoscritti 1383 e 1743 della Biblioteca Communale "Augusta" di Perugia*, introduction by Valentino Martinelli (Treviso: Libreria Editrice Canova, 1981).

4 Philip Sohm, "Lione Pascoli," *The Grove Dictionary of Art Online*, (Oxford University Press). (accessed 7 November 2003). Available: http://www.groveart.com.

5 It is necessary to "abbellir la metropolis per maggior splendore, e per magnificenza maggiore del principe, e per maggior comodo ancora, e per vantaggio maggior dei commercianti e della nazione." Pascoli, *Vite de' pittori*, 177; also see Eugenio Battisti, "Lione Pascoli, Lujigi Vanvitelli e l'urbanistica italiana del settecento," *Atti del Congresso di storia dell'architettura* (1956), 51–64.

6 The importance of utility in *buon gusto* had already been brought up in an oration delivered at the annual prize giving on the Capitoline Hill in 1702 by Giovanni Battista Zappi (1667–1719), *Recitata in Campidoglio nell'Aprimento dell'Accademia del Disegno, sotto gli Auspicij di PP. Clemente XI l'anno 1702*. The utilitarian argument surfaces again in an important address given under the same auspices and in the same place in 1750, when Francesco Maria Zanotti (*Orazione del signor Francesco Maria Zanotti in lode della pittura della scoltura, e dell'architettura recitata in Campidoglio li 25 maggio 1750* [Bologna: Lelio dalla Volpe, 1750]) argues strongly against utility and in favor of disinterested beauty.

7 "L'etruria esulta e ride," L. Rovere, V. Viale, and A. E. Brinckmann, in *Filippo Juvarra* (Milan: Casa Editrice Oberdan, 1937), 96.

8 Although not published until 1754 (by Benedini in Lucca), the book reflects attitudes current from at least a generation earlier. As Bottari himself wrote in his "Avviso" to the first edition, he had been working on the dialogues for twenty years. I am using the 1826 edition, published by Pietro Fiaccadori in Reggio. See also Alba Costamagno, "Agesia Beleminio (G. G. Bottari) e l'Accademia dell'Arcadia nel settecento," *Quaderni sul neoclassico* 3, *Miscellanea* (1975), 43–63.

9 Giovanni Gaetano Bottari, *Dialoghi sopra le tre arti del disegno* (Reggio: P. Fiaccadori, 1826), 90.

10 Ibid., 96: "Fanno come è possono, cioè male, come voi e come tutti veggono, e come dee fare necessariamente chi manca del fondamento principale, e che va tastoni, e opera a caso, e per questo si veggono fabbriche grandi, e d'immensa spesa, tanto sacre, che profane, e tanto pubbliche, che private, le quali fanno pieta, e sono veramente sofistiche, e senza poeter trovarne la ragione, poichè senza ragione sono state fatte, come il rabescame di certi intagliatori in legno nel fare adornamenti di specchi."

11 Ibid., 99: "Bellori" recounts Michelangelo's observation that the artist must have the square (or sextant) in his eye: "che dice Michelangiolo, che bisogna aver le sestet negli occhi." Bottari probably knew this through Zuccari, who wrote (quoting Michelangelo)

"it is advisable, said he, that you make yourself so familiar with these rules and measures in working, that you have the compass and the square in your eyes, and judgement and practice in your hands." ("Ma conviene, disse egli, che tu ti facci sì familairi queste regole e misure nell'operare, che tu abbi nelli occhi il compasso e la squadra: e il giudizio e la practica nelle mani."); Zuccari, *Idea*, as quoted and translated in Erwin Panofsky, *Idea: A Concept in Art Theory*, trans. Joseph J. S. Peake (New York: Icon Editions, Harper & Row, 1968) 78. And one does not have the compass in the eye, Maratti retorts, unless he is steeped in the principles of *disegno* and *prospettiva*.

12 Ibid., 105: "Non dico per altro, che il solo disegno sia bastante a fare un architetto perfetto, siccome, che uno scultore, o un pittore possa saper fondare, e dare tutta la stabilità necessaria a una fabbrica, ovvero scompartirla, secondo le necessarie opportunità, e i commodi bisognevoli, e insieme fare uno spartimento di stanze convenienti, e vaghe, e luminose, ma dico, che la terza cosa delle numerate di sopra da me, che è l'ornato, non si può conseguire, se non con l'eccellenza del disegno."

13 Ibid., 107.

14 G. Vasari: *Vite* (1550; rev. 2/1568); ed. G. Milanesi (1878–85); L. Dolce: *Dialogo della pittura* (Venice, 1557), ed. M. Roskill (New York: New York University, Press, 1968); also in *Trattati d'arte del cinquecento tra manierismo e controriforma*, ed. P. Barocchi (Bari, 1960), 95–139.

15 Elisabeth Kieven, "Rome in 1732: Alessandro Galilei, Nicola Salvi, Ferdinando Fuga," *Light on the Eternal City: Observations and Discoveries in the Art and Architecture of Rome* (University Park: Pennsylvania State University Press, 1987), 354–75, provides the appropriate documentation and an excellent analysis of the critical issues.

16 "Molto andante e scarso, e non secondo il buon costume Romano che richiede ornato di colonne e maggiori aggetti." F. Cerrotti, *Lettere e memorie autografe ed inedited di artisti tratte da manoscritti della Corsiniana* (Rome, 1860), 23. Quoted and translated in Kieven, "Rome in 1732," 259.

17 Kieven, "Rome in 1732," 23: "Idea assai facile e semplice, un contorno troppo quadro, e senza interrompimento o risalto."

18 For Ruggieri's correspondence with Bottari on the Lateran façade, see Oronzo Brunetti, "Sulla Facciata di San Giovanni in Laterano: il cargteggio Ruggieri-Bottari," *Paragone*, 50, no. 593 (1999), 59–80.

19 Cerrotti, *Lettere e memorie*, 30–3; Kieven, *Light on the Eternal City*, 259 (Kieven's translation).

20 Francesco Scotto, *Itinerario d'Italia* (Rome: 1747; reprint, Bologna: Arnaldo Forni Editore, 1977), 364, as quoted in Kieven, "Rome in 1732," 259.

21 Kieven, "Rome in 1732," 260: "The monumental *final* design that covers the whole palace behind blends the great achievements of Baroque architecture – the air of 'performance,' the festive richness of allusions, the allegorical messages – with a rigorous and severe architectural system. The sculpture is still an inseparable part of the whole, equal in right with the architecture. The joy of illusion, the pretended existence of nature in the rocks, animals, plants – the transitory element of the water, all compose a great allegory of the water, 'la visibile immensa mole dell'aqua.'(Salvi)."

22 I suppose I should say his "authorial" voice, since the book was originally published anonymously.

23 John Pinto, "Il 'Buono e venerando antico gusto:' Nicola Salvi and the Fontana di Trevi," lecture presented to at the Bibliotheca Hertziana, Rome, May 2001.

24 Benedetti, *L'architettura del'Arcadia*, 27.

25 Thomas G. Rosenmeyer, *The Green Cabinet: Theocritus and the European Pastoral Lyric* (Berkeley: University of California Press, 1973), 206–14, also discusses the unsettled relation between town and country, between Horace's city mouse and country mouse.

26 Frank Kermode, *English Pastoral Poetry from the Beginnings to Marvell: An Anthology* (New York: Norton, 1972), 14.

27 Ernst Robert Curtius, *European literature and the Latin Middle Ages*, trans. Willard R. Trask (Princeton : Princeton University Press, 1990), 92–4.

28 John A. Pinto, *The Trevi Fountain* (New Haven and London: Yale University Press, 1986), 128–71.

29 Curtius, *European Literature*, 138–44, writes of the theatrical metaphor.

30 Paul Alpers, *What Is Pastoral?* (Chicago: University of Chicago Press, 1996), 80–1.

31 Hereward Lester Cooke, "The Documents Relating to the Fountain of Trevi," *Art Bulletin* 33 (1956), 169–71.

32 Ibid., 170.

33 Pinto, "Il 'Buono e venerando antico gusto,' " 16.

34 Michael McKeon, "The Pastoral Revolution," in *Refiguring Revolutions: Aesthetics and Politics from the English Revolution to the Romantic Revolution*, ed. K. Sharpe and S. Zwicker (Berkeley: University of California Press, 1998), 271: "Pastoral exists to oppose nature and art in such a way as to intimate simultaneously their interpenetration."

35 At one time or another, many of those who worked on the Trevi were Arcadians. In addition to Salvi and the three popes already mentioned, we can add the names of Filippo della Valle, Pietro Bracci, Andrea Bergondi, Francesco Queiroli, and Giuseppe Panini to the list.

36 Susan M. Dixon, "Women in Arcadia," *Eighteenth-Century Studies* 32, no. 3 (1999), 373.

37 Vitruvius, *Ten Books on Architecture*, trans. Ingrid D. Rowland, commentary by Thomas Noble Howe (Cambridge: Cambridge University Press, 1999), 91.

38 Mikhail Bakhtin, *Rabelais and His World*, trans. Helen Iswolsky (Cambridge, MA: Massachusetts Institute of Technology, 1968), 37. Here Bakhtin is writing about the Romantic version of the grotesque, but his remarks are applicable to certain aspects of the pastoralism-Arcadianism of the Trevi.

39 Muratori, *Opere*, VIII, 262: "La prima prerogative pertanto, che qui dee procurarsi, è quella dello Stile. E i precetti dello Stile a noi vengono dalla Rettorica, ma non da quella Rettorica lusseriggiante e fanciullesca, la quale solamente insegna adamplificare con sole parole diverse una medesima cosa, e ad infrascare di Concettini, ed Acutezze false, e ricercate anche le materie più gravi, e dottrinali; ma da quella Rettorica Filosofica, per mezzo di cui discerniamo, qual sia lo stile sano, quale il convenevole ai varj Soggetti, e componimenti, e quali il corrotto, láffettato, e il disdicevole. Lo stil pure e naturle, che spiega le cose con evidente chiarezza, e con parole proprie, e nulla sente di studio, dovrebbe sempre avere la preminenza sopra gli altri, e il pregio di paicaere a tutti … Lo stile ornato, e ingengnoso, mostra più ricchezza; ma se non è modestamente, e moderatamente adoperato, può dispiacere ai migliori."

40 Ibid.

41 William Empson, *Some Versions of Pastoral* (London: Chatto and Windus, 1935), 53: The pastoral is the "process of putting the complex into the simple."

42 D. K. Danow, "Text and Subtext," *Semiotics* (1987), 229.

FIVE: A SHORT HISTORY OF THE ACADEMY OF THE ARCADIANS

1 Michele Maylender, *Storia delle Accademie d'Italia*, 5 vols. (Bologna: Lucinio Cappelli Editore, 1926); Maria Pia Donato, *Accademie romane: Una storia sociale, 1671–1824* (Naples: Edizioni Scientifiche Italiane, 2000); Dino Carpanetto and Giuseppe Ricuperati, *Italy in the Age of Reason 1685–1789*, trans. Caroline Higgit (London and New York: Longman, 1987), 82–5. The literature on the Arcadians is extensive; the bibliography at the end of the text lists the main books that offer a comprehensive view and history of the Arcadians. This chapter is a greatly expanded version of comments originally made in Vernon Hyde Minor, "Ideology and Interpretation in Rome's Parrhasian Grove: The Arcadian Garden and Taste," *Memoirs of the American Academy in Rome*, vol. 46 (2001 [2002]), 183–228.

2 Donato, *Accademie romane*, 67.

3 Christina (Kristina in Swedish) ruled until 1654, when she abdicated the Swedish throne in favor of her brother Charles. Her inability to resolve the economic problems generated by the end of the Thirty Years War may have prompted her to leave Sweden, convert to Roman Catholicism, live out her life in a lovely Roman palace (largely replaced in the eighteenth century by the Palazzo Corsini). Her familiarity with René Descartes, who lived in Stockholm in 1659–60, most likely had something to do with her interest in countering the baroque style with a more "rational" philosophy and poetics.

4 For Christina's Royal Academy in Rome (which promoted *buon gusto*), see Michele Maylender, *L'accademia reale di Cristina di Svezia* (Fiume, 1907).

5 Donato, *Accademie romane*, 68.

6 Michel Giuseppe Morei, *Memorie istoriche dell'Adunanza degli arcadi* (Rome: A. de Rossi, 1761), 19: "Uno di essi trasportato dal piacere … 'Egli mi sembra, esclamò, che noi abbiamo oggi rinovata l'Arcadia.'"

7 An important article on the early years of the Accademia degli Arcadi is Francesca Santovetti, "Arcadia a Roma Anno Domini 1690: accademia e vizi di forma," *Modern Language Notes* 112, no. 1 (1997), 21–37.

8 See Biblioteca Angelica, Rome, Archivio dell'Arcadia, *Catalogo degli Arcadi*, vol. I.

9 Donato, *Accademie romane*, 63: "Per la nobiltà laica, ammutolita dall'egemonia della prelatura e ferma ai margini del rinnovamento erudito dell'accademia e per un vasto pubblico di borghesi delle professioni, resta un'importante occasione di socializzaione."

10 Anna Maria Giorgetti Vichi, ed., *Gli Arcadi dal 1690 al 1800: Onomasticon* (Rome: Arcadia, Accademia letteraria italiana, 1977), lists the following artists (with some foreign names Italianized): Marco Benefial, Andrea Bergondi, Bernardino Ciurini, Tomaso Conca, Domenico Corvi, Domenico de Angelis, Francesco Foschi, Ferdinando Fuga, Giuseppe Ghezzi, Gregorio Guglielmo, Domenico Guidi, Thomas Jenkins, Filippo Juvara, Carlo Maratti, Agostino Masucci, Anton von Maron, Anton Raphael Mengs, Vincenzo Milione, Charles Joseph Natoir, Giovanni Battista Nolli, Vincenzo Pacetti, Giovanni Paolo Pannini, Giuseppe Pannini, John Parker, Paolo Pelli, Francesco Piranesi, Giovanni Battista Piranesi, Niccolò Ricciolini, Hubert Robert, Lodovico Stern, Pietro Subleyras, Francesco Trevisani, Jean-François de Troy, Luigi Vanvitelli, Giuseppe Vasi, Joseph Vernet, and Joseph Marie Vien.

11 G. Ghezzi, *Le pompe dell'Accademia del Disegno solennemente celebrate nel Campidoglio … dedicate dagli accademici alla Santità d N.S. Clemente XI* (Rome: Giovanni Francesco Buagni, 1702). This is only the first in a series of joint publicactions between the Accademia di San Luca and the Accademia degli Arcadia.

12 Ministero per i Beni Culturali e Ambientali Ufficio Centrale per i Beni Librari e gli Istituti Culturali: "Arcadia" Accademia Letteraria Italiana. *Tre secoli di storia dell'Arcadia*, Rome, 1991; see also Maria Teresa Graziosi, *L'Arcadia: trecento anni di storia* (Rome: Palombi, 1991).

13 Liliana Barroero and Stefano Susinno. "Arcadian Rome, Universal Capital of the Arts," in *Art in Rome in the Eighteenth Century* (exh. cat., ed. Edgar Peter Bowron and Joseph J. Rishel (Philadelphia: Philadelphia Museum of Art, 2000), 47–76.

14 Vernon Hyde Minor, *Passive Tranquillity: The Sculpture of Filippo della Valle* (Philadelphia: American Philosophical Society, 1997).

15 Of course one must now take into account the heroic attempt made by the main contributors to the catalogue of *Art in Rome in the Eighteenth Century*. One of the thrusts of the exhibition was to promote the importance – in the old-fashioned sense of that word for art history – of art in eighteenth-century Rome.

16 As mentioned earlier, Barroero and Susinno's essay, "Arcadian Rome," is perhaps the first serious attempt in English to establish the Arcadians as contributors to the cultural ambience – and especially as it affects the visual arts – in eighteenth-century Rome. My approach is fundamentally different from that of these two authors.

17 Giovanni Mario Crescimbeni, *Storia dell'Accademia degli Arcadi, istituita in Roma, l'anno 1690 per la coltivazione delle scienze delle lettere umane e della poesia* (London: Bulmer, 1804) (originally published in Vittorio Giovardi, *Notizia del nuovo tteatro degli Arcadi aperto in Roma l'anno 1726* [Rome: Antonio dei Rossi, 1727]), 5: "I fondatori furono il Cavlaier Paolo Coardi torinese, poi Cameriere d'Onore di N.S. l'ab. Giuseppe Paolucci da Spello, Segretario del Signor Cardinale Spinola Camerlingo di S. Chiesa, Vincenzio Leonio da Spoleti, Silvio Stampiglia da Civitalavinia, Gio. Mario Crescimbeni Maceratese, or Canonico di S. Maria in Cosmedin, l'Avvocato Gio. Batista Felice Zappi Imolese, e l'Ab. Carlo Tommaso Maillard di Tournon Nazzardo, poi Cardinale di S. Chiesa, l'Ab. Pompeo Figari Genovese, Paolo Antonio del Nero Genovese, il Cavaliere Melchiorre Maggio Fiorentino, ora Referendario di Signature, Jacopo Vicinelli Romano, Paolo Antonio Viti Orvietano, e l'Ab. Agostino Maria taja Sanese, ora Canonico di S. Angelo in Pescheria." Because of the schism (see below), Crescimbeni, in his own arrogant fashion, "cancelled" Gravina's participation.

18 Vernon Lee (Violet Paget), *Studies of the Eighteenth Century in Italy*, (Chicago: A. C. McClurg 1908), 29.

19 For Crescimbeni, see Francesco Maria Mancurti, *Vita di Gio'Mario Crescimbeni* (Rome: A. dei Rossi, 1729); M. G. Morei, "Vita di Giovan Mario Crescimbeni," *Vite degli Arcadi illustri*, V (Rome: A. de' Rossi, 1759); Guido Piergiacomi, *Giovanni Mario Crescimbeni: poeta, letterato, sacerdote, nel III centenario della nascita* (Macerata: 1963); Vera M. Gaye, *L'opera critica e storiografica del Crescimbeni* (Parma: Ugo Guanda, 1970); N. Merola, "G. M. Crescimbeni," *Dizionario biografico degli Italiani*, vol. XXX (Rome: Istituto della Enciclopedia Italiana, 1984), 675–8.

20 Crescimbeni, *Storia dell'Accademia degli Arcadi*, 5, in which he states that it is the intention of the academy to "maggiormente coltivare lo studio delle scienze e risvegliare di buona parte d'Italia il buon gusto nelle lettere umane ed in particolare nella poesia volgare."

21 Giovanni Mario Crescimbeni, *L'istoria della volgar poesia* (Rome: per il Chracas, 1698); *La bellezza della volgar poesia* (Rome: A. de' Rossi, 1712); *I comentarj intorno all storia della volgar poesia* (Rome: A. dei Rossi, 1702–11).

22 Giovanni Mario Crescimbeni, *L'Arcadia* (Rome: A. de' Rossi, 1708). The 1502 edition in Venice of Sannazaro's *Arcadia* was unauthorized; most modern editions are based on the one published in Naples in 1504 under Sannazaro's direction.

23 For an overview of Crescimbeni's text *Arcadia*, with special emphasis on the women in Arcadia, see the excellent article by Susan M. Dixon, "Women in Arcadia," *Eighteenth-Century Studies* 32, no. 3 (1999), 371–5.

24 Quoted by Piergiacomi, *Giovanni Mario Crescimbeni*, 47: "L'istoria della *Volgar Poesia* è senza critica, senza novità, senza grazia, ma abbonda di fatti, di citazioni: materia buona!"

25 Crescimbeni, *L'istoria di volgar poesia*, preface: "sol quanto basti per condur l'opera al fin prescritto di far vedere lo stato della Volgar Poesia in ogni secolo fino à nostri giorni."

26 Morei, *Memorie istoriche*, 21–3.

27 Amadeo Quondam, "L'istituzione arcadia sociologia e ideologia di un'accademia," *Quaderni Storici*, no. 23 (1973), 389–438.

28 Ibid., 399: "Una disponibilità notevole, che fa dell'abate il ruolo intellettuale più dinamico dell'assetto instituzionale della cultura settecentesca."

29 For a brief discussion of the relation between Parrhesian discourse and the Parrhasian – note the slight difference in spelling – setting, see Joseph Imorde, "On Wandering Trees and High-minded Speech: The Bosco Parrasio in Rome," *Daidalos* no. 65 (September 1997), 54–9.

30 Years later, Gravina recalled that Crescimbeni had written to him (in 1693) "Gran parte della doglia mi leva il sentir da voi, che non perciò abbiate abbandonata la tutela della povera Arcadia col prudentissimo ristesso, che non dal commune, ma da privato capriccio, ò per dir meglio, malignità, il disturbo derivi." Gian Vincenzo Gravina, *Della division d'Arcadia: lettera ad un'amico* (Naples, 1711).

31 Yves Hersant, *Italies: anthologie des voyageurs français aux XVIIIe et XIXe siècles* (Paris: Robert La Font, 1988), 496; as quoted and translated in Barroero and Susinno, "Arcadian Rome," 49.

32 Amadeo Quondam, *Cultura e ideologia di Gianvincenzo Gravina* (Milan: U. Morsia, 1968).

33 P. Sposato, *Le lettere provinciali di B. Pascal e la loro diffusione a Napoli durante la rivoluzione intellettuale della seconda metà del secolo XVII* (Tivoli: A. Chicca, 1960), reproduces a letter in the appendices regarding the dissemination of the *Les Provinciales*. A Jesuit wrote to a friend that "il Giansenismo non è ne' cuori dei Signori Napoletani, ma è anche vero ch'è nelle loro mani. Le Provinciali uomo che qui non le abbia o almeno non le legga?" (reproduced in Quondam, *Cultura e ideologia*, 35).

34 His letters are in the Biblioteca Nazionale, Naples, MSS XIII B 45, 46, 47.

35 Biblioteca Angelica, Rome, Archivio Arcadia, Manoscritto 19, Fondo Arcadia.

36 Ludovico Sergardi wrote *Sartyrie*, in which he attacks Filodema (Gravina). Sergardi was a vicario generale di sanità in the Curia and a prefect of the Reverenda Fabbrica di San Pietro. He had had some say in the papal decsions about certain heretical propositons made by the Jesuits. Domenico Ottavio Petrosellini, an advocate of Gravina, wrote the satirical play *Il Giammaria, o l'Aracadia liberata*, which ridicules Crescimbeni.

37 The Arcadian poets have not enjoyed a very positive press, yet they should not be so quickly dismissed either. For a careful and sympathetic reading of poetry by members of the Accademia degli Arcadi, see Carmine di Biase, *Arcadia edificante: Menzini–Filicaia–Fuidi–Maggi–Lemene* (Naples: Edizioni Scientifiche Italiane, 1969).

38 Crescimbeni: "Io non parlo perché nel Serbatoio se ne vegono da quindici grossi volumi originali ove apparisce quanto di grande e di magnifico e di nobile è stato prodotto in Italia in ventidue anni e letto in Arcadia" (Biblioteca Angelica, Rome, Archivio Arcadia, Manoscritto 19, sheet 180).

39 Isidoro Carini, *L'Arcadia dal 1690–1890, memorie storiche* (Rome: Filippo Cuggiani, 1891), 23.

40 See Gravina's attack on the question of the so-called *peccato filosofico* – Jesuit probabalism – *Hydra mistica, sive de corrupta orali doctrini* (Naples, 1691). It carried a false reference to being printed in Cologne, Germany; see the modern reprint: *Hydra mystica: con la ristampa della traduzione italiana del 1761 / Gianvincenzo Gravina; a cura di Fabrizio Lomonaco* (Soveria Mannelli: Rubbettino, 2002). He published it under his (revised) Arcadian name Prisco Censorino.

41 "Perloche la vecchia Ragunanza la quale à le Leggi, e la sua istituzione mutata con passare dal numero determinato all'infinito, con perpetuare l'amministrazione, e con ridurre a pochi la facoltà che era tutta del solo commune, à cangiata ancora natura, ed è passata ad un'altro genere di corpo civile perdendo il dritto della sua prima istituzione, il quale s'è tutto per jus accrescendi consolidato nella novella Ragunanza, che per ritenere quelle Leggi, e quella istituzione, s'è da Contraventori segregata." *Lettera ad un'amico* (n.p.).

42 "Imperchè l'anima d'ogni società civile è la Legge, senza la quale il ridotto degl'Uomini non è corpo civile, ma moltitudine, e turba," ibid.

43 Among those who held Gravina in high regard were Winckelmann, Vico, Gottsched, and Vincenzo Monti. In addition, it is worth recalling that Gravina adopted the famous poet Metastasio. His Italian name, Pietro Trapassi, means the same thing as the (Italianate) Greek form of his name Metastasio (metastasis) – to pass from one place to another. He entered the Arcadia in 1718. In 1730, he was off to the court of Vienna, where he remained until his death in 1780.

44 Carpanetto and Ricuperati, *Italy in the Age of Reason*, 86.

45 Ibid.

46 Quoted by Domenico Consoli, *Realtà e fantasia nel classsicismo di Gian Vincenzo Gravina* (Milan: Casa Editrice Bietti, 1970), 35.

47 Gian Vincenzo Gravina, *Della ragion poetica*, ed. Giuseppe Izzi (Rome: Archivio Guido Izzi, 1991), 13: "Omero perciò è il mago più potente e l'incantatore più sagace, poiché si serve delle parole non tanto a compiacenza degli orecchi, quanto ad uso dell'immaginazione e della cosa, volgendo tutta li'industria all'espressione del naturale." This is from Gravina's section on the Homer's use of artifice.

48 Gianvincenzo Gravina, *Della ragion poetica tra'Greci, Latini ed Italiani* (London: T. Becket, 1806), chap. xiii.

SIX: THE PARRHASIAN GROVE

1 This chapter is a somewhat altered version of an earlier article, Vernon Hyde Minor, "Ideology and Interpretation in Rome's Parrhasian Grove: The Arcadian Garden and Taste," *Memoirs of the American Academy in Rome* 46 (2001 [2002]), 183–228.

2 Lee, *Studies of the Eighteenth Century*, 17.

3 Ibid., 17–18. Lee's discovery of the Bosco Parrasio in Rome reads like a parody of Sincero's visit to the Sacro Bosco in Jacopo Sannazaro's *Arcadia*. In chapter 10, Sincero relates that he and his band of shepherds set off in high spirits, ascending the mountain "laughing all the while . . . and before we had gone beyond two slingshots we began from afar to make out bit by bit the revered and sacred wood into which never did any dare enter with any axe or iron, but for many years it had been most religiously preserved inviolate by the country populace for fear of the avenging Gods; and if it be worthy of belief, at one time, when the world was not so brimful of vices, all the pine trees that were there could speak, in meaningful syllables answering to the love songs of the shepherds. Led thither at a deliberate pace by the holy priest, as he directed we washed our hands in a tiny spring of fresh water that welled up at the entrance, since religion did not permit us to go into such a place in a state of sin. Then having paid reverence to holy Pan, and afterward to the unknown gods, if any were there who were hidden away in the secret-sheltering wood so as not to reveal themselves to our eyes, we proceeded, with right foot forward in token of happy augury, each many silently praying within himself that they should be always propitious, as well at that moment as in times of need that might arise in the future." Jacopo Sannazaro, *Arcadia & Piscatorial Eclogues*, trans. Ralph Nash (Detroit: Wayne State University Press, 1966), 101–2. Although Giovan Mario Crescimbeni without question had Sannazaro's Sacro Bosco in mind when planning his Bosco Parrasio, one cannot be sure how well Vernon Lee knew Sannazaro's text. Perhaps it is only an unintended coincidence that her first encounter with the Bosco Parrasio is a burlesque of Sincero's visit to the Sacro Bosco, but I doubt it.

4 "dichiariamo comune questo nostro dominio d'Arcadia," Michel Giuseppe Morei, *Memorie istoriche dell'Adunanza degli arcadi* (Rome: A. dei Rossi, 1761), 21.

5 Giambattista Vico, *New Science*, trans. David Marsh; introduction by Anthony Grafton (New York: Penguin Books, 1999), 159.

6 Paul Alpers, "Pastoral Convention," *What Is Pastoral* (Chicago and London: University of Chicago Press, 1996), 79–134; the quotation from Johnson is in Samuel Johnson, "Life of Milton," in *Milton's "Lycidas": The Tradition and the Poem*, ed. C. A. Patrides, rev. ed. (Columbia: University of Missouri Press, 1983), 60.

7 That elegiac tradition (which will be discussed later under "Iconography") is the one that Panofsky chose to emphasize as of central significance to the visual arts; see Erwin Panofsky, "ET IN ARCADIA EGO: Poussin and the Elegiac Tradition," *Meaning and the Visual Arts* (Garden City, NY: Doubleday Anchor Books, 1955), 295–320.

8 In all of this digging and upacking I will make use of certain powerful theories that have turned up in this past generation of humanistic studies. I make no claim that I have employed only the right theories, and by implication avoided the "wrong" ones. I tend to follow Jonathan Culler in his discussion of the point of theory when he writes: "The point of theory here is double: the encouragement of interdisciplinarity or resistance to compartmentalization, and the bringing to bear of the most interesting and challenging discourses on the objects of study." Jonathan Culler, "Introduction: What's the Point?" *The Point of Theory: Practices of Cultural Analysis*, ed. Mieke Bal and Inge E. Boer (Amsterdam: Amsterdam University Press, 1994), 16.

9 Giovanni Mario Crescimbeni, *Storia dell'Accademia degli Arcadi istitua in Roma l'anno 1692* (London: Bulmer., 1804), 20.

10 Ibid.: "[P]erò l'Adunanza prese per costume di celebrare anche essa nella rinnovazione d'ogni Olimpiade, i Giuochi Olimpici, non già per esercizio del corpo, come si faceva dagli Elei; ma ben per quello degl'ingegni, col mezzo di cinque Giuochi Poetici, nel primo de' quail si contengono brevi ragionamenti, nel secondo Egloghe, nel terzo Canzoni, nel quarto Sonetti, e nel quinto Madrigali o Epigrammi." For a list of these various *giuochi*, see Anna Maria Giorgetti Vichi (ed.), *Gli Arcadi dal 1690 al 1800: Onomasticon* (Rome: Arcadia, Accademia letteraria italiana, 1977), ix–xi.

11 Crescimbeni, *Storia dell'Accademia*, 5: "per quella funzione fecero un finto ma assai vago teatro di più ordini di panche coperte di panni arazzi di color verde, la forma del quale era ritonda; ed era attorniato da molte piramidi fabbricate di legnami coperti di verzura, e d'altezza circa venti palmi, in ciascuna delle quali era collocata una delle lapidi di memoria che soglionsi alzare da questa Adunanza a' suoi uomini illustri defunti; ed allora la prima volta incominciarono a celebrarsi questi Giuochi alla memoria de' morti Arcadi."

12 Note especially Giovan Mario Crescimbeni, "I Giuochi Olimpici Celebrati dagli arcadi nell'Olimpiade DCXX," in *Lode della Santità di N.S. Papa Clemente XI* (Rome: Giuseppe Monaldi, 1701).

13 Ibid., 7–9, which details the locations up until 1712; also see Maria Teresa Acquaro Graziosi, *L'Arcadia: trecento anni di storia* (Rome: Fratelli Palombi Srl, 1991); P. Petraroia, "Il Bosco Parrasio," *Il teatro a Roma nel Settecento* (Rome: Istituto dell'Enciclopedia italiana, 1989), vol. 1 of *Biblioteca italiana di cultura*, 21.

14 The "pastoral" and the "Arcadian" are not mere synonyms of one another; yet their meanings clearly overlap, so that at times their usage is interchangeable. There also are circumstances under which they are concepts distinct from one another.

15 Crescimbeni, *Storia dell'Accademia*, 6–7: "Sogliono ragunarsi gli Arcadi pubblicamente in qualche bosco or prato, sette volte l'anno nella state, cioè dal 1 di Maggio, che il Custode apre, siccome si finge, il Bosco Parrasio, luogo immutabile destinato per le Ragunanze, invitando tutti i Pastori sparsi per l'Arcadi a concorervi, fin a' 7 d'Ottobre, che il medesimo Custode chiude il Bosco, e licenzia i Pastori che vi sono concorsi; e di queste adunanze sei sono destinate per li Pastori che dimorano in Roma, i quali di qualunque grado si sieno debbono recitare i loro componimenti da sè stessi, fuorchè i cardinali, e le dame, che possono farli recitare da altri Arcadi; ed una per la lezione de' componimenti poi che si recitano, sogliono per lo più lasciarsi in segretaria, o archivio, che pastoralmente s'appella Serbatojo."

16 The contents of the cornerstone are discussed by E. Paratore, "Una scoperta in Arcadia," *Strenna dei Romanisti* (Roma: Staderini, 1965), 326.

17 Francesco Milizia, *Architetti di età barocca e tardobarocca*, ed. Giorgio Simoncini (Turin: Testo & Immagine, 1998), 70. For Canervari, see A. Venditti, "Note su Antonio Canevari architetto," *Studi Romani*, xxi, 1973, 358–65; A. Venditti and M. Azzi Visentini, "Antonio Canevari," *Dizionario biografico degli Italiani*, vol. XVIII, (Rome: Istituto della Enciclopedia Italiana, 1975), 55–8; Paola Ferraris, "Antonio Canevari," *In urbe architectus — modelli, disegni, misure: La professione dell'architetto a Rome, 1680–1750*, exh. cat., ed. B. Contardi and G. Curcio (Rome: Museo Nazionale Castel Sant'Angelo, 1991), 331–2; Anja Buschow Oechslin, "Antonio Canevari," *The Dictionary of Art* (London: McMillan 1996), 614.

18 Milizia, *Architetti*, 70: Canevari "se ne andò via dal Portogallo colla coda fra le gambe."

19 Crescimbeni detailed certain requirements: that the site be of adequate size, but not too large; that there be a place for an archive or "serbatoio"; a place for the shepherds to get in out of the rain; that there be good air; convenient for those who did and who did

not have carriages; that it have a good view and available water; that there not be direct sun; that there be no houses nearby; that it be a wood that did not require much yearly maintenance; that it cost no more than 4,000 scudi; and that the property be free and clear. See Biblioteca Angelica, Archivio Arcadia, *Manoscritti dell'Arcadia*, no. 35, carta 2, in which we read in Crescimbeni's hand that the new site "sia di grandezza tanto quanto basta a non più, [. . .] ci sia una casa o possa farvisi per trasportarvi il Serbatojo [cioè la segretaria e l'archivio dell'Accademia] e un portico o altro edificio per trattenere i Personaggi e salvarsi dalle piogge; che vi sia un sito d'aria buona; vicino e comodo per quelli che non hanno carrozza, e con piazza, o altro comodo per le carrozze; che abbia ella veduta; che abbia acqua; che non sia sogetto al sole dalle ore 22 in giù; che non abbia soggezione di case attorno; che possa tutto ridarsi a boscaglia, senza bisogno di mantenimento annuale, considerabile che quando si voglia, ne' tempi avvenire, possa diatarsi; che la spesa tra compra e aggiustamento non possa eccedere li scudi quattromila che vi sono; e (finalmente) che sia libero da canoni e da ogni altro peso."

20 Vittorio Giovardi, *Descrizione dell' nuovo teatro degli Arcadi* (Rome: Antonio dei Rossi, 1727), republished in Crescimbeni, *Storia dell'Accademia*.

21 Paola Ferraris, "Il Bosco Parrasio dell'Arcadia," in *Giovanni V di Portogallo, 1707–1750, e la cultural romana del suo tempo*, ed. S. Vasco Rocca and G. Borghini (Rome: Nuova Argos, 1995), 147.

22 Crescimbeni, *Storia dell'Accademia*, 88.

23 In chapter X of his *Arcadia*, Sannazaro describes the laws found in the great cave of his enchanted bosco: "Down from either side of the ancient altar hung two long beechen scrolls, written over with rustic lettering; these, preserved by former shepherds from one age to another in succession over many years, contained within them the antique laws and rules for conduct of the pastoral life, from which all that which is done in the woods today had its first origin." *Arcadia & Piscatorial Eclogues*, 102.

24 Crescimbeni, *Storia dell'Accademia*, 21: "Il Serbatojo, che è lo stesso che la Segreteria e l'Archivio, sta appresso il Custode, il quale dee tenerne e renderne conto. In esso si conservano i Sigilli pubblici, il Catalogo originale degli Arcadi, gli Attuarij, o Codici de' fatti, che di giorno in giorno accadono, varj tomi di altre scritture originali, l'Effemeride Arcadica, e il Minutario, di tutte le lettere e diplomi che escono in nome dell'Adunanza e del Collegio; e oltre acciò, tutti i componimenti che si mandano da' Pastori abitanti fuori di Roma; e quelli che si lasciano dopo le recite del Bosco da' Pastori dimoranti in roma, de' quali se ne sono fatti fin'ora quindici grossi codici; tutte le lettere che vengono di fuori, le quali ogn'ora si riducono in volume; e ve ne sono fin'ora volumi sedici, e finalmente i libri stampati dall'Adunanza, e buona parte di quelli che sono stati impressi dalle Colonie, e da' Pastori particolari. Nel rimanente il serbatojo è ornato tutto di ritratti d'Arcadi, essendo permesso a ciascun Arcade mandarvi il suo; e vi si conservano anche tutte le lapidi di memoria che fin'ora sono state fatte, per collocarsi a suo tempo nel Bosco Parrasio alla pubblica vista; e in questo luogo si fanno le Congregazioni sì dell'Adunanza come del Collegio, o altre deputate, in tutte le quali di sua ragione entra il Custode, ed ha il voto, e dee notarne, o farne notar gli atti da' Sottocustodi ne' libri pubblici." The original plans called for withdrawing rooms in the pavilions that were to flank the main gate; these, however, were not built.

25 See Paola Ferraris's discussion "L'Arcadia nella diplomazia internazionale. Il Bosco Parrasio gianicolense," *Arcadia: Accademia Letteraria Italiana, Atti e memorie*, ser. 3a, vol. 8.4 (1986–7), 227–68.

26 "perché mi si dà l'occasione di prendere sotto la mia reale protezione un'Accademia tanto conosciuta in Europa e tanto giustamente Stimata, quanto è quella degli Arcadi di Roma." Biblioteca Angelica, Rome, Archivio Arcadia, *Fatti*, IV, f. 56.

27 For Andrea de Mello and other diplomatic relationships between the papacy and the Portuguese crown, see Marco Lattanzi, "I giochi della diplomazia. Il tempo di Giovanni V fra Roma e Lisbona," *Giovanni V di Portogallo*, 475–8.

28 For a review of the troubles with Portugal and the status of the papal nuncio, see Ludwig Frieherr von Pastor, *The History of the Popes*, trans. Dom Ernest Graf, vol. xxxiv, (London: Kegan Paul, Trench, Trubner & Co., 1941) 37, 406–7. Lisbon has retained a Cardinal Protector into the twentieth century.

29 Archivio Corsini, Florence, stanza prima, scaffale n. 2, fila VI, Giustificazioni spettante all'Emo e Rmo dal 1741 al 1744 (Giustificazioni di pagamenti fatti per conto del sudetto dei Beni di Portogallo dal 1741 al 1770), v. 257, pezzo 238. Over a nine-year period (1739–48), Neri took in the extraordinary sum of 80,000 scudi from the Portuguese throne. I would like to thank my wife, Heather Hyde Minor, for this citation. The document reads:

[248] ristretto dell'introito, et esito fatto dell'entrate di Portogallo secondo l'ordini, e commandi di S. Em.za Pne, da Gen.ro 1739, a tutto il primo luglio 1748, come appo cioe
Introito
Entrate di Portogallo da Genn.ro 1739, a tutto il p.mo Lug.o 1748 74580:98 $^{1}/_{2}$
Entrate provenienti del Rotolo Cardinalizio a tt il sud.o tempo 5680:882 $^{1}/_{2}$
Sommano l'entrate 80,261:81
Esito
Spese per il giardino da Genn.ro 1739, a tt Giug.o 1748 15194:24 $^{1}/_{2}$
Spese per la nuova fabrica a tt. Il sid.o tempo 51483:55
Spese Diverse a tt. Il sud.o tempo 13025:89
Somma l'esito 79705:68 $^{1}/_{2}$

30 See also discussion by Christopher M. S. Johns, *Papal Art and Cultural Politics: Rome in the Age of Clement XI* (Cambridge: Cambridge University Press, 1993), 82–3.

31 Ferraris, "L'Arcadia nella diplomazia internazionale," 240: "per mera espressione d'uso di Segreteria, e non per alcuno atto formale di protezione, o di Soggezione, altramente perisca più tosto l'atto, che la presente dichiarazione."

32 Four thousand scudi did not buy much in early-eighteenth-century Rome. As we read in Valesio's *Diario*, for 9 September 1726, with regard to the dedication of the new Bosco Parrasio: "Tutto l'accademia fu in lode del re di Portogallo, accademico d'onore, il quale ha generosamente dati 4.000 scudi per il luogo e di già si sono consumati nella fabrica de' muri fatti per dare qualche piano a quel luogo scosceso, né sono ancor terminati siccome il disegnato abbellimento e sperano dalla generosità di S. Santità che possa contribuire al rimanente." John V's money bought the property and helped with the landscaping – the building of walls to support various landings in the steep ("scosceso") park. It was hoped that the garden would be completed with the generous support of Pope Benedict XIII (given the fact that there's an inscription to him, he must have provided some assistance). Gaetana Scano and Giuseppe Gaglia (eds.), *Diario di Roma di Francesco Valesio* vol. iv (Milan: Longanesi, 1978) 720. About 1,000 scudi went for the land itself (Rome: Biblioteca Angelica, Rome, Archivio Arcadia, *Manoscritto 35*, f. 26).

33 Crescimbeni, *Storia dell'Accademia*, 19: "Io ho detto di sopra, che l'Arcadia non ha protettore temporale; ma non però è priva dello spirituale, essendosi messa sotto la tutela del Santissimo Nostro Signore Gesù Nascente."

34 Ferraris, "Il Bosco Parrasio dell'Arcadia," 137–8. Muratori argued on the side of the Este for keeping Comacchio (which had been invaded by imperial troops as a consequence of certain positions taken by the papacy during the War of Spanish Succession) out of the sphere of influence of the Holy See; he was not successful in his argumentation. as Johns, *Papal Art*, has argued (2–3), however, Muratori made a strong case for restricting the pope's influence to spiritual matters.

35 Annabel Patterson, *Pastoral and Ideology: Virgil to Valéry* (Berkeley and Los Angeles: University of California Press, 1987), 194.

36 Ibid.

37 Ibid., 199.

38 Wolfgang Iser, *The Fictive and the Imaginary: Charting Literary Anthropology* (Baltimore and London: Johns Hopkins University Press, 1993), 31.

39 Patterson, *Pastoral and Ideology*, 199–200.

40 Ibid., 200.

41 Iser, *Fictive and Imaginary*, 31.

42 For the tradition of the Parrhasian conversation (briefly mentioned also in Chapter 5), see Joseph Imorde, "On Wandering Trees and High-minded Speech: The Bosco Parrasio in Rome," *Daidalos* n. 65 (September 1997), 54–9, 54–9.

43 See also Suzanne Kiernan, "The Ridiculous, the Sublime, the Modern: Aspects of Italian Culture in the Early Eighteenth Century," *Studies in Eighteenth-Century Culture* 28 (1999), 1–25. Kiernan draws most of her information on the garden from Cesare d'Onofrio, *Roma val bene un'abiura: storie romane tra Cristina di Svezia, piazza del Popolo e l'Accademia d'Arcadia* (Rome: Fratelli Palombi, 1976), and Giovardi, offering little by way of a new interpretation of the Bosco. She does, however, make fascinating and useful comparisons between Crescimbeni and Vico.

44 The sources for these mythological figures and stories are part of a broad literary culture based on ancient texts; as such, they are well enough known not to require individual citations; I do, however, provide bibliographic references for specific quotations.

45 Ov. *Met* I:691–94 (trans. R. Humphries).

46 The inscription:

IOANNI V.
LVSITANIÆ REGI
PIO FELICI INVICTO
QVOD PARRHASII NEMORIS
STABILITATI
MVNIFICENTISSIME
PROSPEXERIT
CŒTVS ARCADVM VNIVERSVS
POSVIT.
ANDREA DE MELLO DE CASTRO
COMITE DAS GALVEAS
REGIO ORATORE
ANNO SAL. MDCCXXVI.

47 Crescimbeni (and Giovardi), *Storia dell'Accademia*, 83–3: "Nella centina che fanno le dette gradinate si apre un vasto ripiano, dove due fonti che scaturiscono dalle urne del Tevere e dell'Arno, simboli della Latina e Toscana Poesia che si professano in Arcadia, vanno a confondere le loro acque."

48 Panofsky, "ET IN ARCADIA EGO," 314–15.

49 Invoking a not dissimilar oxymoron, The third Earl of Shaftesbury included the grotto in his description of the "natural" garden: "Even the rude rocks, the mossy caverns, the irregular unwrought grottos and broken fall of waters, with all the horrid graces of the wilderness itself, as representing nature more, will be the more engaging, and appear with a magnificence far beyond the formal mockery of princely gardens" Anthony Ashley Cooper, the third Earl of Shaftesbury, "The Moralists," in *Characterisics of Men, Morals, Opinions and Times*, ed. J. M. Robertson (Indianapolis and New York: Bobbs-Merrill, 1964), 125.

50 Codex Arundel, 155r; as quoted in the header of Naomi Miller, *Heavenly Caves: Reflections on the Garden Grotto* (Boston: George Allen & Unwin, 1982), 5.

51 Renato Poggioli, *The Oaten Flute* (Cambridge: Harvard University Press, 1975), 169, associates Pan with the noon hour.

52 Ov. *Met*, 5:639–40 (trans. R. Humphries)

53 Crescimbeni, as we have seen, made the presence of water on this property a condition of sale. The water that seeps down through the grotto comes from the nearby aqueduct – the Aqua Paola – and it also emanates from a natural spring known as the Acqua Innocenziana o Aqua del fontanile delle mole gianicolensi. This spring is formed by an aquifer that, lying at precisely the elevation of the Bosco Parrasio, is sandwiched between clay and sand beds. It also supplied a number of mills that once stood just outside the garden. See Marco Amanti et al. (eds.), *La geologia di Roma* (Rome: Istituto Poligrafico, 1995), 193.

54 Peter V. Marinelli, *Pastoral* (London: Methuen, 1971), 14.

55 Ov. *Met* 15:179–84 (trans. R. Humphries).

56 Bruno Snell, "Arcadia: The Discovery of a Spiritual Landscape," in *The Discovery of the Mind: The Greek Origins of European Thought*, trans. T. G. Rosenmeyer (Oxford: Basil Blackwell, 1953), 300.

57 The Greek form of his name means "spring." See also earlier in reference to Mount Helicon.

58 Erich Auerbach, "Figura," *Scenes from the Drama of European Literature* (New York: Meridian Books, 1959). For further bibliography, see also Marianne Shapiro, "Figuration," *The New Princeton Encyclopedia of Poetry and Poetics*, ed. Alex Preminger and T. V. F. Brogan (Princeton: Princeton University Press, 1993), 408–9.

59 Ov. *Met* V:256–60 (trans. R. Humphries).

60 Ibid., V:265–9.

61 Ibid., 11:234–5.

62 Crescimbeni, *Arcadia*, 219: "v'è un piccol recinto di scelti alberi, in mezzo al quale sorge un rustico fonte, dalla natura così fabbricato, che l'arte non saprebbe inventarne altro nè più ameno nè più geniale."

63 Biblioteca Angelica, Rome, Archivio Arcadia, *Ragunanze*, passim.

64 Quoted in Ernest Hatch Wilkins, *A History of Italian Literature*, revised Thomas G. Bergin (Cambridge: Harvard University Press, 1974), 328. For Perfetti, see F. Waquet, *Rhétorique et poétique chrétiennes: Bernardino Perfetti et la poésie improvisée dans l'Italie du XVIIIme siècle* (Florence: Oschki, 1992).

65 Valesio, *Diario di Roma*, 512–13.

66 For a detailed discussion of the inseparability of nature and art, see especially Edward William Tayler, *Nature and Art in Renaissance Literature* (New York and London: Columbia University Press, 1964).

67 J. L. Austin, *How to Do Things with Words* (Cambridge: Harvard University Press, 1962), 22: "a performa-tive utterance will, for example, be in a peculiar way hollow or void if said by an actor on the stage, or if introduced in a poem, or spoken in a soliloquy. This applies in a similar manner to any and every utterance – a sea – change in special circumstances. Language in such circumstances is in special ways – intelligibly – used not seriously, but in ways parasitic on its normal use." He also set up a series of "felicities" that would guarantee an utterance was sincere, appropriate, and properly contextualized.

68 Wolfgang Iser, *The Act of Reading* (Baltimore: Johns Hopkins University Press, 1979),

69 Benjamin Lee, *Talking Heads* (Durham and London: Duke University Press, 1997), 23.

70 J. L. Austin, *Sense and Sensibilia*, reconstructed from the manuscript notes by G. J. Warnock (London: Oxford University Press, 1962), 114.

71 Ibid., 7.

72 Iser, *Act of Reading*, 59.

73 Austin, *How to Do Things with Words*, 108–9.

74 For Derrida's engagement with Austin, see Jacques Derrida, "Signature Event Context," *Glyph* I (1977), 172–97; the rejoinder by John Searle, "Reiterating the Differences," *Glyph* I (1977), 198–208; and finally Derrida, "Limited Inc abc," *Glyph* II (1977), 162–254.

75 Jonathan Culler, *On Deconstruction: Theory and Criticism after Structuralism* (Ithaca: Cornell University Press, 1982), 119.

76 Ibid., 120.

77 As Culler (ibid., 128) phrases it: "meaning is context-bound but context is boundless."

78 Jacques Derrida, *L'Ecriture et la différence* (Paris: Seuil, 1967), 42, as quoted (and translated) in Culler, ibid., 133.

79 Liliana Barroero and Stefano Susinno, "Arcadian Rome, Universal Capital of the Arts," *in Art in Rome in the Eighteenth Century*, ed. Edgar Peters Bowron and Joseph J. Rishel (Philadelphia: Philadelphia Museum of Art/Merrell, 2000), 47–75.

80 Ibid., 52–5.

81 John B. Carroll, ed. *Language, Thought, and Reality: Selected Writings of Benjamin Lee Whorf* (Cambridge: MIT Press, 1956).

82 Michel Foucault, *The Archaeology of Knowledge and the Discourse on Language*, trans. A. M. Sheridan Smith (New York: Pantheon Books, 1972), 60–3, 69–70.

83 Thomas G. Rosenmeyer, *The Green Cabinet: Theocritus and the European Pastoral Lyric* (Berkeley: University of California Press, 1973), 53. What became Rapin's *Eclogae cum Dissertatione de Carmine Pastorali* (Leyden, 1672) appeared first as introduction to his *Eclogae Sacrae* (1659). It is one of the first attempts to define the pastoral. See also Vernon Hyde Minor, "What Is *Buon Gusto*? The Arcadian View," *Antologia di Belle Arti* (2000), 72–84, nn. 59–62.

84 I commit the rhetorical crime of reification here, presenting the baroque as if it were a being, a thing; this,

of course, is a kind of critical shorthand that permits us to make a quick characterization of a rhetorical practice that was anything but simple, anything but physical, anything but self-contained and delimited. I maintain, just the same, that the characterization is valid and has value.

85 Rosenmeyer, *The Green Cabinet*, 97.

86 Patterson, *Pastoral and Ideology*, 7.

87 J.- F. de Saint-Lambert, "Discours Préliminaire," *Saisons*, trans. in *The Monthly Review* 41 (1769), 496; quoted in Rosenmeyer, *The Green Cabinet*, 179.

88 John Ruskin, *Modern Painters*, vol. 3, chap. 12 (New York: Wiley & Halsted, 1856).

89 L. Spitzer, *Classical and Christian Ideas of Wold Harmony. Prolegomena to an Interpretation of the Word "Stimmung"* (Baltimore: Johns Hopkins University Press, 1963).

90 Bernard F. Dick, "Ancient Pastoral and the Pathetic Fallacy," *Comparative Literature* XX, no. 1 (1968), 27–44.

91 Ibid., 30.

92 Rosenmeyer, *The Green Cabinet*, 238.

93 The literature on otium is considerable; note especially Frank Kermode, *English Pastoral Poetry: From the Beginnings to Marvell* (London: Geroge G. Harrap, 1952), 16; Hallett Smith, *Elizabethan Poetry: A Study in Conventions, Meaning, and Expression* (Cambridge: Harvard University Press, 1952), 2–9; Michael O'Loughlin, *The Garlands of Repose: The Literary Celebration of Civic and Retired Leisure* (Chicago and London: University of Chicago Press, 1978), passim; Rosenmeyer, *The Green Cabinet*, 65–97; Brian Vickers, "Leisure and Idleness in the Renaissance: The Ambivalence of Otium," *Renaissance Studies* 4, no. 1 (1990), 1–37; no. 2, 107–154; and W. A. Laidlaw, "Otium," *Greece and Rome* XV (1968), 42–52.

94 Poggioli, *Oaten Flute*, 9.

95 *Epigram*, v. 22; quoted and translated in Laidlaw, 51.

96 See specifically Crescimbeni's (*Arcadia*) own allegorical sketch of Arcadian shepherds gamboling through the gardens. Stella Rudolph comments on this fanciful description of the Arcadian garden in "Una visita alla capanna del pastore Disfilo," *Accademia Letteraria Italiana: Atti e Memorie, Convegno di Studi* (15–18 maggio 1991), *III centenario dell'Arcadia*, Roma (15–18 maggio 1991), Vol. 9 (1994) 387–415.

97 John Henry Newman, *Historical Sketches* (London, 1899), vol. 2, 385.

98 For a discussion of Muratori's promotion of the pastor at the expense of the preacher, see Alberto Vecchi, "I modi della devozione," *Sensibilità e razionalità nel settecento*, ed. Vittore Branca (Venice: Sansoni, 1967), 95–124.

99 Vickers, "Leisure and Idleness," 6.

100 Francesco Petrarca, *The Life of Solitude*, trans., introduction, and notes by Jacob Zeitlin (Urbana: University of Illinois Press, 1924), 290.

101 Verg. *Ecl. 1.3* trans. David Ferry (New York: Ferrar, Straus and Giroux, 1999); Paul Alpers, *What Is Pastoral* (Chicago and London: University of Chicago Press, 1996), 25.

102 Vickers, "Leisure and Idleness," 7, writes of "Cato's special association of otium with *ambulare*, strolling and gossiping, both forms of time-wasting."

103 All quotations from *The Eclogues of Virgil*, trans. David Ferry (New York: Farrar, Straus and Giroux, 1999).

104 Panofsky, "ET IN ARCADIA EGO," 300.

105 Iser, *Act of Reading*, 22–86.

106 This is the point made by Terry Gifford, *Pastoral* (Routledge: London and New York, 1999) 22.

107 Iser, *Act of Reading*, 48.

108 Ibid.

109 Lee, *Studies of the Eighteenth Century*, 17–18.

110 Biblioteca Angelica, Rome, Archivio Arcadia, *Manoscritti dell'Arcadia*, n. 35, carte 139; 152–84. There was a subscription to restore the garden; Clement XIII gave about half the money necessary; on carta 220, we see that in 1809 the architect Andrea Vici made an impassioned request to restore this garden, the "delight of the followers of Apollo and the Muses."

111 Martin Heidegger, *Der Ursprung des Kunstwerkes* (Stuttgart: Reclam, 1960), 53. Heidegger here explains that the "something else" that happens is in a clearing (both literally and figuratively) and that there is lighting in an open center that is not surrounded by anything, but surrounds everything. The origin of the work of art, in Heidegger's sense, shares some interesting affects and attributes with the Parrhasian Grove.

112 Especially useful for considering the role of pastoral as a tradition is David Gross, *The Past in Ruins: Tradition and the Critique of Modernity* (Amherst: University of Massachusetts Press, 1992).

BIBLIOGRAPHY

Baretti, Joseph. *An Account of the Manners and Customs of Italy; with observations on the mistakes of some travelers.* 2 vols. London: T. Davies, 1769.

————. *A dissertation upon the Italian poetry, in which are interspersed some remarks on Mr. Voltaire's essay on the epic poets,* London: R. Dodsley, 1753.

Bertana, Emilio. *In Arcadia. Saggi e profili.* Naples: Tip. Trani, 1909.

Binni, Walter. *L'Arcadia e il Metastasio.* Florence: La Nuova Italia, 1963.

————. *Classicismo e Neoclassicismo nella letteratura del Settecento.* Florence: La Nuova Italia, 1963.

Bloch, Ernest. "Arkadien und Utopien," *Sensibilità e razionalità nel settecento,* ed. Vittore Branca, Florence: Sansoni, 1967.

Liliana Borsellino, Enzo and Vittorio Casale, *Roma "Il Tempio del vero gusto, Atti del Convegno Internazionale di Studi* (Salerno-Ravello 26–27 giugno 1997). Florence: Edifir-Edizioni Firenze, 2001.

Calcaterra, C. "Il problema del Barocco," *Questioni e correnti di storia letteraria.* Milan: C. Marzorati, 1949.

Carini, Isidoro. *L'Arcadia dal 1690 al 1890 Memorie Storiche.* Rome: Filippo Cuggianti, 1891.

Codignola, Ernesto. *Illuministi, giansenisti e giacobini nell'Italia del settecento.* Florence: La Nuova Italia Editrice, 1947.

Codignola, Ernesto. *Illuministi, giansenisti e giacobini nell'Italia del settecento.* Florence: La Nuova Italia, 1947.

Colicchi, Calogero. *Le polemiche contro l'Arcadia.* Messina, 1972.

Coluccia, Giuseppe. *L'Elvio di G. M. Crescimbeni: alle origini della poetica d'Arcadia.* Rome: Istituto Bibliografico Napoleone, 1994.

Corum, Robert. *Reading Boileau: An Integrative Study of the Early Satires.* West Lafayette, Indiana: Purdue University Press, 1998.

Crescimbeni, Giovanni Mario. *Breve notizia sullo stato antico e moderno dell'adunanza degli Arcadi.* Rome: Angelo dei Rossi, 1712.

————. *Prose degli Arcadi,* Rome: Angelo dei Rossi, 1718.

Dilworth, Ernest. *Selected Criticism: Boileau.* New York: Bobbs-Merrill, 1965.

Fubini, Mario, ed. *La Cultura illuministica in Italia.* Turin: Edizioni Radio italiana, 1957.

————. ed. "Riflessi culturali ideologici nella prosa del primo settecento," *Sensibilità e razionalità nel settecento,* ed. Vittore Branca. Florence: Sansoni, 1967.

Gombrich, E. H. "Norm and Form." The Stylistic Categoreis of Art History and their Origins in Renaissance Ideals, *Norm and Form. Studies in the Art of the Renaissance.* 2nd ed. London: Phaidon, 1971, 81–98.

Goodman, Dena. *The Republic of Letters: a Cultural History of the Enlightenment.* Ithaca, NY: Cornell University Press, 1994.

Kieven, Elisabeth. "Überlegungen zu Architektur und Ausstattung der Capella Corsini," *Studi sul Settecento: L'architettura da Clemente a Benedetto XIV – Pluralità di tendenze,* ed. Elisa Debenedetti. Rome: Bonsignori, 1989, 69–91.

Krantz, Émile. *Essai sur l'Esthétique de Descartes,* Paris: G. Baillière et cie, 1882.

Lotti, Luigi. "Cristina di Svezia, l'Arcadia e il Bosco Parrasio." *Quaderni dell'Alma Roma,* n. 16, Rome, 1977.

Maiorino, Giancarlo. *The Cornucopian Mind and the Baroque Unity of the Arts.* University Park: The Pennsylvania State University Press, 1990.

Maisak, Petra. *Arkadien.* Frankfurt am Main: Peter Lang, 1981.

Marchese, Riccardo and Andrea Grillini. *Scrittori e opere: Storia e antologia della letteratura italiana, 2: Il Settecento.* Florence: La Nuova Italia, 1986.

Mazzali, Ettore. *Barocco e Arcadia.* Milan: Nuova Accademia, 1964.

McGinness, Frederick J. *Right Thinking and Sacred Oratory in Counter-Reformation Rome.* Princeton, NJ: Princeton University Press, 1995.

Natali, Giulio. *L'Arcadia.* Rome: Istituto di Studi Romani, 1946.

Oeschslin, Werner. "'Barock:' Zu den negativen Kriterien der Begriffsbestimmung in klassizistischer und späterer Zeit," *Europäische Barock-Rezeption,* ed. Kalus Garber, Wolfenbütteler Arbeiten zur Barockforschung,

vol. 20 (Wiesbaden: Otto Harrassowitz, 1991), 2: 1225–45.

Pamplone, Antonella. "Pietro Bianchi tra Arcadia e neoclassicismo: un quadro inedito e riflessioni sul rapporto pittura-scultura," *Storia dell'Arte*, 1995, n. 84, pp. 244–268.

Piccolomini, Manfredi. *Il pensiero estetico di Gianvincenzo Gravina*. Ravenna: Longo, 1984.

Pietropaolo, Domenico. "La definizione della poesia nella *Ragion Poetica* del Gravina," *Quaderni d'italianistica* [Ottawa, Canadian Society for Italian Studies], 1985, 52–63.

Piromalli, Antonio. *L'Arcadia*. Palermo: Palumbo Editore, 1975.

Prandi, Alfonso, "Spiritualità e sensibilità," *Sensibilità e razionalità nel settecento* (Vittore Branca, ed.). Venice: Sansoni, 1967, 65–94.

Puppo, Mario. *Critica e linguistica del Settecento*, Verona: Fiorini, 1975.

Quondam, Amadeo. "La crisi dell'Arcadia," *Palatino*, XII, 2, 1968, 160–170.

———. *Filosofia della luce e luminosi nelle Egloghe del Gravina*. Naples: Guida, 1970.

———. "Problemi di critica arcadica," *Critica e storia letteraria (Studi offerti a M. Fubini)*. Padua: Liviana, 1970, 515–523.

Ranieri, Concetta. "Un edizione di poeti arcadi nel Carteggio tra G. M. Crescimbeni e B. Lippi in S. Maria in Cosmedin," *Roma moderna e contemporanea: rivista interdisciplinare di storia*, I. N. 3, 1993, 139–153.

Rinaldi, Alessandro. "Viaggio al Bosco Parrasio. L'Arcadia attraverso i giardini romani," *Gli orti farnesiani sul Palatino*, Rome: École française de Rome, 1990, 485–504.

Rudolph, Stella. *Niccolò Maria Pallavicini: L'ascesa al Tempio della Virtù attraverso il Mecenatismo*. Rome: Ugo Bozzi, 1995.

Sala di Felice, Elena. *L'Eta dell'Arcadia*. Palermo: Palumbo Editore, 1978.

Salviucci Insolera, Lidya. "La committenza del cardinale Pietro Ottoboni e gli artisti siciliani a Roma," *Artisti e mecenati: dipinti, disegni, sculture e carteggi nella Roma curiale*, ed. Elisa DeBenedetti. Rome: Bonsignori, 1996, pp. 37–57.

Segal, Charles Paul. *Landscape in Ovid's Metamorphoses: a study in the transformations of a literary symbol* (Hermes Einzeschriften, vol. 23). Wiesbaden: Franz Steiner Verlag GMBH, 1969.

Spesso, Marco. "Rapporti tra produzione letteraria e progettazione architettonica: l'ambiente arcadico romano intorno alla metà del xviii secolo: Salvi, Vanvitelli, Capponi, e Fuga," *Esperienza letteraria*, 1994, 91–100.

Tateo, Francesco. *"Per dire d'amore," Reimpiego della retorica antica da Dante agli Arcadi*. Naples: Edizioni scientifiche italiane, 1995.

Tintelnot, Hans. "Zur Gewinnung unserer Barockbegriffe," *Die Kunstformen des Baockzeitalters*, ed. Ruold Stamm (Munich: Leo Lehnen, 1956), 13–91.

Toffanin, Giuseppe. *L'Arcadia: saggio storico*. Bologna: Nicola Zanichelli, 1946.

Wittkower, Ruldof. "La teoria classica e la nuova sensibilità," *Sensibilità e razionalità nel settecento* (Vittore Branca, ed.). Venice: Sansoni, 1967, 7–23.

Waquet, Françoise. *Le modèle français et l'Italie savante (1660–1750)*, Rome: École française de Rome, 1989.

Wood, Allen G. *Literary Satire and Theory: A Study of Horace, Boileau, and Pope*. New York: Garland Publishing, 1985.

INDEX

Note: an <u>underlined</u> number indicates an illustration.